EARLY
NETHERLANDISH
TRIPTYCHS

CALIFORNIA STUDIES IN THE HISTORY OF ART
Walter Horn, General Editor
Advisory Board: H. W. Janson, Bates Lowry, Wolfgang Stechow

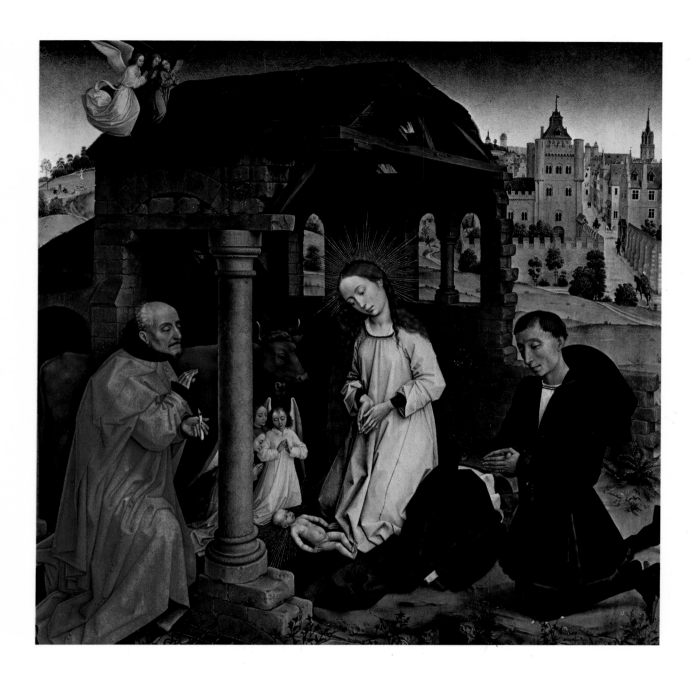

I. Rogier van der Weyden: Nativity, center panel of Bladelin altarpiece. Staatliche Museen Berlin, Gemäldegalerıe Dahlem.

EARLY NETHERLANDISH TRIPTYCHS

A STUDY IN PATRONAGE

SHIRLEY NEILSEN BLUM

University of California Press, Berkeley and Los Angeles 1969

University of California Press
Berkeley and Los Angeles, California
University of California Press, Ltd.
London, England

Early Netherlandish Triptychs is a volume
in the California Studies in the History of Art
sponsored in part by the
Samuel H. Kress Foundation

TO
K.M. B.

Acknowledgments

Of the many people who kindly helped in the preparation of this book I would like to thank especially Professors Robert A. Koch and Sixten Ringbom whose conscientious reading of the manuscript kept me from countless errors but at whose feet none of my present sins can possibly be laid; Mrs. Robin Jacoby whose patient and good-natured attention to the footnotes saved the manuscript from many a pitfall; and Professor F. Van Molle who kindly provided me with a ground plan of the Church of St. Peter in Louvain. I am most obliged to the many people at the Centre National de Recherches Primitifs Flamands in Brussels who allowed me to use all the material at their disposal and willingly gave of their intelligent advice. Generous grants from the University of California and the Woodrow Wilson Foundation made possible a full summer for research, a trip to Belgium, and many of the photographs and color plates in the book. And finally I shall always be indebted to Dr. and Mrs. M. L. Neilsen's private foundation dedicated to the continuing moral and financial support of their daughter.

Several of my former professors, perhaps unknowingly and with heretofore little expression of gratitude on my part, have had much to do with the formulation of this present study: Otto von Simson whose compelling lectures on Early Christian art afforded me my first glimpse of the vital meaning of religious art when seen within its original context; Joshua C. Taylor who put the tools of art history into my hands and then wisely turned me in the direction of the Renaissance; and most particularly Karl M. Birkmeyer whose patient guidance and continued willingness to share his erudition made this book possible. Originally I had intended also to express my gratitude to the late Dr. Erwin Panofsky. Although I never had the good fortune to know him, I have long been, like hundreds of others, a student of his in absentia. This study could not have been undertaken without his many publications in the Netherlandish field. As of today I must trust celestial messengers, surely the most reliable and certainly no strangers to Dr. Panofsky, to deliver my deep appreciation for the vast learning he so generously shared with us all.

S. N. B.

March 14, 1968

Contents

Illustrations

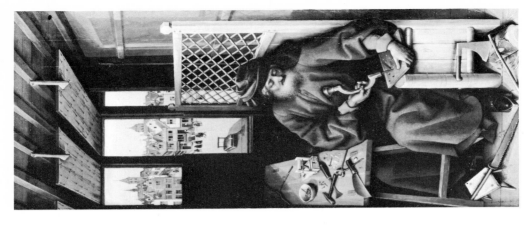

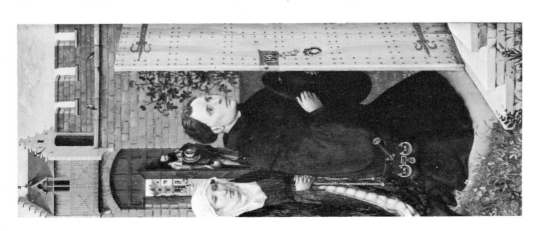

II. Robert Campin: *Mérode altarpiece.* New York, The Metropolitan Museum of Art, The Cloisters Collection, purchase.

1

The Emergence
of the Triptych

Within the stylistic and iconographic studies of Netherlandish painting of the fifteenth century, individual works have usually been considered part of the total oeuvre of an artist. The essential factor in placing and examining these works of art has been the stylistic development of the painter. The history of Netherlandish painting, therefore, is still the history of artists.[1] Even Panofsky's invaluable iconographic and stylistic discoveries are formulated primarily through a monographic treatment of the major painters of the period.[2] This traditional approach to the history of art as the history of artists is indispensable, but it is not sufficient, particularly for such a period. It lifts the object out of its original location and divorces it from its function, thus causing the work to become a vehicle for an art theory based upon an evolutionary principle. The painting loses the inherent autonomy that was created by its peculiar historical context and its donation.

The pervasive force of late medieval Christian iconography was strongly tempered during the fifteenth century by a new, active participation on the part of the donor. The nameless patronage of the Church began to be replaced by the sponsorship of finite personalities, men who were no longer necessarily clerical or royal personages. A new class of people came into existence whose demands for painting reflected their social prominence and their desire to emulate the royal households that had previously held the reins of secular patronage. Because of their wealth and power rather than their birth, these fledgling members of the middle class commissioned the finest artists of the time; they could now vie with kings for the services of such men as Van Eyck, Weyden, or Bouts. Though almost all these Netherlandish artists worked at some time for the Burgundian court, it is significant that their most important extant works were done either for bourgeois patrons or for large confraternities. One might cite here such examples as Jan and Hubert van Eyck's Ghent altarpiece (10, 11); Jan van Eyck's "Rolin Madonna" (9) or Dresden altarpiece; Rogier van der Weyden's "Descent from the Cross" (46), Beaune "Last Judgment" (V), or Bladelin altarpiece (13); Dieric Bouts's "Blessed Sacrament" triptych (51); or the Portinari altarpiece (IX) by Hugo van der Goes.[3]

Illustrations 10, 11, 9, 46, 13, 51
Plates V, IX

This new donor emerged as an aggressive personality who viewed his donation not as an anonymous gift given solely to the honor and glory of God, but as a gift that might, visually and iconographically, record his special part in the transaction. His personality no longer needed to be submerged in the communal glorification of God as it had been during the Middle Ages. He could not yet address God directly as his Protestant descendants would in another hundred years, but he had come to expect some personal recognition from the divine world. The donor believed that through his own works he might gain favor in the sight of God. He might build an entire hospital as did Rolin at Beaune, or pay for a tiny chapel in St. Jacques in Bruges as did Jean de Trompes, but his expectation was the same. Judged by the painting of the period, this new attitude on the part of the donor might best be described as a contractual agreement with the Godhead. The donor would do in this world as much as his money and conscience allowed; in return he expected to share the glories of the next world. Yet the paintings in which such desires are recorded are by no means secular in their effect. Chancellor Rolin's attitude when he confronts the Madonna in her heavenly palace is one of impeccable

Illustration 9 seriousness and unquestionable piety (9).[4] Rolin's devotion, however, no different from that of hundreds of generations of Christians before him, has now gained him access to the Virgin's chamber without the help of an intercessory saint and without qualifications of scale or generalized description of form. He is as large as the Virgin, and the portrayal of his face substantiates the fame of Flemish portraiture.

This new donor, as exemplified by Rolin, is neither nameless nor timid. He is the one to order the painting and thereby hire the artist, choose the location, and at least confirm the subject, if not order it directly. Usually his portrait appears within the work conjointly with the divine figures, and in almost the same scale. His particular wishes can be seen to subtly, and sometimes blatantly, transform familiar religious subjects.

Although Christian themes were augmented, revitalized, and reworked at a tremendous rate and with astounding variety during this period, the artists responsible were still subject to the demands of the donor and of the context of the painting, as well as to those of religious tradition. The artist's invention, now a prerequisite for the art of painting, was still qualified by iconographic custom and by the chosen location of the piece. Much of Netherlandish panel painting of the fifteenth century was not freed from its physical surroundings, despite such striking examples to the contrary as the "Arnolfini Double Portrait." Much of it was still intended for a religious setting, be it private chapel or public church, with which it must be in accord. Historical painting was very rare and pure genre painting did not exist, so far as we know. Although the art of portraiture was highly developed at this time, it was not the dominant mode of painting and often played only a minor role within a sacred work.

It is surprising that in formulating the iconography of many Netherlandish paintings so little attention has been given to the critical role of the donor, the occasion of the commission, and the intended physical setting.[5] The obvious difficulty of this approach is that of complete documentation. One must know not only the artist and the subject,

as we do in most cases, but also the donor and the location of each work, as we rarely do. Few works have such complete documentation. Those that do are most frequently large public altarpieces. Because they were destined for a major church and given by a prominent citizen, the records for these paintings are often found within the city archives. These altarpieces are usually triptychs or polyptychs with movable wings that cover the interior representations. The numerous diptychs in which we can identify the donor constitute the major exception to this type of documented altarpiece. Because diptychs record the donor's private adoration of Christ and the Virgin, they cannot be used to trace the more complicated interplay between the donation and the creation of a public altarpiece. They rely on one simple iconographic formula, which is not conditioned by a specified location.[6] The other extant type of documented painting which is not in the form of a movable altarpiece is the single panel with donor, such as Jan van Eyck's "Rolin Madonna," or his "Madonna of Canon Van der Paele," or Campin's "Madonna in Glory" at Aix-en-Provence. A study of any of these panels, as well as of the movable altarpieces, should further our knowledge of the relationship between donation and artifact.

This study, however, is concerned only with altarpieces in the form of triptychs, which contain three hinged panels: a central panel and two side panels called wings. Since each wing is half the width of the center panel, when both wings are closed they completely cover the interior painted surface. In the triptych there is a distinct separation between two entirely different visual fields: the exterior representation, which is always on the obverse of the two wings,[7] and the interior representation, which covers all three interior panels. In some instances these altarpieces might be more correctly called polyptychs, for their wings or center panels sometimes are made up of more than one panel, and infrequently there are two sets of wings.[8] These polyptychs, however, function in the same manner as the triptych in that their total iconographic program can never be seen at one time, for they contain separate interior and exterior images. Because single panels and pseudotriptychs do not operate in the same way as polyptychs and triptychs, they are not discussed. They are different in kind, for their whole pictorial statement is always visible; they are not additive in form. Through the triptych alone we shall trace the relationship between artist, donor, sacred subject, and physical context.

In the fifteenth century in the North when the art of painting was freed from the manuscript, it often had to carry an iconographic program that had formerly been found in architecture and sculpture.[9] The new painted image was no longer supplementary or even complementary to a text. Instead its entire content was restricted to the visual field of representation. Panel painting did not inherently have such architectural divisions as portal, apse, pier, or window to aid in its iconographic explanation. The triptych form was an expedient means of solving the new problems confronting the panel painter. By using it, he did not have to face immediately the prospect of condensing a total thought realm onto a single panel. The tryptych afforded him a series of units on which he might

continue to weave his many patterns around the life of Christ and the saints. The lack of coordination of the parts and the multiplicity of the units not only accommodated, but actually encouraged, his still medieval, analogical spirit of addition and repetition. It suggested a hierarchy of presentation, which he understood and utilized. The exterior, which is seen first, is preparatory in nature and less complicated in form. The interior is twice as large and has a deeper sense of mystery, since it is both hidden and revealed by the wings. Hence the artist portrayed the primary image or idea on the interior and used the wings as a complement, a lesser foil in the sacred hierarchy, as they were in the physical scheme. The triptych form easily served as a transitional structure to bridge the interval between the predominance of architectural sculpture in the late Middle Ages and the predominance of panel painting which characterized the Renaissance.[10]

The triptych form, particularly in large scale, re-created certain experiences that had previously been found in medieval architecture. The spectator sees both an exterior and an interior setting; the terms themselves are derived from the language of architectural description. He first contemplates the exterior, which is less complex than the interior because it is smaller in size and simpler in iconography. When he passes from the exterior to the interior, just as when he passes through a portal, the content and form of the exterior can be retained only in his memory, for a new visual realm is disclosed. As this new realm appears, the spectator is asked to make a careful, step-by-step progression through it. He is not visually led by a series of driving orthogonals to a single point of reference which contains the nexus of the subject. Instead his attention is drawn toward the central panel, which is larger and carries the most important scene in the hieratical sense. It does not stand alone, however, and in fact often includes more than one representation. Rather than being immediately apparent, the iconography unfolds slowly. The spectator must move through the central panel and then through the two wings. As in a medieval church, the total thought realm is not revealed until all the parts have been experienced. Only in the mental synthesis of the interior and exterior is the full content comprehended.

In a frescoed chapel or a Gothic cathedral the spectator is compelled to move physically through the space. He sets his frame of reference by his position and ambulation. The iconography and the physical layout give him his general direction or set his course. But since he is always smaller than that which surrounds him, he must realize slowly, part by part, the architectural units that contain the visual expression. Before the triptych the spectator remains fixed. He is closer in size to the object that he confronts and he is not physically surrounded by it. The framing device must be his guide, for it is the basic means of separation between the real and the unreal space. It helps to establish the extent of the viewer's inclusion and exclusion from the pictorial world.[11] The triptych is as demanding of its viewer as is an edifice, although in a less complex and dramatic way. The viewer is limited to a fixed pattern of viewing, a pattern that is sequentially ordered in both time and significance. The parts are unified by their adherence to an

expression of a particular Christian concept. In respect to such mental and visual peripatetics the experience may be likened to that of architectural space in which the eye can never encompass the total. In the unification by analogical thought units rather than by visual logic, the iconography of the triptych may be likened to the expression of medieval architectural iconography.

The essentially additive and hierarchical nature of the triptych with its many panels and visual fields made it uniquely suitable for a period whose thought was still largely medieval in its content and symbolism. In Netherlandish painting theological concepts are the predominant principle of visual congruency, for an aggregate of finite objects still find homogeneity in an idea. Like the medieval artists before them, the Flemish painters were not restricted by a necessary agreement between the temporal and the spatial realm. Their time was that of eternity; their space that of infinity. Phenomena found their beginnings in this world but could be combined and visually re-created apart from or in spite of their natural setting. There is a new correctness in the parts and in the objects, but not necessarily in their spatial surroundings or in their relation to one another. Congruity between the subject and its environment was not a prerequisite for the representation. Although God was thought to be reflected in every living thing, His reflection was not forced to conform to the natural laws of all living things. In the Netherlands until the last third of the fifteenth century, the natural world remained in the service of the spiritual world. Correspondingly, it was not until this late period that the triptych with its multiple units became an anachronistic and awkward form.[12]

In the South during the fourteenth century the triptych was most popular in Gothic Siena and Florence.[13] By the beginning of the fifteenth century, it had become an archaic form in Italy. Only such men as Monaco, Sasetta, and Fra Angelico still used the movable triptych. These were not the men who were primarily concerned with the impact of a theoretically devised rationalization of space brought about by the early discovery of mathematical perspective. As soon as focal-point perspective became the major requirement of easel painting, the movable triptych became cumbersome, for it did not permit a rigorously organized single unit of space. Either the wings had to be treated as smaller, separate spatial units, each with its own focal point, or they had to be included in the mathematical layout of the central panel. In the former instance, the finished product exhibited three focal points—a distracting and unsatisfactory solution for the fifteenth-century Italian painter enchanted by the consistent illusionistic unit. In the latter, the necessary hinged division of the panels disrupted the total organization, creating a caesura unnatural to the logic of true perspective. The duality between the interior and the exterior further defeated the possibility of a single spatial realm. The exterior presented an added problem: if it was treated as a single symmetrical unit, the focal point necessarily fell upon the crack. If the "function of the painter," as Alberti defined it, is "to describe with lines and to tint with colour on whatever panel or wall is given him, similar observed planes of any body so that at a certain distance and in a certain position from the centre they appear in relief and seem to have mass," [14] and perspective is

the means used to unify the spatial realm for this subject or "body," then the convergence of the orthogonals on the crack or enframement would lead to some confusion between the surface being transformed and the physical frame surrounding it and separating it from reality. It would exemplify a total misunderstanding of the function of perspective, as Alberti understood it, for, in this instance, it would confuse rather than clarify. In short, it would have been an absurd solution. These many difficulties made the movable triptych anathema to the early Renaissance painters in Italy. Although men like Baldovinetti or Perugino might use the pseudotriptych form—that is, a three-part painting whose wings did not fold but remained fixed, thereby maintaining one visual plane—the true triptych became a rarity in the hands of the "progressive" painters.

The Netherlands in the fifteenth century did not follow the Southern pattern of a fully developed artificial-perspective system, which was enthusiastically employed by almost every painter. The North had no counterpart to that "favorable conspiracy of events found in Florence in the early fifteenth century." [15] The Northern artists were not committed to an unqualified naturalism in which "the painter has nothing to do with things that are not visible. The painter is concerned solely with representing what can be seen." [16] This was not their criterion, but Alberti's. Their growing naturalistic style was still in the service of a symbolic subject matter, which was to convey moral and religious truths above all else. The rationalization of space was a slow internal development coming through visual experimentation and empirical approximation, rather than a mathematical theory developed early in the century by an architect. Consequently the final realization of an artificial-perspective system occurred later in the North than it did in Italy.[17]

The popularity of the triptych in the North is evidenced by the large number of triptychs painted by the Netherlandish masters. From the inception of the style that we have come to associate with the *ars nova* of Melchior Broederlam,[18] every artist used the triptych and many used it frequently. Robert Campin, for example, painted the early Seilern triptych, the Mérode altarpiece, and the lost "Descent" triptych. Jan van Eyck's most famous painting, the Ghent altarpiece, is in the form of a large triptych. He also painted the tiny triptych of the "Madonna Enthroned" in Dresden and began the triptych of Nicolas van Maelbeke. Rogier van der Weyden also used the triptych frequently: the Vienna triptych, the "Last Judgment" altarpiece in Beaune, the "Columba" altarpiece, the Bladelin altarpiece, and the Jean Braque triptych. The form was also utilized by his close followers, as in the Edelheer Master's "Descent" triptych, the Sforza triptych, the Abegg altarpiece, and numerous examples of the Virgin and Child theme.[19] Similar multiple examples can be cited for virtually every painter of this period. The only man who did not use the form to any great extent, or perhaps at all, was Petrus Christus, although possibly the two altar wings in Berlin attributed to him were once part of a triptych.[20] Christus, the artist most concerned with focal-point perspective in the Netherlands, the Piero della Francesca of the North, as De Tolnay

called him,[21] is the one artist who left no complete triptych. He found the form as illogical as did his fifteenth-century Southern contemporaries.

Although more than one hundred extant triptychs were painted in the Netherlands during the fifteenth century, the donor and location of very few are known.[22] In every instance in which this information is known, we find that the triptych was intimately connected with its architectural environment. The frame was only the container for the painted scene. The setting and the purpose were the true context of the painting, for they explain the inherent and projected meanings of the object. The triptych functioned as an altar painting to consecrate, localize, and unify all the sacred references in the chapel or church. Although the subject matter of these triptychs is pictorially confined within the format of the painting, their total meaning can never be fully understood until the original synthesis of object and environment is re-created. Without this additional information we are left with a painting that may be physically intact but is conceptually always a fragment.

This study examines only eleven of these altarpieces. Of these eleven, Rogier van der Weyden painted three between 1440 and 1460; a follower or student of his painted one before 1444; Dieric Bouts painted two during the 1460's; Hugo van der Goes painted one at the beginning of the fourth quarter of the century; Hans Memlinc painted three, which span the last thirty years of the century; and Gerard David painted one just at the turn of the century. Thus the works examined cover the last seventy-five years of the century; at least one work is discussed for each ten-year period. Almost every major artist painting during that time is well represented. Lamentably, the work of Robert Campin and Jan van Eyck must be discussed only in general terms. There is not sufficient documentation for any of their extant triptychs to justify their inclusion in this context.[23]

Even though one can determine its infancy, Northern Renaissance painting, like Southern Renaissance painting, seems to have been born in its maturity. Robert Campin's style was surely formed from the highly developed manuscript tradition of the time and from the contemporary sculptural tradition as found in his native city of Tournai and in the work of Claus Sluter. Even so, Campin's first works inaugurate a new style, anticipated but never consummated by these Franco-Flemish masters of carved stone and illumination. With the arrival of Van Eyck and Campin, Netherlandish painting assumed the iconographic order and plasticity that had been largely the province of sculpture during the preceding Gothic period. There was no concurrent sculptural exploration in the fifteenth century which continued Sluter's innovations or paralleled those of panel painting.

Throughout his career Campin's works took the form of multiple panels: the Seilern triptych (1); the "Betrothal of the Virgin," which was probably the wing of a triptych *Illustration 1*

*Illustrations
2, 5, 47
Plate II*
or perhaps a diptych (2); [24] the Mérode altarpiece (II); the "Descent from the Cross" triptych, a copy of which is now in Liverpool (5); the three large panels now found in Frankfurt of the "Virgin and the Child," "St. Veronica," and the "Trinity" (47), which may all have been part of one large altarpiece; [25] the two wings that remain of the Werl altarpiece in the Prado Museum and the Leningrad diptych. Of Campin's major extant works, only the Dijon "Nativity," the "Madonna of Humility," and the Madonna in Aix-en-Provence were single panel paintings. Unlike his Southern contemporaries, Campin, one of the founders of Netherlandish painting, found the movable altarpiece a suitable and usable form, if not a preferable one.

The popularity of the double or triple panel in the work of Campin must stem partly from his continuation of the complex iconographic programs that were part of his artistic inheritance. Until about 1430, Campin's pictorial surface presented a *horror vacui*, which was filled not merely with objects, but with objects that carried a meaning apart from their literal identity. He achieved more subject matter per square inch of panel than any other Netherlandish painter except, at times, Jan van Eyck.

Illustration 1
Campin's preference for symbolic density can be seen in one of his earliest (if not the earliest) paintings, the Seilern triptych (1). Here the multiplicity of subjects does not take the form of disguised symbols, as it does in the "Betrothal of the Virgin" or the Mérode altarpiece, but it is manifest through iconographic overlap. Although rightfully called an "Entombment," the Seilern triptych presents a large part of the whole Passion cycle. In the center panel Christ is held above the tomb, rather unnaturally upon his shroud, by the Virgin, Joseph of Arimathea, Nicodemus, and one of the Marys. The semicircle around the body of Christ is completed by St. John who supports the Virgin, St. Veronica, and the Magdalen who is anointing Christ's feet. The Entombment thus includes the Lamentation or the Last Farewell of the Virgin and the Anointing of the Body. The Road to Calvary is suggested by the presence of Veronica and the Crucifixion is alluded to by the spear, the sponge, the crown of thorns, and the nails held by angels—scenes that are again recalled in the left wing, where the Mount of Golgotha appears with its three crosses. A ladder, leaning prominently against the center, empty cross, fills in the missing scene of the Deposition.[26] In the right wing the theme of Christ's Passion is replaced by His triumph in the Resurrection.

In the center panel particularly, Campin presents a paradox. At first we behold one scene of the mourning over Christ's death at the time of His burial. Yet the inclusion of the extra figures, Veronica and the angels, detracts from the historical reality of the scene. The crown of thorns and the nails have already become *arma christi* held as symbols of victory by heaven-born angels rather than by Roman soldiers. Similarly Veronica's veil is displayed as a symbol; it has fulfilled its historical function and has become a sacred relic.[27]

Also by the compositional arrangement of the center panel, Campin has taken the Entombment out of a reasonable temporal context. It is set against a gold sky, which is continuous throughout all three panels. The gold background, however, is more dra-

matic and space displacing in the center panel. By carefully locating all the figures who form the back row behind Christ on an inclined plane, by exaggerating their scale so that they do not conform to their position in space (compare their scale to that of the soldiers who appear at about the same level in the middle ground of the right wing), and by allowing their bodies to cover the horizon line, the scene in the center panel is made to appear much closer to the spectator and less fully realized in space than the scenes found in the wings. There is no evidence of the rather long, though tilted, recession of space found on the two wings. The figures are so grouped around the tomb that they purposefully expose Christ's body. Physically and iconographically, Campin has skillfully removed the center scene from a more logical narrative connotation. He emphasizes its higher order of reality by contrasting it with the more "correct" sequence, both historical and physical, which takes place on the wings.

The Entombment might be interpreted as a scene in which the devotional or symbolic meaning and the historical event are interwoven so closely as to be inseparable. It is as if Campin visualized or actualized the most sacred moment of the Mass while painting an Entombment. The tomb becomes the altar supporting the Body and Blood of the dead Christ. The Eucharistic elements are sanctified by the corporal, represented in its original form by the shroud. The Sacrifice, because it is the actual rather than the symbolic one, is attended by angels, the guardians of the Easter sepulcher. The one on the right is dressed as an assistant minister in an alb; his crossed stole signifies that he is about to celebrate Mass. Both angels carry the signs of Christ's martyrdom. The scene is performed before us and the donor. It is extended forward, and Christ's body is turned outward for our comprehension. We view the true meaning of the Mass in its incarnate form. This early work demonstrates an iconographic concern that is uniquely Campinesque. The artist dramatizes a religious subject in such a way that both its physical roots within Christian history and its sacred meaning as codified by Christian liturgy are equally apparent. The transitory historical moment and the permanent ideograph are captured simultaneously.

In the same way that Campin actualized the Sacrifice of the Mass in the Seilern triptych, he actualized the mystery of the Incarnation in the Mérode altarpiece (3). He *Illustration 3* shows the Annunciation, not as a completed event, but as one that is still in progress as the name suggests—a preliminary statement of a coming event. Campin's Virgin does not yet see the angel, for God and his messenger have permeated only half the room: the Holy Spirit has pierced the window, snuffed out the candle, and ruffled the pages of the Old Testament, but has progressed no farther. Gabriel still seeks Mary's attention for he does not yet hold up his hand in a fixed gesture of blessing. The quickening movement of the left side of the panel contrasts with the tranquillity on the right. Mary remains mute, absorbed in her reading; the fireplace behind her is without flame; the candle holder above her head is without taper. The moving diagonals of the left have been replaced by quiet verticals. We witness the angelic entrance, not the Virginal response. We know the Incarnation has not taken place, but we do not question its ultimate

achievement. Within the humble, worthy vessel of the Virgin, a flame will, within the very next moment, be kindled. I know of no other Annunciation that so visualizes the *process* of the Incarnation.[28] In the Mérode "Annunciation," as in the Seilern "Entombment," the historical occurrence and the eternal symbol are equally present.

Illustration 2 Similarly in the "Betrothal of the Virgin" (2), Campin explains visually that, although the union of Joseph and Mary is achieved, man's salvation is not yet accomplished. This is the most literal meaning of the scene. The ceremony takes place outside the door of a cathedral. Only the priest and Joseph are included beneath the archivolt. The Virgin remains without, accompanied on her right and left by two small beings who seem to be angels of the same wingless variety as those who sing with such conviction atop the Ghent altarpiece. Mary's role at the time of the Betrothal and that of the New Church, represented by the rising portal, are comparable in that both are incomplete. Their consummation is attendant upon the birth of Christ. As the portal marks the entry to the more sacred sanctuary, the Betrothal is the prelude to the most sacred event. The church portal that shelters the Betrothal is more finished than the eastern, apsidal end. The apse of the Gothic church is just beginning to take form around the old temple for the cathedral, or the New Church, will enclose the entire Old Testament world, incorporating it rather than replacing it. Thus the Old Order is made to stand at the very heart of the New. The steps leading into the Old Testament temple have just been laid, and buttresses are rising around it. The building program will continue, as will the life of the Virgin, until both their destinies have been fulfilled.

In contrast, Van Eyck was not concerned with recording the process or the visible formulation of religious dogmas. He presents them as completed facts. Although the

Illustrations architecture of his Mellon "Annunciation" (4) and Hubert van Eyck's (?) Friedsam
4, 6 "Annunciation" (6) include both the old Romanesque and the new Gothic, they are part of a single unified system.[29] The ecclesiastical setting is as complete and established as the event itself. They are twofold only in idea; in time and space they are one. The Madonna hears the words of the angel and responds appropriately. Like the architecture, the drama is already a part of a higher order of being, in sharp contrast with Campin's world of becoming.

When Campin used the triptych as a vehicle for his expansive, but also concentrated, iconographic program, he always used the form in its traditional hieratic sense. He maintained the prominence of the center panel for the major devotional scene. He kept this central scene within its own separate spatial situation, never allowing the wings to become a perfect extension of the central space. In the Seilern altarpiece Campin drastically changed the viewpoint between the wings and the center panel. Throughout the Mérode

Plate II altarpiece (II) he implied an explicit hierarchy of levels from panel to panel. The center panel depicts a room that is physically the highest, for one sees only blue sky and clouds from the windows of the Virgin's chamber. St. Joseph's room on the right wing is on a lower level. Though it is still above the city, from it one can see people, houses, and streets below. And finally the donors on the left wing kneel on the ground within a garden.

Although the door to the Virgin's chamber is opened to them, they cannot see her. Not only is her room above their level, but the door that opens into their panel is not hinged convincingly, opening in such a way as to obstruct their vision. The donors' attention is directed toward the Madonna, but they can see her only spiritually.

The inconsistency seen at the framing edge between the left wing and the center panel is also present on the right. St. Joseph is absorbed in his work within a room whose focal points fall in the upper left-hand corner of the space, strongly inclining the room toward the center scene. There is no wall in front of Joseph, but his space is terminated by the frame. Although the room is perspectively oriented toward the center panel, both laterally and vertically it is located in a different and lesser position. In the Seilern triptych and in a more complex fashion in the Mérode altarpiece, the left and right wings are related to the center panel but are separated spatially. Their spatial differentiation underscores their secondary symbolic role.

Although we can briefly discuss Campin's organization for the interior of triptychs, unfortunately we have no exterior representations on the wings of these two remaining complete triptychs. We can only draw some conclusions from the painting on the reverse of fragments: the "Betrothal of the Virgin," the exterior wings of the copy of the "Deposition" triptych in Liverpool, and perhaps from the "Trinity" in Frankfurt.[30] In all these paintings Campin used grisaille, a technique that has since his time been associated with the exterior of altarpieces, although the reasons for its use are not yet fully understood.[31] Campin's use of grisaille dramatizes the essential difference between the anticipatory, simple exterior and the complex interior representation. He preferred individual standing saints for the exterior: SS. James and Clare appear on the back of the "Betrothal" and SS. Julien and John the Baptist on the back of the Liverpool "Descent." [32] In the few remaining exterior representations Campin did not tie the exterior closely to the thematic content of the interior. Nor did he use the compounded iconographic overlap typical of his interior scenes. Instead the chosen saints probably incorporate the dedication of the church or chapel for which the painting was commissioned and/or the specific patrons of the donor, nothing more.

In all the extant examples, Campin placed his donors close to the main theme as witnesses to the holy event. They are located on the interior, rather than the exterior where the main theme would be invisible to them. By placing the donors on the left wing, the preferred side in a religious scheme, Campin followed an older tradition, which was then generally continued throughout the century.[33] In the Mérode altarpiece and the Seilern triptych, the donors are allowed to adore the event without the mediation of a saint. The loss of a saintly intercessor is in keeping with Campin's direct reenactment of the process of the event. Both the donor and the viewer should see the scene as immediately as it is portrayed. The presence of a saint would detract from the re-creation of the scene, making its symbolic aspect too pronounced; the simultaneity of event and symbol so miraculously balanced by Campin would be upset. Only after 1430 did Campin more readily accept an intermediary saint as, for example, in the Werl altarpiece or the Ma-

donna in Aix-en-Provence. But by this time Campin had come under the spell of Jan van Eyck, and the character of his work had changed substantially.

Although the donors in Campin's paintings are present at the sacred event, they are not active participants in that their presence does not dramatically change the iconography, as it does in triptychs by Rogier van der Weyden. They are usually in the same scale as the divine figures and in a comparable, but less favored, space. Many physical, but few ideological, concessions are made to them. Although the donor may have stipulated the iconography for the Mérode "Annunciation" and may have even had something to say about the complexity of the Seilern "Entombment," the effect of his personal will is not recorded within the pictures. A more complete documentation would lead us to the person most responsible for the iconographic innovations, Campin or the patron. But we do not need this information to realize that the donor for Campin was still a passive participant within the iconographic scheme, though not within the pictorial space.

*Illustrations
7, 9, 8*

The role of the donor as an adoring vessel within the scene is retained by Jan van Eyck, as demonstrated in such pictures as the "Madonna Enthroned" in Dresden (7), the "Rolin Madonna" (9), the "Madonna of Canon Van der Paele" (8), the unfinished Maelbeke altarpiece, and the "Madonna of Jan Vos," probably finished by Christus.[34] In all these paintings the donors kneel in adoration before the Virgin, either with or without their patron saints. They are allowed an even closer contact with the divine object than are Campin's donors, frequently sharing the divinity's ground on the same panel. But the relationship between the adorer and the adored is strictly contemplative, as is the overall iconography. Van Eyck's donors do not watch such emotionally charged scenes as the Entombment. In fact, donors generally are not included in those scenes that come from the historical life of Christ. Repeatedly Van Eyck's patrons kneel before the Virgin and Child presented within an ecclesiastical setting. Instead of re-creating the historical incident as a living dogma, Van Eyck brings to life the essence of personal veneration.

Early in his career Van Eyck developed new iconic symbols of adoration. By equating the Virgin with the church edifice in the Berlin "Madonna in the Church," he expressed an abstract concept organically through the figure and inorganically through the structure.[35] Van Eyck also identified the Madonna with the altar of the church. She became in such paintings as the "Madonna of Canon Van der Paele" and the Dresden Madonna, the true *Ara coeli* appearing in earthly form in place of the altar within a man-made church. She is literally the tabernacle for the Body and Blood of Christ.[36] Van Eyck gave liturgical furniture human form and substance by making an architectural monument and a living being coexist. This is Van Eyck's unique realm of incongruity, quite different from that of Campin, but having finally the same powerful effect. The inventions of both men dramatize the religious subject by startling naturalistic innovations and juxtapositions. Verisimilitude of style charges the more familiar Christian images. The physical energy of the description intensifies rather than reduces the sacred content.

*Illustrations
9, 8*

In the "Rolin Madonna" (9) and the "Madonna of Canon Van der Paele" (8), Van Eyck records a further development in the relationship between patron and painting. In

both these pictures the donor, though contemplative and properly humble, is no longer relegated to a minor physical position within the composition. Unlike Campin's donors, he now plays a major role within the compositional and iconographic arrangement. The entire left side of the "Rolin Madonna" partakes of the iconography of mortality and sin. The capital reliefs of the Expulsion, Cain and Abel, and the Drunkenness of Noah all show man trespassing against God, in dire need of salvation.[37] The column in front of Rolin (the only one whose base can be seen) crushes two rabbits, symbolic of sin because of their promiscuity. The iris, the symbol of Christ's Passion, grows on Rolin's side of the Virginal garden. Even though this is the Virgin's palace, half the space has been qualified for and by Chancellor Rolin. In a less subtle fashion Canon Van der Paele has controlled the selection of the saints who appear with him in the "Madonna of Canon Van der Paele." St. George is his name patron and St. Donatian the patron of his church in Bruges.[38] The static equilibrium of the picture has been achieved in spite of the Canon's presence. For what appears to be an "inexorably symmetrical" scheme is a product of the intricate adjustment of all the figures in order to overcome and equalize the large asymmetrical force of the kneeling Canon. The only triptych by Van Eyck in which the donor occupies this same intimate position in relation to the Virgin is the unfinished altarpiece for Nicolas van Maelbeke. In this painting Canon Maelbeke kneels in the center panel before the Virgin without even the separating device of a *prie-dieu*. A phylactery has been introduced, however, which automatically returns the painting to the world of the symbolic.

It is important to realize that in Van Eyck's work even when the donor is allowed to become part of the sacred space he is never in an equal relationship with the Virgin and Christ. One of the devices Van Eyck frequently used, as did Campin in the "Madonna in Glory" in Aix-en-Provence, was to forbid the living figures actually to behold the Virgin. The Augustinian abbot in Campin's picture looks toward St. Peter, and Canon Van der Paele looks at and is introduced to St. Donatian. This device creates an almost magical suspension of the Virgin, who seems at once to appear to us and to disappear before the donor. It is only one of the many ways in which Van Eyck masquerades the seemingly logical extension of his spatial settings.

One might further suggest that the donor had substantial effect on the scale of a few of Van Eyck's pictures. Most of his painting is diminutive in size, though he did paint some very large works. Every one of his larger paintings was commissioned by an important public figure. Apparently when Van Eyck encountered such prodigious and insurmountable forces as Chancellor Rolin, Canon Van der Paele, Provost Van Maelbeke, and, above all, Jodocus Vyd, he produced works much grander in scale than those of his usual modest size.

No other work in Netherlandish painting seems so destined for pictorial immortality as the Ghent altarpiece, the largest and the grandest triptych (polyptych) of them all (10, 11).[39] Jodocus Vyd, who commissioned the altarpiece, kneels before St. John the Baptist. His wife, Isabel Borluut, kneels on the right side, addressing her devotions to St. John the Evangelist. In order to separate the secular from the saintly, Van Eyck used

*Illustrations
10, 11*

full color for the donors and put them into a larger spatial context, whereas he used grisaille for the saints, who stand like statues within very shallow niches. There is again no narrative connection between the patron and the donor; their only connection is that of veneration. The saints, instead of being the name patrons of the donors, reflect a more specific tie to the physical location of the altarpiece. St. John the Baptist was the titular patron of the church for which the altarpiece was intended, as the church in Ghent was not dedicated to St. Bavon until 1540. St. John the Evangelist must have been a special patron of Jodocus, for the chapel in which the painting was placed was probably under his patronage. The altarpiece was dedicated on St. John's feast day, May 6, 1432.[40] Thus the lower zone records the time of the dedication, the location of the altarpiece through the presence of the dedicatory saints of the chapel and the church, and the people for whom the work was commissioned. Like an inscription or a chronicle, this lower zone pictorially localizes the painting in time, place, and donation. Because of its specific and more worldly nature, this zone is the lowest, the closest to the earth.

The zone above presents the Annunciation, iconographically and formally the most important representation on the exterior. Taken from the New Testament, the scene appears in the center and covers a larger area than any other exterior scene. It is not painted in grisaille, as are the divine figures in the lower zone, but its tonality is muted. The devotional aspects of this Annunciation, even though placed in a Flemish interior in the manner of Campin, are as obviously emphasized as they were in the lower zone. Unlike Campin's "Annunciation," very few narrative details clutter the expanse of the empty room. It cannot be confused with a fifteenth-century Flemish house. Moreover, the divine figures are made to appear abnormally large. The mathematical laws of perspective do not determine the scale of these divine beings.

Whereas this scene of the Annunciation is a preparation for the interior, paradisiacal vision, above the Annunciation appear four figures who in turn prepare the world *sub lege* for the coming of Christ: Zachariah, the Erythrean sibyl, Micah, and the Cumean sibyl kneel or rest their elbows on the roof of the Virgin's room. In order to make their purpose absolutely clear, Van Eyck endows them with phylacteries, which give the exact words of their prophecy.

All three zones present different periods in time, from the world of the Old Testament to the world of the fifteenth century. The three architectural zones of the triptych act as divisions by providing physical distinctions between the time prior to the coming of Christ, the era of the New Testament, and the present. The frames become the separating members like the jambs and lintel of a cathedral. Van Eyck, like Campin, views the triptych or polyptych arrangement as an expedient solution for the unfolding of diverse iconographic ideas upon a single painted surface. The divisions of the format are basic to the iconographic interpretation.

The same theme continues when the great doors are opened and the promise of the exterior is fulfilled in the two-storied Paradise that confronts the beholder. The interior, unlike the exterior, is divided into two zones; the exterior realm of promise (the Annuncia-

tion, the prophets, and the sibyls) has become one. The upper zone on the interior contains the major sacred figures: God the Father, the Virgin, John the Baptist, and the angels. In it each panel contains a separate figure or group of figures, thus making each panel division accord with a separate idea. In the lower zone the separation between the panels is less abrupt, for they, in contrast with the upper zone, are painted as if they made up one scene. But within this single scene of the Adoration of All Saints before the Mystic Lamb, the major panel divisions still prevail as an explication of the iconography. The Just Judges, the Knights, the Pilgrims, and the Hermits are grouped together on four individual panels.

Although we do not know who was responsible for the confounding iconography of the interior, it must have been prompted in part by the funerary function of the altarpiece. It was to serve as the major painting within the Vyd chapel. The Van Eycks have given Vyd and his wife the most hopeful, positive assurance of man's salvation, having extended an All Saints' Day picture to include all mankind. As if to underscore the message of ultimate salvation, Jan van Eyck, in an unprecedented gesture, added the nearly life-size figures of Adam and Eve to the upper, most sacred, zone. The two persons responsible for the sins of man have been raised in their pure state of nudity to the level of God and the Virgin. Symbolically they stand for the possible salvation of all mortals.

A few specific motifs within the painting may help to make more concrete its location in the Vyd chapel and its direct connection with Vyd and his wife. In the wing panel to the far left, four of the Just Judges may bear the likenesses of the four counts of Flanders: Philip the Bold, Louis de Mâle, John the Fearless, and Philip the Good.[41] They are impersonating the secular judges riding through Paradise to worship the Mystic Lamb. On the far-right wing, the saint behind the giant St. Christopher, who wears a pilgrim's hat with a shell, has been identified by Panofsky as St. James Major. He may, however, be St. Just, a pilgrim saint with the same attributes as St. James Major, but more suited to this altarpiece as the name patron of Jodocus Vyd.[42] Among the martyrs on the far right of the center panel, St. Lieven, patron of Ghent, can be identified by the gruesome attribute he holds—a pair of pinchers securely grasping a tongue.[43] All these figures may well represent an attempt to relate the theme of the Adoration of the Lamb to the Burgundian dynasty, to the city of Ghent, and probably to Vyd himself.

Based upon the work of Marijnissen and De Schryver,[44] Panofsky has assumed that the triptych was originally placed in the crypt of St. John (St. Bavon), in a chapel directly below the one in the upper church where the altarpiece now stands. In the early part of the fifteenth century the whole apse end of the church was enlarged. Both the fourteenth-century crypt and the upper church were affected by this remodeling.[45] Vyd contributed at least one new chapel, of which there is a record, as his part in the building program. It was probably not the chapel in the crypt as De Schryver and Marijnissen first thought, but the one in the upper church.[46] The Vyds were never buried in their chapel, although in 1435 they arranged to have Masses said on their behalf before their altar. De Schryver has had some second thoughts about his placing the altarpiece in the crypt.[47] Since the writing of his article, he has pointed out that in 1886 De Potter cited in a description of epitaphs

from St. Bavon, recorded between 1455 and 1558, the following sentence regarding the location of the Vyd altarpiece: "Item: in the first chapel near the stairs in which the retable of Adam and Eve stood." [48] This location could refer only to the chapel near the stairs in the upper church. There are no stairs in the crypt. The altarpiece would have been extremely large for the crypt chapel, and there would have been some difficulty in opening it there. Furthermore, since it was a major painting, recognized as a masterwork at that time, one would think it might have been exposed in a more public place, better suited to its size and importance.[49]

Whether in the upper or lower church, the Ghent altarpiece represents the first fifteenth-century example of a triptych whose donation and destination are known. Although fraught with problematic issues, it presents a unity consistent with that found in other triptychs of the period. The requirements of the purpose and the location of the piece overcame the difficulties of combining into a single altarpiece two or even three previous paintings done by two different artists. Neither the donor nor the artist seemed reluctant to undertake such a project. The success of the final work was dependent upon iconological unity. This unity took precedence over discrepancies in the size of individual panels, the scale of figures, and duplexity of hand. If the painting could portray the patron's part in the donation, his chosen dedicatory saints, and an appropriate subject in beautiful forms which could be seen and understood, it had performed its function more than adequately. Surely the first generations who viewed this work were not merely in awe of the remarkable technique or the glistening beauty of the piece alone. They must also have stood in admiration before the complexity of the iconology. No work of the century demonstrates more clearly that this final iconology is the result of extra-artistic effects of physical situation and personal donation.

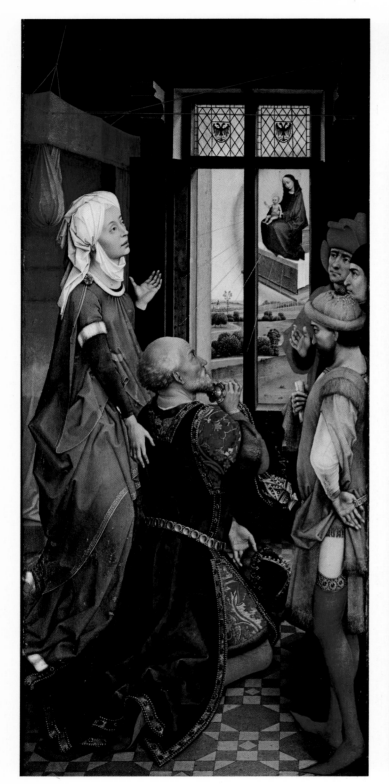

IIIa,b. Rogier van der Weyden: Annunciation to Augustus and Annunciation to the Magi, left and right wings of Bladelin altarpiece. Staatliche Museen Berlin, Gemäldegalerie Dahlem.

2

The Bladelin Altarpiece by Rogier van der Weyden

There are three triptychs by Rogier van der Weyden—the Braque, the Bladelin, and the Beaune "Last Judgment"—whose complete documentation is known. The Bladelin altarpiece (I, IIIa, b, 13) contains the only Nativity within the commonly acknowledged oeuvre of Rogier.[1] This fact seems peculiar because the Nativity was a major Christian theme. Its absence in Rogier's work is the more remarkable since it was popular with many of the artists closely related to Rogier; it was painted by his master, Robert Campin; also by his fellow pupil, Jacques Daret;[2] and shortly before the Bladelin altarpiece by both Petrus Christus [3] and Dieric Bouts.[4]

Plates
I, IIIa, b
Illustration 13

The explanation for the fact that there is only one example of a Nativity within Rogier's work may lie in the discrepancy between the nature of the Nativity subject and the nature of Rogier's painting. Rogier's work is marked by a distinct tendency toward a devotional or symbolic interpretation of any given Christian subject. This tendency often led to an isolation of the major figures and a transformation of their traditional settings. These effects are evident in the Beaune and the Braque altarpieces (see chaps. 3, 4), the Prado "Descent" (46), the "Miraflores" altarpiece (16), and the Vienna "Crucifixion" (15). In these and many other paintings, Rogier de-emphasized the historical particulars of the subject in order to re-create a new devotional icon. He made the objective recognition of the actual event within the Christological cycle less important than the emotional awareness of the isolated subject as an object worthy of veneration.

Illustrations
46, 16, 15

By its literary nature and its narrative implications, the story of the Nativity does not easily lend itself to this type of devotional reinterpretation. There are too many details of setting, such as the manger, the animals, the shed, and the angels, which play a necessary part in the drama. The descriptive nature of the subject per se is difficult to overcome. The same thing may be said of two other themes that are dependent upon the Nativity: the Adoration of the Magi and the Adoration of the Shepherds. Rogier never painted an Adoration of the Shepherds as a primary subject. He painted the Adoration of the Magi only once—in the "Columba" altarpiece (14) in 1462, well after the Bladelin triptych and

Illustration 14

substantially dependent upon it iconographically. Perhaps the Bladelin "Nativity" encouraged him to attempt a major descriptive subject just once more. Even in this Adoration Rogier registered an anachronistic note of protest to the narrative that spreads across the large center panel. He painted a crucifix on the shed above the head of the Madonna and Child and thus referred to an event far beyond the moment of the Adoration; this reference could leave no doubt in the mind of the spectator as to the sacred meaning of the Adoration taking place below it. In a small way this crucifix performed a function similar to that of the imitated *Schnitzaltar* setting in Rogier's earlier "Descent from the Cross." Characteristically, when Memlinc copied this Adoration from the "Columba" altarpiece, he left the crucifix out.[5] Rogier's subtle means of combating creeping naturalism were rarely, if ever, repeated by Memlinc.

Illustration 16 The "Miraflores" altarpiece (16) demonstrates the problem that Rogier faced when dealing with a narrative theme. In the left-hand panel of this pseudotriptych is a scene that was often called a Nativity until Panofsky corrected the identification and called it simply the Holy Family.[6] Rogier so transformed the Nativity theme that he changed its iconographical identity. In this Holy Family, a remarkably nonspecific representation, Mary, Joseph, and the Child are placed within an ecclesiastical setting unrelated to any structure usually associated with the birth or childhood of Christ. None of the usual "extras" are present. The justification for this elimination of historical material is a devotional one. The Christ Child on the lap of His Mother suggests simultaneously His birth and His death, telescoping the beginning and the end of His life into one pictorial unit.[7] The iconography denies historical plausibility for the sake of devotional intensity.

Late in his career when Rogier did paint his first true Nativity in the Bladelin altarpiece, he had no prototype to turn to within his own work. It seems understandable, thanks to the novelty of the theme and the nature of the subject matter, that he went *Illustration 18* directly back to Campin's Dijon "Nativity" (18) for his inspiration. Not since his earliest years had Rogier relied so heavily on his master's motifs. He first placed the major architectural unit, the hut, at an oblique angle into the picture plane, just as Campin had done. The use of the oblique setting was commonplace for Campin, but within Rogier's work this Nativity hut remains the single example of an oblique setting.[8] Because Rogier committed himself to a fully narrative treatment of the subject, he allowed the architecture to take up more physical space, to plunge into depth. The hut is not turned parallel to the picture plane in order to de-emphasize its ability to displace space for the sake of a more hieratic interpretation. Rogier also borrowed Campin's method of disguised symbolism. He found it to be the simplest way of pointing out the symbolic content within the new abundance of naturalistic detail. This was exactly the discovery that Van Eyck and Campin had made before him, but until this moment Rogier had never needed to use it extensively.[9]

In contrast with Campin's single panel of the Dijon "Nativity," the Bladelin altarpiece is a triptych, therefore iconographically richer. It contains four Annunciations: on the exterior, the Annunciation to the Virgin; on the interior, the Annunciation to Augus-

tus on the left wing, the Annunciation to the Shepherds in the background of the center panel, and on the right wing the Annunciation to the Magi. Amid all this preparation, the Advent takes place on the center panel in the Nativity scene.

The Annunciation to Augustus is related in both *The Golden Legend* [10] and the *Speculum Humanae Salvationis*.[11] The literary sources state that the vision took place on the day of Christ's birth. Octavian, or Augustus, the emperor of Rome, was so venerated by his people that they asked to worship him as a god. With due humility, Octavian would not accept such homage until he had consulted the Tiburtine sibyl. When he asked her if he was truly the greatest king on earth, she showed him a vision of the Virgin and Child surrounded by a circle of gold. She told Augustus that this very day a King was born who was more powerful than he, for this King was the Lord of Lords who had come to deliver all people. She explained that in the vision the woman who carried Him was His Virgin Mother, appearing as the Altar of Heaven (*Ara coeli*), the Bearer of Christ. Augustus fell on his knees and worshiped the vision. In honor of this revelation he consecrated the room to the Virgin. The Church of Santa Maria in Araceli in Rome was later built to commemorate this theophany.[12]

In the Bladelin triptych Rogier has modernized the whole scene (IIIa). Augustus and *Plate IIIa* the sibyl are found in a familiar Flemish interior, which is identified with the Holy Roman Emperor only by the presence of the imperial emblem. This too has been updated, for it is the coat of arms of the house of Hapsburg. Augustus is dressed, not in a classical costume, but as a Burgundian duke. He is joined by three spectators who are not mentioned in any of the literary sources. They do not seem to be aware of the vision, only of Augustus' homage to it. Their presence does not bring a new interpretation to the story, but rather, by witnessing the event they reinforce the fact of its occurrence. Panofsky has tentatively identified two of these men as Jean le Févre de St. Remy and Pierre de Beffremont, courtiers of Philip the Good.[13] They play the same role in the painting as they did in life, except that the man they attend is not really a Burgundian duke, but a Roman emperor. They acknowledge the terrestrial ruler. Augustus pays tribute to the universal Ruler.

On the right wing, paralleling the Annunciation to Augustus, is the Annunciation to the Magi (IIIb). According to the *Speculum Humanae Salvationis*, "on the same day that *Plate IIIb* God was born in Judea, His nativity was announced to the orient, to three powerful kings who saw then a new star in which a little Child appeared over whose head was a resplendent cross of gold."[14] This scene is in the foreground of the panel. In the background the Magi are undressing and washing themselves in a river. This symbolic cleansing took place just before they ascended the mountain from which they beheld the Annunciation.[15]

The Annunciation to the Shepherds is painted in very small scale in the upper left-hand corner of the center panel. It is not given the prominence of the other two Annunciations. It appears high on the hill in the background, in a traditional manner found in other Flemish paintings both before and after Rogier.[16]

The other two Annunciations had not been represented or juxtaposed in this way before in Netherlandish painting. Their meaning goes beyond a simple addition of Annun-

ciations. Given equal space and emphasis on the right and left wings, they must be given a further interpretation. According to the *Speculum Humanae Salvationis*, "Jesus Christ did not show His Nativity only to the Jews, but He also did not refuse to manifest it to the pagans. He came to this world not only for the Jews, but He came to save all people." [17] Rogier's panel dramatizes the universality of the Annunciation. On the left wing Christ's birth is told to the West; on the right wing, to the East. He is proclaimed as the universal Savior of both Gentiles and Jews. No other Flemish painting is so concerned with the ecumenical significance of His birth.

Plate I
Illustration 18

Although Rogier borrowed for the central Nativity (I) the basic iconographical and compositional schemes from Campin's Dijon "Nativity" (18), he transformed its symbolic content.[18] He retained the predominance of the ox over the ass, the New Testament superseding the Old,[19] but he turned the ox around so that it might truly see the Christ Child. The ox now witnesses the event in a visually plausible way. The ass is also turned in the direction of the Child, but his vision is obscured by the ox. Thus by position and identity the ass becomes a symbol of the Synagogue's proverbial blindness, for he literally as well as symbolically cannot see the Child.

The Old Testament prefigurations continue in the motif of the shed. Campin's simple hut is replaced by a Romanesque ruin, representing the crumbling of the Old Law at the time of the birth of the New. This Romanesque addition to the Campin wooden structure had already been made by Bouts in his Prado Infancy panels.[20] Rogier adds, for the first time, the single marble column that supports the shed in the foreground. According to St. Bridget and the pseudo-Bonaventure, it is the column on which Mary supported herself to give birth to the Christ Child.[21]

I believe that another Old Testament prefiguration is intended in the disguised symbolism of the two holes in the foreground. It looks as if there is a rather large underground chamber or cistern, one end of which is covered by a grate, the other remaining open. In the *Speculum Humanae Salvationis*, after the description of the Annunciation to the Magi, there is a reference to the cistern of Bethlehem.[22] It is used as an Old Testament prefiguration for the visit of the three Magi to the Christ Child. Three valiant men were sent to Bethlehem to procure water from the well for King David, who was then on the battlefield. They are likened to the Magi in the following way: "The three valiant men went to Bethlehem in order to obtain water from the cistern, and the three Kings went to Bethlehem in order to obtain the water of eternal grace. The three valiant men drew from the terrestrial cistern, and the three Kings received the water of grace from the cupbearer of heaven [as Christ] who was born in Bethlehem, who would administer the water of grace to all men who thirst. . . ." [23]

Illustration 19

Rogier was familiar with this story, for he was working on a pictorial representation of it at about the same time that he was working on the Bladelin triptych.[24] Only a fragment of this painting remains (19). It shows the three valiant men or attendants of David. These men bear the same features as do the attendants of Augustus and have been identified as the same courtiers by Panofsky.[25] The theme of the three valiant men was more familiar

through literary than pictorial sources. Rogier's pictorialization of the Old Testament theme may have suggested his use of the cistern as a disguised symbol in the Bladelin altarpiece, a motif that continued in Flemish painting after its invention here. Memlinc's many Adorations and Nativities attest to its popularity.[26]

Since the triptych is dedicated completely to the Advent, the Annunciation to the Virgin must be included within the iconography. Therefore, the exterior (12), though undoubtedly done by another hand because of its different style,[27] must have been a part of the original program. It is a necessary prelude for the interior events. *Illustration 12*

From the first glad telling of the Advent to the Virgin on the exterior to her own adulation of the Child on the interior, nothing detracts from the miracle of Christ's birth. Three angels hover above the hut singing His praises; three more kneel at the Christ Child's head. The shepherds and the Kings hear the wondrous news and fall on their knees. The position of the Kings, their hands raised in praise, their heads bared, suggests adoration as well as simple reception of the news. Both the Kings of the East and the greatest ruler of the West acknowledge the more powerful Ruler of heaven. All the principal figures in the interior of the triptych are on their knees before the Child; none sees merely a star. All the iconography in the painting suggests exaltation and adoration of Christ as a Child. Since nothing recalls His Passion or His adult life, I do not believe that the column also refers to the Flagellation, as Panofsky suggests.[28] A solitary reference to the Passion in this particular painting would be out of place within the total iconology.

No other Flemish triptych or polyptych concentrates so exclusively on Christ's birth. There are single Nativities or Adorations or Annunciations or combinations of these with scenes from the Passion, but none is so preoccupied by the Advent alone. The multiple Annunciations in Rogier's panel, without ever referring specifically to the Passion, are certainly connected with the concept of redemption. This aspect of the Nativity and its attendant annunciations is repeatedly emphasized in the *Speculum*. References to Christ coming to save both men and angels, to deliver them from their captivity, appear throughout chapter viii on the Nativity.[29] The Bladelin altarpiece reflects the same thought. The joy, the expectancy, and the adoration that attend the coming of Christ anticipate the hope that God, now appearing as man, will convert the whole world and redeem all sinners.

Both Mâle [30] and Winkler [31] accept the *Speculum Humanae Salvationis* as the basis for Rogier's iconography. Panofsky, however, cites *The Golden Legend* as its source, arguing that in the *Speculum* the Annunciation to the Magi is not found in the chapter dedicated to the Nativity, but in the chapter that tells of the Adoration of the Magi. Panofsky also notes that only *The Golden Legend* mentions the incense that Augustus offers before the vision appearing in the sky.[32]

I do not think that this evidence is convincing enough to state definitely that the source for the painting is *The Golden Legend*. True, in the *Speculum* the vision of the Magi is not in the same chapter as the Nativity, but it does follow directly after it: only a chapter number separates the two events. The vision of the Magi precedes the Adoration of the Magi. But this Adoration is also implied in the panel. Not only do the Magi adore the

Child in the Annunciation but, as we have seen, the cistern continues the idea of their adoration right into the center panel. It does so in the old typological sense based primarily on the *Speculum*. The idea of adoration is paramount in the triptych, be it that of the Magi or of Bladelin, Mary, Joseph, or Augustus. Furthermore, *The Golden Legend* states that Augustus was alone with the sibyl, which is not true of Rogier's representation.[33]

The final choice seems not to be simply between these two sources. The spirit and the iconology of the painting are different from both and perhaps take some ideas from each. Many of its motifs are not included in either source. The burning candle and the column come from the *Revelations of St. Bridget*. The motif of the shed comes originally from Peter Comestor's *Scholastic History*,[34] supported to some extent by the pseudo-Bonaventure.[35] The pictorial motif of the altar in the sky has been inspired by Campin's painting of the Madonna in Aix-en-Provence.[36]

It could be argued that important motifs have been omitted if the painting was based on only one literary source. Why does the Christ Child not carry that "resplendent cross" to which the *Speculum* and *The Golden Legend* refer? Why do the vines of Engadi not flourish? [37] Add to this the fact that the whole central scene is clearly inspired by a painting of Campin's, and one is forced to conclude that the Bladelin triptych is made up of a combination of many pictorial and written sources, none of which is fully or exactly transcribed upon the panels. A new unity is achieved. Rogier coordinates the seemingly disparate iconographic motifs into a single hymn of adoration.[38]

The iconographic unity is reinforced by the formal unity. Because of the nature of the *Illustration 13* subject matter, the three interior panels contain three totally different settings (13). By subtle shiftings of position, Rogier achieves a spatial cohesion among all three. The perspective orientation of both wings is toward the center. In addition, all the royalty kneel in three-quarter position facing inward. Both Bladelin and St. Joseph also assume a three-quarter position. In order to attach further importance to the center panel, these two face outward, whereas the Kings face inward. These positions create an active, zigzag motion from wing to center panel, which finally comes to rest upon the vertical Virgin. She, in turn, directs our glance to the reclining Child.

The color tonality serves the same purpose. There is no sharp contrast between the settings. The left wing looks out upon a landscape very similar to that of the left-hand section of the center panel. The foreground and the middle ground of the right wing are also similar to the foreground of the right-hand section of the center panel. Although none of the landscapes are actually contiguous from one panel to the next, by suggestion—through tonality and configuration—one is given a sense of a unified environment rather than of three abruptly juxtaposed, unrelated scenes. The landscape is one familiar to the Netherlands, containing within it a Flemish village. Even though the chateau is strongly Romanesque in character, the houses, the streets, and the people all recall the fifteenth century. The interior setting of the left wing is of the same period. The main figures, except the Virgin and Joseph, are dressed in contemporary costume. All these factors give

continuity to the three events, making them all appear to be happening at the same time and place.

Rogier used only the physical fact of the three separate panels to distinguish the three scenes. They are his only real time dividers. In other paintings in which he depicted more than one scene, he would often use an elaborate architectural framing device both to set them apart and to give them devotional, as opposed to narrational, continuity. In the "Miraflores" altarpiece, for instance (16), the three scenes are framed by sculptural portals, which act as "quotation marks" to set each one apart from the others and to de-emphasize the historical sequence.[39] The religious iconography of the portals themselves adds a specifically sacred overtone to the whole painting, just as the shrine setting did for the Prado "Descent." When Rogier used the same three arches in the St. John altarpiece, the devotional content was slightly lessened by the fact that the scenes beneath the arches were more rationalized (17).[40] There was more genre detail and the scenes took place within an expanded spatial envelope extending far behind the arches. In this pseudotriptych there seems to be an incipient conflict between the descriptive and the devotional. Only the center panel remains relatively free from this tension. It does so by reverting to the old "Miraflores" solution of one scene, placed far in the foreground, made up of only two figures, without any additional narrational references.

Illustration 16

Illustration 17

In the Bladelin triptych, which is even more descriptive than the St. John altarpiece, Rogier avoided this conflict by lessening the hieratic implications of the subjects. He did not frame the scenes with a religious architectural motif unrelated to the setting. On the other hand, he detracted from the historicity of the three subjects by making the scenes appear to be happening simultaneously. Rome, the Orient, and Bethlehem are all skillfully incorporated into the same Flemish world. This apparent unity of the whole spatial situation is directly connected with the content. All three scenes celebrate the birth of Christ; thus they are one. But because the right and left wings are iconologically only witnesses to the actual event taking place in the center panel, they are separated by slight inconsistencies, most noticeable at the framing edge. In this triptych, instead of using symbolic architectural props to counteract the descriptive nature of the subject, Rogier used logical, visual, artistic devices, which were part of the growing naturalism of the subject, to comment upon it. He turned the rationalizing back upon itself, infusing the few and subtle descriptive inconsistencies with symbolic content. Religious intention, not visual logic, finally determined the outcome.

In the center scene Joseph and Mary, who kneel in adoration before the Child, are joined by a figure who has no part in the biblical narrative (I). A lay figure, dressed in contemporary clothes,[41] shares in the devotion of the Holy Mother and the appointed father of Christ. He is not separated by panel, minimized by size, or introduced by patron saint. Compositionally he completes the triangle begun by Mary and Joseph. The only distinction made between him and the saintly figures is that he must kneel outside the hut; nevertheless, he is one of the three major protagonists who surround the Christ Child. This

Plate I

Illustration 23
figure is Peter Bladelin, the donor of the triptych (23). His presumption is similar to that of Nicolas Rolin in Jan van Eyck's "Rolin Madonna." A secular, living figure is included in a religious painting, which is rationally described in worldly terms. Bladelin is not even separated from the religious object of devotion by a *prie-dieu;* he worships as an equal. Nor is the place of his worship set above the real world and therefore marked out as a heavenly realm, as in the "Rolin Madonna." Bladelin worships within a continuous Flemish landscape, a landscape that contains a view of the city of Middelburg dominated by his chateau. Whereas the landscape background of the two wings and upper left-hand part of the center panel contains scenes that continue the holy narrative, the landscape of the right-hand section behind Bladelin is wholly secular, an architectural attribute of the contemporary figure. Not only has Bladelin been included in the central scene of devotion, but he has also taken over the otherwise sacred landscape.

The identification of this chateau as Bladelin's and consequently the explanation for the donation of the triptych come ultimately from a drawing made by Antonius Sanderus.[42] In his *Flandria Illustrata*, published between 1641 and 1644, Sanderus used a drawing of Bladelin's chateau in his description of the city of Middelburg. This drawing coincides exactly with the chateau seen in Rogier's painting. The coincidence, however, is too close for critical comfort. Sanderus undoubtedly copied his rendition from Rogier's painting.
Illustrations 21, 22
(See 21 and 22 for comparison.) He views the chateau from the same angle as does Rogier, high up looking slightly down on it; he chooses to render the same side of the chateau; and he produces an identical number of windows, doors, and crenelations. Moreover, someone has neglected to shut the right-hand door, just as in the chateau of the Bladelin triptych. By the middle of the seventeenth century the chateau would no longer be extant in this condition, for it had gone through several fires by then as well as the pillaging and destruction brought on by the Counter-Reformation.[43]

The fact that Sanderus copied Rogier's painting of Bladelin's chateau and did not make his own drawing from the actual chateau led Dr. Henri Pauwels of the Brussels Musées royaux des beaux-arts to postulate that the painting may not have been done for Bladelin at all.[44] We have no other portraits of him and only circumstantial and traditional evidence, reinforced by Sanderus, that this was Bladelin's chateau. The painting itself was never recorded in the archives of Middelburg as far as the reading of these documents by De Smet and others has gone.[45] It was not found in that city. Only a later copy of it was found in Middelburg in the kitchen of Canon Andries in 1836. This discovery finally brought to light, after much false accusation and misinformation had been published, the original, which was at that time in the shop of a certain Mr. Nieuwenhuys. He notified the Kaiser Friedrich Museum in Berlin of its whereabouts. The museum bought the painting before the Belgians had finished arguing about whether or not Canon Andries had discovered the original or a fake.[46] We are left then by this confusing series of circumstances to weigh the evidence of Sanderus' copy of the chateau.

Antonius Sanderus was a distinguished professor, theologian, and Latin poet, as well

as a Flemish historian and archaeologist. He was a scholar of extraordinary patience, whose work is still held in highest repute. *Flandria Illustrata* is an excellent example of his careful, detailed work. In these monumental volumes he set out to document as much of Flemish architecture and geography as one man could in a lifetime. He went from village to village making his studies. Ironically, according to Dr. Pauwels, it would seem that every drawing in these volumes was made on the spot, except the one of Bladelin's chateau.

Surely a man like Sanderus would have done his best to establish the fact that this painting was done for Bladelin and that the building behind him was indeed his chateau in the city of Middelburg. For all we know, Sanderus may have seen the painting in the city itself. Having no better example of the principal building of Middelburg, he used Rogier's interpretation. The fact that it is the exception to a well-established rule within his work should not necessarily detract from its validity.[47]

Coupled with this evidence is the evidence of the unique iconography, which also makes a convincing argument for the accepted identification of the donor and the destination of the painting. Peter Bladelin was a pious Flemish burgher of low birth who became during the course of his lifetime one of the most important men in the Burgundian court.[48] He was probably born about 1410. In 1435 he married Margerite van de Vageviere and built a home in Bruges where he was soon made director of communal finances. Having proved himself an able financial administrator, Bladelin was appointed by Philip the Good to his council in 1440. Bladelin remained in the service of the dukes of Burgundy for the rest of his life as financier, counselor, *maître d'hôtel*, and eminent diplomat. In the last capacity he was sent to England with Olivier de la Marche to obtain the deliverance of the Duke of Orléans, who had been imprisoned in England since the battle of Agincourt in 1415. It seems a strange coincidence that Charles of Orléans's release was effected by Philip of Burgundy, his hereditary foe. It is not known whether Bladelin himself made the final arrangements for the large ransom fee, most of it paid by Philip, which accomplished Charles's release. But on November 3, 1440, the Duke was set free after twenty-five years of a rather amicable captivity, having been maintained by the proper English in a state due his rank. Bladelin's loyalty to Duke Philip was clearly demonstrated between 1448 and 1453, when Ghent was attempting to revolt. Bladelin was able to hold for the Duke the city of Bruges, whose sympathies lay in large part with the Gantoise. Bladelin's close tie to Philip is further evidenced by his membership and his rank of treasurer in the Order of the Golden Fleece. The Duke was more subject to the counsel of this exclusive body of men, originally limited to twenty-four, than to that of anyone else in the ducal government, except that of Chancellor Rolin.

During Bladelin's years as a public servant he also realized a purely personal project, a project so vast that one can only marvel at his energy and efficiency. This enterprise was the founding and building of the entire city of Middelburg in Flanders. Every record that attempts to give a reason for his undertaking the project states that Bladelin and his wife were unable to have children; to compensate for their lack of heirs, to utilize

their great wealth, and to ensure their being remembered, they decided to build a city on a spot where no city had previously existed.[49] For the first time since the Romanesque period in northern Europe, an entire town was built by a single person.[50]

The land on which the town was founded originally belonged to an abbey in Middelburg, Zeeland, which had established in Flanders a small farm (*Hofsteede*) where a few monks lived and worked. In 1440 the abbey in Zeeland ceded this land to Colard Lefevre of Bruges, Bladelin's brother-in-law. Bladelin bought the land from him about 1444 and leveled the few buildings that the monks had left. He began his chateau in 1448 and four years later he began work on the town proper which was to include among its major buildings a hospital, an hôtel de ville, a church, and his chateau. The final authority for the surrounding walls and gates was given in 1464. Bladelin named the town Middelburg in honor of the town in Zeeland (present-day Holland) which had originally possessed the land.

Bladelin's next problem was one of population. By turning his efforts to securing dwellings for homeless people, he was able to establish Middelburg as a refuge and at the same time to populate his city quickly. He was indirectly helped in his task by Charles the Bold. Charles had razed the city of Dinant because the people had tried to revolt. Bladelin, diplomat that he was, obtained permission from Charles, without arousing his anger, for the citizens of Dinant to come to Middelburg. His generosity was coupled with shrewdness. The majority of the people of Dinant were brass and copper workers; they began Middelburg's most important industry.

The connection between the triptych and the city of Middelburg is found in the Church of SS. Peter and Paul. Bladelin may have chosen St. Peter as titular saint because Peter was both his own and his father's name patron. He did not limit his dedication to this one saint, however; he included St. Paul. When Peter and Paul are linked together, they represent the two acknowledged heads and founders of the Christian Church: St. Peter as the founder of the Church of the converted Jews, and St. Paul of the Gentiles. Thus in mutual relation they symbolize the Church universal. They take first place both as Apostles and as preachers of Christianity throughout the East and the West. The dedication of Bladelin's church and the interpretation of the two Annunciations in the Bladelin altarpiece are part of one and the same concept.

The Church of SS. Peter and Paul was designed to serve the religious needs of the community. But Peter Bladelin, founder of the city and builder of the church, also made this Gothic edifice into a funerary "chapel" for himself. His tomb competed in prominence *Illustration 20* with the main altar. It was placed in a niche in the north wall of the choir (20), in the most sacred part of the church, the sanctuary. It boldly displayed his coat of arms and his monogram PB. It may have originally had a recumbent figure on top and/or a large monument erected apart from the tomb proper directly in front of the altar. The evidence is not clear.[51] All except the tomb was destroyed during the iconoclastic occupation of the church in 1581. When his wife died in 1476, Bladelin's tomb was opened and she was placed inside.[52]

In his last testament, written three weeks before his death in 1472,[53] Bladelin ar-

ranged to be carried to the church if he should happen to die outside the city of Middel-
burg. He requested that a procession of forty torchbearers, consisting of the poor people
of Middelburg, who would be paid for this service, carry his body in a devoted and proper
way to the church. He asked that the church be draped in black for thirty days and ar-
ranged that gifts of money be given to all the poor who came to the funeral. He further
asked that the anniversary of his death be celebrated every year in the church and that it
be remembered by giving away sixty pieces of money to the poor. His anniversary is still
celebrated by the faithful citizens of Middelburg.

This is the final setting into which we must place Rogier's triptych. It was probably
ordered about 1452 and must surely have been completed by the time the church was dedi-
cated in 1460.[54] We do not know upon which altar it stood. Besides the main altar dedi-
cated to Peter and Paul, Bladelin's church had five other altars.[55] One was dedicated to the
Holy Cross because Bladelin was said to have a relic of the True Cross which he en-
shrined in his church.[56] A second altar was dedicated to St. Sebastian probably because
Bladelin was a member of the Archers' Guild. He allowed the guild to hold special services
in his church. Also, as treasurer of the Order of the Golden Fleece, he must have consid-
ered St. Sebastian a favorite patron.[57] A third altar was dedicated to the Virgin. When
Bladelin wrote his last testament, he commended his soul to the care of the Virgin, to
SS. Peter and Paul, and to St. Sebastian.[58] When he built his funerary church, he dedicated
three of the altars to the same saints.

Two other altars remain: one dedicated to his wife's patron saint, Margaret, and the
other to St. Bernardino of Siena. The reason for the latter dedication seems to be somewhat
of a mystery. St. Bernardino was a Franciscan monk of great popularity in the early fif-
teenth century. Virtually alone he rejuvenated the Order of the Observants. He died in
1444 and was canonized soon afterward in 1450. The earliest account of his life was com-
piled in 1445, only one year after his death, by Barnabas of Siena. The altar at Middelburg
may be the first altar dedicated to him; it is certainly the first in Belgium.[59] Perhaps
Bladelin thought of St. Bernardino as the contemporary counterpart of SS. Peter and Paul.
He may have regarded St. Bernardino as the greatest living exponent of the mission that
Christ had given to the first Apostles fourteen hundred years before.

Only two of the six altars might have held the triptych. So important a work by a
well-known painter may have stood on the main altar.[60] As already noted, its dedication to
Peter and Paul as representatives of the Church universal is an extension of the iconog-
raphy of the painting. In the triptych the announcement to the universe made salvation
possible; in the dedication of the altar and the church Bladelin names the first appointed
mortals who could make salvation a reality, those who were charged by Christ to preach
and baptize in His name.

There is perhaps an even stronger possibility that the triptych stood on the altar
dedicated to the Virgin.[61] Next to the Christ Child, the Virgin is the central character of
the altarpiece, appearing on both the exterior and the interior. Bladelin kneels beside her.
Earlier in his life Bladelin had paid her similar artistic homage. One can still see on the

facade of his house in Bruges a reconstructed sculptural group beneath a Gothic niche which shows Bladelin kneeling at her feet.[62] His triptych displays the same close identity with the Virgin. Bladelin's proximity to the Virgin and her important role within the painting lead me to believe that it was probably placed on her altar rather than on the main altar. If placed there, it would reflect in its iconography both the dedication of the church and the specific dedication of the altar to the Virgin.[63]

Even though there is no patron saint, no coat of arms, and no reference to the Passion, I believe that the painting is a funerary painting as well as a votive painting to the Virgin.[64] Although it was not located, as far as we know, above Bladelin's tomb, it served a second purpose just as the church did. Both are dedicated to the general theme of salvation, localized within the sanctuary by the presence of Bladelin's tomb. In the painting the theme of salvation is just as directly associated with Bladelin. It is not the Magi who kneel before the newborn Child; they see only a Child in a star. Augustus, too, sees only a vision. The man who has reached the birthplace of the Savior is neither shepherd, nor king, nor emperor, but Bladelin. By his position he links the birth of the past with the adoration of the present. He is the only secular figure to whom the Advent is no longer merely an announcement; to him it is a reality. He and the Virgin, man's greatest advocate, kneel together. Because the Nativity takes place outside the city of Middelburg, there is no need for a symbolic coat of arms. The landscape illusionistically contains the chateau that identifies the donor. The inclusion of a patron saint of yet another era might have detracted from the unity of time and place which Rogier has so boldly achieved. Besides, Bladelin, like Rolin, wished to address the Virgin and Child directly with his plea. He must have thought that his devotion to the Virgin and his newly founded city for the protection of the poor and homeless were introduction enough; that surely these would gain him special consideration on the day of Last Judgment.

Perhaps Bladelin's piety and love justified his inclusion within the circle of the Holy Family. Perhaps his power, wealth, and desire were the primary reasons for his presumption. His contemporaries, however, found him a most honorable man. Chastellain concludes that "none more industrious and diligent than he could well be found . . . comely alike in person and in morals." [65] In all the copies I have found which were done after the *Illustrations* Bladelin "Nativity," no one dared to repeat his presumption (24, 25).[66] Bladelin either is *24, 25* replaced by an adoring shepherd or is left out altogether. No other contemporary figure ventures to take his place. Similarly his chateau is transformed.[67]

Bladelin himself must have been the one who suggested the Nativity as a subject to Rogier. This scene was a natural choice for Bladelin because it easily allowed him to participate with the Virgin, respectfully, in a scene of adoration. His desire to be included as a member of the Holy Family undoubtedly encouraged Rogier to portray the scene in a dramatic-narrative fashion. This altarpiece, placed within Bladelin's funerary church, within his city, on an altar whose dedication was specified by him, reflects the setting, the dedication (be it to the Virgin or to SS. Peter and Paul), and the desire and devotion of its donor. Part of its peculiar character within the Rogierian oeuvre can be explained only by the fact that it was painted at the request of Peter Bladelin.

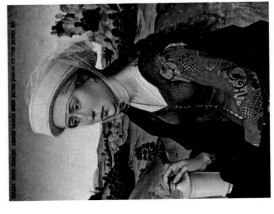

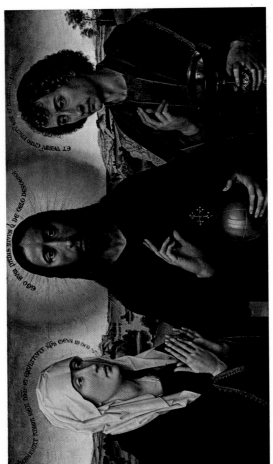

IV. Rogier van der Weyden: Braque altarpiece. Paris, Louvre.

3

The Jean Braque Altarpiece
by Rogier van der Weyden

Of all the Netherlandish triptychs whose destinations and donations are known, the Jean Braque altarpiece (IV, 26–29) is the only one that was not commissioned for a public or semipublic altar. Painted for a private home, it remained in the possession of the Braque family from its commission in the middle of the fifteenth century until the end of the sixteenth century.[1]

Plate IV
Illustrations 26–29

Jean Braque, whose coat of arms appears on the exterior of the triptych, was a descendant of an old, wealthy French family whose members had found favor in the court of Valois as advisers and financiers from the fourteenth century.[2] Probably as a result of the civil wars between the Armagnacs and the Bourguignons, a branch of the Braque family had moved to the French city of Tournai in the Flemish province of Hainault in the early part of the fifteenth century. Jean's wife, Catherine of Brabant, was also of French origin, her family having been naturalized as citizens of Tournai a short time before the Braque family. Possibly in 1450, but no later than April, 1451, Jean and Catherine were married.[3] About two years later, on June 25, 1452, Jean Braque died.[4] He was thirty-two or thirty-three at the time; Catherine was about twenty.

The Braque triptych is usually thought to have been commissioned by Jean and Catherine sometime during their brief marriage.[5] Stylistically it is in accord with paintings done by Rogier van der Weyden during the 1450's. The head of Christ in the center panel of the Beaune "Last Judgment," completed in 1452, is almost identical with that in the Braque altarpiece.[6] Although I agree with the approximate dating of the Braque triptych, I do not believe that the painting was commissioned by both husband and wife. As Leprieur has suggested, it seems far more probable that Catherine commissioned the painting upon her husband's sudden and premature death.[7]

There is evidence of Catherine's deep devotion to her husband which would also explain her desire to memorialize him in some way. Although she was married a second time for some thirty years, in her last testament in 1497 she requested burial in the Church of the Frères-Croisiers in Tournai, next to her first husband, Jean Braque.[8] Her wish was

fulfilled when she died in 1499, almost fifty years after Jean's death. In the same testament she bequeathed the altarpiece to Jean's only living descendant, her grandson, Jehan Villain.[9] He was the son of Agnes Braque, the only child of the marriage of Catherine and Jean.

The iconography of the triptych itself supports the idea that Catherine alone commissioned the altarpiece. The exterior left wing depicts a yellowish-brown skull leaning against what appears to be a broken brick (26). In the upper right corner is the Braque coat of arms: a sheaf of wheat on a simple shield. The frame around the panel is painted in imitation of red bricks. The following inscription is written on the top and bottom of the frame: "Look, you who are so proud and miserly, / My body, once beautiful, is now becoming as meat (wormy flesh)." [10] On the right wing is a cross bearing an inscription and the Braque-Brabant coat of arms, both within the same bricklike frame. The inscription is taken from the beginning of the forty-first chapter of Ecclesiasticus: "Oh death how bitter is the remembrance of thee to a man that liveth at rest in his possessions, unto the man that hath nothing to vex him, and hath prosperity in all things, yea unto him that is yet able to receive meat." [11]

Illustration 26

The left wing, that identified with Braque, is devoted to the death of man. The skull, suggesting Adam, but also all mortals as his descendants, rests on a broken stone fragment which is possibly a reference to the rocky mount of Golgotha.[12] The mournful aspect of the skull is also expressed in the verse, which points out the transience of earthly things, reminding us that even a beautiful body will inevitably decay.

In contrast with the hopelessness of death, the right wing presents in equally stark terms the promise of salvation through the cross. The Crucifixion is treated in synoptic form, yet the cross combined with the skull on the left wing vividly recalls the moment of Christ's death and the sin of Adam as its cause. Though permeated with sadness and human mortality, the cross remains a symbol of redemption. In contrast with the skull, it reminds man that he may hope for everlasting life because of Christ's sacrifice. The body will die, but the soul may find immortality.

The left wing makes death explicit through the presence of the skull and the words of the inscription. This generalized conception of the death of every man is associated with Jean Braque, for the nameless skull is accompanied by the Braque coat of arms. Since Jean Braque was already dead, his lifelike portrait was not included. Instead the skull and coat of arms refer to Braque as an anonymous member of all mankind since Adam. The left wing is a symbolic dedicatory portrait of the deceased.

The right wing, identified with Catherine through the combined Braque-Brabant coat of arms, bears a lament that poignantly reveals how difficult it is for one still young and full of life to accept death. This wing symbolizes Catherine's role as widow, for it both laments Jean's death in words she herself might have spoken and, through the sign of the cross, formulates the hope for Jean's salvation.

The juxtaposition of cross and skull in this form is unique. In its symbolic condensation it is much like Rogier's Philadelphia diptych [13] but its idea must have come directly

from funerary sculpture. The inscriptions and the grim death's-head are both typical of a *memento mori*. This painting, however, was not located on or near a tomb, but remained within the Braque household. Rogier combined the iconography of a tomb monument for Jean Braque with that of an altarpiece whose main theme was immortality.

The exterior, earthly view of death is in striking contrast with the sacred realm that is revealed when the outer doors are opened (IV). The simple, dully colored exterior in *Plate IV* no way prepares one for the loveliness of the interior. The holy figures here are solemn and immobile, as are the objects on the exterior, but they are also intensely beautiful. Though somber of mien, they are resplendent in their costumes. Their glory is enhanced by the warm, green landscape, the blue sky, and the golden sun behind them. The warmth of eternal life has replaced the doleful view of present death.

The five figures who solemnly confront the spectator are, from left to right, John the Baptist, the Virgin, Christ, John the Evangelist, and Mary Magdalen. All five are shown *en buste*, after the tradition introduced in the fifteenth century by Robert Campin.[14] The *en buste* representation gives the figures added stature, causing them to appear much larger than their actual size on the panels. It compensates for the loss of impact often associated with a work done in small scale. It also places the figures in strong contrast with the landscape behind them which seems to recede below and away from the viewer while the figures confront and move toward him. The proximity to the viewer and the isolation from the setting are enhanced by the use of the frame. The saints seem to stand directly behind the frame, rather than in the landscape. They use the frame as a ledge on which John the Baptist rests his book, Christ His globe, and John the Evangelist his left hand. They seem to project beyond the gold boundary line, incorporating the frame into the pictorial representation.

Any suggestion of intimacy or lack of definition between the sacred and profane worlds is not to be inferred from the change in the usual function of the Renaissance frame. The five figures are clearly divine, unrelated to our world as well as to that which spreads out behind them. They are not a part of the same system of natural laws which is found in the landscape. In order to maintain the divinity of the figures, Rogier utilized the device of the "plateau" setting, as Millard Meiss called it.[15] In the lost "Crucifixion" from the "Turin-Milan Hours," reputedly by Jan van Eyck, in which the same phenomenon takes place, we can actually see the plateau.[16] In Rogier's triptych its presence is implied. The *en buste* figures are raised bodily above the landscape and, in order to account physically for their presence in this position, one must postulate a ledge of ground high above and far in front of the landscape.

As if in response to the resurrected Christ and his company of saints, Nature herself seems to have been reborn. The sunny, placid quality of the background suggests a paradisiacal setting, but I do not think that this is so. If it were Paradise, there would be no reason why the divine figures should not locate themselves comfortably within its perspectival setting. They would not need to create a second system of "unnatural" laws. Instead, the figures seem to exist in a timeless vacuum suspended between finite

space and infinity.[17] They appear in man's world, dressed in his clothes, but they retain a physical autonomy of their own. They seem to be in our world, but in fact they hang above it without visible support.

Although they have the features of men, as divine creatures they are static and im- mobile. Formally they are part of a more rigid and hieratic scheme than appears in the landscape. Perfect symmetry is maintained by the grouping of the three figures in the center panel and continued in the flanking of John the Baptist and Mary Magdalen. The separation of the latter two figures from the central group and the stronger emphasis on the central figures are complemented by the triptych format with its built-in hieratic divisions. The figures, other than Christ, are shown in the medieval manner of isocephaly. The alignment of the heads is repeated in the hands and the shoulders of the figures; all the lines described are parallel to one another and to the horizon line. The geometric de- vices that form a stiff, locked composition, are, however, relieved by the warmth and the reality of the faces and the draperies, by the intensity of the color, and by the soft undulations of the background.

In order to increase Christ's dominance within the group, Rogier employed another illusionistic-symbolic technique, which he had already used in both the "Seven Sacra- ments" altarpiece [18] and the Vienna "Crucifixion" triptych.[19] The figure of Christ, here only His head, by a series of careful adjustments is raised above the heads of the other saints and placed against a more rarefied space. Although His shoulders are level with John the Evangelist's, the top of His head is above the heads of John and the Virgin. The subtle elongation between neck and hairline, combined with the frontality of the figure, makes Christ appear even larger and more important than he actually is in relative scale. Reinforcing the naturalistic dramatization of Christ's superior divinity, the horizon line behind Christ's head drops just slightly so that His head is completely surrounded by heavenly air, whereas the horizon intersects the lower part of the heads of all the other figures. The placement of the sun behind His head is a further example of illusionistic symbolism. It is at once sun and halo.

Essentially we are confronting a fifteenth-century adaptation of a medieval idea. The subject is not extended by analogy or disguised symbolism. It is emphasized, but not expanded, by illusionistic-symbolic devices. Although the landscape contains a tiny scene of the Baptism on the left wing, it is not a disguised symbol but is easily recog- *Illustration 46* nized, appearing almost as an attribute of John the Baptist. As in Rogier's "Descent from *Plate V* the Cross" (46) or in his Beaune "Last Judgment" (V), all the subject matter of the triptych is seen and grasped quickly. Since the Braque triptych is smaller in scale, a closer view is required, but the impact and intention are the same.

Although the figures are presented clearly and directly, as a group they constitute a major iconographic problem. Their identity is evident, but the reason for the choice *Illustration 29* of these particular saints and their specific arrangement is not. In the center panel (29) we seem to be confronting a Deesis, a Greek term meaning prayer or intercession. In both the Eastern and Western pictorial traditions, it is applied to three figures: Christ and two intercessors. The intercessor on His right is always the Virgin; the one on His

left is usually John the Baptist. Rogier used the traditional Western representation of the Deesis in the Beaune "Last Judgment." There the Virgin and John the Baptist intercede for mankind before Christ at the time of Judgment. They are a part of the standard iconography of the whole Last Judgment scene. In the Eastern tradition the Deesis group more frequently appears as an independent subject, but its meaning is the same.[20]

The Braque Deesis is unusual in that it isolates the Deesis group and does not include John the Baptist. He has been placed on the left wing, and his position as intercessor has been taken by John the Evangelist. A substitution within the Deesis is not without precedent. In Russian and Roumanian icons John the Baptist is often replaced by St. Nicholas because of the latter's popularity in those countries.[21] The Deesis mosaic in the tympanum over the entrance door of St. Mark's in Venice makes special note of the basilica's patron by placing St. Mark, rather than St. John, to the left of Christ. In Western Deesis iconography, however, there is a tradition that regularly substitutes John the Evangelist for John the Baptist. In almost all the great French cathedrals, Rheims being the major exception, John the Evangelist intercedes for the damned.[22] This substitution was of rather short duration, beginning in France in the thirteenth century and lasting there until the end of the fifteenth century.

The popularity of the French Gothic Deesis, however, is not necessarily an explanation for the appearance of John the Evangelist in the Braque altarpiece. For Rogier, who must have been aware of the tradition, did not use this form of the Deesis in the Beaune "Last Judgment," done at almost the same time for a hospital in France itself. In this painting John the Baptist remains on Christ's left.

The peculiarity of the presence of the Evangelist is coupled with the peculiarity of his gesture. It is not the usual one of intercession, for he does not pray before Christ, as the Virgin does, nor does he appear simply as a standing saint identified by his attribute. Rather than holding his poisoned cup with an emerging snake, John holds and blesses a chalice. His gesture is not one intended to exorcise a demon, but is one of benediction, similar to the gesture that Christ uses over the globe. The reference to John's cup as a chalice is reminiscent of the words spoken by Christ to John and his brother James. They offered to share the cup with Christ, and He replied, "Ye shall drink indeed of my cup, and be baptized with the baptism that I am baptized with" (Matthew 20:22–23). In the Braque altarpiece, in imitation of Christ, John has taken over His cup and His gesture. Even his hand has been raised to correspond to the level of Christ's hand, rather than to that of all the other saints.

The visual proof of John's imitation of Christ is found in a Deesis group on the tympanum of St. Sulpice in Favières (Seine et Oise) (30). Here the figure of Christ is not enthroned, nor is He in the act of judging. He stands, holding a chalice in His left hand, blessing with His right. John the Evangelist is on His left, kneeling in his usual French role as intercessor. It is this action of Christ which John has usurped in the Braque triptych. As far as I know, it is the only time within a Deesis group that John the Evangelist blesses a chalice.

The words above John's head also imitate the words of Christ. The inscription

Illustration 30

above Christ reads, "I am the living bread which came down from heaven" [23] (John 6:51), and the verse concludes, "if any man eat of this bread, he shall live for ever: and the bread that I will give is my flesh, which I will give for the life of the world." [24] We read above John's head: "And the Word was made flesh, and dwelt among us" [25] (John 1:14). John's message, like his gesture, is a repetition, a restatement of the words and actions of Christ. Through both the significance of the Crucifixion is complete; the holy rite of the Eucharist is established. Christ absolves the world; John, in imitation of Christ, blesses the cup that made the absolution possible. According to one tradition, it was John the Evangelist who first celebrated Mass in priestly habit.[26]

Even Christ's role within the Deesis has been changed. From the thirteenth century on, Christ of the Last Judgment appeared as the enthroned Judge, displaying his wounds.[27] The appearance of Christ at Favières differs somewhat from this iconographic type, but the reference to His redemptive sacrifice is the same in that He holds a chalice and displays His wounds.[28] In the Braque Deesis Christ appears as the *Salvator Mundi*, a sovereign ruler rather than a judge. He no longer shows His wounds, and His chalice has been given to St. John. His death and triumph are explained wholly by symbol: His Crucifixion by the jeweled cross above the orb, His forgiveness by the gesture of benediction over the globe, His power of salvation by the cross and by the reflection of the mystical window within the globe. Both the light seen through the window and the window itself are symbols of salvation.[29] After their first appearance in the Braque altarpiece, they became traditional attributes found on the orb of the *Salvator Mundi*.[30]

In the attributes of His person Christ appears as the Savior of the world rather than as the Son of Man. The order and the presence of the saints, however, symbolically record the major events of His life. John the Baptist appears on the left wing as the Precursor (27). He holds open his book of prophecy and points toward Christ. The familiar words—"Behold the Lamb of God, which taketh away the sin of the world" [31] (John 1:29)—issue from his open mouth. As the last of the prophets and the first of the martyrs, he represents the living link between the Old Testament and the New. John announces the coming of Christ and His mission on earth; then the Virgin proclaims His birth. Her words—"My soul doth magnify the Lord, And my spirit hath rejoiced in God my Saviour" [32] (Luke 1:46–47)—were spoken during her meeting with Elizabeth. Christ is shown next, John the Beloved on His left. The presence of the Virgin and John the Evangelist on either side of Christ signifies both the beginning and the end of Christ's life on earth. The Virgin alone suggests His birth, and the Virgin with St. John, His Crucifixion. The last figure on the right, Mary Magdalen with her ointment jar, recalls Christ's burial (28). Above her head is the inscription, now written in a straight line since it is a statement about her rather than a quotation: "Then took Mary a pound of [costly] ointment . . . and anointed the feet of Jesus" [33] (John 12:3). This incident took place during Christ's visit to the house of Mary and Martha. Her action was repeated at the time of the Entombment.[34]

The Magdalen completes the references to Christ's life on earth. As John the Baptist unites the world prior to Christ with the world of His historical presence, Mary

Illustration 27

Illustration 28

joins this world with the world of the spectator. She is dressed in contemporary clothes rather than apostolic robes. She embodies the hope of salvation for all mankind. As *The Golden Legend* reminds us, on the day of the Resurrection Christ appeared first to the Magdalen in order to demonstrate that He had died for sinners.[35] The time encompassed by all the figures, from left to right, suggests biblical history from the Old Testament to the present. The two are united through the grace of Christ. Pictorially He is the dominant figure in the center; all the saints, regardless of their place in time, turn toward Him.

The saints do not reenact any of the historical events of which they speak. They are presented in purely symbolic fashion, having no narrative communication with their environment. Like Christ, they do not suggest human passion or action. The events of their lives referred to in the inscriptions have an end beyond their earthly meaning. They serve to identify the various saints as witnesses to Christ's divinity. Any contact they had with Him on earth is recalled only because of its sacred nature.

John the Baptist's prophecy of the birth of Christ and the act of Baptism, seen in the background of the painting, revealed Christ's divinity to the world. The words of the Virgin were spoken at the time of the Visitation. During this meeting Elizabeth was the first earthly being to recognize the divinity of Mary's Child, saying, "And whence is this to me, that the mother of my Lord should come to me?" (Luke 1:43). Elizabeth's child, John, was the first human being absolved from sin by Christ, having been sanctified in his mother's womb.[36] Both the gesture and the words of John the Evangelist speak of Christ's redemptive power. Mary Magdalen, like John the Baptist, is an example of it. One was redeemed prenatally, the other after a life of promiscuity. The Magdalen holds her jar in her veiled hand as if it were a sacred vessel. She first anointed Christ's feet after the resurrection of Lazarus. The Raising of Lazarus was the greatest miracle Christ performed on earth, for, according to the Gospel of St. John, Lazarus was the only person whom Christ revived after death. The words Christ spoke to Martha during this miracle are the clearest statement of His divine mission: "I am the resurrection, and the life: he that believeth in me, though he were dead, yet shall he live" (John 11:25).

Every figure on the interior symbolizes by his presence and his words the divinity of Christ. The attributes and the gesture of Christ emphasize His sacred rather than His human nature. The sun and the sky behind Him are controlled for the same purpose. Around His head shines the light of divinity, "the true Light, which lighteth every man that cometh into the world" (John 1:9).

The portrayal of Christ's life on earth as the Son of God rather than as the Son of Man comes primarily from the Gospel of St. John.[37] In this Gospel Christ appears as the divine Logos; His earthly form is merely a disguise necessary for the accomplishment of His ultimate purpose: the saving of mankind. Most of the historical events of Christ's life are not recounted by John. The childhood events are omitted entirely, for his Gospel begins with the Baptism. Christ does not grow and develop on earth, as He does in the Synoptic Gospels, but appears from the beginning as a perfected divinity.[38]

One of the reasons for St. John's appearance within the Deesis must be that his Gospel was responsible for a large part of the iconology of the altarpiece. Next to Christ he is the most influential figure and the one whose traditional role is most transformed. All the inscriptions in the triptych come from his Gospel, except one, that of Mary. Because the Virgin's presence had to relate to the birth of Christ (not recorded by St. John), Rogier had to turn to another Gospel, St. Luke's, for an inscription. But the philosophy of St. John's Gospel permeated even this selection. The words chosen from Luke do not expound upon the physical birth of Christ. Instead they are the words of the Magnificat in which the Mother glorifies her unborn Child as her God and Savior. She does not refer to Him as her Son.

The only pictorial reference in the triptych to a historical event in Christ's life is the scene of the Baptism in the left wing. As in the Gospel of John, it is presented chronologically at the beginning of the time sequence. It was during the Baptism that Christ first appeared to the world as the Son of God. The only narrative scene in the painting presents the historical moment wherein Christ's divinity was publicly revealed.

The explanation for the fact that St. John and his Gospel have been responsible for a majority of the iconographic innovations in the triptych does not seem to lie in any pictorial tradition. Even if we were to account for John the Evangelist's presence in the Deesis as coming from the French tradition, we could not account for the manner in which the Deesis is presented. Christ no longer judges, and John no longer intercedes. Even the Virgin's gesture, in this context, could be interpreted as adoration as well as intercession. The three figures do not reflect the transient state of judgment, but rather the eternal state of bliss presided over by the *Salvator Mundi*. John, by taking Christ's cup, pictorially explains the means of obtaining salvation. The words of the Virgin were spoken at the time the first mortal was saved by Him. This person, John the Baptist, appears on the left.

The unique elevation and influence of John the Evangelist and his Gospel can be understood if we accept him as the patron saint of Jean Braque. We have only Braque's name to suggest that he was; there is no chapel dedication to turn to since this was a private altarpiece. Perhaps Braque did not appear within the painting presented by his patron saint because he was already dead. The moment of introduction was past. Perhaps at Catherine's request, Jean Braque's patron saint, John the Evangelist, was directed to play the major role, taking the place of the deceased and imitating Christ in his gesture of absolution. To enhance further St. John's importance, his Gospel was used to underscore the unique iconography of the painting.

By a series of subtle iconographic changes, Rogier personalized the whole altarpiece for Jean Braque without including his likeness. On the exterior the fact of death is paramount. Braque's name is closely associated with the skull of Adam, his wife's with the lament from Ecclesiasticus. On the interior the fleeting state of mortality is replaced by the promise of Christ and His saints. No reference to a human situation mars its perfection. As the wings open, death becomes life in the true Christian sense.

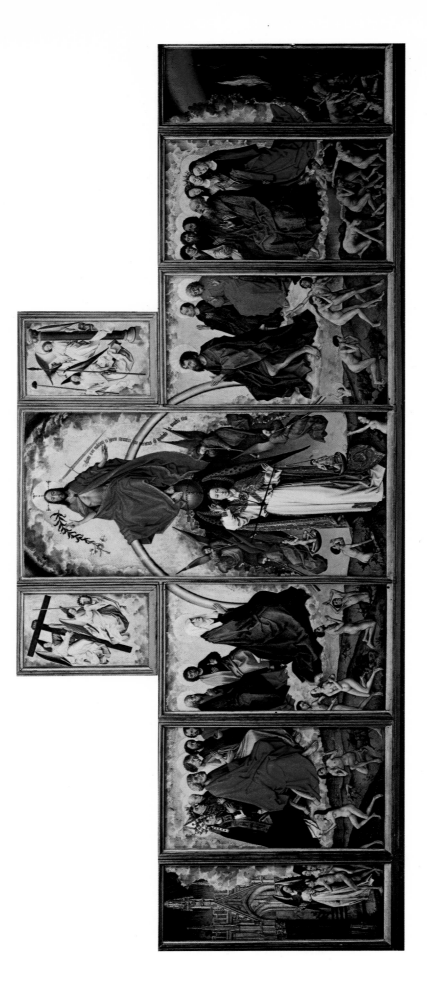

V. Rogier van der Weyden: Last Judgment altarpiece. Beaune, Hôtel-Dieu.

4

The Last Judgment Altarpiece
by Rogier van der Weyden

Not unlike Peter Bladelin, Nicolas Rolin, another high official in the court of Philip the Good, combined a public building with a private memorial in a costly and lavish architectural monument. Instead of creating a whole city as Bladelin had in Middelburg, Rolin built in the center of Beaune, near the marketplace, an entire hospital complex of some twenty-five rooms. For its chapel, called the great hall, he commissioned Rogier van der Weyden to paint his largest altarpiece, a polyptych of the Last Judgment.

Rolin's decision to build an hôtel-Dieu, or hospital, must have been influenced by conditions in Burgundy at the time.[1] Despite the fact that the Treaty of Arras (1435) had largely reconciled the affairs between the French and the Burgundians, internally the sufferings of the French people had increased. Illegal bands of soldiers, called *escorchers*, wandered through the country, pillaging at will. Fire, murder, famine, and finally, between 1438 and 1440, the plague, swept across the ravaged land.

By 1441 Rolin had decided to build his hospital, though he did not yet know whether it should be located in Beaune or Autun.[2] In that year he secured permission for its construction in either city from Pope Eugene IV.[3] The Pope gave Rolin a large sum of money to aid in the building, and he granted indulgences to all who contributed to the cost of construction. The hospital was to be run by the clergy, whom the Pope made directly responsible to himself.

Although Rolin felt a deep personal affection for Autun, where he was born and raised, he decided to build his hôtel-Dieu in Beaune. Autun already possessed a rich abbey with a hospital; Beaune did not. And the population in the vicinity of Beaune, decimated by the plague, was desperately in need of a hospital.[4] Moreover, Beaune was of greater political importance to Burgundy than was Autun, for it served as a second capital within the duchy, partly because it was closer to the Netherlandish holdings of the Burgundian dukes than was the official capital at Dijon. Philip the Good maintained a residence there, as did many of the richest and most influential men of Burgundy.[5] The Parliament of the province and the Estates General of Burgundy both assembled in Beaune. Nicolas Rolin

was, above all else, a shrewd politician. Although he chose to be buried in his native city, he located his hospital in Beaune, a major nerve center of the dukedom. The city willingly gave him much of the land, and Philip the Good contributed a large sum of money and granted many privileges for construction of the hospital.[6]

The hospital was dedicated to the "all-powerful God, to His Mother the Virgin, and to St. Anthony Abbot." [7] Although it was built "wholly for the practice of works of piety and mercy," [8] it was not limited to care of the poor alone. Because the bourgeoisie and the nobility often could not be cared for adequately in their own residences, Rolin provided many special rooms for them in his hôtel-Dieu. They were usually cared for at their own expense and often, in gratitude, left large donations to the hospital.[9]

Construction of the building probably began late in 1441 or in 1442. In 1446 and 1447 Rolin acquired additional land for a cemetery from the Franciscan Minors who owned a nearby monastery.[10] The chapel was consecrated on December 31, 1451, and the Hospital Sisters of Valencienne, who had come to Beaune from Malines, were installed the next day.[11] The first patients were received then, and on January 10, 1452, the first person was buried in the cemetery.[12]

It is thought that Rolin hired the Flemish architect Jehan Wiscrère to build the hôtel-Dieu.[13] Its plan was based on that of the hôtel-Dieu in Tonnerre. Architecturally Rolin's hospital is one of the most important fifteenth-century buildings still to be found in France, rivaling the house of Jacques Coeur in Bourges in its luxurious ornamentation and furnishings (32–35).[14] In style it is typical of late Gothic, Flemish architecture with its sharply peaked roofs, marked alternately by large and small gables and dormer windows, all of which are topped by slender spires. The building complex is constructed around a large inner court, which has a fountain on one side.[15] (See the plan of the hôtel-Dieu, 31.) The great hall is located just to the left of the principal entrance. It is the only part of the building which is not divided into two stories. The lower level also contained a twelve-bed infirmary, which was used, in addition, for washing and preparing the dead for burial; a door opened directly from it to the cemetery. Rooms such as the Chamber of St. Anne and the Chamber of St. John the Baptist on the west side were used for the care of the nobility. The remaining rooms on the lower level were for the routine upkeep of the hospital: the pharmacy, the baking house, the kitchen, the laundry, the grange, the living quarters for the male clerics, and the refectory for the sisters. The second story contained the sisters' dormitory and infirmary, a library, and several more rooms for the nobility, including the Chamber of the King.[16]

In the great hall the substance and justification of Rolin's hôtel-Dieu are given concrete form as a sanctuary for the sick. This vaulted room is formed like a large chapel, measuring some 72 meters in length and 40 meters in width (34).[17] It contained three altars at the western end, and its southern wall was pierced by long Gothic windows. The nave section contained thirty beds, each of which held two patients. Thus the congregation of the sick within the room numbered as many as sixty. The nave was separated from the sanctuary by a pierced screen, which allowed the sick to see and partake

Illustrations 32–35

Illustration 31

Illustration 34

of the Mass. It was surmounted by a Calvary with the Virgin, St. John the Evangelist, and St. John the Baptist. In addition each of the beds held two statues of saints. This room, which housed the largest number of the sick, revealed the dual character of the hôtel-Dieu, as a hospital consecrated to the care of the poor and devotion to God.[18]

The major altar in the apsidal end was sheathed in marble and surrounded by four columns, each supporting an angel.[19] On it stood a richly jeweled cross reliquary containing a fragment of the True Cross.[20] It was given to the hôtel-Dieu by Guigone de Salins, Rolin's second wife and dedicated partner in the construction of the building. Rogier's "Last Judgment" was originally placed on this altar.

The exterior of the "Last Judgment" altarpiece is divided into six compartments, which correspond to the individual panels that make up the wings (36). Because it is a double-hinged and multiple-paneled triptych, it is often called a polyptych. The upper two panels, which contain the Annunciation, are hinged separately from the lower four panels and therefore open independently from them. The lower area contains on its four panels Nicolas Rolin, St. Sebastian, St. Anthony, and Guigone de Salins. Its size, complexity, and iconography strongly suggest the Ghent altarpiece.[21] When the drab exterior opens to the brilliant interior, one is again reminded of Van Eyck's famous work. On the interior the division of panels is no longer adhered to; one continuous scene is presented as in the lower area of the Ghent altarpiece. Since this was the only time Rogier used so elaborate a form for the triptych and this type of donor iconography for the exterior, it may very well be that he was trying to emulate the Ghent altarpiece, perhaps at the request of Rolin.

Illustration 36

The four divine figures on the exterior, SS. Anthony and Sebastian, the Virgin and Gabriel, are all painted in grisaille. They appear to be standing in shallow sculptural niches. The donors, painted in naturalistic color as were Vyd and his wife, kneel within small cells whose depth is cut off by a curtain suspended about two-thirds of the way back. The light falls upon the six units consistently from the left, corresponding to the actual light source in the great hall.

Nicolas Rolin and Guigone de Salins both wear black robes trimmed with marten fur. They kneel in three-quarter position, each before a *prie-dieu* draped with a cloth bearing their respective devices: the keys for Nicolas, the tower for Guigone. Behind each of them is an angel bearing their full coat of arms. The angel behind Nicolas is the only bright spot in the muted exterior. He emerges like an apparition wearing brilliant red and bearing a helmet and keys of shining gold. This is the only means of drawing extra attention to Nicolas; in all other respects Guigone is treated as his equal, though of course she is located on the less important, right side. Guigone addresses her devotion to St. Anthony, who inclines his head in her direction. The two do not appear to be looking directly at each other, but they are turned toward each other. Nicolas and St. Sebastian, on the left, repeat the theme of saint and devotee.

According to the few sources we have, Guigone was a model of Christian virtue.[22] Born of an eminent Burgundian family, she was characterized by pious, charitable acts.

She was so enthusiastic about the building of the hôtel-Dieu that some authors even credit her with the initial idea of founding the hospital.[23] Her devotion to the project was such that after the death of her husband in 1462 she renounced her inheritance and position in order to consecrate her life to the care of the sick. She became a hospital sister of the hôtel-Dieu, donned the nuns' habit, and took their vows.[24] She died in their service in 1470.

Nicolas, on the other hand, was a man of the world, severely criticized and praised by Chastellain [25] and deeply loved by Philip the Good. Born in 1380 a simple bourgeois, he rose to the highest post in the land, incurring the hatred and envy of many.[26] For eleven years he served as counselor to Duke John the Fearless and was with him on the bridge at Montereau in 1419 when the Duke was murdered by the French. Philip the Good, upon the death of his father, immediately relied upon the advice of the older statesman. Within three years he made Rolin his chancellor, and Rolin served the Duke in that capacity for nearly forty years. Rolin became for the house of Burgundy what Richelieu and Colbert were later for the Bourbon kings.[27] He promoted the centralization of the state and the establishment of the absolute power of the Duke by his excellent organization of both internal and external affairs.[28] He became Philip's closest adviser, trusted in matters of finance, diplomacy, and administration, and was appointed to rule in Philip's absence in 1454. Rolin's greatest single accomplishment in the diplomatic field was the Peace of Arras. Even the humiliated king, Charles VII, gratefully acknowledged Rolin's service by awarding him a large grant of land.[29] This treaty finally effected a reconciliation between Philip the Good and Charles VII. The King issued a formal apology for Duke John's murder. Although Philip recognized Charles VII as his legitimate sovereign, he refused to pay homage to him; from that time forth the proud Philip never bent his knee before the French king. Philip's dukedom became in practice a kingdom with Philip its undisputed leader and Rolin his second-in-command.

In Philip's service Rolin amassed a considerable fortune. As a man of wealth whose life was dedicated to public service, he felt some obligation to return a part of his riches to God and to the general populace; therefore, he built the hôtel-Dieu. Even if this duty was also born of an ostentatious desire to display his wealth, as Henri Pirenne suggests, it resulted in many material and spiritual benefits for the inhabitants of Beaune.[30]

Illustration 36

The two saints to whom Guigone and Nicolas address their prayers are not their name patrons (36). The appearance of St. Anthony is easily explained, for he was one of the dedicatory saints of the hospital. He was probably invoked as patron because of his particular care for the sick and his popularity among the Burgundians. Philip the Bold held St. Anthony in special favor, because he was born on Anthony's feast day. He made Burgundy a fief of St. Anthony, thereby making the saint the patron of all Burgundians.[31] Philip the Bold named his second son Anthony, and later Philip the Good named his natural son Anthony. Perhaps reflecting the same spirit, Rolin named two of his sons Anthony: one natural son and one son by his first wife.[32] In the Netherlands the chivalric Order of St. Anthony was second in importance only to that of the Golden Fleece.[33]

The presence of St. Anthony on the altarpiece gives us a *terminus ante quem* for its completion. In 1452 the dedication of the hôtel-Dieu to St. Anthony was changed to St. John the Baptist. Rolin feared that the hospital Order of the Antonines might at some time claim a right to the foundation, for it had not been stated in the original papal authorization that they had no special privileges.[34] Rolin relayed his fears to the Pope, Nicholas V, who suggested that the dedication be changed to St. John. Rolin agreed and the Pope granted the change, this time prudently adding that the Order of St. John the Baptist could not at any time demand rights within the hospital.[35] The altarpiece was finished before this dedicatory change in 1452; it could have been started at any time after 1443 when Rolin received the first charter.[36]

The reason for the selection of St. Sebastian is less apparent. Sebastian shared Anthony's popularity in Burgundy, particularly after 1430 when Philip the Good selected him as patron saint for his new Order of the Golden Fleece. St. Sebastian, along with St. Anthony, was one of the saints most frequently invoked for protection against the plague.[37] Some authors claim that he was depicted in the altarpiece as a personal patron of Nicolas because he was a member of the Order of the Golden Fleece.[38] If this was the reason for St. Sebastian's inclusion, however, it would seem that Nicolas should at least wear the collar of the order so that he might clearly identify himself with its patron saint. It would also seem that Guigone should have chosen a saint whose presence similarly suggested a more personal devotion. Curiously, the only possible reference to a personal patron found within the entire hôtel-Dieu is the statue of St. Nicholas on one of the four pinnacles above the main portal. He is one of a group of three statues, the others being the Virgin and St. John the Baptist. They were probably all put into place after the dedication was changed. The Virgin appears with the new dedicatory saint, John the Baptist, and St. Nicholas is probably included in honor of Pope Nicholas, who was responsible for the rededication, rather than for Nicolas Rolin. On the fourth spire over the portal are the arms of Nicolas and Guigone. As is usual throughout the hospital, their double role in the donation is stressed rather than the singular recognition of either one.

On the exterior of their altarpiece they appear as cofounders of the hôtel-Dieu, asking not for personal intercession, but for protection for their hospital. Since the hôtel-Dieu was to serve the Burgundians primarily and was established through Burgundian wealth, the donors paid tribute to two favorite Burgundian saints. Indirectly they honored the Duke of Burgundy, the two most important chivalric orders in his dukedom, and the entire populace. More directly these saints were associated with the hospital's function, both favoring the sick and giving them protection against the dreaded plague. Although Rolin officially dedicated the hôtel-Dieu only to Anthony, surely the altarpiece suggests that Sebastian shared Anthony's role as patron.

The upper zone of the exterior, hieratically the more sacred realm, contains no mortal figures and no reference to the contemporary setting. The Annunciation was probably not painted by Rogier.[39] If one compares the figures of the Virgin and the angel Gabriel with those of SS. Sebastian and Anthony, differences of quality are ap-

parent. The lower saints appear less harsh, and able to breathe and move more easily. The transitions from light to dark are more subtle and complete. To use Panofsky's simile,[40] the lower figures appear to have been turned to stone and brought back to life again; the upper figures have reached only the first stage of this magical transformation.

Though done by another hand, the Annunciation was undoubtedly part of the original iconography, since it was a traditional subject for the exterior of triptychs. On feast days of the Virgin, a parament reputedly made by Guigone herself was placed upon the

Illustration 41 main altar below the triptych.[41] It too displayed the Annunciation (41). It should be recalled that the hôtel-Dieu was dedicated not only to St. Anthony, but also to the Virgin and to the all-powerful God. Both Anthony and the Virgin Annunciate appear on the exterior. God is revealed within.

As the triptych is opened, all the compartmentalization of the exterior disappears

Plate V as the Last Judgment unfolds across the seven panels, luminous in gold and pink (V). Christ appears in the center seated upon the traditional rainbow as Judge of the world, raising His right hand in blessing. The lilies of mercy extend above this hand accompanied by the inscription, lettered in white: "Come, ye blessed of my Father, inherit the kingdom prepared for you from the foundation of the world" (Matthew 25:34).[42] Christ's left hand extends downward with the double-edged sword of justice above it and the inscription, in black: "Depart from me, ye cursed, into everlasting fire, prepared for the devil and his angels" (Matthew 25:41).[43] On either side of Christ, separated by the small wing divisions, four angels carrying the instruments of Christ's Passion remind the viewer that even as the supreme Judge, Christ is yet the Son of Man. He has won through his suffering the right to judge each man according to his works.[44] Seated at the ends of the rainbow, completing the Deesis, are the Virgin and John the Baptist. Although sitting on benches, they appear to be semikneeling figures. Their gestures are of supplication, for they are the two who might intercede before the impartial judgment of Christ.

The twelve Apostles are seated in a semicircle behind the Virgin and John, six on each side. The first Apostle on either side is easily identified. Peter, in the red robe, sits on the left, and Paul, in the green robe, on the right. Peter's robe carries his motto "credo in unum Deum." The identification of the other Apostles is not clear. According to F. de Mély who bases his interpretation upon the color of their robes,[45] next to Paul on the right sit Philip, Andrew, Simon, John, and Matthew; on the left are Mathias, James Minor, Thomas, Bartholomew, and Thaddeus. They are accompanied by seven figures who have not yet been satisfactorily identified. On the left are a pope, a king, a secular figure, and a bishop, and on the right, a queen and two other women. Although they are all nimbed, they wear contemporary costumes and seem to come from the community of men. Since these figures are already in Paradise, they cannot be the general representatives of humanity who are often included as part of the procession of the blessed or the damned in medieval depictions.[46] They are not general types, but, rather, specific portraits.

Heaven and earth are united by the figure of St. Michael (37). As high priest he *Illustration 37*
stands below Christ with his scale, performing on earth the actual judgment which is
heralded by four trumpeting angels on either side. The evil in man is represented by
the tiny figure in the lower pan of the scale, identified by the word *peccata* inscribed in
black letters above his head. The goodness of man is shown in the upper scale; *virtutes*
is inscribed in white above him. The damned are driven toward Hell, which appears as
a fiery pit in the last panel on the right. The blessed move toward Paradise, which is
dominated by a golden Gothic portal. An angel points the way and welcomes those whose
virtue has triumphed.

Throughout the whole altarpiece the polyptych format is utilized iconographically.
On the exterior every panel division corresponds to a subject division. On the interior
the long format—approximately 18 feet, 4 inches—suggests the lateral extension that
Rogier emphasized in the Last Judgment. He ignores many of the individual panel di-
visions in order to obtain the effect of a single scene. The semicircle of the tribunal takes
no heed of the separate panels and the frames cut directly through the groups, leaving
a head on one side and drapery on the other. The end panels define the realms of Para-
dise and Hell, though the unifying cloud of heaven extends into these panels, refusing
to grant them full independence. The center and largest panel can be viewed as a sepa-
rate unit. Here Christ and St. Michael appear in full face, one above the other. The four
angels who surround Michael and the two mortals in his scale turn toward him. The two
figures of the Deesis are excluded from the panel, relegated to a lesser position as are
the angels with the *arma Christi*. Within this panel the vision of Christ and St. Michael
is an isolated image, dramatic and simple in form, the major coordinate of the whole
Last Judgment scene.

Most of the elements found in this "Last Judgment" come from a long iconographic
tradition. The Last Judgment in fourteenth-century medieval plays was divided into
five acts based primarily on the Gospel of St. Matthew.[47] The first act was the foretelling
of the coming of the General Judgment by disastrous events. The second act was the
appearance of the Son of Man in the clouds as the immortal Judge looking as He did
on earth and as the living God. He was flanked by the figures of John and Mary. The
moment Christ revealed himself, the trumpets sounded and the dead arose. They were
all about the age of thirty-three, the age Christ was when He triumphed over death.
Then the actual Judgment took place. The Apostles, sitting on twelve thrones, served
as the presiding tribunal. Michael as the angel of death had the major role in this act.
Following the General Judgment, the last act consisted of the separation of the sheep
from the goats. All these acts are present in the triptych, except the first; it was omitted
as a prelude to, rather than as an integral part of, the Judgment proper.

Rogier's "Last Judgment" relies heavily on late medieval iconography. He reverts
to a High Gothic pictorial tradition in the juxtaposition of Christ as Judge appearing
above the Psychostasia, in the reintroduction of the motif of the lily and the sword, in
the horizontal layout with its absence of depth, and in the scale differentiation between

the mortal world and the holy world.[48] Rogier was certainly familiar with Gothic Last Judgments, as they profusely adorned cathedrals including the one at Tournai. In closer proximity to Rogier's own time were the paintings of the "Last Judgment" by Jan van Eyck [49] and the "Last Judgment" in the town hall of Brussels, which Rogier would have seen when he executed his Justice panels there.[50] The latter representation, which is known by a later drawing, was similar to the "Last Judgment" by Stephen Lochner in Cologne.[51] These contemporaneous Last Judgments are characterized by a great deal of confusion and detail, especially in the realm of the damned. Though Rogier used their iconography, he greatly simplified and schematized their representation. "Instead of evoking chaos he glorifies a supreme and final order." [52] He reorders the composition and invents new motifs within the familiar context. He represents Hell without the devil or a monster to drag the damned downward. The damned cast themselves into the pit. The Psychostasia has been reinterpreted, virtue now being the lighter and sin the heavier.[53]

It seems entirely fitting that this altarpiece in the chapel of the sick should have as its main theme the final appearance of Christ as Judge of the world. The hospital was dedicated "en honneur du Dieu tout-puissant, et de sa très glorieuse mère Marie." God and Christ are inextricably united in this dedication as they are in the image of Christ of the Last Judgment. The Last Judgment theme is itself most germane for a sanctuary of the sick. To them death was omnipresent; the fear of damnation and the hope of resurrection were constantly in their thoughts. Surely the poor sick within the great hall were the legitimate heirs of this tableau. It was always in their presence, and even when the large wings were closed, they knew of the Last Judgment hidden behind them.

The emphasis on death and salvation is not confined to the triptych. It was the dominant iconographic motif throughout the chapel. Christ's Crucifixion was represented twice: on the screen and in the main window above the altar. The mourning over Christ's death was shown in the Pietà in the same window. The altar to the left of the main altar held a representation of the Resurrection of Christ. The only other scene from His life was the Raising of Lazarus which ornamented the altar on the right. There is no record of a series of Infancy or Mariological scenes within the chapel. The single saints invoked on the altars are those who witnessed Christ's death and Resurrection: the Lady of Sorrows, Martha and Mary Magdalen, and John the Evangelist. Also included are SS. Barbara and Catherine, both special patrons of the dead, and St. Anthony, patron of the hospital.[54]

The only other theme comparable in importance is the secular theme alluding to the donors. Their multiple signs commingle with the religious figures. As already noted, the entrance to the hospital is dominated by their devices. The long vestibule is painted with their entwined initials, N and G. These are repeated again on the exterior of the house of the head priest (*Beau-père*), and on cupboards, candelabra, and other pieces of furniture throughout the hospital. The tiles that pave the rooms, beautifully designed by the sculptor Jehannin Fouquerel, carry both their initials and a turtledove on an oak branch with a star and the word *Seule*. The turtledove on the oak branch was Guigone's

symbol and the word *Seule* Nicolas' chivalric device. The device was a sign of the fidelity and honor in which he held Guigone, very similar to the one that Philip the Good adopted after his marriage to Isabel: "Aultre n'aurai, Dame Isabel." [55]

In the great hall the references to the two founders are more numerous. The vaults, the windows, and the large chandelier all bear their arms. The floor repeats the pattern of their devices. On feast days the chairs and beds were covered by tapestries on which their arms were embroidered. One of these tapestries, which is still extant, displays St. Anthony Abbot on a field of red with their devices (40).[56]

Illustration 40

Only in the great hall is there a reference to any other secular figures. Here Rolin allowed Philip and Isabel to share the glory of the hôtel-Dieu with Guigone and himself. The large stained-glass window above the altar which contained the portraits of Rolin and his wife also contained those of Philip and Isabel praying before the Pietà.[57] In the vaulting the festoons bearing the escutcheons of the founders also carry those of the Duke and Duchess. In the windows on the west wall, the shields of Nicolas and Guigone appear in grisaille along with the effigies of all four of Nicolas' children by his first marriage.[58]

The great hall seems to dramatize the dual intention embodied in the building of the hôtel-Dieu. It is an enduring witness to Nicolas and Guigone's profound desire to provide for the sick: its decoration demonstrates their equally intense desire to create a memorial to themselves. And within the great hall the "Last Judgment" altarpiece reflects the same duality. It too is a public monument and a private memorial.

The justification for such a proliferation of personal references, combined with the pervading iconography of death and resurrection, comes, I think, from the fact that the great hall of the hôtel-Dieu had yet another purpose besides being sanctuary and sickroom. It was also a funerary chapel for the Rolin family. Actually only Guigone, Rolin's first wife Marie des Landes, and his daughter Philipote were buried there,[59] but the effigies of Nicolas and his three sons all appear. Nicolas is shown again on Guigone's copper tomb plate, where she is presented in her widow's garb and he as a chevalier.[60] The tomb is located directly in front of the main altar. There is a multiplicity of donor portraiture in the most sacred area of the chapel: on the tomb plate, on the altarpiece, and in the window above.

The sepulchral function of the hôtel-Dieu was made quite clear by Nicolas himself in a set of statutes written for the hospital in 1459.[61] In some of the rules we sense a new urgency and desire to make clear that it was part of the duty of those within the hôtel-Dieu to partake of intercessory activities on behalf of the donors. Nicolas requested that two services be said every day at Matins and Vespers: the Office of the Virgin and the Office of the Dead. These were to be followed by fifteen Paternosters and fifteen Ave Marias with a special recommendation to God for Nicolas and his wife. In another statute he asked that the bread that had always been given to the poor now be given expressly "for me and in my name." He made provisions for the services that were to take place in the hôtel-Dieu at his death and at the death of Guigone.[62] He

had given food and care to the poor and the sick. In return he assumed that they would naturally pray for the salvation of their benefactor. If they did not, Rolin had guaranteed that the nuns and the priests would.

Rolin's hope for salvation was based primarily on his donation of the hôtel-Dieu. It is no wonder that he and Guigone did not invoke personal intercessors on the exterior of their altarpiece. Their whole establishment was to speak for them; consequently they prayed for its care and success. The building of the hôtel-Dieu was Rolin's attempt to accomplish on a grand scale the Christian act of *misericordia* for which Christ had promised a place in Paradise. Part of this promise is inscribed on the painting that Rolin commissioned. Christ speaks to those who are saved: "Come, ye blessed of my Father, inherit the kingdom prepared for you from the foundation of the world." The verses conclude, "for I was an hungred, and ye gave me meat: I was thirsty, and ye gave me drink: I was a stranger and ye took me in: Naked, and ye clothed me: I was sick and ye visited me: . . . And the King shall answer and say unto them, Verily I say unto you, Inasmuch as ye have done it unto one of the least of these my brethren, ye have done it unto me" (Matthew 25:34–40).

Rolin must have felt that his building of the hospital had been undertaken in exactly this spirit. He had spared no expense. He had honored God and the saints throughout. He had built it for the poor and the weak. Though he gained no worldly benefit from it, he did expect an otherworldly reward for it. He dramatized his personal hope within the handsome altarpiece. On the exterior he and his wife humbly kneel before the patrons of the hospital, reminding us that they were responsible for this great establishment. On the interior they selected the scene of the Last Judgment, the time in which man shall be judged by his deeds alone.

Perhaps Rolin's vision of his final reward explains the presence of the extra figures behind the apostolic tribunal. Rolin, taking Christ's words literally, placed himself in heaven, assuming that his beneficence had earned him this position. He included his family and those who had helped him most in building the hôtel-Dieu, just as he had included them in the great hall. If this hypothesis is correct, the king is Philip; the Pope, Nicholas

Illustrations 38, 39

or Eugene; the bishop, Rolin's son Jean; and the secular figure, Rolin himself (38). On the right side (39), the queen is Isabel; the two other women are Guigone and perhaps Rolin's first wife Marie des Landes or his daughter Philipote.[63] The fact that the hôtel-Dieu had prepared Rolin's entry into heaven might be suggested by the gates of Paradise which bear a marked similarity in detail to the portals and dormers of the hospital in

Illustrations 35, 38, 42

Beaune (cf. 35 and 38). When Memlinc copied Rogier's scheme for his "Last Judgment" in Danzig (42), he left the contemporary figures out and transformed the Paradise portal into a fantastic and ornate Gothic structure. Like the copyists of the Bladelin triptych, Memlinc too did not dare repeat the presumption of the donor. The new setting and donation for the old theme would not or could not accept it.

Rolin referred in the foundation charter of the hospital quite specifically to the type of contractual agreement with the Godhead suggested by the altarpiece: "On this Sunday,

the fourth day of the month of August in the year of our Lord 1443, disregarding all human concerns and in the interest of my salvation, desiring by a favorable trade to exchange for celestial goods temporal ones, that I might from divine goodness render those goods which are perishable for ones which are eternal . . . in gratitude for the goods which the Lord, source of all wealth, has heaped upon me, from now on and for always, I found . . . a hospital." [64] With the completion of the hôtel-Dieu, Rolin's part had been accomplished; he trusted God would keep His side of the bargain.

Time and again in the early years of the fifteenth century, the individual donor asserted his right to divine attention. His increasing dominance of the pictorial space and subject matter need not be regarded as an increasing secularization of the religious content. It is less religious only from a medieval point of view. In the Northern Renaissance, as in the Southern Renaissance, there is a marked change in religious reality. Devotion is expressed in far more personalized terms, and the idea of imitation is more logically developed. Duke Philip the Bold made the entire sculptured portal of his funerary chapel in Champmol an expression and actual representation of his desire for salvation by having SS. John the Baptist and Catherine commend him and his wife to the Virgin. The iconography usually reserved for a tomb plaque dominated a church facade. Bladelin took over the role and position of an adoring shepherd or Magus within a Nativity scheme. Reigning dukes and princes repeatedly impersonated the three Kings. It must be remembered that they never took over Christ's role, but only worshiped Him in closer proximity—spatially and historically. Man and God now met in a world that was familiar to both. Man need no longer bow his tiny back and crane his neck in order to express his devotion to an omnipotent being. He became a more logical extension of God's image; the difference between man and God became a matter of degree of perfection rather than of order of being.

One indeed may question Rolin's audacity in placing himself, his family, and his friends in Paradise. As we have already seen in the "Rolin Madonna," he was not a shy man, but one more than eager to confront his Maker. Somehow his presumption seems even bolder in the Beaune altarpiece. In this painting Paradise has already been achieved, whereas in the "Rolin Madonna" Rolin appears only as a humble visitor; one is constantly reminded of his human, sinful nature. But the only qualification made for the secular figures in the Beaune "Last Judgment" is one of position. They appear behind the heavenly tribunal and have obviously been crowded together. One can hardly see the face of the bishop, and the third woman is represented by merely a head. Rolin himself is farthest away, although his portrait-like features stand out sharply. The scale of these figures appears to be somewhat smaller than that of the Apostles, although the seeming difference could be attributable to perspective recession. Nevertheless, it is most unusual in Rogier's work to find secular figures in smaller scale, no matter what the explanation. They are most often in a foreground position assuming the size of the divinities. In the Beaune altarpiece, by placing these figures outside and behind the circle of Apostles, Rogier must have been indicating their lower station.

If the identification of these figures is correct, the Beaune "Last Judgment" illustrates one of the most overt wish fulfillments of the fifteenth century, hardly equaled by Justinian and Theodora when they led the Eucharistic procession down the choir walls of San Vitale. But perhaps within the hôtel-Dieu, on its major altar in the sanctuary of the poor, the temerity of the vision found full acceptance. Its meaning within this context must have been abundantly clear and needed no artistic or historical apologia.

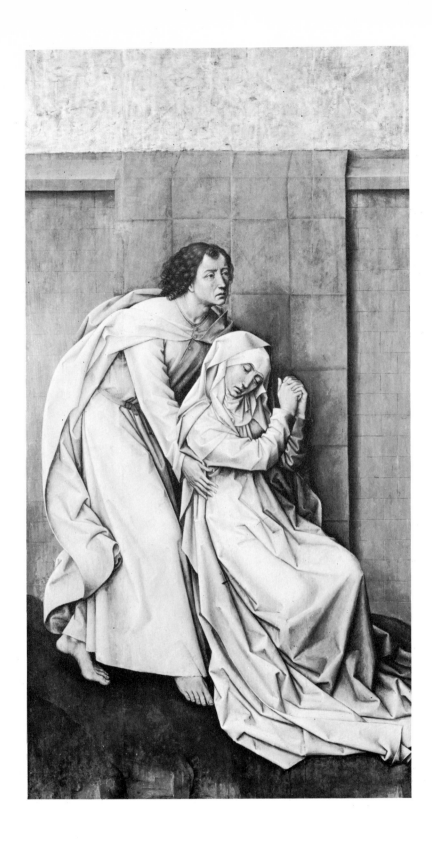

VI. Rogier van der Weyden: The motif of the Swooning Virgin and St. John, left wing of Calvary diptych, Philadelphia Museum of Art, John G. Johnson Collection.

5

The Edelheer Altarpiece by a Follower of Rogier van der Weyden

In 1443 when the Edelheer triptych (43, 44) was placed in the Church of St. Peter in Louvain, it stood as a proud testimony to the wealth and devotion of the Edelheer family. The large altarpiece was the first painting given by an individual for the decoration of the newly constructed choir. Now it hangs mutely on the aisle wall, its socioreligious function forgotten by an age that measures art in terms of esthetic quality.[1] *Illustrations 43, 44*

For a number of reasons, the Edelheer triptych is justly considered of little interest. Its center panel is a close copy of a very famous painting by Rogier van der Weyden, the "Descent from the Cross" (46), located in the Prado Museum.[2] Its interior wings are a stereotyped presentation of the donors and its exterior wings are so badly damaged that only the subject can be identified. In histories of fifteenth-century Netherlandish painting, the Edelheer triptych is at best included as a footnote, and that only because it serves as the *terminus ante quem* for Rogier's "Descent." It is condemned for the sin of imitation; what had been a virtue in the Middle Ages became a vice with the dawn of the Renaissance. *Illustration 46*

Although stylistically inferior and undeserving of praise, the Edelheer triptych is singularly complete as a visual document of fifteenth-century funerary art. It is painted on both the exterior and the interior, and its subject, donation, and location are all known. The center panel admittedly is a copy, but the exterior contains an iconographic innovation which alone should make the piece worthy of study. Although Von Simson has noted that the representation of the swooning Virgin on the left wing is a unique and important invention, he has not considered the reasons for the occurrence of the motif on this altarpiece.[3]

St. Peter's, the largest church in Louvain, is located on the Grand Place directly across from Louvain's famous hôtel de ville. A church had probably been on this spot as early as the tenth century, but it burned in 1130 and again in 1176, each time being rebuilt.[4] At the beginning of the fifteenth century, the Chapter of St. Peter decided to embark upon a new building program, which would considerably enlarge the existing structure.[5] Construction began in 1410,[6] but the church was not finished until the sixteenth century. The

first part of the new church to be completed was the choir. Its chapels were given to various confraternities and guilds with the understanding that they would decorate and maintain them.[7] The Confraternity of the Blessed Sacrament received two chapels: one dedicated to St. Erasmus and the other to the Blessed Sacrament.[8] The butchers were given the Chapel of St. Andrew, the linen weavers the Chapel of SS. Philip and James, and so *Illustration 45* forth. (See the plan of St. Peter's, 45.) In this way organized lay groups contributed directly to the maintenance of the church.[9]

As the work progressed, wealthy families also began to decorate windows, chapels, and altars. The first family to contribute was that of William Edelheer,[10] which received a chapel between that of St. Sebastian, belonging to the Archers' Guild, and the Chapel of St. Dorothy, maintained by the university's society of rhetoric, called La Rose.[11] Edelheer must have obtained his chapel sometime before 1439, the year of his death; he could have acquired it as early as 1433, the earliest date recorded for the distribution of any chapel.[12]

In their chapel William Edelheer and his wife Adelaide Cappuyns founded a chaplaincy. Their eldest son William was made the first rector and regularly said Mass before the altar.[13] In his last testament of 1473, William (the son) added a second chaplaincy and provided additional funds for its support. The altar in the chapel was dedicated to St. James, the Holy Spirit, and the Blessed Virgin.[14] Above this altar stood the Edelheer triptych, and below it the family tomb.[15]

Illustration 43 The donation of the triptych is recorded on the exterior of the right wing (43). An inscription at the bottom of the panel reads: "This retable has been given by Master William Edelheer and Adelaide his wife, in the year of our Lord 1443."[16] Because of the appearance of this date on the painting, the chapel is thought to have been founded in 1443.[17] Since by that time William had been dead for five years, he must have obtained the chapel and ordered the painting long before. In 1443 the painting must have been given to the church, and possibly the chapel was dedicated and the chaplaincy officially established then.[18] Although William Edelheer did not live to see these events, surely he was responsible for all the initial planning.

Illustration 44 The center panel (44) of the Edelheer triptych is one of the earliest copies of Rogier's Prado "Descent," which is tentatively dated 1435 by Panofsky.[19] It was readily available to the Edelheer artist, if not in Rogier's studio, in the Church of Our Lady Outside the Walls in Louvain for which it was commissioned. It too was originally a triptych. The wings are no longer extant, but we know that the Resurrection and the four evangelists were depicted on the interior.[20] The exterior, so far as we know, was not painted until the sixteenth century.[21] The Edelheer Master took only the scene of the Descent from Rogier; the interior wings of his triptych were reserved for the members of the donors' family.[22]

On the right wing, St. Adelaide [23] presents Adelaide Cappuyns and her two daughters, Adelaide and Catherine. St. Adelaide, the wife of Emperor Otto the Great, was the daughter of Rudolph II, a tenth-century ruler of Upper Burgundy. Hence she is connected by birth with the fifteenth-century domains of the Flemish and would find a special veneration among them.[24] Although she was of royal blood and became an empress, she had yet

another reason to carry the crown. After the deaths of her son and her grandson, she became regent of the Holy Roman Empire for a short while. She died in 999, and though never formally canonized she was popularly recognized as a saint and appears frequently in collected lives of saints. Her appearance here is easily justified as the name patron of Adelaide Cappuyns and her eldest daughter.

On the left wing, St. James Major, identified by his pilgrim's staff and shell, presents Edelheer and his two sons. The elder son William, the priest, can be identified by his robe and tonsure, directly behind his father. The other son must be James because of the presence of St. James. Edelheer's fifth child, Louis, is not represented, probably because he died at the age of five in 1435. The left wing of the triptych repeats the veneration of St. James already found in the altar dedication.[25] He was the patron saint of Edelheer's second son and also of Edelheer himself. In some documents, including this painting, Edelheer's first name appears as William, but it appears in other documents as James.[26] Apparently he used both names. For the altar of his funerary chapel and the wings of his triptych, he preferred to be represented by St. James. Perhaps, had he been alive at the time the painting was completed and the inscription written, he would have used the name James there as well.

When the Edelheer Master copied Rogier's "Descent" (46), he made no attempt to alter the positions of the figures or their relationship to one another. When we see how ineptly he handled the simple foreshortening of the hands of both St. Adelaide and St. James Major on the wings, we should applaud his modesty in not attempting to change the complicated positions of Rogier's figures. By changing the shape of the panel to a simple rectangle which extended well above the heads of the characters, the artist eliminated the effect of the incongruity between setting and figures which played a major part in Rogier's invention. The Edelheer Master retained the scale of the figures and the inconsistency between the gold, shrinelike background and the living, rather than sculptural, figures placed in front of it. But he enlarged the background shrine in order to accommodate the figures logically into its space. The patron saints on the wings, who are equal in scale to the figures in the center panel, demonstrate how comfortably they can stand in the extended space. Instead of being a critique on the existing stylistic development as was Rogier's "Descent," the Edelheer "Descent" remains within the realm of the plausible.[27] By taking Rogier's figures and placing them in a realistic setting, the artist demonstrates his own relation to the decade of the thirties. He is a part of the mainstream of the developing illusionistic style, as were Jacques Daret and the later Campin. Unlike the master he copied, he did not share in the heroic attempt to infuse the growing naturalism with a new sacred content by combining into one setting two realms of human activity which operate on independent levels of scale and meaning. The "Descent" of the Edelheer Master "corrects" Rogier's painting and returns it to the fold of the ordinary.

Even though the wing figures are set against the same continuous background and are the same size as the center figures, they are obviously not a part of the Descent proper. All the figures on the wings are kneeling in adoration: a series of eight stiff, upright,

Illustration 46

parallel verticals in opposition to the writhing, contorted, grieving figures on the center panel. Only the central cross repeats their solemn rigidity. Like them, it is a symbol of devotion, taken out of its narrative role. The repeated gestures and positions of the donors and their saints, their simple placement against a flat backdrop, their gaze, fixed on the center scene, repeated in every countenance—all these isolate them from, and subordinate them to, the passion of Christ. The divine figures have been given life; the living have been immobilized.

The Descent from the Cross is related briefly in the four Gospels, but did not receive much attention until the end of the Middle Ages. Then the theme was expanded by the many mystery plays and specifically by Bonaventure's *Meditations upon the Passion of Our Lord*.[28] Rogier's composition includes all the persons mentioned by Bonaventure: the three Marys, the Virgin, John, Joseph of Arimathea, and Nicodemus.[29] To this group he added two more figures who have no literary source, so far as I know. The man lowering the body of Christ from behind the cross has been called Simon of Cyrene even though, according to biblical texts, Simon only helped Christ carry the cross and did not take part in the Descent. Like Veronica, he was immortalized by one compassionate gesture toward Christ on the Road to Golgotha.[30] Because they both helped the anguished prisoner, it is easily understood why they might be included in scenes of the Passion, sharing the heavy affliction of Christ's death with His most beloved. The identification of St. Veronica in such scenes is certain, that of Simon is much more questionable. Pictorially an extra figure is sometimes included at the top of the cross to assist in the descent.[31] In Rogier's picture this man is strikingly different in type from the rest of the group. He has large, heavy features—thick lips and a broad nose. Unlike the other men, his curly hair is bound with a cloth. In Rogier's work he is similar in type to the third and youngest Magus on the right wing of the Bladelin altarpiece.[32] This figure too is unlike his companions. Though his skin is not black, the third Magus may well be Balthasar, the representative of the peoples of Africa. Before the convention of depicting Balthasar as a black man became more popular, Rogier used the heavy-featured, swarthy-skinned type for the Negro character.[33] Since Simon's home was Cyrene, a town on the northeastern coast of Africa, he could also justifiably be portrayed in this fashion.[34]

The other unidentified figure is the older, bareheaded gentleman behind the Magdalen. He has been called St. Peter because of the saint's traditional age and appearance.[35] Even though he and St. John were the first to go to Christ's tomb, it is very unusual to find Peter as a participant in a Deposition scene. His identity is complicated further by the fact that he carries an ointment jar. As only the Magdalen and Nicodemus brought ointment to the Entombment, it is difficult to understand why St. Peter might hold a jar. A further contextual justification must be found before he can be identified with certainty.

Illustration 5 The immediate pictorial prototype for Rogier's "Descent," as Panofsky points out, is the "Descent from the Cross" by Robert Campin (5), a triptych known only through a copy in the Walker Art Gallery in Liverpool and an original fragment of the "Good Thief" in Frankfurt.[36] This Descent also contains three unidentified male figures: one help-

ing to lower the body and two pagan bystanders on the far right. None of them bear any resemblance to Rogier's Simon or Peter.

Rogier has changed Campin's composition considerably, eliminating all the historical, narrative aspects of the setting and the physical effort of lowering the body. He has turned all the figures forward against a neutral fond rather than allowing them to be set into space upon Golgotha. Joseph and Nicodemus do not struggle to free the body, but hold it forth as a sacred object to be contemplated and adored. All attention is directed toward the body of Christ, for it is the central, dominant interest, turned outward to receive supplication, not unlike the body of Christ in Campin's Seilern "Entombment."

The devotional interpretation of the veneration of Christ's dead body is heightened by the new motif of the swooning Virgin. She no longer merely falls uncontrollably into the arms of St. John as she has since the days of the Pisani. Her action has been compositionally rearranged so that her body directly parallels Christ's in gesture and in attitude.[37] As Von Simson discovered,[38] she visually enacts the role that St. Bridget [39] and Bonaventure [40] made so popular. She too is "crucified." Her emotional suffering is so intense at the time of the Crucifixion that it takes physical form; she swoons as if dead. The same idea is found earlier in the *Speculum Humanae Salvationis:* "All the time that Our Lord suffered His Passion, the Virgin Mary was present, and by her Compassion she herself endured all the things which were done there." [41] The *Speculum* further elaborates this parallel between the actions of the Virgin and of Christ by following the seven stations of Christ's Passion with the seven sorrows of the Virgin. The two cycles in this order symbolize redemption and coredemption: "Christ vanquished the devil by His Passion, Mary by her Compassion." [42] Thus the swoon, the physical sign of Mary's Compassion, takes on a deeper meaning as the Virgin becomes the Coredeemer. The relationship between Mother and Son is raised to a devotional level that transcends the limits of time and place. The devotional aspect is intensified by use of the gold fond. Setting and figures, though physically incongruous, are spiritually in agreement. Their physical inconsistency points out and is overcome by their spiritual unity. The shrine, like the swoon of the Virgin, becomes a further sign of divinity.

Rogier's introduction of the pictorial theme of the swooning Virgin was undoubtedly influenced by contemporary literature, as Von Simson believes. Its appearance in this altarpiece, however, could be explained more fully. Rogier's "Descent" was intended for the main altar of the Church of Our Lady Outside the Walls. This chapel, as it is sometimes called, was built by the Archers' Guild in 1364.[43] Each member of the guild bequeathed his crossbow to the church. In 1365 the guild placed a picture of the Virgin of Sorrow within the church, probably upon the main altar which was dedicated to her.[44]

Undoubtedly one of the reasons the archers dedicated their church to the Virgin of Sorrow was because of her traditional representation. In both the pictorial and the literary arts, her sorrow was metaphorically expressed by a sword, and infrequently by an arrow, which pierced her heart. This representation came originally from the words spoken to the Virgin by Simeon—"Yea, a sword shall pierce through thy own soul also" (Luke

2:35)—and was popularized in the Franciscan hymn, *Stabat Mater*.[45] In the medieval mind the sword of the Virgin's sadness, like that of St. George or like the arrows of St. Sebastian, was easily associated with the weapons of the militant Order of the Crossbowmen.[46]

Depiction of a Virgin pierced by a sword was perhaps thought too gruesome or over-symbolic for the painters developing the new descriptive style of the fifteenth century. They portrayed her sorrow more often in terms of the actual events that caused it or in disguised symbols, such as the familiar iris or columbine.[47] Rogier, faced with the problem of decorating an altar dedicated solely to this aspect of the Virgin, invented a solution based on the idea of *imitatio*. The pictorial convention for the bodily Passion of Christ was established in the Descent. He added to this the bodily Compassion of the swooning Virgin. With this new motif he could express her sorrow directly, as the dedication demanded, without resorting to use of a symbolic sword. He could feature her sorrow as her "death" without infringing upon the new demands of plausibility. And through her new position she gained a major role in the drama, rather than the secondary one she still had in Campin's "Descent."

When the Edelheer Master copied Rogier's "Descent" for his center panel, he committed himself to Rogier's new theme of Passion and Compassion. The interpretations of the Virgin on the exterior right wing as the swooning Virgin and of the Christ figure on the left wing in the "Trinity of the Broken Body" as the Man of Sorrows are extensions of *Illustration 43* this theme (43). The exterior of the Edelheer triptych isolates even more dramatically the devotional aspect of the interior, displaying only the blunt reality of the parallel suffering of Christ and of the Virgin. All references to the historical situation have been omitted. The bodies are held up before us only as contemplative objects. They are painted in grisaille and set in separate niches upon pedestals.[48] There are no contemporarily clothed actors to soften the moment of suffering with their sympathetic weeping. On the interior the attention of one specific family and their patron saints is concentrated upon the death of and the lamentation over Christ, but on the exterior no one intervenes between the pictorial reality and the living spectator. The body of the Virgin "fainting as if dead" and the body of Christ complement each other. In the Virgin's imitation of Christ's suffering, the viewer finds an ideal object for, and a demonstration of, his own compassion.

Panofsky has suggested a prototype for the conception of John and Mary as an individual *Andachtsbild*, such as we find on the right wing. On one page of a manuscript executed in the workshop of the Master of the Rohan Hours about 1425 (from the Robert *Illustration 48* Garrett Collection), the center scene is the "Descent from the Cross" (48).[49] To the right is an individually framed picture representing St. John holding the swooning Virgin. Similarly on the left, two of the Holy Women form another separate unit. I do not think, however, that these figures are any more of an *Andachtsbild* than the same two figures in *Plate VI* Rogier's Philadelphia diptych (VI). In the Garrett manuscript the center scene of the "Descent" contains all the historical figures *except* John and Mary and the two Holy Women. Joseph and Nicodemus are taking down the body, and Mary Magdalen is at the foot of the cross. Two bystanders are on the right. The scene would not be complete with-

out John and Mary, even if they are presented in a framed unit separated from the central composition. In the Philadelphia diptych the swooning Virgin in the arms of St. John is on the left wing, the crucified Christ on the right. Together they refer to the three people traditionally associated with the Crucifixion. In both paintings only the isolation of the swooning Virgin and St. John is new. In the Edelheer triptych, however, not only are they isolated but they are in no way related to the historical scene of the Crucifixion or Descent. Mary's Compassion is venerated for its own sake. The interpretation grew out of Rogier's motif in the "Descent." Its isolated repetition on the exterior reinforced the dedication of the altar to the Virgin.

The left wing, commemorating the Holy Spirit, also presents an iconographic innovation. Pictorially the Holy Spirit could be shown in three different ways: as one of the Three Men forming the Trinity; as a flame of light as in Pentecost scenes or in the Transfiguration; or as a dove, most commonly found in the Annunciation, the Baptism, and the Trinity.[50] The Holy Spirit was never shown as a single figure or object. Since none of the biblical scenes was appropriate for the generalized dedication to the Holy Spirit, the Edelheer Master used a representation of the Trinity. It intensified the devotional aspect of the altarpiece rather than the historical, and it included the Holy Spirit as a major participant.

In his representation of the Trinity, the Edelheer Master employed a relatively new interpretation called the "Trinity of the Broken Body," in which Christ is portrayed as the Man of Sorrows. This type of Trinity was painted several times by Robert Campin. Both his Frankfurt and Leningrad versions are closely related to that of the Edelheer Master. Campin's idea probably originated in the school of artists working for Philip the Bold and John the Fearless at Champmol at the end of the fourteenth and the beginning of the fifteenth century. It may stem from a sculptural invention by Sluter himself.[51]

The Trinity of the Broken Body grew out of an older scheme called the *Gnadenstuhl* in which an enthroned God the Father holds forth the body of Christ on the cross.[52] A dove hovers between the head of Christ and God. In altering this motif, the artists of the late fourteenth century substituted the Man of Sorrows for the crucified Christ. They wished to associate God the Father more directly with the pain of the Passion, just as they had the Virgin. If God truly loved His Son then He too must share in the "Pitié." [53] But God, unlike Mary, could not lament as a mortal would. He could, however, physically associate Himself with the suffering Christ by holding up the mutilated body now equal in scale to His own. In this new interpretation God no longer symbolically presented His sacrificed Son on the cross, but actually touched and supported His dead body as He does in the Malouel tondo (49). In this painting, probably painted in the court of Philip the Bold, the *Illustration 49* Man of Sorrows is supported and entirely surrounded by figures: God and His choir of angels on the left and the Virgin and St. John on the right. No breath of air or glimpse of landscape detracts from their presence. The density of the figural composition, made up entirely of suffering beings, adds to the sorrowful interpretation, much as it does in Rogier's "Descent." In the Malouel "Pietà" one can easily see the humanizing effect produced by God the Father's new physical proximity to Christ. The mystical meaning of the

Trinity is almost overcome by the tide of grief which spreads from figure to figure across
the panel.

From the ruinous state of the left wing of the Edelheer triptych, we find that the
Edelheer Master has added to the Trinity of the Broken Body two angels, who stand to the
right and the left of the pedestal. They are not the weeping angels or the supporting angels
of the Burgundian representations of this theme, such as are found in the Malouel tondo.
The Edelheer angels take no physical part in the scene. Instead they solemnly bear the lilies
of mercy and the sword of justice, very like the angels who draw aside the curtains to re-
veal God the Father Enthroned in the *Très-Belles Heures de Notre Dame* (formerly Turin,
Royal Library, fol. 14), by a follower of Jan van Eyck. The words *Justicia* and *Misericordia*
are inscribed below the Edelheer angels, adding to this wing the theme of the Last Judg-
ment.

Although Campin used the motif of the Trinity of the Broken Body several times, he
did not combine it with the Last Judgment theme. Neither the Leningrad nor the Frank-
furt Trinity introduced symbols of justice and mercy. The combination of a Man of Sor-
rows and the Last Judgment, however, did exist before the appearance of the Edelheer

Illustration 50 triptych. Panofsky cites one Northern example by Master Francke in Hamburg (50).[54]
It shows Christ displaying His wounds, while two angels bear the cloth of honor behind
Him and two other angels carry the lily and the sword. Panofsky explains the combination
of motifs as follows: ". . . this identification of the Man of Sorrows with the Judge
[is] entirely justified on doctrinal grounds because at Doomsday Christ will show His bit-
ter wounds to all mankind saying: 'Behold what I have suffered for you; what have you
suffered for me?' " [55]

The Last Judgment also logically combines with the Trinity, for the mystery of the
Trinity made possible Christ's Resurrection. The dead Christ becomes the Redeemer
through the spirit of God. Only as the Redeemer can He be the Savior of mankind. During
the Last Judgment salvation will ultimately take place. We are reminded of God's power
of redemption through the presentation of Christ's Sacrifice. We are reminded by the
angels of the time when it will occur.

We do not know who was ultimately responsible for the new combination of the
swooning Virgin and St. John with the Trinity–Last Judgment scene. Rogier was exploring

Plate VI at least part of the theme in the Philadelphia diptych (VI). In it he isolated the Virgin and
John on a separate panel against a cloth of honor similar to that found behind Christ. The
swoon of the Virgin was here combined with a gesture of adoration directed toward the
cross. In the Edelheer altarpiece the Virgin clasps her hands in a very similar way, but
they are pulled in toward her body as a further expression of her grief. In Rogier's repre-
sentation of the Virgin, her head, hands, and knees all partake of the swoon, but they also
extend beyond in a gesture of homage to Christ. It is a most curious combination of two
motifs totally lacking in the Edelheer Virgin. In regard to the motif of the Trinity, surely
Rogier must have been familiar with at least one of Campin's representations which he
may have passed on to the Edelheer Master. Or the latter might have taken it directly from

Campin, for his Trinity seems almost a composite of Campin's Leningrad and Frankfurt panels. From the former he took the figure of God the Father painted in grisaille and standing in a niche (47). He made even more poignant their relationship, for Campin's God *Illustration 47* holds Christ beneath Christ's left arm. The Edelheer God supports the weight of His Son with His right hand and with His left touches Christ's loin cloth in a more intimate gesture of protection. What remains of the figure of Christ is very close to that found in the Leningrad Trinity. The turn of the parallel legs and the gesture of the arms are very much alike. By turning Christ's left palm outward, the Edelheer Master again increased the aspect of suffering. As for the Last Judgment theme, it too may have an immediate prototype. In a silverpoint drawing of the "Eucharist," done by a follower of Weyden, we find a Trinity of the Broken Body which includes the angels of justice and mercy, the same motif we see in the Edelheer Trinity. Though the drawing certainly dates after the Edelheer altarpiece, it suggests that the motif might have come directly from Rogier's studio. Thus all the elements for this new iconography of the swooning Virgin and the Trinity–Last Judgment appear in and around the work of Campin and Rogier. But whether invented by them or by a Weyden follower, they are particularly suited to the Edelheer altarpiece. By using the Trinity of the Broken Body, rather than the more immutable *Gnadenstuhl*, the Edelheer Master was able to retain on the exterior the parallel of the suffering of Christ and the Virgin, stated as the main theme on the interior. There is a tight iconographic homogeneity between the exterior and the interior of the triptych; in fact it is one of the most closely coordinated triptychs in Netherlandish painting. As eclectic as the Edelheer Master may have been, he thoroughly understood the iconographic practices of the best masters of his time. After borrowing the interior scene directly from Rogier, he did not then settle for the traditional patron saints or Annunciation for his exterior representation. Moreover, he consciously coordinated all the iconography with the dedication of the altar to the Virgin, the Trinity, and St. James. There is nothing redundant or simplistic about his iconographic approach. Already within the decade of the forties, this type of iconographic complexity was exceptional.

The concentration upon the Passion of Christ, the sixth sorrow of the Virgin, and the participation of God the Father in the physical agony of the Son make this painting very compelling as the main altarpiece for a funerary chapel. The entire theme of the triptych concerns death and salvation, not only of Christ, but also of the swooning Madonna. By her suffering she assisted Christ in His mission. It is a universal lesson in mercy and compassion echoing the words of the Virgin recorded by St. Bridget: "For as Adam and Eve sold the world for an apple, so we redeemed the world with a heart." [57] On the exterior the suffering of Christ and His Mother is given a doctrinaire presentation and is explicitly united to Christ's triumph as Judge of the world. On the interior the divine sacrifice is re-enacted before the Edelheer family. They witness it in prayerful silence, symbolizing in their attitude of devotion the function of the altarpiece and the personalized meaning of the Descent. The triptych visualizes the prayer of William and Adelaide for the salvation of their souls. It suggests that their devotion to Christ and their veneration of James, the

Virgin, and the Holy Spirit might allow them to witness, and eventually to share in, Christ's divine realm. The reference to the Last Judgment is directly connected to the intercessory function of the altarpiece. One is tempted to read the exterior as a personalized Deesis: the Judge with His angels appearing on the left, the two intercessors, John and Mary, on the right, and inscribed below them the names of those seeking protection, William Edelheer and Adelaide Cappuyns.

This pictorial prayer for salvation had a verbal counterpart that was also initiated by William Edelheer. Every day after Mass was said in his chapel, the officiant, probably his son, stood on the funeral stone of William and his wife and recited the Miserere and the De Profundis for the repose of their souls.[58] The intercessory nature of the Edelheer triptych is as explicit as this prayer. Iconographically, if not esthetically, its success can be measured by its inventive use of new devotional motifs, all of them directed toward a single end. Every representation, whether it is the stiff depiction of the donors, the copied "Descent from the Cross," or the new motif of the swooning Virgin, has been affected by William Edelheer's funerary demands.

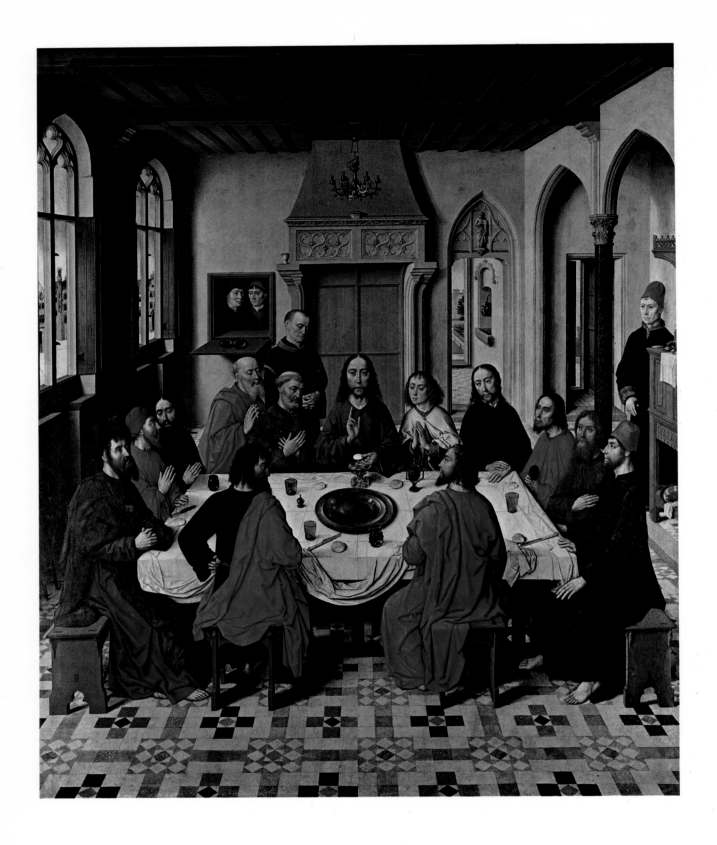

VII. Dieric Bouts: Last Supper, center panel of Blessed Sacrament altarpiece. Louvain, Church of St. Peter.

6

The Altarpiece of the Blessed Sacrament by Dieric Bouts

During the first decades of the fifteenth century, the triptych was the result of a co-operative venture by patron and painter. The reciprocal relationship established by such artists as Van Eyck and Rogier van der Weyden with their patrons produced paintings whose unique iconography and interpretation were dependent upon both artist and donor. So creative was the relationship that some of the artists' greatest paintings emerged from it. The painter willingly invented new schemes in order to accommodate the donor in his choice of subject matter. He must have been attracted by the difficult problem of relating the new demands of a lay public for personal, human recognition within representations that had been primarily of religious figures. Never had these Christian themes been altered so sharply by the desires of a single human ego.

Rogier's work demonstrates the extent of the inventions developed to meet the new demands. Rogier created a kind of illusionistic symbolism in such settings as the Braque altarpiece and at virtually the same time was willing to use a medieval formula in the Beaune "Last Judgment." He even resorted to disguised symbolism in the Bladelin altarpiece. All three triptychs have familiar themes: the Last Judgment, the Deesis, and the Nativity. But Rogier's representations of all three themes neither followed the rules established by their innumerable medieval prototypes, nor corresponded to paintings of similar subjects done in the fifteenth century. Each is unique—the result of the union between the artist and the donor. The Bladelin altarpiece was a triumph for all concerned. Bladelin was given personal elevation in his appearance with the Holy Family and in the selection of the subjects; Rogier painted his first Nativity, integrating three scenes in an original way, and the bonds of religious propriety, though immensely stretched, were not broken, for the devotional-symbolic content remained supreme.

About 1450, when artists like Christus began to deal with phenomena, such as focal-point perspective, whose proper province was in the realm of painting qua painting, the relationship between artist and donor faltered and changed. Whereas Rogier continued to paint until 1460 without modifying his fundamental attitude toward religious painting,

younger men such as Christus and Bouts became deeply involved with the art of picture making. Visual effect began to take precedence, minimizing the role of the donor and simplifying the iconographic content.

One of the first Northern examples of single focal-point perspective [1] is Dieric Bouts's altarpiece of the "Blessed Sacrament," commissioned for the Church of St. Peter in Louvain (VII, 51–53).[2] This triptych contains a sense of order, logic, and rationality rarely found in earlier Netherlandish paintings. It is peopled with restrained human beings who neither weep nor swoon, who address one another with complete civility, who seem, in short, creatures of intellect rather than of passion. Bouts's figures exist as locations on an illusionistic, three-dimensional plane rather than as psychological entities. They are subject to the same laws as are rocks and trees and hence lose much of their individuality. Panofsky refers to them as having a "congenital stiffness" as a result of Bouts's consuming interest in landscape and pictorial space per se.[3]

Plate VII
Illustrations
51–53

The poise and tranquillity are the more remarkable since three of the four scenes depicted on the interior wings (52, 53) are charged with dramatic possibilities. The Gathering of the Manna by the children of Israel, on the upper part of the right wing, portrays a situation in which food is provided for a starving people in the wilderness. Manna and quail, appearing miraculously in answer to a prophecy of Moses, served as the Israelites' only sustenance for forty days. But Bouts's Israelites respond with a composure and a dignity more suited to witnesses of a holy event than to hungry exiles gathering their daily ration. Three figures in the foreground kneel around a sacred vessel, carefully picking up the round bits of manna, not unlike Magi kneeling before the Christ Child.

Illustrations
52, 53

Similarly the Meeting of Melchizedek and Abraham, on the upper left wing, has the appearance of a religious ceremony rather than of a historical event. The men confront each other as priest and devotee. Abraham extends his left hand, raises his right hand to remove his hat, and bends his knee in homage. We hardly recognize these men as the two powerful rulers who have met for the first time after Abraham's triumph over the five kings.

In the Dream of Elijah, on the lower right wing, Bouts not only used a static distribution of the figures to achieve composure, but also omitted the most dramatic moment of the story, that of Elijah's waking and finding the miraculous gift of food. In the foreground Elijah lies at peace. The angel who was sent to awaken and feed him does so gently, his hand resting lightly on Elijah's shoulder, the water and bread carefully placed on the ground behind Elijah's head. The only reference to Elijah's waking is in the upper-right background, where, staff in hand, Elijah resolutely walks into the wilderness refreshed. Only the Feast of the Passover on the lower left wing is inherently static.

Plate VII

Since all these scenes serve as Old Testament prefigurations for the Last Supper, presented on the center panel, their symbolic character is of greater importance than their historicity. The restrained geometry of Bouts's style is, in this instance, perfectly attuned to the ceremonial content of the work. In the Last Supper (VII) the static organization and the sacramentarian interpretation of the theme are even more pronounced than they

were in the wing panels. A single room entirely fills the pictorial space. It has been placed parallel to the picture plane; its lateral walls correspond to the side limits of the panel, and the ceiling and floor to the top and bottom of the frame. The next major division in the center panel is the table, which also is rectangular and is lined by figures on all four sides.[4] The row of Apostles on the right and that on the left repeat in the lines described by their heads those described by the foreshortened walls and ceiling. For example, the Apostles in the foreground are part of a series of parallel lines which begins at the base of the painting in the floor tiles and culminates in the ceiling beams. Every animate and inanimate object in the center panel is controlled by this architectural cube of space. All the perspective lines meet in a point directly in the center above Christ's head. The placement of the standing attendant directly to the right of Christ constitutes the major disturbance of the symmetrical layout and thereby further concentrates attention on the figure of Christ. Around Him both balance and imbalance attain their greatest intensity. But there is no dramatic exchange. Christ causes all movement to stop. The Apostles appear only slightly agitated in the foreground; some heads are turned away from Christ. But the nearer the Apostles are to Him, the more solemn is their adoration. The Apostles on either side of Christ are turned toward Him, their hands crossed or folded. The largest number of people are gathered on His side of the table, drawing attention to Him and adding physical weight to His presence. He is the only figure in the center panel to look directly out of the picture plane. Along the invisible central vertical axis, Christ holds the wafer over the chalice and raises His hand in consecration.

The Last Supper scene as portrayed by Bouts is a major exception in medieval and early Renaissance iconography. After the Early Christian period in both the East and the West, the Last Supper was depicted as a dramatic event in which the major protagonists were Christ and Judas.[5] The element of tragedy, the treason of Judas, took precedence over the mystical elements of the scene. The liturgical theme that glorified the sacrament was limited primarily to Early Christian and Byzantine art.[6] The new pictorial interpretation of the Last Supper became a dramatization of the words of denunciation—"One of you shall betray me" (Matthew 26:21)—rather than a commentary on the sacramental words—"This is my body" (Matthew 26:26).[7] Another human element, Christ's love for John, was added to the confrontation of Christ and Judas and often replaced it. The moment of tenderness during which John fell asleep on Christ's breast, immortalized by artists like Giotto, had become commonplace in Western art by the thirteenth century.[8] The relationship between Christ and the beloved on the one hand and His relationship with the betrayer on the other continued to appeal to painters throughout the Renaissance.

Only during the fifteenth century was this essentially Gothic formula altered. In the rare variations on the theme, the act of communion and the act of consecration were separated.[9] The drama of Judas' betrayal and of John's falling asleep was omitted. When the focus was on the act of communion, the Last Supper was shown as the distribution of the bread and wine by Christ. In Joos van Ghent's "Communion of the Apostles" in Urbino or in a fresco of a similar subject by a follower of Fra Angelico in San Marco, Christ walks

among the disciples and actually passes the host to them.[10] The Last Supper as an act of consecration was portrayed even less frequently.[11] One of the earliest works reviving this liturgical theme is Bouts's altarpiece in which Christ does not break the bread but blesses the host. In fact, this triptych may be the very first example of the reappearance of this theme in Western art.[12] It was to become much more popular in the seventeenth and eighteenth centuries as a result of the controversy over the Last Supper initiated by Luther's belief in consubstantiation. Only after the Council of Trent drew up new rules regarding the meaning of the host, did the consecration of the bread and the wine again become a major part of the iconography of the Last Supper.[13]

Bouts's painting is unusual for the fifteenth century not only because of its interpretation but also because it is the first panel painting of the Last Supper done in the Netherlands. As far as we know, neither Campin, nor Eyck, nor Christus, nor Rogier painted the subject. Only after Bouts's representation did several other Last Suppers appear in Flemish art.[14] Bouts's painting was a direct result of its commission by the Confraternity of the Blessed Sarcament to adorn its altar in the Church of St. Peter in Louvain. Without the commission Bouts too probably never would have painted a Last Supper.[15]

The Confraternity of the Blessed Sacrament was the earliest one to receive a chapel in the newly constructed choir of St. Peter's.[16] In 1433 the brothers were given two apsidal chapels for two altars in the northern ambulatory and a place under the arcade of the pillars of the choir to erect a tabernacle (54, 55).[17] Bouts's altarpiece was painted for the larger of the two chapels. Dedicated to the Blessed Sacrament, it was the major chapel of the confraternity, which had its seat in St. Peter's. When ordering the triptych from Bouts, the brothers asked that it be dedicated to the Eucharistic rite. The altarpiece was commissioned in 1464, the year of the 200th anniversary of the Feast of Corpus Christi.[18] The confraternity was founded in 1432, and it had owned the chapel for thirty-one years. It does not seem to have been an accident or merely a result of increased wealth and power [19] that, after a time lapse of three decades, the brotherhood ordered the altarpiece in the very year that commemorated the second centennial of the founding of its feast day.

Illustrations 54, 55 (margin)

Two centuries before, the incident that led to the origin of the Feast of Corpus Christi had taken place near Louvain. Living in Liége in the thirteenth century was an Augustinian nun, St. Juliana, who was prioress of the hospital of Mount Cornillon.[20] About the year 1230 she had a series of visions in which she saw a full moon lacking one segment. The moon signified the liturgical cycle, and the missing piece, the omission in the cycle of the Feast of the Holy Sacrament. St. Juliana told the archdeacon of Liége, Jacques Pantaléon, of her vision, saying that it was the will of God that the Church should set aside one day for a special feast in honor of the Holy Eucharist. Jacques Pantaléon became Pope Urban IV in 1261.[21] St. Juliana had died by that time, but her friend, called the Blessed Eve, continued, on Juliana's behalf, to insist upon the institution of the feast day. Accordingly in 1264 Urban IV wrote the bull *Transiturus de hoc mundo*, which established the Feast of Corpus Christi within the liturgical year. It is sometimes claimed that he received another incentive for founding the feast while he was in Orvieto in 1263.[22] He was said to have

been brought the bleeding host from Bolsena as evidence of the miracle that had recently taken place in that city. The day chosen for the feast would normally have been Maundy Thursday, the day of the Last Supper.[23] But since many functions already occurred on this day as a part of Holy Week and since it was a time of sadness, Urban IV thought it necessary to select another day. The first Thursday after Trinity Sunday was chosen. At Urban's request, St. Thomas Aquinas drew up the services of the day.[24]

Because of the death of Urban IV shortly after the bull was published, the celebration did not immediately become popular.[25] It began to gain popularity only after a new decree by Clement V was issued in 1311, ordering adoption of the feast.[26] By the time Bouts's triptych was painted and the confraternity was founded in Louvain, it had become the principal feast of the Church. The two great yearly processions of the Church of St. Peter from the fourteenth century on were the Kermesse, celebrated the first Sunday in September in memory of the founding of the church,[27] and the *Fête-Dieu* or the Feast of Corpus Christi. By the nineteenth century the Kermesse had been abandoned, but the *Fête-Dieu* is still a major celebration in Louvain.

Bouts's triptych was largely the outcome of the popularity of the Eucharistic cult during the fifteenth century. As one of the principal gifts of the confraternity to St. Peter's, it played an important role in the church and in the city. Another gift of similar significance was the large monstrance tower (54) placed outside the chapel of the Blessed Sacrament against one of the pillars of the ambulatory. Given by the confraternity in 1450, it was sculpted by Matthew of Layens, the man who designed the hôtel de ville in Louvain.[28] It is a Gothic stone tower 12.5 meters high and adorned with eight bas-reliefs of the Passion and statuettes of the Apostles. An imposing piece of sculpture, it was designed to venerate the host and thus had a purpose similar to that of the painting of the "Blessed Sacrament." It may still be seen in St. Peter's. Such monstrance towers, both large and small, were built concurrently with the development of the Feast of Corpus Christi. When the cult began to spread in the late thirteenth century, the host was held in a closed ciborium.[29] Later the ciborium was elongated and made transparent. The first monstrances, or *ostensoria*, designed, as the name indicates, to expose the host, were made in Liége, the city of St. Juliana.[30] Monstrances in the form of elegant Gothic towers with pinnacles, turrets, and flying buttresses, like the monstrance in St. Peter's, were typical of the fourteenth and fifteenth centuries. During the sixteenth century the monstrance took its present form, as a round sun with rays emanating from its center.

In the "Blessed Sacrament" altarpiece the confraternity honored the institution of the Eucharistic rite. At the time of the Last Supper, according to the Synoptic Gospels, Christ first took bread, then blessed it and distributed it. He then took wine and did likewise, consecrating the bread and the wine separately.[31] Christ's action in Bouts's painting is not historical. Blessing the wafer and the chalice, as Christ does in the altarpiece, comes not from biblical history, but from the liturgy of the Roman Catholic church.[32] In the painting Christ is enacting the role of a priest at the time of consecration during the Mass. He addresses his actions not to the Apostles but to a larger congregation. In the foreground a

Illustration 54

space is left between Judas and the Apostle to his right so that the viewer has an unobstructed view of the Eucharistic elements. The figure of Christ has undergone the same transformation as in the Braque altarpiece. His whole torso, and particularly His head, have been lengthened in order to make Him appear larger than the Apostles. The spectator is forced to concentrate upon the face and the gesture of Christ which capture the attention like a Byzantine icon.

At the time of the Last Supper Christ was received by two men, Zachée and Tubal.[33] But Bouts's painting includes four servants, all dressed like Flemish burghers. The Last Supper and its attendant scenes also have been transported to fifteenth-century Flanders. The Upper Room is late Gothic in style and it would seem that from its window one can look down upon the Grand Place of Louvain with its town hall. It is often suggested that the four extra men in the Last Supper and the two Flemish spectators watching the meeting of Melchizedek and Abraham represent the two theologians and the four men of the confraternity who signed the contract for the painting.[34] If this is true, one figure must have been omitted since the man standing to the right of the table, by the buffet, is undoubtedly Bouts himself. In 1855 Molanus found a manuscript of the accounts of the Confraternity of the Blessed Sacrament. In it was a drawing of the head of this man and underneath, the inscription: "I, Dieric Bouts, declare myself satisfied and well paid for the work I have executed for the Confraternity of the Blessed Sacrament." [35] Bouts and the men of the confraternity are depicted as servants or bystanders in order to express their devotion to the Eucharist. The spectator is one step removed from them. He is likened to a worshiper who, from a more formal point of view, directly beholds the act of consecration.

This liturgical interpretation of the Last Supper and its relationship to the viewer reflects the Eucharistic practices of the time. The increase of Eucharistic devotion in the late Middle Ages, stimulated by the institution of the Feast of Corpus Christi, was accompanied by a decrease in the laity's participation in the actual act of communion. Mystics like Thomas a Kempis emphasized the union of the individual with Christ rather than the corporate union among members of the laity within the Church, expressed through the act of communion.[36] This concept, so different from that of the early Church, was already supported by St. Thomas, who viewed the consecration of the host by the priest as far more important than the communion of the people.[37] The priest became the symbolic representative of the laity. The official body of the Church meeting at the Lateran Council in 1215 greatly encouraged this attitude by decreeing that the laity need commune only once a year, at Easter.[38] By taking a less active part in the service, the laity was reduced more and more to the role of spectators: witnesses rather than participants. Finally on June 15, 1415, the withdrawal of the chalice from the laity was formally sanctioned.[39]

It is no wonder that the Eucharistic species gained new importance after affirmation of the doctrine of transubstantiation in 1215. They were no longer regarded as symbols by believers, but instead, after the act of consecration, the host or chalice was mystically transformed into the actual Blood and Body of Christ, manifesting his Real Presence. For a moment the faithful beheld Christ Himself. The meaning of the Passion was far more con-

crete, and hence the possibility of redemption became acutely real. Because at this time it was believed that either species contained the Body and Blood of Christ, it was possible to venerate them separately. One need not have both present in order to represent the death and resurrection of Christ. After the cup was denied the laity, the host gained in stature. Elevation of the host was far more pronounced and occurred more frequently than elevation of the chalice. The climax of the Mass came to be the lifting up of the consecrated wafer.[40] Because the host was regarded as the *totus Christus*, people actually fought over the best seats in the cathedral from which to view it.[41] Similarly, during the Feast of Corpus Christi, it was the host that was adored by the people, for it was the host that was carried and displayed during the procession. The monstrance tower constructed by the Confraternity of the Blessed Sacrament for St. Peter's was also merely a magnificent container for the wafer.

In Bouts's painting Christ holds above the chalice the consecrated wafer. By giving the wafer more emphasis than the cup, the artist reflects the liturgical practices of the time. The doctrine of transubstantiation is uniquely pictorialized, for the believer can behold not only the species, but also the God to whom they refer. Christ, acting as both priest and God, demonstrates the magical transformation taking place during consecration. Even more than a Crucifixion, this sacramental Last Supper recalls the true meaning of Christ's sacrifice. His earthly suffering has been transformed into His eternal triumph. Even though the biblical text must be "Jesus took bread, and blessed it" (Matthew 26:26), this Last Supper has little to do with the historical record. Both Christ and the species are given the primary position, being made as visible to the spectator as was the priest during Mass. They transcend the momentary action just as Leonardo raised his Christ above the actions of the Apostles. Bouts's Apostles, unlike those of Leonardo, are physically restrained; they create no movement counter to that of Christ, for most of them sit transfixed. They turn or bend in such a way as to direct all attention to Him, and the laws of perspective are used for the same purpose. The belief in the Whole Christ being present in the act of consecration, particularly in the displaying of the host, is demonstrated visually in order to clarify the belief for which the Confraternity of the Blessed Sacrament was founded. Rather than being a last farewell, or a drama of treachery, or a distribution of the species, this Last Supper is an affirmation of the promise of everlasting life gained through Christ's death.

Bouts's work generally is not characterized by the highly symbolic attitude found in this painting. In his several Lamentations and Descents, the actors are arranged comfortably within a landscape setting. The environment contains few, if any, symbolic details, and it is not rearranged in order to appear extremely static. The cross is often not centered and the figures are dispersed asymmetrically. Christ, however, and the other principal participants are usually turned toward the viewer. Frequently the figures move far back into the pictorial space, as they do in the panels of the "Justice of Otto" in Brussels. Here the narrative is further increased by the inclusion of several scenes within each panel. Bouts also did not use disguised symbolism to any great extent. Even in such works as the four

Infancy panels in the Prado one can hardly call the symbolism of the sculpted portals disguised. They are done after the manner of Rogier but in the most obvious way. The scenes they depict read chronologically from left to right on each panel. Behind this sculptured framework the major scenes are devoid of symbolic additions.

Bouts was not responsible for major theological innovations as were Rogier and Jan van Eyck. His contribution, instead, rests in the painter's realm, particularly in the development of landscape painting.[42] Thus it is not surprising that the first documented commission in the Netherlands which states all the iconography for the intended painting is for this altarpiece.[43] Bouts himself was not responsible for choosing any of the subjects. They were all listed in the contract given him by the Confraternity of the Blessed Sacrament; moreover, the brothers hired two theologians, Jan Varenacker and Gilles Bailluwel, to inform Bouts about the order and the accuracy of the subjects he was to paint. They probably had much to say about many details of the painting. Since the contract stipulates only that the center panel represent the Last Supper, the theologians, in accordance with the wishes of the confraternity, must have been responsible for the new interpretation in which Christ's action is in keeping with the institution of the feast whose anniversary was being celebrated. They must have suggested further that the painting correspond to the liturgical thought of the time.

We do not know who was responsible for the few suggestions of disguised symbols in the center panel. The figure of Moses, another Old Testament prefiguration of Christ, appears as a statuette over the door. A lavabo in the anteroom, which is suspended over a drain rather than a basin,[44] probably symbolizes the washing of Christ's hands before instituting the first Mass. The basin and towel below the buffet may suggest the Washing of the Feet, symbolic of the apostolic baptism. A further reference to Christ's sacrifice is the empty plate directly in front of Him, in line with the chalice, the wafer, His hand, and His head. A similar plate in the Passover feast holds the paschal lamb. In the New Testament rite Christ Himself has taken its place.

The confraternity based the iconographical arrangement of the triptych on the *Biblia Pauperum* and the *Speculum Humanae Salvationis*. The former named two Old Testament scenes as prefigurations for each New Testament scene, and the latter, three.[45] For the Last Supper both sources use the Meeting of Melchizedek and Abraham and the Gathering of the Manna as prototypes. The *Speculum* adds the Feast of the Passover. In Bouts's triptych pictorial necessity, based on a concept of symmetry whereby each wing was divided into two parts, required the use of a fourth scene, the Dream of Elijah.

Apparently the theologians used the *Speculum* as their main source in informing Bouts about the iconographical meaning and the description of the scenes. In the Meeting of Abraham and Melchizedek the two protagonists appear in an open area within a long valley, perhaps suggesting the Valley of Save, filled with the soldiers of Abraham. The victorious and more powerful Abraham genuflects before the King of Salem. The *Speculum* explains:

Melchizedek went to meet Abraham and offered him bread and wine in which act the Holy Sacrament was prefigured. Melchizedek was king and priest of the sovereign God and because of that he prefigured Jesus Christ who was King of Kings and who created all the kingdoms of this world. He is also the priest who celebrated the first Mass that ever was. Melchizedek then, king and priest, offered to Abraham bread and wine. But Jesus Christ, under the species of bread and wine, instituted this Holy Sacrament of the altar.[46]

This prefiguration underscores not the Last Supper per se, but rather Christ's role in it as the first priest celebrating the first Mass. Secondarily it asserts the spiritual power of the priest over the earthly power of the king.

The Feast of the Passover, the Jewish festival commemorating God's promised protection of the Israelites, follows almost literally, except for its fifteenth-century setting, the description in Exodus which is repeated in the *Speculum*. All the figures stand, holding their staffs according to the ancient Hebraic tradition. "And thus shall ye eat it; with your loins girded, your shoes on your feet, and your staff in your hand; and ye shall eat it in haste: it is the Lord's passover" (Exodus 12:11). The meal follows the Jewish custom of eating a roasted lamb with head and feet intact, unleavened bread, and bitter lettuce—all carefully laid out on the tilting table top.[47] The *Speculum* relates the Passover to the Last Supper as a celebration of deliverance.

The Last Supper of our Lord was prefigured in the paschal Lamb which the Jews were accustomed to eating on Thursday before the Saturday of Passover. Our Lord commanded the children of Israel to eat the said lamb when they were delivered from the captivity of the Egyptians. Similarly Jesus Christ instituted the first Holy Sacrament of the altar when He delivered us from the power of the devil.[48]

The analogy between the two scenes is visually emphasized. In the two interiors the square table with its sparkling white cloth, the stressed focal-point perspective of the tiled floor, and the central platter are almost identical. According to the Christian calendar, the last celebration of the Passover was on Maundy Thursday, just before the first celebration of the Last Supper.

The Gathering of the Manna takes place in a wilderness landscape at dawn, exactly as God had promised. The Israelites do not gather loaves of bread or little wafers, but tiny dots of manna as "small as the hoar frost on the ground" (Exodus 16:14). With the small figure of God in the sky and the gathering of the manna in the foreground, Bouts combined the prophecy of the day before with the actual event. In this combination he (or the theologians) stressed the analogy with the Last Supper stated by the *Speculum*:

As the time drew near when Jesus Christ would suffer His passion and death, He instituted the holy communion of His blood and body so that He would be remembered forever. . . . This was prefigured in the blessed manna from heaven which was given to the children of Israel when they were in the wilderness. . . . Jesus Christ sent the blessed manna, a material and temporal bread, to the Jews; but to us He has given a transubstantial and eternal bread. The blessed manna was called the bread of heaven though it did not come from heaven, but was created by God in

the air. . . . But Jesus Christ, our blessed Savior, was the true living bread who descended from heaven and was made our food. God gave only a symbol of the true bread to the Jews, but He gave us the true bread and not the symbol. . . . When the blessed manna descended the dew of the sky came with it, by which it is shown that to him who deserves to receive the Holy Sacrament from the altar, to him is also given the grace of God.[49]

It is God's gift to man which is important. To the Old Testament believers He gave miraculous bread; to us He gave His only begotten Son. The attitude of the Israelites as they devoutly pick up the manna and place it in a sacred vessel further suggests the holiness of the event and the symbolic meaning of the substance.

The fourth prefiguration of the Dream of Elijah comes from the First Book of Kings (19:4–8):

But he himself went a day's journey into the wilderness, and came and sat down under a juniper tree: and he requested for himself that he might die; and said, It is enough; now, O Lord, take away my life; for I am not better than my fathers. And as he lay and slept under a juniper tree, behold, then an angel touched him, and said unto him, Arise and eat. And he looked, and, behold, there was a cake baken on the coals, and a cruse of water at his head. And he did eat and drink, and laid him down again. And the angel of the Lord came again the second time, and touched him, and said, Arise and eat; because the journey is too great for thee. And he arose, and did eat and drink, and went in the strength of that meat forty days and forty nights unto Horeb the mount of God.

Bouts's Elijah sleeps beneath a tree with the hearth cake and cup of water by his head. It is probably the angel's second visit, after which Elijah returned to the wilderness, depicted in the background by the same craggy rocks as in the Gathering of the Manna above. This scene is analogous to the Eucharistic rite in that the bread and wine are a source of strength and a renewal of faith.

The total iconography of this triptych is less complex than any we have discussed. The wings are devoted only to the Old Testament, the center panel to the New. The four prefigurations are merely appendages to the Last Supper, for they have no meaning apart from the drama enacted on the center panel. The wings do not expand the content as they do in the Bladelin and the Braque altarpieces. Instead they are related to the center panel in the older typological sense.[50] The confraternity added the Dream of Elijah apparently for no special reason except that it was another suitable Old Testament prefiguration. That the scene of Elijah is unique to this painting is iconographically, I believe, of little interest.[51] Bouts could have used as well a number of other scenes, such as Abraham and the Angels at Mambre or the Sacrifice of Abraham or that of Abel—all prefigure the Eucharistic rite.

The four wing scenes are presented in biblical chronological order beginning at the upper left with a scene from Genesis and proceeding below it to the Passover from Exodus, and then in the upper right the Gathering of the Manna from a later chapter in Exodus and below it the Dream of Elijah from the First Book of Kings.[52] This order may or may not have been prescribed. It was not the order given in the original contract, which read the Gathering of the Manna, Melchizedek and Abraham, the Dream of Elijah, and the Feast

of the Passover. Nor is it the order found in the *Speculum*. Apparently the easiest solution to the problem of sequence was to place the scenes one after the other, just as they appear in the biblical narration.[53]

Because he had to represent four Old Testament scenes, Bouts divided each wing panel in half, thus further stressing the wings' secondary function in relation to the center panel. Because of the division all the figures in the wings are necessarily a quarter the size of those in the Last Supper. This solution is very unusual for fifteenth-century triptychs in the North. Usually the wings are treated as single spatial units. Sometimes additional scenes appear in the landscape background, but each wing contains essentially one pictorial space. The division of a wing into two distinct scenes is much more typical of the early thirteenth- and the fourteenth-century development of the triptych form in Italy.[54] Neither Bouts nor those who commissioned him were evidently disturbed by the fact that, amid all the modernity of the use of single-point perspective, they had reverted to an archaic solution for the wings of their triptych and for their iconography.

The subject choices in Bouts's triptych and their relationship to one another do not reflect a sense of iconographic urgency. For the first time in our study we encounter an iconography that is excessively redundant, that is not tightly knit or truly interdependent except in the simplest of juxtapositions. Upper and lower scene, left and right wing, are equally important as subjects, and each scene has the same meaning in relation to the center panel. The whole altarpiece is based on one idea: the sacramental Last Supper. This theme is further substantiated by the intended subjects ordered for the exteriors of the wings. According to the contract, one wing was to show the Old Testament scene of the Shewbreads.[55] These were the twelve loaves that were prepared weekly and set beside the altar to be eaten later by the priests. The subject for the second wing is not known because of a hiatus in the original document, but one can be relatively certain that it was consistent with the other scenes on the wings and represented yet a sixth time an Old Testament prefiguration. The exterior wings were probably never painted; they were later gilded by Bouts's sons Albert and Dieric the Younger.[56]

Also for the first time, we find that the triptych form is not being used in a dramatic or a hieratic sense. The exterior representation is no more than a simple prefiguration of the event found on the interior. It does not prepare the worshiper in the sense that the Annunciation has in so many other instances. The original scheme for the exterior would have been absolutely the same in meaning as the scenes found on the interior of the wings. Both are adjuncts. The most that can be said about the hieratic function of the wings is that, both outside and inside, they serve to separate the world *sub lege* from the world *sub gratia* of the center panel.

In this study and in the development of Netherlandish painting, Bouts's triptych exemplifies a major change. The balance between the role of the donor, the function of the painting, and the invention of the artist now seems to be disturbed. The first two factors have gained control; the iconographic invention of the artist is secondary. To Bouts himself we can attribute with certainty only the pictorial composition and the depiction

of the figures, the landscape, and the architecture. But neither the selection of specific details of content nor the major divisions of the altarpiece were dependent upon him. He had been hired to paint a given subject in the form of a triptych. He was not required to think about it nor to expand upon it iconologically. Perhaps one reason for Bouts's loss of initiative is that the painting was not commissioned by a single donor but rather by an entire confraternity which hired two theologians to advise the painter. But more important is the fact that the artist himself seems to have lost his deep concern for what had been an important aspect of the art of painting.

The justification for the existence of the altarpiece, for all its iconography, for the new interpretation of the Last Supper, for the very appearance of the Last Supper itself, is due to the confraternity. To try to explain the presence of this Last Supper and its sacramentarian interpretation in terms of the artistic tradition of the period is somewhat misleading for it continues to stand out as a major iconographic exception. When seen within its original context, rather than being an artistic anomaly it becomes almost an artistic command performance. Few iconographic choices were left to the artist, Dieric Bouts.

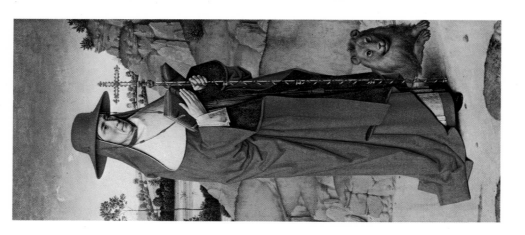

VIII. Dieric Bouts: Martyrdom of St. Erasmus altarpiece. Louvain, Church of St. Peter.

7

The Martyrdom of St. Erasmus Altarpiece by Dieric Bouts

Of all the triptychs considered in this study, the origin of the Erasmus altarpiece (VIII) is the most elusive. The Erasmus altarpiece was the major painting for the smaller of the two adjacent chapels received by the Confraternity of the Blessed Sacrament in 1433 (see 45). We are not sure who commissioned the work, but it too was painted by Dieric Bouts and was begun shortly after the altarpiece of the "Blessed Sacrament." [1] The length of time taken by the confraternity to complete its chapels makes the efficiency and speed of William Edelheer the more impressive. Within eight years he had installed in his chapel in St. Peter's a large triptych and had supplied various ornaments for the altar; he had provided for the future maintenance of the chapel and established a chaplaincy there. The Confraternity of the Blessed Sacrament, a collective body, took thirty-five years to complete the decoration of its two chapels.

Plate VIII

Illustration 45

The Erasmus triptych and its chapel are dedicated to St. Eramus, who lived during the early part of the fourth century.[2] He was reputedly from Antioch, but he was called the bishop of Formiae in Italy, because his relics were found in that town in the sixth century. In 842 the Saracenes destroyed the town and his relics were taken to Gaëta. Thus he is sometimes referred to as St. Erasmus of Gaëta. Very little is known about his life. He was supposed to have been imprisoned in Palestine for his zealous preaching and then rescued by the archangel Michael. Another legend tells of his retiring to Mount Lebanon and there being fed miraculously by a raven; for this reason the raven is sometimes used as his attribute. Finally Diocletian arrested and tortured him in a variety of ways. He was put into red-hot armor, thrown into molten lead and pitch, and then, all else having failed, beheaded.

The center panel of the triptych shows the saint being subjected to yet another form of torture, one not included in any of the accounts of his life and death. Erasmus' intestines are being wound around a rod. This unusual form of martyrdom stems from a misunderstanding. At one time Erasmus quelled a severe storm at sea, thus becoming an important patron of sailors. As such, his attribute was the windlass. In countries where this imple-

ment was unknown, primarily in Belgium and France, it was thought to be the symbol of his martyrdom.[3] Because of the misplaced windlass, Erasmus immediately gained the special veneration of those suffering from stomach ailments.

The confraternity's reason for selecting St. Erasmus as the dedicatory saint of their second chapel in St. Peter's is not known and is not easily hypothesized. Erasmus' patronage seems to be limited primarily to sailors and thus he was popular in the North as one of the fourteen auxiliary saints.[4] But Erasmus was by no means one of the saints most frequently portrayed except in the Campagna in Italy, the land in which he had lived.[5] There is no indication that St. Erasmus was a favored patron of the city of Louvain or that he had any connection with the Confraternity of the Blessed Sacrament in Louvain or elsewhere. The only explanation adduced thus far for the confraternity's dedication of their chapel to St. Erasmus was their wish to honor Erasme van Brussele, a member of their brotherhood and the mayor of Louvain at the time that the "Blessed Sacrament" altarpiece was painted. Thus he must have been a popular and important member of the community. He was apparently in high standing within the confraternity as well, since he was one of the four men to sign the contract with Bouts for the "Blessed Sacrament" altarpiece. Whether or not Van Brussele was ultimately responsible for the choice of St. Erasmus as patron of the chapel, the dedication was undoubtedly caused by some such unique or personal circumstance.

Even has suggested, and many others have agreed, that the triptych was ordered by Ghert de Smet,[6] the master of schools (*magister scolarum*) of Louvain shortly before 1466.[7] In that year De Smet requested that an annual Mass be said for his soul on the feast days of SS. Jerome, Erasmus, and Bernard.[8] All three saints are found on the altarpiece. St. Jerome is on the left wing, identified by his red cardinal's robes and his friendly lion; and St. Bernard is on the right, dressed in a black cloak with his white Cistercian gown underneath. He carries his pastoral staff, and a demon, signifying his conquest over the devil, lies at his feet. The exterior of the triptych apparently was unpainted.[9]

De Smet's alleged donation of the piece is based upon the appearance of the three saints and the fact that he was a member of the confraternity. His connection with Bouts and with Erasme van Brussele is confirmed by the fact that he was also one of the men to sign the contract for the altarpiece of the "Blessed Sacrament." Since the Erasmus chapel belonged to the confraternity and was not the donation of an individual, it served, as did other confraternity chapels in the Middle Ages, as a place for Masses to be said for its deceased members.[10] Guild rules often provided for the recitation of as many as sixty Masses for the soul of a former member.[11] In keeping with this tradition, the Masses for De Smet are recorded in the confraternity's register, not in the general archives of St. Peter's.[12]

When De Smet was near death,[13] he apparently ordered a triptych for the chapel in which he, as a brother, would receive special protection. Besides the triptych, he provided for Masses to be said on his behalf. He commissioned an altarpiece that would serve both the confraternity in general in its veneration of St. Erasmus and himself in particular in its veneration of SS. Jerome and Bernard. If De Smet was responsible for the commission,

his choice of St. Erasmus was not a personal one, but was based on the wishes of the confraternity, for the chapel had been dedicated to St. Erasmus since 1433. De Smet's altarpiece was not ordered until some thirty years later. He selected St. Erasmus as the major saint to accord with the dedication of the chapel.

SS. Jerome and Bernard were both great monastic saints and scholars. Bernard was the founder of the Cistercian Order and Jerome the founder of the Jeronomites. St. Bernard supported traditional authority and faith in the face of such revolutionaries as Peter Abelard. Kings and popes, queens and priests, came to Bernard for advice throughout the twelfth century. Though called the Doctor Mellifluous because of his impressive preaching ability, he appears in Bouts's triptych holding a book, in a contemplative role rather than an active one. He was considered virtually a Doctor of the Church during his own time, although this title was not officially declared until the nineteenth century.[14] St. Jerome appears not as a hermit, but as a cardinal with a book in his hand. He is shown as the patron of clerics, theologians, and scholars because of his role as one of the four Church Fathers and as author of the Vulgate.[15] Ghert de Smet was a schoolman, and the Church of St. Peter and the Confraternity of the Blessed Sacrament were closely associated with the University of Louvain.[16] It is no wonder that a patron of learning was selected.

The two saints actually witness the martyrdom of Erasmus, for they are within a single landscape that flows continuously through all three panels. The landscape is so unified that in several places even the width of the frame seems to have been taken into consideration. For instance, both the hillock, which is split between the upper section of the left wing and center panel, and the rocks and lower hills in the center panel and right wing suggest that a segment has been covered by the frame. The upper right-hand section of the center panel displays the one curious exception to this self-conscious treatment of the three panels as one. Here neither the hills nor the road seem to adjust exactly to the frame or to the right-wing landscape. In order that the saints may more convincingly see the event, they are turned in three-quarter position, their eyes directed toward St. Erasmus. The whole drama is, naturally, a historical impossibility: Jerome was born during the reign of Diocletian in the third century A.D.; Erasmus lived a century later; Bernard was not born until 1091. In the Erasmus altarpiece Bouts gathered together, without qualification, a mixed group of Early Christians, Flemish burghers, and a medieval saint. They appear to have just met in a deserted northern province in order to witness the martyrdom of St. Erasmus, an occurrence that in fact took place in Italy under the direction of the Roman emperor. Bouts used the simple divisions of the wing panels to set apart the three worlds of Bernard, Jerome, and Erasmus, but he made no attempt to justify pictorially their simultaneous presence.

Throughout the medieval period saints were juxtaposed with little or no regard for historical plausibility. In fifteenth-century Netherlandish painting, however, the rationalizing effect of the spatial unit modified such temporal impossibilities. Disparate saints joined together for specific reasons of donation were set apart in various ways. They were placed on separate panels or in separate sculptural niches, often on the exterior of altarpieces. If they were located together within a single environment, they were either

grouped around the figure of the Virgin and Child as part of a *Sacra Conversazione* or they were shown as intercessors for a specific donor. In the latter instance the patron was shown kneeling in prayer and the saints stood or sat on either side of him as they do in Campin's Madonna in Aix or Van Eyck's Dresden triptych. Christ or the Virgin remained the sacred object, unifying all the participants by their act of timeless devotion. But in the Erasmus altarpiece, although the saints are undoubtedly included because of their peculiar relationship to the patron, their inclusion is not clarified pictorially. There is neither kneeling donor nor iconic Virgin and Child to explain their presence. As in the "Blessed Sacrament" altarpiece, Bouts was concerned not with religious, but rather with visual, rationality. His concept is additive, though his space is synthetic.

All the figures in the altarpiece appear on the foreground plane, projected against the landscape. The landscape serves as a background, complementing in its quiet extension the attitudes of the figures. In formal arrangement the painting is somewhat reminiscent of the Braque altarpiece and the Vienna "Crucifixion." But none of the careful adjustments of the landscape carry symbolic connotations as they do in the work of Rogier. The landscape exists only for its own sake as a physically beautiful area in which to place the saintly figures.

The drama of Erasmus' martyrdom is thoroughly neglected. In Bouts's depiction of the grisly torture, his ability to purify any scene of misery or discomfort, of blood or passion, reaches its height. At first glance we are quite unaware of what is taking place. The saint is stretched out before us, bound and stripped of his clothing. Though in the process of being tortured, he is thoroughly at peace. The narrow staff of the elegantly dressed potentate who oversees the affair is lighter in tone and exactly parallel to the saint's intestine and thus obscures its presence. The executioners perform their duty as if they were participants in a slow-moving rondo: one up, one down; legs crossed and legs apart. A frown slightly creases their brows, and one bites his lips in mild consternation. The bystanders, watching in quiet contemplation as if scientifically analyzing the possibility of winding out a man's intestines in one continuous strand, are arranged carefully and stand lightly on the ground. The landscape behind the figures is green and peaceful with rolling hills and meandering roads, its rhythm neatly coinciding with the foreground dance of death.

Everything in the center panel is turned parallel to the picture plane as it was in Bouts's Last Supper. The windlass repeats the right angles of the frame. The figures are in an upright, vertical position, which contrasts with the horizontality of Erasmus and the landscape. The two basic directions are locked into a fixed perpendicular relationship, which tends to detract further from the reality of the human situation by freezing the movement of the figures. By their placement they have been abstracted to such an extent that they seem to be acting out a dream. SS. Jerome and Bernard are present at the event but do not really see it. St. Erasmus is in pain but does not really feel it.

The beauty of the painting lies in its visual effects, in its serenity, in its light and color, and in its simple presentation and integration of figures and landscape. There is little

to be added to our understanding of the content. Even if we were certain that Ghert de Smet was the donor, we would probably discover only that he ordered a painting that was to show in its central panel the Martyrdom of St. Erasmus and on its wings SS. Bernard and Jerome. As to the iconography, no more need be added except the ultimate reason for the selection of these three saints.

The only additional information that would help in deciphering the iconography would be the presence of a donor. As in the altarpiece of the "Blessed Sacrament" we are left to speculate whether or not one or more of the bystanders might be identified as a donor. For instance, does the figure standing to the left in the center panel, who looks sideways across the picture plane, represent De Smet?

If either the "Blessed Sacrament" or the St. Erasmus altarpiece does include a donor, then the traditional relationship between the donor and the scene he adores has been obscured. He is still a witness to the scene, but he now impersonates a character whose presence is historically plausible. He does not kneel in devotion nor is he introduced by a patron saint. There are no saints at all in the altarpiece of the "Blessed Sacrament" who might be considered as intercessors, and certainly none of the three saints in the Erasmus altarpiece would qualify as a name patron for Ghert de Smet. These extra figures can be explained as servants or bystanders, but they cannot by their actions be identified as donors. The scenes have been made so plausible that one cannot, with certainty, separate a fifteenth-century donor from an Early Christian.

If the donor were to be painted as a kneeling devotee within such a scene, he would upset its rationality. The dramatization of a Christian story by Flemish actors within Flemish settings is by now so spatially perfect and observably correct that the spectator may view the painting as a literal extension of his own world. The painter forces the donor, if indeed he is present, to play a role that is historically consistent with the scene. He is not set aside to adore the event, but he is made a part of it; otherwise he would upset the new pictorial contemporaneity.

The roles of both the artist and the donor have fundamentally changed. In selecting the subject matter, as for example in the altarpiece of the "Blessed Sacrament," the patron called in a third party. Neither the artist nor the donor trusted his own religious knowledge in handling the theme. The confraternity knew what subject it wanted, but it had to turn to the theologians at the university in order to advise the painter how to represent it.

Both Van Eyck and Rogier had the reputation of being gifted painters and learned men. They were called upon to use both faculties in the creation of their works. During the middle of the century the age of artistic specialization began. Bouts needed only to be a gifted painter. He could go to an expert for questions of religious subject matter. The donor, though still specifying the subject, no longer dramatically affected its outcome.

The Erasmus triptych, far more than the altarpiece of the "Blessed Sacrament," shows how the object of our study is lost when the concerns of the artist are so divergent from the subject and the function of the painting. Because Bouts is one of the first "mod-

ern" painters interested primarily in pictorial composition and visual harmony, his paintings are iconologically lean. He places the prescribed subjects within a new, contemporary landscape, within a new world of light and air derived from the observation of ephemeral, phenomenological changes. He gives the subjects a natural beauty they had never had before, but we need little extra-artistic information to understand their meaning. Bouts's investigations were not fully developed in the Netherlands until the end of the century. Within the next decade, the work of Hugo van der Goes ignored the direction that Bouts foreshadowed. Goes returned in some ways to an archaistic rendition of his subject. The artist as theologian returned briefly. The reciprocal relationship between the artist and the commission was tenuously grasped again, and the religious subject matter regained its former authority.

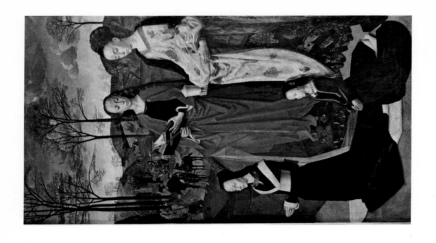

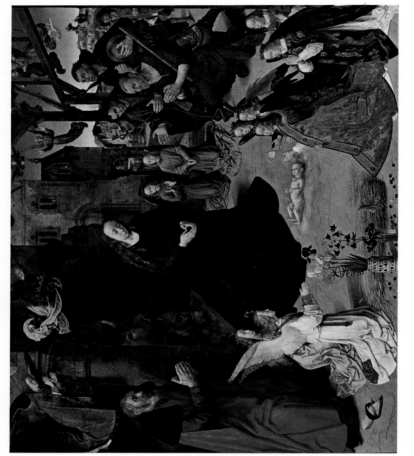

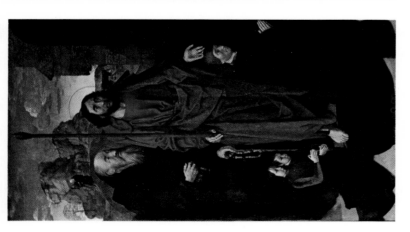

IX. Hugo van der Goes: Portinari altarpiece. Florence, Uffizi.

The Portinari Altarpiece
by Hugo van der Goes

Unlike the triptychs of Bouts, Hugo van der Goes's Portinari altarpiece (IX) is saturated with symbolic content. It represents the last full flowering of disguised symbolism. Not since the days of Campin and Van Eyck had Flemish painting been so impregnated with significant naturalistic detail which, however, is curiously concentrated in the center panel. The interior and the exterior of the wings use other devices to underscore their symbolic content.

Plate IX

In the center panel (58) old and new motifs are combined to present the most complicated symbolism found in a Nativity of the fifteenth century.[1] The physical setting consists of the skeleton of a shed, shown on the right, combined with a heavy Romanesque structure that extends on the left into the left wing. The Romanesque building, just beginning to show signs of deterioration in the section appearing in the left wing, traditionally signified the end of the Old Testament era with the coming of Christ. This structure has as its major supporting member a huge column against which the Virgin was said to have leaned when giving birth to the Child. The positions of the ox and the ass are similar to those in the Bladelin triptych: the ox, symbolizing the Church, raises his head in recognition of Christ; the head of the ass is lowered, representing the Synagogue's proverbial blindness. In the murky shadows above their heads hovers the devil, the prince of darkness who was put to flight by the birth of Christ.[2]

Illustration 58

The masonry building in the background is the well-preserved, but abandoned, palace of David, which is identified by the harp sculpted in the tympanum. The letters *PNSC* probably stand for the words *Puer Nascetur Salvator Christus*, which are part of the Christmas liturgy.[3] This is the first time that such a palace has appeared in a Nativity in Flemish painting. It suggests both the location of the Nativity in Bethlehem before the house of David [4] and the genealogy of Christ. Bethlehem is symbolized again in the sheaf of wheat in the foreground. According to St. Gregory, "it was all the more fitting that the Lord should have been born at Bethlehem, since Bethlehem means 'house of bread': for it was He who said: 'I am the living Bread which came down from heaven.' " [5]

The wheat with its reference to bread further symbolizes Christ's death as embodied in the Eucharistic sacrifice, and the leaves on the vase next to the sheaf of wheat may be those of the grape. The flowers in the vase augment the Passion symbolism. The scarlet lily symbolizes the blood of the Passion, and the carnation, the three nails of the cross.[6] This theme is combined with that of the Virgin's Compassion. The iris represents the sword that pierced the *Mater Dolorosa*'s heart, and the seven columbines, her seven sorrows. The latter probably also refer to the seven gifts of the Holy Spirit. The theme of the Trinity is intricately and repeatedly used in the number of blossoms and the groups of adorers. The twenty violets symbolize the humility of the Virgin and also that of the twenty humans on their knees before the Child.

The Sacrifice of the Mass, symbolized by the wheat, is further explained by the robes of the angels.[7] Those who surround Christ wear the linen alb, which is traditionally worn by the assistant ministers at the first High Mass of a young priest. The angels at the top left and the lower right wear the cope, customarily worn by the archpriest at such a Mass. The two angels to the right of the kneeling angel in the cope wear the dalmatic. None of the angels wears the chasuble, the vestment of the celebrant of the Mass, for Christ himself is not only the Sacrifice, but the priest as well: "The chasuble that He wears is His human flesh which He assumed at the Incarnation precisely that He might offer Himself as the victim for sin." [8] The position of the small Child must also be a reference to Christ's death. He looks like a sacrificial victim, helplessly alone in the midst of His adorers. Goes does not use the motif of the cloth as Rogier had—to represent both the swaddling clothes of the baby and the sudarium of the martyr.[9] Instead, as Rogier portrayed the Child lying across the knees of His Mother in remembrance of the Pietà, Goes places the Child on the ground as the sacrificial host of the Nativity. His body lies in a horizontal position parallel to that of the sheaf of wheat. They both rest on the stone floor, which is marked as holy ground by the halo of light beneath Christ and by Joseph's discarded patten in the foreground.

To this scene of the Nativity with its intricate use of disguised symbolism, Van der Goes adds scenes that precede and follow the birth of Christ. In the upper left corner of the left wing (59) Joseph and Mary are wending their way to Bethlehem. Joseph assists the Virgin as they begin their descent down the hills which will lead to the place of the Nativity. The inclusion of the ox and the ass walking behind them, rather than the usual representation of Mary astride the ass, comes from Bonaventure's *Meditations:* "Wishing to obey the command, Joseph started on his way with the Lady, taking with him an ox and an ass, since the Lady was pregnant and the road five miles long from Bethlehem to Jerusalem" [10] The Annunciation to the Shepherds is shown in the upper right-hand corner of the center panel. This is a prelude to the Adoration of the Shepherds which is part of the Nativity proper.

In the background to the right of the palace of David, two women are leaning against a wooden gate. The one to the left appears to be distinctly older than the other. Behind them is a large domestic structure very much like the structures found in scenes of the

Illustration 59

Visitation and identified as Elizabeth's home.[11] If this scene does represent Elizabeth's meeting with the Virgin, neither figure is in the traditional position of the encounter. Furthermore, the Visitation should precede the Nativity. In all other scenes Goes has maintained a chronological order, moving from left to right, from background to foreground. On the left wing the journey precedes the birth; on the right wing the procession of the Magi follows the Adoration of the Shepherds. It seems more likely that the two women represent the midwives called by Joseph to attend the Virgin. The motif of the two midwives was found early in Flemish painting in Campin's Dijon "Nativity." Hugo is not so explicit as Campin about their role, but one can see that the older woman faces forward, toward the Nativity scene, whereas the other turns her back on it, perhaps symbolizing the belief of Zebel and the disbelief of Salome.

Unlike his Flemish predecessors, Goes creates in the center panel much visual excitement through the use of spatial inconsistencies. Irrational elements appear often without warning, sometimes without explanation. Although the work of Campin or Van Eyck might be described as spatially inconsistent, it is never permeated by a sense of arbitrariness or forcibly contained chaos. Goes creates such abrupt changes within the space that the rationalizing effects of perspective are nullified. Unlike Bouts, Goes does everything he can to overcome the force of perspectival logic. The architecture is not used to define and limit the space, and there is no sense of a fluid spatial continuum between the parts. Although the space itself is organized according to the laws of perspective,[12] the figures within it neither conform to these laws nor have a single law unto themselves. The angels are of various sizes, but all are smaller than Joseph, Mary, and the shepherds. They are unified only by their act of devotion rather than by their relative scale. The contrast between the figures is repeated in the architecture. The oversized Gothic column is inconsistent with the spindly wooden beams of the shed. The large stone masonry arch of the left wing is not connected convincingly to the arch of the center panel; in fact it does not need so large a column to support its weight. The wooden frame, without walls, becomes a foil for the brick masonry of David's palace. The palace appears as a solid, space-displacing unit, whereas the shed seems as insubstantial as the angels hovering about it. The large palace in turn contrasts with the small house in the distance. The space between the two is confused by the fact that they have been placed right next to each other.

To the tension of contrasts is added a sense of *horror vacui*. The pictorial space seems to be brimming over with animated creatures. Only the middle-ground area around Christ is uninhabited. The blank space is especially conspicuous because of the density around it. In the midst of all the visual diversity, the Child remains the center of attention. His is the only form to inhabit the only clear space in the painting. Never was the image of the Word made flesh more poignant. The divine Child is shown in His weakest state, unprotected even by clothing or manger. Everyone may approach Him without fear; yet none dares trespass His empty space. All the power and glory that had been foretold in the coming of Christ are concentrated in that tiny body of light which is

strong enough to withstand and hold in abeyance the many impinging forces within the painting.

Illustrations
59, 60

The use of disguised symbolism, of a large middle-ground area, of spatial tensions and contrasts, and of extended religious subject matter exists only in the Nativity. None of these elements appears on the exterior or the interior wings. Standing sternly sober, in firm contrast to the activity of the center panel, the four saints on the interior wings present their patrons (59, 60). On the left St. Thomas, holding his lance, presents Tommaso Portinari. St. Anthony Abbot, with his tau and bell, stands behind Anthony, the eldest of Portinari's sons, and his little brother Pigello. On the right Tommaso's wife, Maria Baroncelli, and his daughter Margherita kneel before their patron saints: Margaret with her dragon and the elegantly dressed Mary Magdalen with her ointment jar. The right wing represents one of the few instances in which the patrons do not kneel directly in front of their own name saints. For some reason they are reversed.[13] All nine figures are turned passively toward the Nativity. Their marked change in scale, unlike the changes of scale in the center panel, is not disturbing because it can be logically explained. The donors as mortals are shown in smaller scale; the saints as divinities are larger. Yet there is one inexplicable phenomenon in the wings. The head of the dragon at Margaret's feet looms up, striking a sudden, ominous note within the placid setting.

The wing figures are all placed within the foreground area. The landscape recedes behind them almost as if it were a backdrop, largely because of the elimination of the middle ground. Consequently the saints appear even taller. The landscape is not exactly contiguous with the center panel as it was in Bouts's Erasmus altarpiece, but it suggests the same scenery. As already noted, the stone arch continues between the left panel and the center panel. On the right wing the background, which contains the procession of the Magi, is not unrelated to that in the upper right of the center panel. The scout for the Magi's train asks directions from a shepherd who looks very much like those who have already reached the Nativity scene.[14] The grayish-white foreground in all three panels also helps suggest a continuous space, which actually does not exist. As in the Bladelin altarpiece, the space of the wings is adjusted slightly so that the donor and the saints do not appear to be sharing the identical ground of the Christ Child.

The wings do not compete with the center panel in importance. They return to their traditional role as the carriers of a lesser subject, donor portraiture. The donors and their patrons are kept in a subordinate position, and they adore as representatives of future generations, not as part of the historical moment. They direct all movement back to the central point of attention. They repeat, but now in a different stance and from another station, the manifold gestures of adoration of the Child in which every member of the triptych participates. These figures fill and crowd the foreground area of the wings and thus heighten the effect already created within the center panel. They diminish further the apparent size of the Christ Child. He seems even more helpless in relation to the monumentality of the standing saints.

The exterior of the wings also regains its traditional role, for it depicts the An-

nunciation (57). Since it is preparatory in nature and serves as a protective cover for *Illustration 57* the interior, it is painted in grisaille. The Virgin is seated on the left by her open book, and the dove of the Holy Spirit hovers above her head. Her meditation has been interrupted by the entrance of Gabriel, who appears on the right wing in a shallow niche, identical to that of the Virgin. Gabriel is captured at that instant between stability and instability, first depicted by Rogier van der Weyden.[15] His position suggests halted flight, for he neither stands nor kneels. Goes expands the effect of the motion of the angelic descent by presenting Gabriel with hands and wings upraised and with garments flowing upward behind him. All aspects of his gown and body reflect the suddenness of his appearance. In his three-quarter suspended movement he is a dramatic foil for the frontal, composed Madonna, who demurely awaits his message. All the narrative aspects of the event have been subordinated to a symbolic interpretation. Gabriel carries only his staff; Mary's open book has no text and the vase of lilies has been omitted. The environment is just large enough to enclose each separate figure and the shadow it casts. The figures do not meet in a fully developed interior space; instead the setting suggests two sculptural niches, such as might be found on the exterior of a cathedral.

From the time of Van Eyck the sculptural abstraction of the Annunciation was well known in the Netherlands and was often used on the exterior of triptychs. An example of it appeared on the exterior of the Beaune "Last Judgment." The only iconographic difference in Van der Goes's Annunciation is that the positions of the angel and the Madonna have been reversed, as they were only once before in Flemish painting, on the exterior of the Bladelin triptych. The reversal [16] places the angel to the heraldic left of the Virgin, the lesser position, generally assumed by the donor in a diptych. Thus the holiness of the Virgin is accentuated. The usual left-to-right reading, which always begins with a recognition of the angel, is also reversed. Rather than suggesting the simple question-and-answer arrangement of an entering angel on the left received by a seated Virgin on the right, the reversal helps to maintain tension as it forces the eye to move back and forth between the two figures. One's attention is continually drawn back to the figure of the Virgin.

Stylistically this Annunciation has an extraordinary vitality not found in earlier depictions. It has moved from an intimate, detailed world in which every stroke is impregnated with the spirit of God to a more humanly dramatic realm in which the detail is strikingly confined to the figures. Although painted in grisaille, the figures are not sculptural in quality, only in tonality. Rather than reducing their nature, the painterly, finite detail monumentalizes it. They are too perfect to be human. In scale they are hardly removed from reality at all, for they are nearly life-size. But they live and move in an environment that is devoid of life and movement. It is an empty, airless space, which the action does not begin to fill. Realistic figures exist in an unreal setting. Because of the abstraction of the spatial area, the figures appear disembodied. The confrontation of opposites is so well balanced that it seems to heighten the tangibility and the grandeur of the figures. They are at once and without conflict ideal and actual; they are both in

time and beyond time. The use of grisaille adds the final weight to this delicate balancing, for it contributes the last veil of abstraction. Living creatures are not black and white; only the Virgin and Gabriel can support such a contradiction.

But within the sustained harmony there is again a note of inexplicable tension. It is sounded by the glaring bird, which descends above the head of the Madonna. It seems to share with Gabriel the gesture and position of halted flight, but rather than appearing as the peaceful dove of the Holy Spirit, the bird looks more like a bird of prey with its wedge-shaped head, large beak, and extended talons. Like Margaret's dragon, the bird seems to draw one into the disturbing realm of the subconscious. Though we can explain its presence, we cannot logically justify its form.

On both the exterior and the interior of the triptych Goes displayed a firm determination to maintain the supernatural importance of the subject while describing it in explicitly naturalistic terms. Grisaille is not used on the interior to effect the final transformation from the earthly to the divine. But through visual inconsistencies and a multiplicity of disguised symbolic detail, Goes overcomes the possibility of the scene's ever being confused with a mundane event. On the wings he presents donors and patrons in an archaic manner; even tiny halos appear around the heads of the saints. On the exterior Goes eliminates all aspects of the setting; on the interior he compounds them. In both cases religious symbolism remains supreme. All his stylistic, narrative, and symbolic inventions are directed toward this end. Such motifs as the hovering devil, the bundle of wheat, and the elaborate flower symbolism have not appeared in Flemish painting before. The representation of Joseph and Mary on the road to Bethlehem, the two midwives at the gate, and the scout asking directions may have their medieval antetypes, but they have no immediate ancestors in fifteenth-century panel painting. Goes's ability to create iconologically relates him to the artists of the first half of the century rather than to his contemporaries. Nevertheless, he reflects the contemporary crisis in the extreme tensions found between the religious subjects. His spatial dislocations and apparent inconsistencies are quite unlike those of Van Eyck and Rogier.

Tommaso Portinari, for whom the triptych was painted, was the representative of the Medici firm in Bruges.[17] He came from a long line of Florentine financiers. His grandfather had managed the Bruges firm before him, and his brother Pigello managed the branch in Milan.[18] Although his business was in Bruges, Tommaso returned frequently to Florence. In 1470 he married Maria Baroncelli, a Florentine lady also from a rich banking family.[19] They had six children of whom there is a record. Antonio, the eldest, spent most of his life in Florence. His brothers Francesco and Guido lived in England, the latter serving as a military engineer for Henry VIII. Maria and one of her sisters entered a convent in Florence.[20]

Tommaso acquired great wealth and power from his position in Bruges. Under Piero de' Medici, in 1465, he was made a copartner in the business, and under Lorenzo he gained practically unlimited authority. His speculative ambitions, always curbed by

Cosimo and Piero, finally led to disaster under the rule of Lorenzo.[21] Tommaso had been particularly favored at the Burgundian court.[22] Philip the Good employed him as a counselor, and Charles the Bold foresightedly made him his treasurer. In spite of repeated warnings from the Medici, Portinari lent heavily to the Burgundian dukes, especially to Charles the Bold.[23] When the Duke was killed at Nancy, he was deeply in debt to the Medici firm. The Bruges branch could be saved only by a large advance from Lorenzo himself.[24] Portinari, however, was not to be repressed. He continued to lend to the ducal family, first to Mary, Charles's daughter, and then to her husband, Maximilian I of Austria. This loan too proved disastrous, and the whole Medici firm in Bruges had to be closed in 1485.[25] Portinari, having cleverly saved his personal fortune while losing that of his employer, was finally discharged. He then entered the service of Henry VIII of England. He spent part of his time in England and part of it in diplomatic missions to Flanders. Toward the end of his life he relinquished most of his interests to his son Antonio.[26] Tommaso died in Florence in 1501.

Tommaso's most illustrious ancestor was Folco Portinari, the father of Dante's Beatrice. About 1285 Folco founded the hospital of Santa Maria Nuova in Florence,[27] the chapel of which was destined to contain Van der Goes's altarpiece some two hundred years later.[28] The hospital opened in 1288 with twelve beds. Although Folco died the next year and was buried in the church,[29] he provided in his will for the continued patronage of the hospital by his descendants.[30] By the fifteenth century Christoforo Landino recorded that it could accommodate more than three hundred persons.[31] The international fame of the hospital was such that both Henry VIII and Leo X sent for information concerning its organization so that they might duplicate its success.

The hospital chapel, originally dedicated to the Virgin, had the name of Santa Maria Nuova. Later the old Romanesque Church of St. Giles, which was on the north side of the piazza of Santa Maria Nuova, was incorporated into the hospital's expanding complex.[32] The chapel dedication was then changed to include both the Virgin and St. Giles.[33] The latter saint was particularly auspicious because he is sometimes called upon as a patron of the sick and crippled since he once miraculously recovered from a severe arrow wound.[34] In his honor the hospital was run by the so-called Crutched Friars.[35]

During the first quarter of the fifteenth century the Portinari family began to reconstruct the old Church of St. Giles, transforming it into its present Gothic form (see plan, 56). It became the main chapel for the women's section of the hospital. Bicci di Lorenzo was charged with the work and began construction about 1418.[36] Pope Martin V consecrated the building in 1420 before any of the decoration was complete. As the Pope knelt at the entrance to the cemetery, he gathered up a handful of earth and conceded to all who died within Santa Maria Nuova as many years of indulgence as he had grains of earth in his hand.[37] Two frescoes depicting this scene of consecration appear on the facade of the church, on either side of a terra-cotta relief of the Coronation of the Virgin.[38] To the left, in a painting by Bicci di Lorenzo, Martin V is seen consecrating the church

Illustration 56

and hospital.[39] On the right he is shown confirming the order on the *spendalingo*, or governor, of the monastery. This scene, painted by Gherardo di Giovanni in 1474, was entirely repainted by Francesco de Brino.[40]

In the church choir a fresco cycle of the life of the Virgin, which is no longer extant, was painted between 1439 and 1453, primarily by Domenico Veneziano and Castagno.[41] The choir chapel served from 1435 until about the middle of the century as a meeting place for the Painters' Guild. For a time it was called the Chapel of St. Luke.[42] Consequently the first painting recorded for its altar was the lost work of "St. Luke Painting the Madonna," done by Niccolo di Pietro Cerini in 1383.[43] This was followed by a painting by Lorenzo Monaco[44] and another unknown work by Baldovinetti. The fourth painting for the principal altar was the triptych of the "Nativity," commissioned by Tommaso and painted by Hugo van der Goes.

The Portinari altarpiece must have been painted sometime between 1473 and 1476 —a dating based on the birth dates of the children of Maria and Tommaso.[45] Their first child, Margherita, was born in 1471. Antonio was born in 1472, and Pigello in 1474. All three appear in the triptych. Another girl, Maria, was born in 1475, and Guido in 1476. Neither of these two is shown. Therefore the painting must have been almost completed by 1475.[46] Pigello may have been added toward the very end, just after he was born. He is crowded in beside his brother and appears as a child of three or four, rather than the infant that he must have been at the time. Maria and Tommaso may have taken the large triptych to Florence in 1480 and installed it in the church, for they lived in Florence between 1480 and 1482.[47] The triptych must have been in the church before 1485, the year in which Ghirlandaio painted his "Adoration of the Shepherds" for the Sassetta chapel in Santa Trinità, because the heads of the shepherds in his painting were directly inspired by those in Goes's painting.[48]

In the Portinari altarpiece Van der Goes returned to an earlier phase of Flemish painting. Painting of the latter part of the century is characterized by an increasingly naturalistic style and a loss of religious content. Goes tried to reintroduce into this milieu painting with a deeply symbolic content. In the Nativity, he infused an old, established theme with a new religious fervor unequaled since the days of Rogier van der Weyden. Strangely, none of the iconographic invention in the painting can be attributed to its donation. Unlike every other altarpiece discussed in this study, the triptych does not become an extension or a concretization of its surroundings and its commission. It does not depict saints whose presence might help the sick of a hospital; it does not even contain a reference to St. Giles, the patron of the hospital. The donors, who were partly responsible for the support of the hospital, are not pictorially related to their foundation as Rolin and his wife were in the Beaune altarpiece. The only relationship between the painting and its setting is that the principal scene and the chapel are dedicated to the Virgin. Portinari must certainly have told Goes that the painting was to commemorate the Virgin. It is also quite possible, as Professor Koch suggests, that the city of Florence is honored by the prominent use of the iris in the still life; the royal fleur-de-lis is part

of the coat of arms of the "city of flowers." [49] But the Nativity itself is universal in its interpretation. The donors are presented in a way traditionally found on funerary plaques and paintings for centuries. The whole altarpiece would be suitable in any religious setting. In other words, the iconography is not vigorously transformed because of its location and donation.

We recognize in the Portinari altarpiece the iconography of the portable or autonomous easel painting. Like the "Arnolfini Double Portrait," it carries with it all the meanings necessary for its interpretation. It does not rely on situational factors to complete its explanation. Since Goes is iconographically imaginative, the lack of functional relationship probably resulted from a lack of information, not a lack of invention.

As far as we know Hugo was never in Florence.[50] He had seen neither the hospital nor the Church of Santa Maria Nuova. He did not know of its fame and importance within the city, and he probably was unfamiliar with the legends that surrounded it. Portinari may not have told him that St. Giles was also its patron. Furthermore, the Portinaris themselves were relative strangers to him. They were foreigners living in Bruges; their families and background were Florentine. Goes probably did not know the history of the hospital and its long tradition within their family. Therefore when he was asked to paint a triptych in honor of the Virgin, he turned to a theme with which he had been preoccupied throughout his life: the Adoration of the Shepherds.[51] Portinari had little or nothing to do with the artist's selection of this theme. To the Adoration Goes merely appended the portraits of the donors. To Van der Goes it was really an autonomous painting. This anomaly, however, does not necessarily indicate a breakdown between the donor and the artist. Although Goes is entirely responsible for the iconography, whereas the donor was with Bouts's work, we should not conclude that Goes's invention was so personal that he was not concerned about its relationship to the particular donation. This interpretation would not fit either the general work of Goes or this specific triptych.

In the Portinari altarpiece the iconography is not highly subjective, as it is, for example, in the work of Bosch. The representation of the Nativity is based on known literary, liturgical, and artistic examples. Goes's personal contribution lies in the combination, selection, and representation of the various subjects. The same can be said of his Vienna diptych, which combines for the first time the Lamentation and the Fall of Man.[52] Another work by Goes whose location is known demonstrates clearly that the artist was concerned with the interdependence of the iconography and the setting. Two panels, supposedly intended as organ wings for the Collegiate Church of the Holy Trinity in Edinburgh, were, like the Portinari altarpiece, painted in Bruges far from their final destination.[53] Goes probably knew even less about Sir Edward Boncle, provost of the church in Scotland, who commissioned them, than he did about Tommaso Portinari. Yet every bit of the iconography of the wings is dictated by their function and by the royal family who gave the organ and founded the church.[54]

Had the Portinari altarpiece been done for a church in Bruges or Ghent or had

Tommaso Portinari given Goes more information, the outcome would probably have been quite different. It might have not only represented a final attempt to utilize disguised symbolism in a meaningful way but also maintained the painting as a cooperative venture between the donor and the painter. Instead Goes, at Portinari's expense, painted a subject with which he personally was very much involved. The result is perhaps one of the largest truly autonomous easel paintings of the fifteenth century.

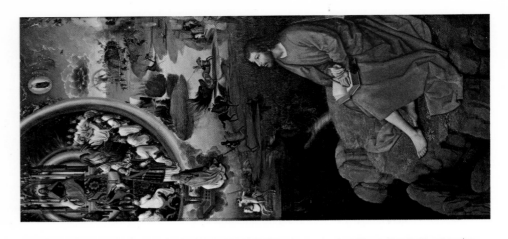

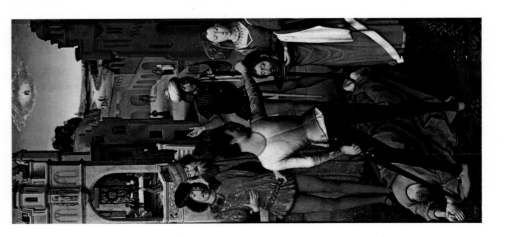

X. Hans Memlinc: Altarpiece of the Two St. Johns. Bruges, Hospital of St. John.

9

The Altarpiece of the Two St. Johns by Hans Memlinc

Like the altarpieces done for the Portinari family and Chancellor Rolin and his wife, Memlinc's largest altarpiece, usually called the "Mystic Marriage of St. Catherine" (X), was also destined for the main altar of a hospital chapel, that of St. John in Bruges. *Plate X* Partly supported by the city of Bruges,[1] this hospital was not wholly the product of a private donation as were those built by Folco Portinari and Nicolas Rolin. It is, instead, an early example of the growing concern of the medieval township for its residents. By the end of the fourteenth century Bruges could boast of four city hospitals: St. John's, which cared for men, women, and children; that of the Holy Spirit, which cared for aged women; St. Julien's, which cared for pilgrims and poor countrymen; and the leper hospital of St. Mary Magdalen.

The hospital of St. John was founded in 1188.[2] Construction on the building, however, continued as late as the fifteenth century. The infirmary was built in the second half of the thirteenth century, and its two enormous rooms were extended between 1473 and 1475 to form the large chapel that was to house Memlinc's altarpiece.[3] At that time the infirmary contained two hundred and forty beds.[4] Here, as in the hôtel-Dieu in Beaune, the inmates could partake of the holy office from their beds.

Very little of the original buildings now remains, for a major reconstruction was undertaken in the nineteenth century. The massive pillars and arches of the infirmary (66) are the same, however. Although the chapel is now walled off from this room, it *Illustration 66* is still intact. Its location and dimensions remain the same, but it, too, has been reconstructed and presently contains much Baroque ornamentation. The original entrance to the hospital on the south side of the church has been closed. Its thirteenth-century sculpted tympanum has been placed inside on one of the walls of the former infirmary.[5] Most of the fifteenth-century paintings that decorated the chapel, including Memlinc's altarpiece, are now in a room designated as the museum, which is located off the old infirmary on the north side of the complex.

The altarpiece was commissioned when the new chapel was built. Inscribed on its

frame is the date 1479, which, as with the Edelheer triptych, probably refers to the date on which the altarpiece was finished and installed.[6] The work must have been ordered sometime before 1475 because of the appearance on the exterior of brother Anthony Seghers, who died in that year.[7] Since it is a large work, it may have been commissioned as early as 1473, when the apse and the altar of the chapel were begun.

Ordered by the Augustinian brothers and sisters who ran the hospital,[8] the altarpiece was only one of several works that Memlinc painted for these clerics. Both the "Shrine of St. Ursula" and the Jan Floreins altarpiece were also given to the church by the clerical donors who appear within them.[9] Since Augustinian canons were allowed to hold private property, their churches, like this chapel, were often rich in funerary plaques and elaborate altarpieces.[10]

Illustration 61 Memlinc's triptych for the main altar displays upon its exterior (61) the two officials in charge of the brothers and sisters in the hospital, the master and the prioress, joined by two other clerics. On the left wing Anthony Seghers, a brother since 1445 and master of the hospital from 1461 to 1466 and again from 1469 until his death in 1475, is introduced by his patron saint, Anthony, who carries his customary tau staff.[11] Behind him kneels James de Cuenic, a brother since 1469 and bursar of the hospital from 1488 to 1490. Cuenic is presented by St. James Major, identified by his pilgrim's staff and hat. On the right wing, kneeling in similar position, is Agnes Casembrood, a sister since 1447 and prioress or superior for twenty-five years, from 1455 to 1460 and again from 1469 until her death in 1489. She kneels in front of her name patron, St. Agnes, identified by the lamb at her feet. Behind the sister superior is Clair van Hulsen, a sister from 1427 until her death in 1479. She is protected by St. Clare, who holds a large monstrance tower. The two groups are enclosed in a shallow room defined by back and lateral stone walls and by a checkerboard floor. This space is partly screened from the viewer by three columns and four trefoil arches, which at first glance seem to form two niches, but which actually are part of a single colonnade.

On the exterior, as has often been true, the colors are muted and cool. St. James's cloak is light blue; St. Anthony's is dark gray. Agnes is wearing green; and Clare, brown and black. The religious figures are all wearing the Augustinian habit of black and white; the architecture is in grisaille. By contrast, the interior displays a blaze of color, from the gaudy carpet and the bright brocade of Catherine's gown to the fiery vision of St. John on Patmos. The subdued world of the clerics bears little resemblance to that of the saintly congregation of the interior. Similarly the shallow exterior space contrasts with the panoramic landscape of the interior.

Illustration 62 The center panel (62), like the exterior wings, is symmetrically balanced in relation to a central focal point. Four saints appear beside the Madonna and Child. On the left St. John the Baptist, accompanied by his lamb, points, as the precursor, to the Christ Child; St. Catherine is portrayed at the moment of the mystic marriage, her wheel and sword on the floor before her; St. John the Evangelist appears on the right, exorcising the demon in his cup; and in front of him St. Barbara reads her missal, her tower stand-

ing behind her. All the saints seem preoccupied with their own meditations. The scene appears to be a gracious and courtly *Sacra Conversazione* in which the gentlemen saints stand politely behind the seated ladies, while an angel plays a gentle musical accompaniment upon a portable organ. The Virgin, enthroned beneath a baldachin, is absorbed in reading the Book of Wisdom, held by another angel to her left. Two more angels hover above her head, holding the crown of life, the symbol of her final exaltation.

The whole group is enclosed by an architecturally undefined interior, which opens by means of a double colonnade onto a landscape. The columns are decorated with figurative capitals representing scenes from the lives of the two St. Johns. On the left, above the head of John the Baptist, is the Vision of Zachariah and next to it the Birth and Naming of John the Baptist. The capitals behind John the Evangelist contain, to the left, the Drinking of the Cup by the Priest of Diana and the Resurrection of Drusiana.

Beyond the columns the landscape depicts other events from their lives. On the left between the two engaged columns are, from top to bottom, John Praying in the Wilderness, John Preaching, and John Being Led to Prison. Between the two columns is the Burning of John's Bones at Sabaste. In the background to the right of John the Evangelist are, from top to bottom, John Baptizing the Philosopher Crato in a Church, John's wife and disciples kneeling behind him, John's Departure for the Island of Patmos, and John's Immersion in Boiling Oil.

In addition to the religious events found throughout the landscape, a contemporary secular scene appears between the two columns to the left of John the Evangelist. It represents the town crane of Bruges which was located on the rue Flamande. In the distance is the little Romanesque Church of St. John and "to the right, at the corner of the rue Fleur-de-Blé, [is] the house named Dinant in the course of construction." [12] This scene is related to the hospital, but it has nothing at all to do with the two St. Johns. The town crane, or *la Grue*, was the place where wine was measured for the city. The right to measure wine in Bruges was given to the hospital of St. John in the fourteenth century in order to help the city repay a considerable loan that it had contracted with the hospital.[13] This right, and the right of *poinçonnage* given the hospital order in 1470—that is, the right to fish in the river Reye, which flowed behind the hospital—were two ways in which the city indirectly contributed to the hospital's support.[14] Since Bruges was then a major commercial center, the city's wine trade was large and the position of wine measurer was a very lucrative one. When Memlinc's triptych was painted, the brother in charge of wine measuring was Josse Willems; he held this office from 1467 to 1488.[15] He was also made master of the hospital after the death of Seghers in 1475 and thus held both positions by the time the altarpiece was finished.[16] The Augustinian brother standing just below the scene of John's Immersion in Boiling Oil is thought to be either Josse Willems or Jan Floreins, another brother who became wine measurer in 1488.[17] Since Willems held the office at the time of the commission of the painting, it seems more logical that he was depicted rather than Floreins.

The right and left wings of the interior also commemorate the two St. Johns. On

Illustration 64 the right wing (64) John the Evangelist is shown on the Isle of Patmos, pen in hand, recording his apocalyptic vision. The vision is transcribed with astonishing literalness, almost as if Memlinc had sat down at his easel with Revelation before him and carefully painted the major events of chapters 4 through 12. Beginning in the upper left we see the Enthroned One surrounded by a rainbow and seated upon a throne with seven lamps. Around him are the twenty-four elders clothed in white and crowned with gold (Rev. 4:2–5). The four beasts, each with six wings, stand before the throne (Rev. 4:6–8), and below it an angel points out the vision to John and announces the breaking of the seven seals. The first four seals are the famous four horsemen of the Apocalypse: the white horse of victory, the red horse of war, the black horse of famine, and the pale horse of death with Hell following behind him (Rev. 6:1–8). All these appear on a diagonal, which moves across the center of the panel along the edge of the water. Behind the pale horse of death is the scene of the earthquake, the falling of the stars, and the attempt by some to hide in caves from the destruction of the world. These events took place at the opening of the sixth seal (Rev. 6:12–17). The seventh seal is announced by seven angels with trumpets who can be seen at the very upper edge of the rainbow. Before their horns sounded, an angel with a censer knelt before the throne, offering upon the golden altar the prayers of all the saints (Rev. 8:1–6). Then the first trumpet sounded and fire was cast into the sea. The sea became blood and all living creatures died. With the third trumpet a burning star fell upon the earth, and with the fourth the sun, moon, and stars were smitten (Rev. 8:7–12). The fifth trumpet announced the falling of the star that opened the bottomless pit out of which came smoke and locusts in the shape of horses. They were ready for battle and had crowns and faces like men, hair like women, and tails like scorpions. They were the first woe, loosed upon the world to torment mankind for five months (Rev. 9:3–12). These figures appear to the far right just above the people running into the caves. With the sixth trumpet came the second woe in the form of an army of horsemen, appearing just beyond the locusts, who by breathing fire and smoke and sulphur caused three plagues to fall upon men (Rev. 9:13–19). Then a mighty angel, clothed in a cloud, came down from heaven with a rainbow over his head and an open scroll in his hand, his right foot in the sea, his left upon the earth. The angel raised his hand toward heaven and declared that the mystery of God would be resolved (Rev. 10:1–11). His figure is standing below an enormous cloud just above the army of horsemen led by four angels. With his proclamation the seventh trumpet sounded and the first sign appeared in the heavens. It was the Apocalyptic Woman clothed with the sun, the moon at her feet, and her head crowned with twelve stars (Rev. 12:1–2). Then a huge red dragon appeared with seven heads and seven diadems, his tail dragging the stars of the heavens. He stood before the woman as she brought forth a male child (Rev. 12:3–6). This vision is seen in the heavens in the upper right-hand corner. Just to the right of it is the final scene of the casting out of the devil by the archangel Michael (Rev. 12:7–9).

This was the first time that John's vision had been presented in so elaborate a way in a panel painting. Generally St. John is portrayed in fifteenth-century Netherlandish

painting on the Isle of Patmos in quiet contemplation. None of the inner workings of his mind are externalized.[18] The tapestry and manuscript traditions of the twelfth and thirteenth centuries had shown each event, but in a long narrative fashion. Memlinc transcribed the poetic images into painted scenes as Jean Bondol had done in his *Angers' Apocalypse*, but Memlinc viewed the whole from the aspect of a long naturalistic tradition. He condensed the apocalyptic events into a single image, occurring at one time and place. In Memlinc's representation of the holocaust lies the germ of the fantastic forms that were to become in the work of Bosch a major innovation of the late fifteenth century. Memlinc's conflagration with its tiny monsters had a fully rational explanation, for its literal text is available. With the work of Bosch the vision became the private property of the painter, perhaps never to be completely unraveled by a twentieth-century mind. Nevertheless, Bosch's painting is dimly prefigured here, to an extent that disclaims his work as an unheralded exception in Netherlandish painting.

The left wing (63) brings us back from the visionary world of one saint to the concrete demise of another. The Decapitation of St. John the Baptist is portrayed with equally keen attention to literal detail, from the spurting of the blood to Salome's refined disdain and polite acceptance of the head. In smaller scale in the background are the scenes preceding John's death. In the upper left background is the palace of Herod, where Salome requests John's head. To the right of the palace in the distant landscape, John makes Christ known to Andrew and James. At the riverbank he performs the Baptism, God the Father appearing in the sky above. In the courtyard on the right are the disciples, sent to visit the imprisoned Baptist.[19] *Illustration 63*

The relationship between the iconography of the triptych and its role in the hospital of St. John is not entirely clear. Unlike the Portinari triptych, which bore no direct relation to its setting, Memlinc's triptych seems to have several plausible associations, none of which seems to take precedence.

The central image of the Virgin may suggest a dedication of part of the hospital, perhaps the chapel itself, to her. She was certainly venerated in the sculpted tympanum, which represented her Death, Ascension, and Coronation, as well as the Last Judgment. St. John the Baptist appears because the hospital was dedicated to his patronage.[20] In the triptych he shares his position with John the Evangelist. The Evangelist's presence may be a result of the long medieval tradition of combining the two St. Johns; the Evangelist reinforces the patronage of the Baptist.[21] The association begins with the parallelism of their names, but there are other reasons as well. The death of the Evangelist was said to coincide with the anniversary of the birth of the Baptist, and thus they celebrate the same feast day. This coincidence is possible because John the Baptist is the only saint besides the Virgin to celebrate a feast on his birthday as well as his death day. John and the Virgin share this distinction because both were born without sin.[22]

The appearance of all four saints, however, appears to be as much a matter of expediency as of individual design. For some time between 1468 and 1480 Memlinc used the same four saints in a similar arrangement. In the Donne triptych (65) SS. John the *Illustration 65*

Baptist, John the Evangelist, Catherine, and Barbara all appear as they do here, on either side of an enthroned Virgin.[23] The two female saints stand and present the two kneeling donors, Sir John Donne and his wife Elizabeth. The standing figure of John the Baptist is on the left wing; John the Evangelist is on the right wing. This is probably an intercessory triptych, Catherine and Barbara appearing as popular auxiliary saints. At least one of the St. Johns (if not both) appears as the name patron of Sir John Donne. The altarpiece for the hospital of St. John used the same scheme. Memlinc merely eliminated the donors from the center panel, replaced them with the seated figures of SS. Catherine and Barbara, and moved the two St. Johns inward from the wings.[24]

Besides commemorating the patron of the hospital and the Virgin, the altarpiece may also be regarded as personifying the *vita activa* and the *vita contemplativa* exemplified in the lives of the brothers and the sisters of the hospital. In their life of seclusion and in their acts of mercy, they combined physical and spiritual care for the sick with a life of renunciation dedicated to God. Like St. Catherine, patroness of nuns, they were wedded to Christ and devoted to the studious, contemplative life. Like St. Barbara, patroness of men at arms, they were dedicated to the active life of good works.[25]

This division may be paralleled by the two major scenes shown on the wings. The presentation of the vision of John the Evangelist associates him with the contemplative life. We see his passive recording of the startling events that God permitted him to observe. The left wing, on the other hand, is given over to the Beheading of John the Baptist, the final dramatic, physical end to one of the most active lives of any Christian saint. This idea could be carried a step further. The earthly counterparts of the interior saintly exemplum of the dual nature of the Christian life are shown on the exterior. The four brothers and sisters of the hospital of St. John are the living examples of those dedicated to the *opus Dei* and the *opus mundi*. Before we accept this interpretation, we must again recall the Donne triptych. There would be no reason for the identical saints in this triptych to represent the active life and the contemplative life. Only the fact that the altarpiece of the two St. Johns was done for a hospital run by clerics allows us to entertain the idea.

One other explanation for the iconography remains: it might well be a personal, intercessory monument. The triptych may have been done primarily for the four members of the hospital shown on the exterior and presented as a major expiatory altarpiece containing five celebrated intercessory saints on the interior and their individual patron saints on the exterior. Certainly the other altarpieces given by the clerics to the chapel had this as a major purpose.[26] Memlinc's triptych, placed as it was on the main altar, may thus have served a double function: that of personal propitiation and that of public altarpiece, which portrayed the role of the religious community within the hospital and venerated the saints who might particularly favor the sick.

We have encountered triptychs that served more than one purpose before—most commonly, family funerary monuments that served also as general public altarpieces. But we have neither encountered the kind of iconographical ambiguity that we find in this

altarpiece nor seen altarpieces that repeat with very few changes the basic iconography of another work. Apparently Memlinc was not indifferent to the total setting of this altarpiece, but he was willing to duplicate a scheme if it sufficiently fit a very different context. In this sense the iconographic treatment of the altarpiece is removed even further from the attitude of the earlier masters than was that demonstrated by Bouts in the Erasmus altarpiece. In Bouts's work the iconography lacked embellishment, but its meaning and relation to its location were clear. The iconography, though meager, was direct and straightforward. Similarly in Bouts's "Blessed Sacrament" altarpiece the iconography was repetitive, but it was also unique and expressed specifically the attitude of those commissioning the altarpiece. Memlinc's altarpiece reflects an even greater loss of innovation and a disinterest in the creation of iconographic themes suitable for a single location.[27] Although the triptych is influenced by its setting, the connection has become so weak that the sacred content is peculiarly generalized.

The difficulty in the final interpretation of the painting is evidenced superficially in the naming of the altarpiece. It is frequently called the "Mystic Marriage of St. Catherine." [28] This name is misleading, for the Mystic Marriage is no more central to the overall content than is John the Baptist's recognition of the Christ Child. The Mystic Marriage is expressed merely as an attribute of St. Catherine. The only two people involved in the scene are a rather indifferent Christ Child whose Mother is reading a book and a St. Catherine who looks into the distance, disassociating herself from the whole scene except for her indolently raised left hand. The work has also been called a *Sacra Conversazione* or a *Virgo inter Virgines*,[29] but these names too are misleading. Although the attitudes of the saints might suggest these subjects, the total iconography does not. Neither would account for the extension of the lives of only the two St. Johns in the background and in the wings. Others, more exactly but less informatively, simply refer to the piece as a "Madonna and Saints."

The loosening of the iconographical sense in this altarpiece is not limited to the area of interpretation. The most overt iconographical "mistake" is found on the exterior. If only these two wings were extant and were unpainted on the reverse, one would immediately assume that they were the *interior*, not the *exterior*, wings of a triptych. They demand to be separated by a devotional object. The two sets of devotees are placed into a similarly foreshortened space as if they were in a single environment. The floor, walls, and square impost blocks clearly determine the focal point, which falls directly on the spot where the wings join, a point that is defined by the meeting of two halves of a column. This arrangement creates a highly unsatisfactory visual emphasis, which directs one's attention toward nothing of pictorial importance. It appears as if the two groups are praying to each other or to some unknown spirit lurking in the crack; both ideas are absurd. The subject is not suitable for a single panel or for two wings that are treated as if they were one panel.[30] Goes did not allow the focal point to fall on the crack on the exterior of the Portinari triptych even when the figures could logically have been

placed into a single setting. Memlinc not only does not seem to be offended by the location of the focal point, but goes on to place his devotees solemnly before each other, without the necessary interruption of a devotional icon.

The scheme of the wings makes sense only when they are opened and the enthroned Virgin is visible. Christ and His mother must be the object of the Augustinians' devotion. But Memlinc makes no attempt to explain this fact to the viewer by uniting the exterior and the interior. The architecture of the exterior bears no relation to that of the interior. The figures appear in completely different environments; not a single motif is carried from the outside to the inside. The only connection between the two seems to be the desire to justify incongruity at any cost. For the first time the triptych form with its movable wings seems archaic and unsatisfactory. In the hands of a master dedicated to the "accurate rendition of space," the exterior of a triptych is a natural place for the problem to be first dramatized. The same difficulty might have occurred in one of Bouts's triptychs if he had painted the exterior of the wings. Goes avoided it only by the greatest of subtleties. Memlinc seems either unaware of the problem or totally disinterested in it.

On the interior of the triptych are other, though less dramatic, iconographical problems. The architectural setting cannot be adequately explained, for it is neither apse, nor cloister, nor chapel. The Madonna's position suggests that appearing in earlier paintings by Jan van Eyck in which the Madonna and Child take the place of the altar in a church.[31] But in the Memlinc triptych her surroundings do not justify this interpretation; the architecture does not conform to a specific church interior as it does in Van Eyck's paintings. In an earlier time the architecture might have enlarged the religious content and symbolic importance of the scene as in Van Eyck's many Madonnas in ecclesiastical interiors or as in Rogier's use of the arch motif.[32] If it did not extend the meaning, at least it was identifiable. In Memlinc's altarpiece it does neither. The architecture has become merely a formal device used as the primary means of organization. It allows the landscape scenes to be seen and yet to be separated from one another. It adds a note of stateliness, enhancing the mood with a rather fuzzy ecclesiastical overtone, thereby adding to the general dignity of the scene but not to its depth. Like the overall iconography, the architectural setting remains always an impression and never a certainty.

In former times the historiated capitals would have been the vehicles for disguised symbols. But here the sculptured capitals are not symbolic at all, in either a disguised or an obvious way. Like the wings, they just add to the long narration of the lives of the two St. Johns. They have no significance different from that of the scenes in the landscape background. In order to read the whole story, one must move from capital to landscape, from background to foreground, from center panel to wing, without concurrent chronological or analogical reasons. At the same time one must sort out the religious from the secular event, the contemporary world from that of the past.

Moreover, the scenes in the landscape, the capitals, and the wings are not determined by any order. The large-scale scenes in the wings merely add to the basic information of the center panel. They neither begin nor end the narrative. Although the vision

from Revelation contains almost all the elements described in the chapters used, these too do not appear in any biblical order. They are scattered indiscriminately in both the background and the foreground of the visionary landscape. The loss of causation between the scenes is better realized when compared with the determined ordering of events and the tight unity of scenes in the work of Rogier. For instance, in the imitated sculptured scenes in the voussoirs of the "Miraflores" and the St. John altarpieces, the order and the choice of scene are inextricably bound with the events taking place below the arch.[33] One altarpiece is arranged chronologically; the other is not. Yet the order of both is motivated by devotional necessity. The wings of the Bladelin altarpiece fundamentally extend the interpretation of the Nativity in the center panel. They are not merely additive narrational units.

Like Bouts, Memlinc unified his altarpiece of the two St. Johns by visual rather than religious means. The scenes are distributed in the given space according to Memlinc's pictorial sense. His composition is based on a rather simple premise, that of balance and symmetry. The interior is divided in two: everything having to do with John the Evangelist is on the right, and everything relating to John the Baptist is on the left. The four saints are equally balanced on either side of the Madonna, a division statically reinforced by the architecture. The subtle equation of red and green throughout the interior complements the basic composition. None of the asymmetrical elements break the simple harmony, for each rhythmic disturbance has its balancing counterpart: one angel faces outward, the other inward; St. Barbara's tower is stabilized by St. John the Baptist's lamb; the leftward swing of the pattern in the cloth of honor is set against the rightward turn of the Madonna's head. The extra weight created by St. Catherine's wheel and richly embroidered dress is reduced by placing her upon a brocaded carpet, next to an angel in a brocaded gown. In order to add weight to St. Barbara, she is seated outside the area of the carpet and is turned away from the angel whom she barely overlaps. Moreover, both the angel and Barbara wear contrasting gowns. The only unresolved movement in the entire altarpiece is created by St. John's executioner, who comes directly from the executioner in Rogier's "St. John" altarpiece. Memlinc, or his follower, appears to have been unable to reintegrate the executioner and his action into the basic symmetry that pervades the rest of the altarpiece.

In this triptych physical reality and visual sensation have become more important than symbolic density. The sensuous beauty of the center panel dominates the altarpiece so strongly that one is only casually interested in reading the narrational elements in capitals and landscape. The observer does not approach this painting as he does the "Rolin Madonna," exploring more and more deeply the symbolic content until he discovers that even the arrangement of the floor tiles aids in the exposition of the confrontation between man and God. On the contrary, in Memlinc's altarpiece the eye is soothed by the coloristic and compositional harmony. There is neither the rigidity of Bouts's Erasmus and "Blessed Sacrament" altarpieces, nor the agitated drama of color and emotion of Rogier's painting. Never has the terror of Revelation been so gently portrayed. God and his choir of elders

are emblazoned like a beautiful medallion in the midst of a fairy tale of disasters. We are as bemused as St. John himself, for it is a dream to us as well as to him. On the other hand, the left wing concentrates entirely upon the dramatic gesture of the actual beheading of St. John the Baptist. Rather than emphasizing the spiritual significance of the act, it impresses upon us only the physical horror of the historical event. The extraordinary harmony between the finite and the infinite maintained by the early Flemish painters has been lost. The general acceptance of focal-point perspective has added to this disintegration. The continued use of the triptych form has dramatized the dilemma. But the problem is universal in the late fifteenth century. Memlinc's altarpiece is only one of many paintings of this period in which complex religious iconology has given way to the laws of physical beauty.

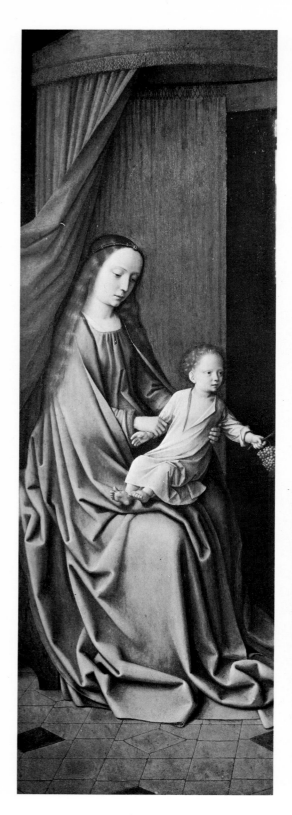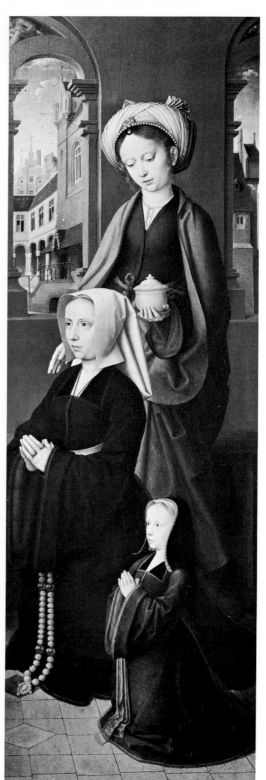

XI. Gerard David: Virgin and Child with Mary Magdalen, Madeleine Cordier and daughter, exterior of Baptism altarpiece. Bruges, Musée Communal des Beaux-Arts. *Copyright ACL Brussels.*

10

The Dissolution of the Triptych

Memlinc's altarpiece of the two St. Johns brings us to an impasse. The paradoxes contained in this work could not be sustained; something had to give way. Memlinc never again attempted the kind of iconographic multiplicity found in the center panel of this triptych. Lacking the synthetic ability to unite the iconography of this altarpiece for the hospital of St. John, Memlinc found another solution. He simplified his subject matter, reducing the content whenever possible to one major idea for each panel. If one panel contained many scenes, these were shown in a clear narrative (usually chronological) order. They no longer skipped illogically from landscape to capital, implying a second level of reality which actually did not exist. Memlinc clarified his imagery by placing it within an understandable framework, a framework that rarely suggested a previous order of disguised symbolism. If an architectural setting was used, it was either the one literally called for by the subject or only an ornamental backdrop for the Virgin, embellished with pagan *putti* and garlands as frequently as with such Old Testament figures as Adam and Eve. Memlinc's inclination toward repetition became even more pronounced; he duplicated scenes and motifs to an extent never before witnessed in Netherlandish painting.

The last three triptychs to be considered, two by Memlinc and one by David, all demonstrate the final disintegration of the triptych form. These paintings are characterized by a simple, linear iconography and the consistent use of focal-point perspective. With the demands of the latter for a greater time-space unity, the triptych format became more and more unwieldy, both formally and symbolically. The iconographic requirements of the donor were far less complicated. His role within the painting was no longer formative in the sense that his presence still transformed a familiar religious scheme. Now he always appeared as a lesser devotee, taken out of the central, more sacred space. These trends can easily be seen in Memlinc's St. Christopher triptych (67).

Illustration 67

This altarpiece was painted for the highly respected Moreel family of Bruges,[1] whose members had lived in the city since the thirteenth century. William Moreel, having inherited both a landed estate and the title of Seigneur of Oost Cleyhem from his father,[2]

was one of the wealthiest and most politically active men in Bruges. In 1490 his name was included in a tax list of the forty richest men in the city, and the next year the list contained the names of only ten men who paid a higher tax than he.[3] He served as burgomaster of Bruges in 1478 and again in 1483 and as treasurer in 1489.[4] Because of his title he held the office of *écoutète* in 1488.[5] This position in the Middle Ages was always held by a lord who was invested with the power of granting certain judiciary privileges, not unlike a prefect of police.

Moreel, an ardent Flemish patriot, had asserted the rights of the citizens of Bruges, first against the French and then against Maximilian of Austria. He was so energetic in his demands that when Maximilian made his peace with Flanders he refused to grant amnesty to Moreel and instead, in 1481, imprisoned him for five months.[6] Later Philip the Handsome granted Moreel a well-earned indemnity, which added to his already large income. Moreel was married to Barbara van Vlaenderberghe van Herftvelde. During the course of their marriage they had eighteen children.[7] Moreel's wife died in 1499, and he died shortly after in 1501. Long before their deaths they had ordered the St. Christopher altarpiece for their funerary chapel in the Church of St. Jacques in Bruges.

The church, founded toward the end of the twelfth century, underwent a major enlargement between 1457 and 1518. The reconstruction began in the apse end; the choir was completed in 1470. Many of the rich merchants of the city, such as members of the Moor, Portinari, and Gros families,[8] took part in the building program. As their contribution, William Moreel and his wife founded a chapel on March 20, 1484.[9] They were given permission from the vestry to use a site thirty-three feet long and nine feet wide along the south aisle beyond the rood screen. This area was to serve as a chapel, although it was not architecturally separated from the rest of the church. In this chapel the Moreels dedicated an altar to SS. Giles and Maur [10] and at the foot of the altar placed a tomb intended for two people.[11] They provided that before this altar intercessory prayers be said continually for their souls.

In spite of all their careful preparation, Moreel and his wife were buried outside the church in the cemetery, and it was only at the request of their son John, in 1504, that they were transferred into their chapel tomb.[12] Besides the tomb and altar, they richly provided for all the necessary ornaments of worship, among which was the large St. Christopher triptych painted by Memlinc. The lower frame of the wings and the center panel bear the same date as the chapel donation, 1484. Moreel's choice of Memlinc as the artist best qualified to execute this triptych for his funerary chapel was probably based on their past acquaintance. They both were members of the Confraternity of Notre Dame des Neiges.[13] Memlinc had already painted the portraits of Moreel and his wife, now found in the Musées royaux des beaux-arts in Brussels.[14]

Illustrations 69, 70

For their funerary triptych Memlinc painted the whole family in the most traditional manner—as kneeling devotees on the interior wings (69, 70). William and Barbara are represented with sixteen of their children; the other two presumably were born after 1484.[15] The left wing depicts, in an open landscape with a chateau and other buildings

in the background, William Moreel kneeling before a *prie-dieu* with his five sons behind him.[16] Standing at his side is his name patron saint, William of Maleval, better known as William of Aquitaine, founder of the order of the Hermits of William or the Guillau-mites.[17] The saint is dressed in a black Benedictine habit, which covers a suit of armor, symbol of his former life as a warrior and also a reference to his victory over the Saracens. He holds a flag, which displays his arms, and at his feet is a dragon referring to the legend of his temptations. He is the name patron not only of William Moreel, but also of his eldest son, named William, who kneels directly behind his father.

On the right wing, in a similar landscape with a chateau, Barbara Vlaenderberghe repeats in reverse the kneeling position of her husband. St. Barbara, holding her tower, acts as her intercessor. Behind her kneel her eleven daughters, the eldest wearing the habit of a Dominican nun. The only daughter who can be positively identified is Maria. Slightly to the right and behind the nun, she is recognizable by the letters of her name which are printed on her headband.[18] Weale states that the head of William was probably drawn from the portrait in Brussels, whereas that of Barbara was probably done from life, since she appears older because of her anxiety over her husband's imprisonment.[19] A comparison of the four heads does not seem to bear this out. Both seem slightly older than in the Brussels portraits,[20] but one would be hard pressed to say which was from life and which was not. Furthermore, by this time Barbara had had three years to recover from her husband's five-month sentence.

The center panel (68) presents SS. Maur, Christopher, and Giles in an open land- *Illustration 68* scape, which is in approximate agreement with that of the wings, its horizon line being roughly the same. The three saints do not appear in any historical or narrative setting; they are merely identified by attribute and related by environment. They stand as three large, isolated figures, introspectively involved in their own meditations.

The representation of a standing saint or of saints as the primary devotional image in a triptych, as in the Moreel altarpiece, occurs in the latter half of the fifteenth century. Before then it was usual only to venerate Christ or the Virgin in the center panel.[21] As saints began to be placed in the center of triptychs, they were not depicted as isolated cult images. Instead they were shown more dramatically in scenes from their lives. Bouts's "Martyrdom of St. Erasmus" is the earliest extant triptych of this kind.[22] Other later examples of triptychs wholly concerned with the life of a saint are the triptych of the "Life of St. Godelieve" in the Metropolitan Museum of New York,[23] the "Legend of St. Barbara," the center panel of which is in the Musées royaux des beaux-arts in Brussels,[24] and the large polyptych of the "Life of St. James Major" in the John Herron Art Museum of Indianapolis.[25] The use of a single saint as a devotional image, unrelated to a legendary scene, is less frequent; it seems to be more characteristic of triptychs painted toward the very end of the century. Two examples of this scheme, both dating either from the end of the fifteenth or from the beginning of the sixteenth century, are the "St. Christopher" triptych in Antwerp's Museum Mayer van den Bergh [26] and the anonymous altarpiece of "St. Jerome Penitent" in the Prado.[27] Bosch was responsible

for the largest number of triptychs painted strictly in honor of saints. Among them are the "Retable of the Hermits" and the "Martyrdom of St. Julia," both in the Doge's Palace in Venice, and the "Temptation of St. Anthony" in Lisbon.[28] The "St. Christopher" altarpiece by Memlinc is an important work within this new iconography of triptychs. It represents an early instance in which the center panel is dedicated to saints who are presented as static cult images.

In the early triptychs that employ this new hagiolatry, donors occur very rarely. Although the saints in the Erasmus triptych at Louvain may have been special patrons of the donors of the triptych, the donors themselves are not specifically shown, at least not in an attitude of prayer.[29] Besides the Moreel triptych, the only comparable instance in which kneeling donors are included is the "Martyrdom of St. Hippolytus" by Bouts and Goes (72). In this triptych, done roughly between 1468 and 1475, the donors, Hippolytes de Berthoz and his wife, Elizabeth de Keberswijck, kneel alone on the left wing and confront the scene of St. Hippolytus' martyrdom, which takes place on the center panel.[30] Here the reason for the veneration is quite clear: Hippolytes has elevated his name patron to the rank of a primary sacred image rather than using him only as an intercessory figure. St. Hippolytus is venerated not only on the interior, but on the exterior as well, for both SS. Elizabeth and Hippolytus are represented in grisaille on the outside wings. The whole altarpiece is simply given over to praise of the donors' name patrons.

Illustration 72

In the Moreel triptych in which the donors also venerate saints, no such obvious logic is displayed. We know the family, the chapel, the dedication of the altar, and the church, yet we do not know from any extant documents why Moreel chose to honor St. Christopher as the major saint in his altarpiece. Only from the funerary function of the triptych, justified by its location in St. Jacques, can we formulate a possible answer. The Church of St. Jacques served as a necropolis for the Moreel family.[31] William's father was buried in the church in 1447 and his father's brothers, Michael and Giles, were buried in its cemetery. William's only brother, Liévin, was buried in the cemetery first, but two years after the bodies of William and Barbara were moved into their chapel, he was reburied with them. Liévin had ten children, six of whom were buried in St. Jacques. When William's eldest son died in 1515, he too was placed beside his mother and father in their chapel. Thus the majority of the Moreels placed themselves under the protection of St. James. As the patron of their funerary church, he became one of their most important intercessors.

St. James shares his feast day, July 25, with St. Christopher. They celebrate their anniversaries together in the Mass for that day. They are also preeminent patrons of pilgrims and they are frequently associated in that role. For example, the lives of both were depicted in a fresco cycle in the Church of the Eremitani in Padua, done between 1448 and 1455 in a chapel dedicated to them.[32] The Moreel family not only placed themselves under the patronage of St. James by being buried in his church, but in their triptych also venerated his companion, St. Christopher.

In his own right St. Christopher was one of the most popular Christian saints, primarily because of his particular effectiveness against *mort subite*. A single glance at the figure of St. Christopher would protect one for the day. If unexpected or sudden death occurred, St. Christopher could expiate a victim who was at that moment unable to receive the sacrament of Extreme Unction.[33] Thus figures of St. Christopher were painted or sculpted on the exterior of churches throughout the Middle Ages. The fact that they were often large is not wholly explained by Christopher's legendary stature. It was quite important that the saint could be seen at a considerable distance. Numerous inscriptions attest to his peculiar powers: "Whoever shall behold the image of St. Christopher shall not faint or fail on that day," [34] or "You need not fear death on the day that you behold the face of St. Christopher." [35] It is, I believe, this signal power over death which accorded St. Christopher his principal place in the funeral chapel of the burial church of the Moreel family.[36]

Strangely, the altar proper was dedicated not to St. Christopher but to the two saints who flank him in the center panel, Maur and Giles. The latter, also a famous pilgrimage saint, was another of the superior intercessory saints.[37] He is one of the five saints listed by Smits as preeminent *noodhelpers;* Barbara, Catherine, George, and Margaret are the other four.[38] The Moreel family included three of the five on their triptych: Christopher and Giles on the interior and, as we shall see, St. George on the exterior. St. Giles gained this special privilege because of his intercession for Charles Martel. He forgave Martel for a sin that Charles did not dare reveal.[39] Therefore it was believed that all who invoked St. Giles for the forgiveness of sin were assured of divine absolution on the condition that they did not indulge in it again.

St. Maur does not share Giles's popularity as an intercessor. Possibly he was an old patron of the family, for the derivation of the name Maur is from the Latin *maurus*, meaning swarthy, brown, or Moor. This becomes in French, as well as in English, the antecedent *mor*, but in Flemish it becomes *moor*. Since the Moreels originally came from Savoy,[40] the name may stem from the French root. Another possible reason for St. Maur's inclusion is the fact that he was an important Benedictine saint. He was one of the first missionaries to France, sent by St. Benedict in the year of his death to found the first French Benedictine abbey. At that time Benedict gave him the book of the order, which he holds in the triptych.[41] The Moreel family may have held the Benedictines in special veneration, since three of the saints on their triptych—Maur, Giles, and William—are of this order.

William Moreel must have felt that the three central saints embodied a deeply personal intercessory power, so much so that in his altarpiece he was willing to honor them above the Virgin, but not above Christ. Although St. Christopher is the central image, he does not command this place of honor alone. On his shoulders he carries the Christ Child and in his hands the blooming staff, proof of Christ's miraculous presence. The Child's position and His gesture make Him more than an "attribute" by which we identify St. Christopher. He represents the culminating point of the iconographic and the

formal arrangements. All the figures are statically placed on the foreground plane. The donors and their children form a slightly receding diagonal into the background of each wing; this line begins a complementary movement from the wings toward the center panel. The position of the donors, kneeling before their *prie-dieu* pushed against the edge of the wing panels, brings to mind the figures of Rolin and his wife on the exterior of the Beaune "Last Judgment." Their three-quarter placement is echoed by their patron saints who present them to the three central saints. The action of the patron saints is continued with some variation by SS. Maur and Giles. They do not actually introduce the donors, but their inclined heads and slightly turned bodies continue the movement toward the full-front, central image of St. Christopher. St. Christopher, however, looks not out, but upward, toward the Christ Child. Christ returns his glance and thus resolves the final movement of the formal arrangement. He also is placed above all the figures. The heads of the donors define one horizontal level, the saints another; Christ alone defines the third. His head is near the top of the center panel and the entire landscape behind St. Christopher opens up, isolating Christ's image. Although the painting is dedicated primarily to the three central saints, Christ is clearly a part of the sacred image. Memlinc's iconography is not so unusual as it may have first appeared since he incorporates within his elevation of the three saints the figure of Christ. The desire to include Christ may also have encouraged the use of St. Christopher as the central saint.

Illustration 71 The exterior of this large triptych represents in grisaille on the left wing St. John the Baptist with his lamb and on the right wing St. George Slaying the Dragon (71). Both are frontal images placed into shallow undefined niches. The light falls on both saints consistently from the left. Weale believed that the exterior was done after the deaths of Memlinc and of Barbara and William Moreel.[42] He dated it 1504, the year in which the bodies of Barbara and William were transferred into the chapel by their son John. Weale supposed that the two sons, John and George, then ordered their own name patron saints to be placed on the yet unfinished exterior.[43] This thesis seems highly probable. There is no known reason why Barbara and William might have ordered SS. George and John to be placed on the exterior. If, however, they were painted at the request of their two sons, the exterior is further support of the funerary intention of the whole altarpiece. In this instance the boys added their own patron saints to the altar, thereby visually including their personal request for salvation. Similarly some of the children would later request burial within the chapel proper. The patrons that the two sons invoked were also powerful funerary saints. St. George is a very old and venerated saint, included as one of the fourteen intercessors in Germany, and St. John the Baptist, as we have noted before, has particular powers of intercession, for he is most often included as the third member of the Deesis.

This triptych demonstrates that even though the artist's hand and the donor may change, the intended function of the piece may continue to control the content. The triptych is a single funerary statement in that it venerates all the saints thought necessary to intercede for the Moreel family. Parents and children alike share a common in-

tention. No disguised symbolism detracts from, or even extends, the singularity of purpose. There is not a hint of narrative, despite ample opportunity and precedent for it. This lack is particularly striking in that the five saints represented on the interior are placed before an extensive landscape which easily would have accommodated narrative detail.[44] Memlinc no longer makes even a pretense at an extended iconography, as he did in the altarpiece for the hospital of St. John. He now minimizes it to the barest essentials. The content is simple. The saints have one function within the piece, an intercessory function which is repeated at every Mass said for the souls of the Moreels, before their altar, above the family tomb, and within their crowded funeral chapel.

Memlinc's last large altarpiece does not utilize the simple solutions of the Moree triptych. Its long iconographic program is a study in contradictions. The painting, completed three years before Memlinc's death in 1494, was done for the Greverade family of Lübeck. Two brothers, Adolphe and Heinrich Greverade, who lived intermittently in the Netherlands, probably ordered the altarpiece during one of their frequent visits.[45] As far as we know, Memlinc painted the entire polyptych in Bruges without ever having seen the Greverade chapel in the Cathedral of Lübeck for which it was intended. Just as in the St. Christopher triptych, the iconography of the whole altarpiece is based strictly upon the dedication of the altar as elaborated by the donor. In the Greverade altarpiece Memlinc demonstrates again his willingness to follow, almost pedantically, a given subject. He makes no attempt to unify it, even though the subjects are more heterogeneous than any we have seen. Apparently Memlinc merely painted the subjects the donors stipulated, allowing the multiple scenes to find their synthesis in their coexistence on the multiple panels of a single altarpiece. In one sense the double-winged triptych made his solution easier; he simply placed a separate subject or idea on each set of wings.

The Greverade family belonged to the large and prosperous merchant class of Lübeck. They undoubtedly became acquainted with the work of Memlinc during their periodic visits to the Netherlands. Adolphe and Heinrich took over the family clearing and exchange bank in the last part of the fifteenth century; thus they were constantly engaged in commercial relations with Bruges, since both Bruges and Lübeck were important cities of the Hanseatic League. Lübeck had been the headquarters of the entire league since 1418, and Bruges had been the league's headquarters in the Netherlands since the thirteenth century.[46] Because Bruges served as a collecting point for merchandise from Flanders, Spain, and England, it was continually involved in financial relations between these countries and the German merchants. Owing to his business connections, Heinrich often maintained a residence in Bruges.[47] Adolphe, though beginning his career in the banking business, later renounced his interest in order to become a priest. In 1497 Pope Alexander VI deemed him worthy of a canonship in Lübeck because of his "honorable way of life, his strong morals, and his integrity." [48] Adolphe spent most of his priest-

hood in the city of Louvain, however. Thus he too had a chance to see at firsthand a good deal of Netherlandish painting. He died in Louvain in 1501. Heinrich had died the year before in Italy, while on a pilgrimage to Rome.[49]

Although the brothers often were away from their native city, they made many religious donations to the churches of Lübeck. They established a vicary in the Church of St. Mary and in the cathedral,[50] and they gave at least three major works of art to these churches. To the Church of St. Mary they gave a painting of the "Mass of St. Gregory," reputedly by Bernt Notke, and the "Passion" diptych by Herman Rode.[51] They gave Memlinc's "Passion" altarpiece to the cathedral.

Illustrations 73–75 Memlinc's altarpiece (73–75) is a double-winged triptych; hence there are three separate scenes: the exterior scene made up of two panels of equal size, the first interior scene made up of four equal panels, each half the size of the exterior wings, and the second interior scene made up of three large panels in the form of a triptych. In the fifteenth century this type of polyptych was quite rare in the Netherlands, and it is the only example in Memlinc's work.[52] It was common in Germany, however. These German polyptychs were often in the form of *Schnitzaltäre*, carrying a sculpted scene on the interior which was covered by two sets of painted wings.[53] Since the Greverades were familiar with this type of altarpiece and since they wished to make an important and large donation, they probably requested that Memlinc employ the form.

There are several vexing questions concerning the specific commission and the actual placement of Memlinc's painting. The following events have to be correlated in some way. The date 1491 appears on the lower bevel of the frame of the Crucifixion panel on the interior. This is assumed to be the year when at least the interior of the painting was finished. In 1493, two years later, the Greverade brothers founded a vicary in the Church of St. Mary. In 1501 Adolphe provided in his will for another vicary in the cathedral. In 1504 this vicary was actually established by the bishop, and the altarpiece which had been completed by Memlinc some thirteen years before was put into place in the Greverade chapel in the cathedral.

Max Hasse seems to have set forth the most logical explanation of these events.[54] He contends that the brothers ordered Memlinc's triptych sometime before 1491, planning to place it in the cathedral and to found a vicary at the same time in their new chapel. An unforeseen event, however, must have led them to change their plans and to found their vicary instead in the Church of St. Mary in 1494. Hasse assumes that it was the scandal of 1489 in the cathedral which caused them temporarily to forsake their original donation. In that year Bishop Albert Krummedik died. He left behind an enormous debt, which took most of the congregation by surprise. Even his successor was uninformed and resigned his post because of it By the time Adolphe was ready to write his will, the affair had righted itself. He then founded another vicary in the cathedral as he had first intended, and Memlinc's painting was put into place. It is assumed that Adolphe had the painting by 1501 at the very latest and kept it in his possession until he gave it to the cathedral in 1504.

Hasse's evidence rests on the fact that Herman Rode's diptych, painted for the Church of St. Mary, was iconographically very similar to Memlinc's altarpiece (77, 78). They both displayed on their principal panel multiple scenes from the Passion, culminating in the Crucifixion proper. In contrast with this narrative rendition, the exterior wing of Rode's diptych repeated the Crucifixion, this time as a devotional scene taking place in a low-vaulted crypt of a Gothic church. St. John the Evangelist and the Virgin were frontally placed on the foreground plane to Christ's right, whereas St. Jerome knelt in three-quarter position to His left. St. Jerome also appeared in almost exactly the same position in the right-hand background of the interior wing before another miniature Crucifixion. Memlinc also utilized an ecclesiastical setting for his second pair of wings, but he placed within it, instead of the Virgin and the Evangelist, SS. John the Baptist, Blasius, and Giles—all saints whose patronage was related to the cathedral. St. Jerome, the family patron, appeared in both altarpieces. Rode did, however, add the Death of the Virgin on the interior wing. It paralleled the death of Christ and was probably added in order to stress the dedication of the church to Mary. Hasse assumes that Rode's diptych is a simplified version of Memlinc's painting, ordered at the time the Greverades decided to withdraw their donation from the cathedral. Its peculiar lack of stylistic and iconographic unity might be explained thus.

Illustrations 77, 78

Hasse also thinks that Memlinc's painting was commissioned by both brothers, even though only one donor figure appears on the interior of the left wing of the Passion.[55] Since both founded the vicaries in St. Mary's and the cathedral, he believes it more likely that both ordered the altarpiece for their cathedral chapel. Weale and Friedländer think that it was ordered by Heinrich, because he was living in Bruges and would have had contact with Memlinc and because only one donor is represented.[56] Hans Schröder, who wrote a monograph on the painting, thinks Adolphe commissioned it, because he was the one who finally established the vicary and dedicated the altar to the four saints represented in the painting.[57]

The total iconography of the polyptych suggests that even if both brothers were not directly responsible for the commission they must have conferred about its content. On the exterior we see the familiar and popular scene of the Annunciation (73). It takes place in the usual two shallow niches, the Virgin and the angel standing on a raised platform. They appear in grisaille, but the flowers at the feet of the Virgin curiously are painted in color. The vase stands, not between the Virgin and the angel, but to the Virgin's left. The use of the Annunciation and the emphasis on the Virgin are appropriate for the cathedral chapel, as it was dedicated to St. Mary and the Holy Cross.[58] Also in agreement with this dedication, the final scene depicts the Passion.[59]

Illustration 73

Between the exterior Annunciation and the interior Passion are the wings bearing the four saints whom the Greverades honored in the dedication of their vicary and their altar in the cathedral (74). St. Blasius, on the left, and St. Giles, on the right, may have been selected because they were two of the fourteen intercessory saints.[60] According to Schröder and Hasse, St. Blasius also was the second patron saint of the cathedral.[61] St.

Illustration 74

John the Baptist, who stands next to him, appears as the main patron of the cathedral, and St. Jerome probably appears as the patron of Adolphe, the clergyman.

The four saints are placed within a Gothic interior whose tile floor is similar to that beneath the pedestals of the Virgin and the angel on the exterior. By placing Gabriel and Mary in two different niches, each with its own perspectival system, Memlinc maintained unity of panel and subject. But on the second set of panels Memlinc found himself in the same dilemma as he had encountered on the exterior of the altarpiece for the hospital of St. John. The four saints stand on the foreground plane of one interior space, but bear no psychological or dramatic relation to one another. They are presented as separate objects of devotion, each on an individual panel. Only their simple gestures and attributes break the profound rigidity of their stance and the surrounding room. Their shared interior resembles a narrow projecting chapel, raised by a step from the general level of the church. It is articulated by two engaged columns on either side, double lancet windows on the back wall, and one ocular window in each of the side walls. The pictorial presentation of the room ignores the division of the wings, the focal point again being the crack. The slightest separation between the wings destroys the spatial illusion. In practice the wings do not remain absolutely parallel, but usually tilt inward, continually upsetting the logic of the projected space.[62]

St. Blasius, wearing a bishop's mitre and an elaborate chasuble over his alb, holds his staff of office in his right hand. His liturgical garments suggest those worn by the bishop on feast days. The hackle at his feet is symbolic of his martyrdom, and the candle in his left hand is a sign of one of his miracles. He cured a boy who was strangling on a fish bone by taking the candles that the boy's mother was about to offer at the church and touching the boy's throat.[63] St. John the Baptist stands next to Blasius, quietly pointing to the lamb at his feet. St. Jerome, dressed in cardinal's robes, is extracting the thorn from the foot of the lion. St. Giles rests his hand on the deer he saved from an arrow wound. The arrow, as Giles's attribute, here pierces his right arm.

Illustration 75

The final interior scene of the Passion is very different in its presentation (75). A full narrative rendition of the subject spreads across the width and into the background of all three panels. Almost all the figures are active. They no longer stand solemnly aloof, but vigorously participate in every event. The awareness of the spectator, which seemed so much a part of the first interior wings, is gone. In these panels, particularly in the left

Illustration 79

wing, Memlinc used the pictorial style of the Turin "Passion" (79), done at about the same time, and of the earlier panel of the "Seven Joys of Mary" in Munich.[64] Many events that took place at different times are all presented together in one panel. The scenes weave among the hills, in and out of various architectural structures gathered together as props to house and separate the different events. No attempt is made to correlate time and space into one representation.

The Passion cycle begins at the upper part of the left wing with the Agony in the Garden, followed by the Betrayal, and Peter Cutting off Malchius' Ear. The scenes below take place in the town: Christ Led to the House of Caiaphas, Peter Denying

Christ, the Scourging of Christ, the Mocking, the Crowning with Thorns, and Pilate Washing His Hands. At the lower portion of the panel, in much larger scale, is the scene of the Carrying of the Cross. It takes place outside the city gates leading up to the mount of Calvary. To the left of this scene appears the kneeling Greverade brother.[65] Like the donors in Memlinc's Turin "Passion," he is unaccompanied by patron saint and kneels on the outskirts of a scene. Although within the sacred space, he is ignored by everyone.

On the center panel the Crucifixion is extended into the middle ground and made more dramatic in its presentation. The crosses of Christ and the two thieves stand out above everything else. The viewpoint is strategically broken so that we are forced to look up at the crucified Christ and down on all the scenes below Him. Longinus and the Centurion emerge above the crowd of spectators. In the lower left the Virgin swoons in the arms of John and Mary, while the Magdalen addresses her grief and devotion to the cross. In the lower right the soldiers gamble for Christ's garment.

The historical narration is concluded on the right wing. The Entombment takes place in the foreground, the Resurrection above and behind it. In small scale in the landscape to the left, we see Christ's Appearance to the Magdalen and the two Marys Coming to the Tomb. In the building to the right is the scene of the Doubting Thomas, and above, Christ's Appearance to the Apostles on the Road to Emmaus, the Supper at Emmaus, and, to the left, Christ's Appearance on the Sea of Tiberius. Finally in the upper left corner is the Ascension.

The whole narrative of the Passion and of Christ's appearances after death are spread across the interior of the altarpiece. Memlinc gives up the single setting appearing on the first two sets of wings and turns to a continuous narrative running from left to right. Although there is a great massing of figures, the visual logic is simple. One now reads the panels from the top of the left wing to the bottom, across the center panel, and then from the bottom of the right wing to the top. There is one horizon line, one set of hills, and one little city in which all of the Passion takes place. Only the Crucifixion is singled out. Memlinc treats the three panels as consecutive pages of a book which tell as much of the story as possible.

This polyptych, like all of Memlinc's work, is stylistically related to an earlier Netherlandish tradition. Memlinc again and again used motifs and even whole figures and scenes from Rogier.[66] His treatment of landscape, the gentleness of his figures, their general proportions and costumes—all are direct developments from the style of the early fifteenth century. But his lack of concern for the total work is not at all characteristic of the earlier masters.

The altarpiece of the hospital of St. John shows an incipient dissolution within the devotional unity. The Greverade polyptych represents a profound break from the earlier tradition. It contains two antithetical points of view. The first two sets of wings are concerned with figures that appear in simple, sedate positions and settings. The Annunciation and the four saints are clearly intended to stimulate contemplation. No narrative

is incorporated into any of these presentations. Yet in the Crucifixion panels narrative concerns overrun the whole surface. One is confronted with a vast amount of space filled with a multiplicity of descriptive scenes. Even though the center panel is arranged in such a way that the figure of Christ predominates in a strong central position, and even though the swooning Madonna has been turned toward the spectator, the effect generally is not one of devotional intensity. The balance between the storytelling elements and the devotional elements is lost. Each set of panels is complete, seemingly composed for itself alone. For in this late work Memlinc did not strive for harmony within the total work. By comparison, the panels of the altarpiece for the hospital of St. John are far more coordinated: the donors appear on the exterior, the devotional scene on the interior. In it at least all the historical scenes from the lives of the Baptist and of the Evangelist are relegated either to the wings, to the capitals, or to the landscape, while the saintly congregation of the center panel maintains command as devotional figures.

What appears to be a conflict of styles [67] within the Greverade altarpiece actually constitutes a deeper conflict of meaning. The contemplative realm of devotion and the active realm of narration are harshly juxtaposed. Even within the seemingly consistent narrative of the interior panels of the Passion, the position of the donor demonstrates the disharmony. He appears as a kneeling devotee, in no way trying to impersonate a figure within the narrative. Yet he and his devotion are utterly lost within the animation of the Passion scenes. His position would seem even more distressing if a patron saint stood behind him making a gesture of presentation, for the holy figures could not be less concerned with a spectator or a devotee or even an intercessory saint. There seems to be no possibility of reciprocal action. Only the harried grief and prayers of the Magdalen seem to reach through the crowd to the figure of Christ. Though the unidentified Greverade brother ordered the subjects and dictated the form of the altarpiece, he could not force Memlinc to include him logically within the sacred scenes. He became an appended spectator, pushed back to the farthest corner, affecting neither the pictorial space nor the iconography.

Along with the loss of harmony between subjects, there is also a loss of iconographic causality or consistency. To follow the Annunciation with the Passion would be perfectly acceptable, indeed quite traditional. But to interrupt the two representations with four standing saints, separated by time and place from the Christological story, is peculiar. The fact that Christ and the Apostles appear on St. Blasius' chasuble and the Apocalyptic Virgin on his staff is not of sufficient importance to unite the saints to the rest of the iconography or to one another, as Hasse suggests.[68] These representations do not function as disguised symbols. The patron saints appear solely because the donors asked that they be included. Memlinc's solution was to set aside one pair of wings for them. They might have been placed more logically on the outside wings, but two factors mitigated against that position. Tradition favored the exterior grisaille Annunciation, which fit so easily on the two panels. Furthermore, since this was to be a double-winged triptych, the four saints fit equally well on the next four panels. Ease of presentation is now the most convincing argument for the arrangement of content.

This triptych demonstrates a further loss of invention in that it utilizes scenes and figures that had appeared before in the work of Memlinc and other Flemish masters. We have seen how the arrangement of the Passion scenes is very similar to that found in the Turin panel. The scenes of the Crowning with Thorns, the Flagellation, and the Denial of Peter are nearly identical. The Crucifixion scene itself comes from an old Eyckian tradition, found in variation in Joos van Ghent's "Calvary" (*ca.* 1465).[69] The Resurrection and the Entombment of Christ take place in a Rogierian Italianate tomb, which first found its way into Netherlandish painting in the Uffizi "Entombment." [70] All four standing saints come from earlier representations. The St. John was painted in a similar pose by Memlinc in the altarpiece for the hospital of St. John and with some variation in the Sir John Donne of Kidwelly triptych. He too comes directly out of Rogier's work, his closest parallel being the St. John in Rogier's "Medici Madonna." [71] We have already seen St. Giles in the St. Christopher triptych. For the Greverades Memlinc merely reversed Giles's stance and turned the hind's head outward. Giles's book is replaced by a bishop's staff, perhaps to suggest his ecclesiastical office in honor of Adolphe's priesthood. St. Jerome is very close to Bouts's representations of him in the Erasmus altar. St. Blasius does not seem to have a direct forefather in Netherlandish painting, but he is not unlike many of Memlinc's standing saints. For instance, one might compare him with Memlinc's St. Lawrence, executed as an altar wing in 1472.[72] The subjects used by Memlinc and other artists at the end of the fifteenth century became even more static than those of Bouts. They were borrowed, copied, and repeated, with little or no variation. It was probably largely a matter of coincidence that the hospital of St. John could use the subject from an altarpiece that Memlinc painted for Sir John Donne, or vice versa. The fact that the scheme was repeated and that there seems to be no single interpretation for it suggests that Memlinc's iconographic imagination was limited—but more important, that the limitation was self-imposed. His repetition of forms and "misuse" of motifs need not be interpreted pejoratively. Rather it is evidence of a change in intention.

For example, in the altarpiece of the two St. Johns, Memlinc painted an essentially decorative architectural setting, which included historiated capitals. The subjects depicted on the capitals were not important; the idea of a decorated capital was. Because of Jan van Eyck's use of such historiated capitals, we tend to say that Memlinc misunderstood their meaning and infer thereby that he was a lesser painter. But Memlinc did not care for complicated symbolism; he cared for decorative form. That is what he copied from Van Eyck. And one may assume that it was also the beauty of the painting, not its complex symbolism, which now appealed to his public. The artists of the last decades of the century continued to perfect the realm of physical beauty developed by Bouts. Memlinc took pleasure in rich brocade, variegated postures, carved marble capitals, and porphyry columns. His use of an entwined garland from the South carried as little of its original content as did his use of Van Eyck's ecclesiastical setting.

The change in the relationship between artist and donor is strikingly illustrated in the portrayal of the donors in Memlinc's triptychs. The patron, still wishing to be included in the painting, was content to leave his placement entirely up to the artist. Mem-

linc did not try to integrate the donor physically within the religious space or to include him as part of the religious interpretation of the subject. For Memlinc the donor was merely a quiet witness who never intruded upon the religious scene. He was not allowed to interfere with the pictorial or the iconographic statement.[73] In Memlinc's work the tight interaction between the traditional iconography and the man ordering it was lost. The donor's demands gradually decreased, and he returned to his former medieval role as a passive witness. He was cast into familiar scenes, established formulas of devotion. Both artist and donor seem to have lost interest even in consulting a religious expert to suggest a suitable or more particularized subject. The past readily provided innumerable iconographic schemes; they needed to look no further.

In the Greverade triptych the donor is not only relegated to the wing section, but he is not even allowed the protection of a patron saint. He is pushed toward the edge of the panel and is very small in scale. The scenes that unfold around him have nothing at all to do with him. So little attention is given to his identity that although we know the reasons for the commission, the location of the altarpiece, and the two brothers responsible for it, we do not know exactly which one is the donor. In fact, having this information would not affect the interpretation of the piece.

Like Memlinc, Gerard David, the last of the *primitifs flamands*, retained a strong stylistic link with the earlier masters. His triptych of the "Baptism," painted between 1500 and 1510, is the final proof of the dissolution of the iconographic and formal ideas that surrounded the use of the triptych, ideas established by the very men from whom David learned his style. This altarpiece marks chronologically and ideologically the end of an era.

Plate XI
Illustration 80 David's "Baptism" triptych (XI, 80) [74] was painted at the request of Jean des Trompes, who, like William Moreel, was an important official of Bruges.[75] Trompes had been treasurer of the city in 1498 and had served as city counselor from 1499 to 1502 and again in 1505. He was elected burgomaster of the city in 1507,[76] but could not accept the office because he was not a native of Bruges.[77] Trompes died in Bruges in 1516 and was buried in the Church of Notre Dame. He was married three times: first to Elisabeth van der Meersch who died in 1502, then to Madeleine Cordier who died in 1510, and finally to Jacquemine van de Velde.[78] Jean des Trompes's first two wives appear on the "Baptism" triptych. On the right wing of the interior Elisabeth van der Meersch is presented by St. Elizabeth of Hungary. By her side kneel her four daughters —Adewijc, Anne, Jeanne, and Agnes. On the left wing Jean des Trompes kneels with his son Philip and is presented by his patron saint, John the Evangelist.[79]

These are the traditional wing scenes of donor and patron saint which Hugo van der Goes reintroduced in the Portinari altarpiece. They constitute an archaic and commonplace solution. Used by Goes, the old form was infused with a sense of urgency and

underlying tension by the changes in scale and the adjustments of the landscape. David does not use any of these devices to separate his donors from the sacred event; instead he places all the figures comfortably into a single setting. The "Baptism" and its attendant scenes take place in a landscape calculated according to the laws of focal-point perspective and peopled with figures, both secular and sacred, who easily conform to the logic of the spatial layout. Almost no qualifications are made for the historical impossibility of this grouping of figures. The scenes containing the donors are separated only by the physical division of the wing panels. Otherwise the members of the Des Trompes family are located on the same ground as Christ.

In the background of the Baptism are two other scenes from the life of the Baptist, John Preaching in the Wilderness and the *Ecce Agnus Dei*. They are separated because they are in the background plane and thus are smaller in scale, but they are in the same perspectival system as the Baptism. In these scenes, as in those of the donors, no attempt is made to invent ways and means whereby different historical events might plausibly share the same pictorial space. Even the device of the columns which Memlinc employed to separate the lives of the two St. Johns has disappeared. The focal-point perspective is used so consistently that, as its discovery implied from the very beginning, the painting has literally become an extension of our world. Only in the Baptism scene is there some evidence of the artist moving beyond visual reality to the realm of devotional presentation. The angel, Christ, and St. John are all on the foreground plane, thereby de-emphasizing the extensive depth behind the figure of Christ. The angel turns in pure profile, and St. John holds a three-quarter position. In order to lend force to the frontal plane and to the static, central image of Christ, the dove and God the Father appear above His head on the same vertical axis. The positions of the figures are borrowed from a reversal of the center panel of Rogier's St. John altarpiece (17).[80] Nevertheless, they do counteract the logical flow of space.

Illustration 17

In his iconography and arrangement of figures, David surrendered the ability to create thematically, directing most of his energy toward the laying out of pictorial space and a detailed recording of the vegetation.[81] None of his figures is actively involved in defining the impressive extension of landscape. David's painting suggests the same loss of interaction and communication between persons and their environment which we find in the work of his alleged teacher, Geertgen tot Sint Jans.[82] Whereas Bouts's figures still are important points within the spatial vacuum, David's and Geertgen's cluster together in a few distinct areas, almost fearful of venturing out to control the vast new space that now flows so effortlessly around them.

The donors stare blankly and submissively at the scene of the Baptism; only the face of Jean des Trompes shows a fleeting look of concern, an individuality not found on the faces of the other persons in the altarpiece.[83] Because the countenances of the other members of Trompes's family show no emotion, they appear lacking in devotion; a veil seems to have fallen between them and the sacred object. They seem neither to see nor to believe. There is none of the devout concentration of Rogerian donors or the underlying

conflict of the soul so frequently seen on the faces of Goes's figures. One need only compare the daughter of Tommaso Portinari with any of the daughters of Elisabeth and Jean. Margherita Portinari betrays an age and a wisdom far beyond her years; the furrowing of her brow is childlike in effort but suggests adult comprehension. The Trompes children are masked and incapable of feeling. Like a series of little wooden dolls, they kneel behind their mother.

Plate XI
 The loss of individuality among the secular figures is perhaps best demonstrated by the women on the exterior (XI). On the right wing Jean des Trompes's second wife, Madeleine Cordier, and her first child, Cornelia, are presented by the wife's patron, Mary Magdalen. Madeleine Cordier's face is so like that of Elisabeth van der Meersch that one might think they were sisters.[84] The oval of the head and the disposition of their features are extraordinarily similar; the one note of individuality is in the form of their noses. All the females in the triptych seem to have been pressed from the same mold, and it is difficult to tell whether the original model resides within the painting or was taken from an archetype unrelated to the Trompes family.

 The enervation of form and feeling in the mortal beings is also evident in the religious figures. All seem to be dutifully performing a ritual whose meaning is only dimly remembered. Even the face of the Savior seems mute and expressionless, His pose forced and stiffened, His gesture unconvincing. Memlinc's figures, by comparison, seem relaxed; though not deeply involved, at least they are at ease with the religious subject matter.

 The iconography of the exterior, however, displays the most essential change from the earlier tradition; in fact, it is totally without precedent. The exterior portrays the introduction of Madeleine Cordier and her child by Mary Magdalen to the Virgin and Christ. Christ extends His grapes with a gesture that reaches across the two panels, deliberately connecting the two groups. In terms of its total iconography this scene might be either a single panel or a diptych, for there is neither a formal nor an iconographic connection with the interior scene of the Baptism. This scene appears on the two exterior wings of the triptych only because both women, on the exterior and the interior, were married to Jean des Trompes. The donor's desire to keep all his family on one altarpiece, coupled with the artist's willingness to connect such disparate themes, resulted in the peculiar iconography. The logic of the religious content had little effect on the final outcome of the painting. It is held together primarily by the accident of marriage. Devotional rationalism has given way to the convenience of consanguinity. By comparison, Memlinc's "Passion" altar seems far more consistent in its abrupt juxtaposition of separate religious groups.

 We have very little to suggest Jean des Trompes's initial reason for selecting the Baptism as the central scene. It might have been simply the traditional veneration of the two St. Johns. Jean des Trompes is introduced by the Evangelist and witnesses the most important scene in the life of the Baptist. Both might be looked upon as his name patrons. The choice of subject might also have been influenced by the triptych's intended desti-

nation; it is believed to have been painted for the Church of St. Basil.[85] Over the door of this church was an old Gothic bas-relief of the Baptism [86] which might have suggested the subject for the painting. Nevertheless, the triptych was placed in the north chapel of the church, which was dedicated to St. Lawrence and built in 1503 for the Clerks of the Court.[87] St. Lawrence appears nowhere in the triptych. The Church of St. Basil is actually the crypt or lower chapel of the Church of the Holy Blood, one of the most important churches in Bruges for the veneration of the Eucharist. It housed as its major relic a few drops of the blood of the Savior, brought from the Holy Land at the end of the Second Crusade in 1149 by Theodoric of Alsace, count of Flanders.[88] The grapes in the hand of the Christ Child on the exterior may have been used because of this famous relic and the dedication of the upper church.

The triptych was probably ordered sometime around 1503, near the time of the death of Jean des Trompes's first wife.[89] This dating is based on the supposition that it was not commissioned until the construction of the chapel of St. Lawrence had at least begun. It may, however, have been ordered before Elisabeth's death in 1502.[90] Since Madeleine Cordier, Jean's second wife, died in 1510, the triptych must have been finished by then. In fact it must have been finished even earlier, perhaps about 1508,[91] for Madeleine had three children and only one is represented in the painting. The triptych was not put into place until 1520. At that time the heirs of Jean des Trompes gave it to the Brotherhood of the Clerks, who owned the chapel, and they placed it upon the altar for which it was intended.[92]

In its total iconography the triptych demonstrates a loss of both internal coherence and specific connection with its intended context. In the widest interpretation of the subject and the situation, the Baptism repeats a scene found on the doorway of the crypt, and the grapes reflect the dedication of the upper church. There is no reference to Lawrence, the dedicatory saint of the chapel, or to Basil, the dedicatory saint of the crypt. The triptych itself combines two totally different devotional scenes. Even if both are tangentially related to their setting, they are related to each other only by the marriage of the donor.

It appears that both donor and artist are now satisfied to go their separate ways, meeting only to effect what is largely a business transaction. The donor may have chosen the scene from a limited number of subjects suggested to him by the artist, but the inventive potential of the art of painting now belongs to the painter. Since the subject matter is, for the most part, established, the means of representing it become all-important. The donor is reduced to selecting the artist and paying the price. He is not projected as an active element within the structure of the painting, as he was during the early decades, but he has returned to his medieval role of passive adorer. The only difference is that he is now a part of the same man-made perspective system as are God and the saints. The importance of the location has also diminished. If the dedication of church or chapel has little effect on the iconography of the altarpiece, then the painting has become, in essence if not yet in fact, an autonomous work. The artist is the dominant, controlling

force. His voice has risen above and finally silenced the chorus of religious tradition and individual patronage. In the North the way is now open for the modern artist, whose work, despite its subject, is characterized first and foremost by its individual style.

In David's "Baptism" the presentation of the donor is the most overt example of a secular figure directly sharing the sacred ground of Christ. In no other triptych have we encountered such a presumption, such a loss of hieratic respectability. We would have to turn back to paintings like the "Rolin Madonna" by Jan van Eyck or Rogier's Bladelin triptych or Vienna "Crucifixion" in order to find a similar placement of the donor. But in these earlier works the donor's audacity is qualified, or one might say thoroughly overcome, by the attendant religious symbolism present throughout the scenes. In the Jean des Trompes triptych the sacred manners of the donor have changed. The barrenness of sacred content and the visual plausibility of the whole scene both add to the verisimilitude, which begins to supersede the religious content. The loss of religious intensity, like the loss of religious rationality, inherent in the exterior and interior wings of triptychs up to this time, represents a qualitative difference. Although we recognize the format and the style, the overall explanation—the iconology—is of a different era. The sixteenth century, with all its archaisms, conflicting subjects and styles, and confusion of traditional religious iconography, is clearly before us.

The dissolution of the relationship between artist and donor is paralleled by the increasing obsolescence of the triptych form. It too, like David's style, is the remnant of an earlier period whose meaning has been lost to a new generation. The exterior and interior of David's triptych do not provide a formal explanation for their iconography but only add to our confusion. Both might just as well have been separate paintings. Although David used earlier stylistic forms and continued to portray the donor, his triptych exemplifies the disintegration of the very tradition from which he borrowed. He attacked it from within and destroyed it with its own weapons. In the North, as in the South, when the interest of the painter turned to the art of depicting a rationalized unit of space, the triptych form with its architectural divisions and its many fields for representation became inconvenient. Instead of aiding the artist as it had at the beginning of the century, it became a hindrance. By the end of the century, the triptych form remained, but its symbolic structure was largely ignored.

Notes

1. The Emergence of the Triptych

[1] A few of the major examples are Max J. Friedländer, *Die altniederländische Malerei* (14 vols.; Berlin, 1924–1933; Leiden, 1935–1937); Fierens-Gevaert, *La Peinture en Belgique: les primitifs-flamands* (4 vols.; Brussels, 1908–1912); Fierens-Gevaert, *Histoire de la peinture flamande des origines à la fin du XVᵉ siècle* (3 vols.; Paris and Brussels, 1927–1929); Wolfgang Schöne, *Die grossen Meister der niederländische Malerei des 15. Jahrhunderts* (Leipzig, 1939).

[2] Erwin Panofsky, *Early Netherlandish Painting* (2 vols.; Cambridge, Mass., 1953).

[3] The Ghent altarpiece was commissioned by the burgomaster Jodocus Vyd for the Church of St. Bavon (then St. John the Baptist) in Ghent. The "Rolin Madonna" was commissioned by Nicolas Rolin, who was chancellor to Philip the Good but was not of noble birth, for the Cathedral of Autun. The Dresden altarpiece was ordered by an Italian gentleman, Michele Guistiniani. Rogier's "Descent from the Cross," now in the Prado, was ordered by the Archers' Guild of Louvain. Each of the other works menioned is treated in an individual chapter.

[4] For a discussion of this painting, see Panofsky, *op. cit.*, I, 139, 192–193.

[5] It would be grossly unfair not to mention that Erwin Panofsky, Jules and Joseph Destrée, and Fierens-Gevaert, to name only a few, have provided much of the documented, extra-artistic history of many Netherlandish paintings. Usually, however, this information is given as introductory, factual material, tied only loosely to the iconography. It has not often been thoroughly investigated and interwoven into the whole text.

[6] For the evolution of the diptych and some major examples of the form, see Panofsky, *op. cit.*, I, 294 ff. For a more recent and complete discussion see Sixten Ringbom, *Icon to Narrative* (Abo, 1965), chap. 1.

[7] The exterior of triptychs has not always been painted and many have been defaced or sawed apart. All the triptychs discussed here, however, with only one exception, either were painted on the exterior or had a recorded, though never executed, subject.

[8] "The Last Judgment" altarpiece by Rogier van der Weyden and the "Greverade Passion" altarpiece by Hans Memlinc have multiple wings.

[9] For a discussion of this problem, see Karl M. Birkmeyer, "The Arch Motif in Netherlandish Painting of the Fifteenth Century," *Art Bulletin*, XLIII (March, 1961), 12 ff.

[10] *Ibid.*

[11] John White, *The Birth and Rebirth of Pictorial Space* (London, 1957), p. 104.

[12] See pp. 92–93, 106, 112.

[13] For examples of the triptych form characteristic of the thirteenth and early fourteenth centuries in Italy, see Edward B. Garrison, *Italian Romanesque Panel Painting* (Florence, 1949), Nos. 325–332, 345–351, 355. The Sienese and Florentines of the fourteenth century took up the form and the iconographic schemes developed in the thirteenth century in Italy. The interior wings were usually divided laterally into two or three compartments each. The top scene was often the Annunciation, the angel appearing on the top of the left wing, the Virgin on the top of the right wing. Sometimes the Annunciation is found in the spandrels above the center scene, if the center panel is rectangular. The lower zones represent saints or Christological scenes of the Infancy or the Passion. The center panel contains the larger, more hieratic image. Very often it depicts the Madonna Enthroned. These scenes usually occur against a gold background, which is frequently elaborated upon by the addition of actual wooden gold-relief niches to separate the scenes and to isolate and intensify the central image. If saints appear on the wings, they do not look directly toward the center panel, although they may turn slightly toward it. If there are narrative scenes, their action does not point toward the center. This fourteenth-century scheme is continued by such men as Sasseta and Giovanni di Paolo in the fifteenth century. (Many examples of these fifteenth-century triptychs may be found in the Municipal Museum of Siena. See those of Giovanni di Paolo and others listed in Enzo Carli, *Guide to the Pinacoteca of Siena* [Milan, 1958].) A simplification takes place and the representations are more naturalistic, but basically the iconography remains constant. The most sacred image is in the center; the wings are only a complement. The complexities of the relationship between the interior and the exterior and the development of the iconography of the wing panels which are found in Netherlandish painting do not seem to exist in Italy. The subtle variations within a wing panel which keep it subordinate but also intimately related visually and iconographically to the center panel do not constitute a problem that interested Southern painters in the fifteenth century. They generally employed the form within the tradition established in the thirteenth century. Instead of revitalizing and expanding the triptych form, the stylistic innovators of the South ignored or rejected it.

[14] Leon Battista Alberti, *On Painting*, trans. John Spencer (New Haven, 1956), p. 89.

[15] White, *op. cit.*, p. 110.

[16] Alberti, *op. cit.*, p. 43.

[17] It is now generally agreed that Filippo Brunelleschi first developed true, artificial focal-point perspective between 1415 and 1420 in Italy. See Erwin Panofsky, "Die Perspektive als 'symbolische Form,'" *Vorträge der Bibliothek Warburg* (1924–25), pp. 258–330. See also Richard Krautheimer and T. Krautheimer-Hess, *Lorenzo Ghiberti* (Princeton, 1956), pp. 234 ff.; and Erwin Panofsky, *Renaissance and Renascences in Western Art* (Uppsala, 1960), I, 123–127. After perspective was discovered in the South, it was used consistently by painters and sculptors throughout the century. In the North,

focal-point perspective was used, particularly by Petrus Christus, after 1450. It formed the basis for paintings that were created toward the middle and the end of the Renaissance in the North, rather than those that originated the style at the beginning of the century. For the development of perspective by Petrus Christus, see Panofsky, *Early Netherlandish Painting*, I, 310 ff.

[18] For the derivation of the term *ars nova* and its meaning in relation to Netherlandish painting, see Panofsky, *Early Netherlandish Painting*, I, 150–151. For a discussion of Melchior Broederlam as the most important panel painter before Van Eyck and the first to introduce disguised symbolism into his painting, see *ibid.*, I, 131–132. The one work that serves as the basis for our knowledge of the style of Broederlam is the Dijon altarpiece (illus. *ibid.*, II, pls. 50, 51). Broederlam painted the wings of this *Schnitzaltar* for the Chartreuse of Champmol between 1394 and 1399. Jacques de Baerze sculpted the interior.

[19] The locations and illustrations of the works cited are as follows:

Robert Campin: Mérode altarpiece, New York, Metropolitan Museum Cloisters (II); Seilern triptych, London, Count Seilern Collection (1); Copy of the "Descent" triptych, Liverpool, Walker Art Gallery (5); "Trinity," "Madonna and Child," and "St. Veronica," Frankfurt, Städelsches Kunstinstitut (Panofsky, *Early Netherlandish Painting*, II, pl. 93).

Jan van Eyck: Ghent altarpiece, Ghent, St. Bavon's (10, 11); "Madonna Enthroned," Dresden, Gemäldegalerie (7); Nicolas van Maelbeke triptych, Boston, Museum of Fine Arts (Panofsky, *Early Netherlandish Painting*, II, pl. 130).

Rogier van der Weyden: Vienna "Crucifixion" triptych, Vienna Kunsthistoriches Museum (15); "Columba" altarpiece, Munich, Alte Pinakothek (14); Jean Braque altarpiece, Paris, Louvre (IV); Bladelin altarpiece, Berlin, Dahlem Museum (13).

Followers of Rogier van der Weyden: Edelheer triptych of the "Descent," Louvain, St. Peter's (43, 44); Sforza triptych, Brussels, Musées Royaux des Beaux-Arts; Abegg altarpiece, Switzerland, Zug, Abegg Collection (Panofsky, *Early Netherlandish Painting*, II, pl. 247); "Virgin and Child," Brussels, Musée Assistance Publique (cited as one example of the type).

[20] The "Annunciation," "Nativity," and "Last Judgment" panels are located in the Dahlem Museum in Berlin (illus. Panofsky, *Early Netherlandish Painting*, II, pl. 256). The "Last Judgment" wing is a free copy of Jan van Eyck's "Last Judgment" in the Metropolitan Museum in New York. Panofsky (*ibid.*, I, 309 n. 1) assumes that the Christus panels were originally wings of a triptych. On the other hand, he assumes the Van Eyck panels to have been simply a diptych (*ibid.*, I, 237–240). Two panels attributed to Christus are in the Kress Collection at the Washington National Gallery; one represents a kneeling male donor, the other a kneeling female donor. If the attribution is correct, these would certainly have been two wing panels of a triptych.

[21] Charles de Tolnay, "Flemish Paintings in the National Gallery of Art," *Magazine of Art*, XXXIV (1941), 181.

[22] For a catalogue of the only authenticated early Netherlandish paintings see Jacque-

line Folie, "Les Oeuvres authentifiées des primitifs flamands," *Bulletin de l'Institut royal du patrimoine artistique*, VI (1963), 183–256. In the course of my work on this book, I compiled a corpus of fifteenth-century Netherlandish triptychs, based primarily on the information kindly made available to me at the Centre National de Recherches Primitifs Flamands in Brussels. I recorded 127 complete, extant triptychs. Of this number I could be certain of the location and donation of only twelve, eleven of which are treated at length in this study. I omitted a detailed discussion of the Ghent altarpiece because of the complexities of hand and location; it has not yet been ascertained whether the altarpiece was originally located in the upper or lower church in St. Bavon's (see pp. 15–16, above). Moreover, Professor Lotte Phillips has in preparation an eagerly awaited article that may solve many of these problems.

It is surely possible that I have not found some of the records that may identify the locations of more than these twelve triptychs. I have not included such works as Rogier van der Weyden's "Columba" altarpiece, because the record of its location in the Church of St. Columba in Cologne dates from 1495. We do not yet know if it was placed there directly after it was painted about 1460. Also the Jan Floreins triptych by Memlinc, which was placed in the chapel of St. John's hospital in Bruges, has been omitted because we do not know precisely where it was placed within the chapel, and it does not add substantially to our information concerning Memlinc's work within the triptych format (see chap. 9, n. 10). I have included only painted triptychs, not *Schnitzaltäre*, which bring up further problems of differences in hand and media. Hence the Broederlam altarpiece and the altarpiece for the Church of St. Vaast in Arras, painted by Jacques Daret, have been omitted.

[23] Of the remaining original triptychs by Campin, we know neither the name of the donor nor the location of the "Entombment" altarpiece in the Seilern Collection in London. The Mérode altarpiece in the Metropolitan Museum Cloisters in New York was done for Inglebrechts of Malines, probably for domestic use. Information about the latter, however, is neither certain nor specific. The destination of the Dresden "Madonna in a Church" by Jan van Eyck is not known. The altarpiece he painted for Nicolas van Maelbeke, at present in the Boston Museum of Fine Arts under custody of the United States government, was left unfinished at Van Eyck's death in 1441. Only when Maelbeke died in 1445 was it placed on his tomb in the Virgin's chapel of St. Martin's Church in Ypres.

[24] Although sometimes thought to be a diptych (Fierens-Gevaert, *Histoire de la peinture flamande*, II, 10), Panofsky (*Early Netherlandish Painting*, I, 161) suspects it was the wing of a triptych.

[25] Panofsky (*Early Netherlandish Painting*, I, 169) assumes that these panels were all wings of a triptych. Since the "Trinity" was originally on the reverse of the "St. Veronica" panel, we can at least be sure that this was a wing panel. I find it difficult, however, to accept the "Madonna and Child" panel as a wing. It would be unprecedented, so far as I know, to have a standing Virgin holding Christ on the interior wing of a triptych balanced on the opposite side by a standing saint. What could then be on the

center panel? It is more likely that the three panels formed a diptych or were part of an enormous polyptych.

[26] Rogier did much the same thing in his Uffizi "Entombment" (illus. Panofsky, *Early Netherlandish Painting*, II, pl. 193). Perhaps inspired by Campin's work, he too gave the burial scene strong overtones of the complete Passion cycle. In the background we see the Road to Calvary and the three empty crosses on Golgotha. In the foreground Christ is held up as the Man of Sorrows, but also in the position of the crucified Christ. The Crucifixion is further recalled by the presence of the Virgin to His right and John the Evangelist to His left with the Magdalen kneeling at His feet. Joseph and Nicodemus add the reference to the Deposition. The tomb lid is transformed into a stone of unction displaying Christ's feet on His shroud. For some reason, unknown to me, John the Evangelist also is permitted to stand on this holy place.

[27] I do not support J. G. Van Gelder's ("An Early Work by Robert Campin," *Oud Holland*, LXXXII, pt. 1/2 [1967], 13–14) recent identification of this figure as Mary Cleophas. Because there are elements of the whole Passion cycle present, I find nothing irregular in identifying the woman with the outstretched handkerchief as Veronica. Nor does she hold the cloth up to her weeping face as does Rogier's figure.

[28] David M. Robb ("The Iconography of the Annunciation in the Fourteenth and Fifteenth Centuries," *Art Bulletin*, XVIII [Dec., 1936], 480–526) discusses the innumerable types in which there is always reciprocal action by the Virgin, even if she only inclines her head or folds her hands in prayer.

[29] For a discussion of the architectural symbolism, see Panofsky, *Early Netherlandish Painting*, I, 133–134, 137–139.

[30] In assessing Campin's attitude toward exterior iconography, the Frankfurt "Trinity" should be considered separately. It was done about 1430 when his style underwent a significant change. His figures became more monumental, his space more logical, and his themes less complicated, whether exterior or interior.

[31] Panofsky (*Early Netherlandish Painting*, I, 161), following De Tolnay, credits Campin with the first use of simulated statues painted in grisaille for the reverse of an altarpiece. If Campin did indeed introduce this technique into panel painting, it would be further evidence of his dependence upon a sculptural tradition and his desire to invent new ways of showing many levels of meaning in one altarpiece. For the most complete discussion of grisaille, see Molly Teasdale-Smith, "The Use of Grisaille as a Lenten Observance," *Marsyas*, VIII (1959), 43–54.

[32] The presence of the Bruges coat of arms, and the representation of St. Julien on the exterior right wing of the Liverpool "Descent," have led scholars to assume that the copy must have been done for the hospital of St. Julien in Bruges (see Panofsky, *Early Netherlandish Painting*, I, 167 n. 1). On the back of the "Good Thief" fragment (the right wing), however, one can see the remains of a wall, a niche, and a baldachin. St. Julien may never have been represented. The copyist may have replaced Campin's original exterior representation with the patron saints required by the hospital.

[33] The one minor change in the scheme appears when donor and donatrix are sepa-

rated. In this instance the male stays on the preferred side and the female, with or without her daughters, is placed on the only proper panel remaining, the right wing. The major exception to this rule is the "Adoration of the Magi," attributed to Hugo van der Goes in the Lichtenstein collection. The donor is accompanied by St. Stephen on the right wing. The left-wing position, however, has been "correctly" given over to two of the adoring Magi, the first having already reached the manger in the center panel. Occasionally the donors appear in the center panel as in Rogier's Vienna "Crucifixion" or Memlinc's Sir John Donne triptych in the London National Gallery. In these instances, too, the primacy of the space to the right of the Virgin or Christ is maintained over that of the left.

[34] For illustrations of the Maelbeke altarpiece and the "Madonna of Jan Vos," see Panofsky, *Early Netherlandish Painting*, II, pls. 130, 128.

[35] For a discussion of this iconography, see *ibid.*, I, 144–148.

[36] De Tolnay discusses the same symbolism of the Virgin and Child as an *autel vivant* in Piero della Francesca's Montefeltro altarpiece (see "Conceptions religieuses dans la peinture de Piero della Francesca," *Arte Antica e Moderna*, no. 23 [July–Sept., 1963], p. 234).

[37] See Panofsky, *Early Netherlandish Painting*, I, 139. Here he also describes the symbols of salvation and purity which permeate the Virgin's half of the chamber. Among them are the capitals, the roses, and the lilies in the garden.

[38] *Ibid.*, I, 183.

[39] The major part of this short discussion of the Ghent altarpiece is based on Panofsky's extensive treatment of the painting (*Early Netherlandish Painting*, I, chap. viii). His work summarizes all the findings made up to that time and adds much original information. For further bibliographical references, see his notes for chap. viii (I, 215–246).

[40] The year is given as a chronogram in the last line of the exterior inscription. Even if the hexameter on the frame dates from the sixteenth century, it is very likely a faithful copy of the original inscription (*ibid.*, I, 206–207).

[41] *Ibid.*, I, 210 and n. 2. Panofsky (*ibid.*, I, 217) suggests that the Just Judges "are admitted to the hierarchies of the Blessed, not as an accepted category of saints but as the ideal representatives of a specific group of living dignitaries who hoped to be included with the Elect."

[42] See Alfons Dierick, *Van Eyck, the Mystic Lamb*, trans. Monique Odent (Ghent, 1958), p. 28.

[43] Panofsky, *Early Netherlandish Painting*, I, 209.

[44] A. P. De Schryver and R. H. Marijnissen, *De Oorspronkelijke plaats van het Lam Gods-retabel. Nieuwe gegevens betreffende het van Eyck-probleem* (Antwerp, 1952).

[45] See F. De Smidt, *Krypte en Koor van de voormalige Sint-Janskerk te Gent* (Ghent, 1959), pp. 82, 111.

[46] De Schryver and Marijnissen, *op. cit.*, p. 12 and n. 37. Although Vyd may also have acquired at this time the crypt chapel in which Hubert van Eyck supposedly was buried, it was not his major contribution to the church.

[47] Dr. De Schryver and I first discussed this problem in Ghent in 1960. Since then he has kindly written me confirming his doubt that the painting was originally in the lower chapel.

[48] "Item inde eerste cappelle, naest den trappen, daer de tafele van Adam ende Eva staet" (F. De Potter, *Second cartulaire de Gand* [Ghent, 1886], p. 376).

[49] Reflected in the brooch of one of the singing angels in the left wing is a long lancet window. If Van Eyck was recording an actual reflection, as he often did, this might be one of the lancet windows of the upper chapel.

2. The Bladelin Altarpiece

[1] There is, of course, the tiny Nativity represented as a sculptured group in the archivolt of the left panel of the "Miraflores" altarpiece.

[2] In the Arras altarpiece commissioned in 1434 (illus. Erwin Panofsky, *Early Nether-landish Painting* [2 vols.; Cambridge, Mass., 1953], II, pl. 108).

[3] In the "Nativity" in the Washington National Gallery and the "Nativity" in the Wildenstein Collection in New York (illus. *ibid.*, II, pls. 256, 257).

[4] In the Infancy panels in the Prado Museum dated *ca.* 1445–1450 (illus. *ibid.*, II, pls. 260, 261).

[5] For two examples by Memlinc, see the Jan Floreins triptych of the "Adoration of the Magi" in the hospital of St. John in Bruges and another triptych with the same theme in the Prado Museum in Madrid.

[6] Panofsky, *op. cit.*, I, 261.

[7] *Ibid.*

[8] See Panofsky, *op. cit.*, I, 278: ". . . so far as I know [the Bladelin hut is] the only prominent 'oblique view' in Flemish panel painting between the *Friedsam Annunciation* and Gerard David's *Justice of Cambyses*."

[9] Previously Rogier's use of symbolism was more obvious, occurring often as part of a sculptural decoration; thus it was set apart both by its sculptural form and by the use of grisaille. Another type of Rogierian symbolism which again is not truly disguised symbolism in the manner of Van Eyck is found in such works as the Vienna "Crucifixion" and the Braque altarpiece. For a discussion of this type, see pp. 31–32.

[10] Jacobus de Voragine, *The Golden Legend*, trans. William Caxton (1483) (7 vols.; London, 1900), I, 27.

[11] *Speculum Humanae Salvationis*, trans. Jean Miélot (1448), ed. J. Lutz and P. Per-drizet (Mulhouse, 1907–1909), I, pt. 2, chap. viii, p. 128.

[12] Charles Huelsen, "The Legend of Aracoeli," *British and American Archaeological Society of Rome Journal*, IV (Feb. 14, 1907), 40.

[13] Panofsky, *op. cit.*, I, 278. Emile Mâle (*L'Art religieux de la fin du moyen âge en France* [Paris, 1931], p. 255 n. 5) believes that the source for these three men comes

from the mystery plays then current. He cites two, played in Rouen, in which Augustus was "accompanied by his faithful seneschal, provost, and high constable." Also in this play Augustus takes up the censer at the moment the Virgin appears in the heavens.

[14] "Ce mesme jour que Dieu fu ne en Judee, sa nativite fu annunchie en Orient a trois puissans roys, qui veirent lors une nouvelle estoille, (en) laquele leur apparoit ung petit enfant, sur la chief duquel resplendissoit une croix d'or" (*Speculum Humanae Salvationis*, I, pt. 2, chap. ix, p. 128).

[15] The same motif appears on the rather free copy of this altarpiece in the Cloisters in New York. The scene is identified in the catalogue by James Rorimer, *The Metropolitan Museum of Art, the Cloisters Catalogue* (New York, 1951), pp. 101–102. The source for the identification comes from *The Golden Legend* (I, 44–45), which records that the Magi every year ascended a mountain "which was called Victorial, and three days they abode there, and washed them clean, and prayed our Lord that he would show to them the star that Balaam had said and prophesied before."

[16] For example, see Petrus Christus' "Nativity" in the Wildenstein Collection in New York, his Nativity in the Berlin diptych, or the Portinari altarpiece by Hugo van der Goes.

[17] "Jhesu Crist ne moustra mie seulement sa nativite aux Juifz, mais aussi ne le refusa il point manifester aux payens. Il ne venoit pas seulement en ce monde pour les Juifz, ains il entendoit de sauver toutes gens" (*Speculum Humanae Salvationis*, I, pt. 2, chap. viii, p. 128). The *Speculum* identifies the pagans with Augustus in the West. On the other hand, the pseudo-Bonaventure equates the pagans with the Magi of the East: "On the thirteenth day the boy Jesus manifested Himself to the gentiles, that is, to the Magi, who were pagan." He juxtaposes this Annunciation with the Annunciation to the Jews as personified by the shepherds (Bonaventure, *pseud.*, *Meditations on the Life of Christ: An Illustrated Manuscript of the Fourteenth Century*, trans. Isa Ragusa, ed. Rosalie B. Green and Isa Ragusa [Princeton, 1961], pp. 45–47). Both sources insist on the theme of universal salvation whether opposing East and West or pagan (Gentile) and Jew.

[18] Panofsky, *op. cit.*, I, 278.

[19] *Ibid.*, I, 135 ff.

[20] The motif of the hut appears twice in the Infancy panels. It appears in both the Nativity and the Adoration of the Magi. Bouts adds to the wooden hut of Campin a Romanesque wall in ruins, thereby identifying the setting with the crumbling of the Old Dispensation at the time of the birth of the New. When Christus used the hut in the "Nativity" in the Washington National Gallery, he, too, added the Romanesque ruin.

[21] Panofsky, *op. cit.*, I, 277 and n. 3; Bonaventure, *pseud.*, *Meditations*, p. 32.

[22] *Speculum Humanae Salvationis*, I, pt. 2, chap. ix, p. 129.

[23] "Ces trois robustes alerent en Bethleem, pour avoir de l'eaue de la cisterne, et les trois roys vindrent en Bethleem, pour avoir de l'eaue de la grace eternele. Les trois robustes tirerent de la cisterne terrienne, et les trois roys recurent l'eaue de grace du bouteillier du ciel. Celle cisterne de Bethleem figuroit doncques que le bouteillier du ciel

devoit naistre en Bethleem, lequel administreroit eaue de grace a tout homme qui auroit soif, et puis donneroit pour neant eaue a ceulx qui n'auroient de quoy. Le roy David offroit a Dieu l'eaue qu'on lui apporte, pour lui rendre graces . . ." (*ibid.*).

[24] The subject of this fragment and its tentative attribution to Rogier are discussed by Panofsky, *op. cit.*, I, 278 and n. 2.

[25] *Ibid.*

[26] It is strange that this Old Testament prefiguration has not been cited before, since the motif is so prominent in this triptych and is found in many Northern paintings done after the Bladelin altarpiece. Another part of the iconography which probably has further significance is the fact that one end of the cistern, that nearest Joseph, is covered, whereas the other end is open. When the motif is repeated, it usually appears only as a single uncovered hole. As yet I have no suggestion for what the dual aspect of the cistern means in the Bladelin triptych.

[27] Panofsky, *op. cit.*, I, 277 and n. 1, attributes the exterior to a French-trained, if not a French-born, artist, whose style is reminiscent of the "Annunciation" in Ste. Madeleine at Aix-en-Provence.

[28] *The Revelations of St. Bridget* (cited in *ibid.*, I, 277 and n. 3) gives the additional Flagellation reference to the column, whereas the pseudo-Bonaventure cites only the reference to the birth of Christ.

[29] "Car par elle [the Nativity] l'homme est delivre de la captivite du diable. Par elle aussi est restaure le tres buchement des mauvais angeles"; and again: "O bon Jhesu, ottroie nous telement honnourer ta glorieuse nativite, que nous ne recheons encoires une fois en la captivite du frauduleux ennemi d'enfer! . . ." (*Speculum Humanae Salvationis*, I, pt. 2, chap. viii, p. 128).

[30] Mâle (*op. cit.*, p. 236) justifies this acceptance on the basis of Rogier's having seen a manuscript in which the vision of the sibyl and Octavian is placed next to the vision of the three Magi by mistake. I do not think that it is necessary to go so far to prove that Rogier used the *Speculum* as at least one of his sources (see pp. 19–20, and Emile Mâle, "L'Art symbolique à la fin du moyen âge" II, *La Revue de l'art ancien et moderne*, XVIII [Sept., 1905], 196–197). For other pictorial prototypes of the Vision of Augustus, see *Speculum*, I, pt. 2, pp. 193–194.

[31] Friedrich Winkler, *Der Meister von Flémalle und Rogier van der Weyden* (Strassburg, 1913), pp. 159 f.

[32] Panofsky, *op. cit.*, I, 277 and n. 2.

[33] *The Golden Legend* also contains not one, but two, versions of Octavian's vision. The first is similar to that found in the *Speculum;* the second took place on the Capitoline Hill. There is no reference to the second version in this triptych.

[34] Referred to as a source in Jacobus de Voragine, *The Golden Legend*, trans. G. Ryan and H. Ripperger (2 vols.; London, New York, and Toronto, 1941), I, 47.

[35] Bonaventure, *pseud.* (*Meditations*, p. 32), refers to the Nativity as taking place in a cave, which Joseph the carpenter may have closed.

[36] The throne has now been placed upon an altar.

[37] *Golden Legend*, trans. Caxton, I, 27; *Speculum Humanae Salvationis*, I, pt. 2, chap. viii, p. 128.

[38] In this triptych there is another very pervasive iconographical motif, for which I have no explanation. It is the persistent grouping of three. There are three Magi, three adults kneeling around the Child, three angels with them, three angels on the roof, three attendants with Octavian, and three scenes altogether. One thinks automatically of the veneration of the Trinity, but the reason for its inclusion is unclear.

[39] For a discussion of the use of this architectural framing device in the "Miraflores" altarpiece, see Karl M. Birkmeyer, "The Arch Motif in Netherlandish Painting of the Fifteenth Century," *Art Bulletin*, XLIII (March, 1961), 13–14.

[40] Birkmeyer discusses fully this greater rationalization of the pictorial space in the St. John altarpiece (*ibid.*, pp. 16–20).

[41] Bladelin wears a garment that became popular during the reign of Philip the Good (see M. Beaulieu and J. Baylé, *Le Costume en Bourgogne de Philippe le Hardi à la mort de Charles le Téméraire (1364–1477)* [Paris, 1956], p. 26).

[42] Antonius Sanderus, *Flandria Illustrata* (3 vols.; Cologne, 1641–1644), I, 301.

[43] For a discussion of the successive periods of destruction in Middelburg, see Karel Verschelde, *Geschiedenis van Middelburg in Vlaenderen* (Bruges, 1867), pp. 75, 100–103.

[44] I obtained this information in a conversation with Dr. Pauwels in Brussels in 1959; he confirmed it some years later in a letter. He was kind enough to discuss with me one of his many projects, that of the authenticity of Sanderus' drawing of the Bladelin chateau and his firm belief that the chateau is not that of Middelburg in Flanders. As yet, none of his findings have been published.

[45] See n. 48, below.

[46] For a full discussion of this cloak and dagger affair, see Alfred Michiels, "Rogier van der Weyden, sa biographie," *Gazette des beaux-arts*, XXI (June–Aug., 1866), 220 f.

[47] For a biography of Sanderus and a complete listing of his works, see V. Fris, "Antoine Sanderus," *Biographie nationale de Belgique* (Brussels, 1911–1913), XXI, 317–367. The chateau and the city in the background of the painting do not correspond to the fifteenth-century plan of the city of Middelburg, nor does the consistently Romanesque style of the architecture seem likely in a building begun in 1448, as Panofsky (*op. cit.*, I, 277) pointed out. Thus far it has been very difficult to establish the exact identity of most buildings and cities in paintings of the earlier Netherlandish masters, such as Campin, Van Eyck, and Weyden. Though they undoubtedly used their own landscape as a model, they rarely transcribed the familiar geography literally. Rogier's pictorialization of the chateau may follow this tendency. Only two facts are actually known: in the middle of the seventeenth century this was thought to be Bladelin's chateau by a distinguished scholar, and in the middle of the nineteenth century a poor copy of Rogier's painting was found in Middelburg.

[48] The sources I have used for Bladelin's life and the history of Middelburg are:

J. J. De Smet, "Le Chevalier Bladelin surnommé Leestemakere et la ville de Middelbourg, en Flandre," *Académie royale de Belgique, extrait des bulletins*, 2^ième^ sér., XXII, no. 11 (1866), 1–11; J. J. De Smet, "Pierre Bladelin," *Biographie nationale de Belgique*, II, 445–447; Verschelde, *op. cit.*; Michiels, *op. cit.*; and Ernest Gilliat-Smith, *The Story of Bruges* (London, 1905), pp. 316–319.

[49] See the sources cited in n. 48.

[50] Verschelde, *op. cit.*, p. 29.

[51] I believe that the first evidence comes from Sanderus, *op. cit.*, I, 301: "Iacet *Bladelinus* ante aram maximam egregio ante turbas monumento conditus, vidua *Margareta de Vagevier* vsufructum in parte, *Joanni de Baenst* Eg. D. S. Georgii & *Judoco de Worssemaer* haereditatem adeuntibus sed modico tempore." Bladelin's tomb is now certainly in a niche to the left of the main altar and appears to have always been there. (Karel [Charles] Verschelde ["Testament de Pierre Bladelin Fondateur de Middelbourg en Flandre," *Annales de la Société d'émulation pour l'étude de l'histoire et des antiquités de la Flandre, Bruges*, 4^e^ sér., III (1879), 11 n. 1] records that Bladelin was buried in a niche in the north choir area.) Nevertheless, there could have been a funerary monument separate from the tomb. J. J. De Smet in the *Biographie nationale de Belgique* suggests this possibility.

[52] In 1865 the tomb was opened and examined. There seemed to have been room for only one coffin in the tomb. Apparently both Bladelin and his wife were buried in the same container, for the bones of a man and a woman were found together. No trace of the coffin was left (Verschelde, *Geschiedenis*, p. 57). Bladelin may have originally planned that his wife be buried in the Church of Notre Dame in Bruges. He founded a chantry chapel in that church dedicated to his wife's patron saint Margaret (W. H. James Weale, *Bruges et ses environs* [Bruges, 1884], p. 116).

[53] For a copy of the complete testament, see Verschelde, "Testament de Pierre Bladelin," pp. 9–32.

[54] Panofsky (*op. cit.*, I, 277) dates the triptych about 1452. Georges Hulin de Loo ("Roger van der Weyden," *Biographie nationale de Belgique*, XXVII, 237) states that according to the costumes it could not be much later than 1448. It was already imitated by Herlin in 1462 after his return to Nördlingen.

[55] Verschelde, *Geschiedenis*, p. 150. He also records that by 1472 there were already three more altars dedicated to the Holy Spirit, to St. Anthony, and to St. Matthew. In 1480 an altar dedicated to the Holy Trinity was added. See Verschelde, "Testament de Pierre Bladelin," p. 15 n. 1.

[56] In the seventeenth century Peter de Brune executed several paintings for the Chapel of the Holy Cross in the Church of Notre Dame in Bruges. These paintings, which can still be seen in the chapel, tell the legend of a reliquary of the Holy Cross. Bladelin and his wife and the Church of SS. Peter and Paul are represented in the story.

[57] Verschelde, *Geschiedenis*, pp. 150 f. In his testament (pp. 18 f.) Bladelin lists as one of his gifts a chain with a shield to be given to the head of the Guild of St. Sebastian. He also gave the poor guild brothers a room in the hospital of Hyle, a nearby town. The

first person to be buried in the church was an archer of Philip the Good, Robert de la Mota, who died May 7, 1460. Bladelin's name appeared on the book of St. Sebastian in Bruges.

[58] Verschelde, "Testament de Pierre Bladelin," p. 11.

[59] Verschelde, *Geschiedenis*, p. 150.

[60] Michiels (*op. cit.*, p. 222) suggests that it was for the main altar. In 1630 when the church was being restored, Jan Ricx made a Nativity for the main altar (Verschelde, *Geschiedenis*, pp. 156–157).

[61] The *Biographie nationale* (XXVII, 237) states that it came from the altar dedicated to the Virgin. As far as we know, the original painting remained in the church until 1580 (Verschelde, *Geschiedenis*, p. 155).

[62] This can be seen in Bruges at the Hôtel Bladelin, 19 rue des Aiguilles.

[63] One other possible interpretation should be mentioned: that the altarpiece may also reflect Bladelin's longing for an heir. Since he was still a young man and childless, the repeated references to Christ as a Child may also contain the hope that his prayers to the Virgin might yet bring him a child.

[64] I am using the term "funerary painting" throughout this study to refer only to those works that were commissioned for placement upon the main altar in a chapel in which the donors were to be buried. I believe this proximity to the tomb, along with the intentional coordination of altar, chapel, and burial place on the part of the donor, allows us to differentiate between such paintings and more general, intercessional works.

[65] Quoted in Gilliat-Smith, *op. cit.*, p. 317.

[66] Max J. Friedländer (*Die altniederländische Malerei* [14 vols.; Berlin, 1924–1933; Leiden, 1935–1937], II, 103 no. 38*a*, *b*) mentions two copies, both of which replaced Bladelin with a shepherd. In the Cloisters altarpiece mentioned in n. 15 above, Bladelin has also been omitted (24).

[67] Rogier did use Bladelin's chateau in another triptych whose original destination is still uncertain. It appears in the background of the center panel of the Adoration of the Magi in the "Columba" altarpiece in the Alte Pinakothek in Munich (14). In many ways this altarpiece was inspired by the Bladelin triptych, not only as the other major descriptive Nativity theme in Rogier's work (see pp. 17–18) but also in terms of its subject. As Panofsky notes (*op. cit.*, I, 287), its theme is a restatement of the idea of the Bladelin altarpiece: "Christianity's eternal hope for the ultimate conversion of the whole world, including the Jews."

3. The Jean Braque Altarpiece

[1] The altarpiece remained in the family until 1586, when it was sold in Ghent with the consent of all the heirs. It did not appear again until 1845, when it was found in the

home of a painter named Evans, living in London. He sold it to the Duke of Westminster, whose daughter, Lady Theodore Guest, in turn sold it to the Louvre in 1913, where it may now be seen (see Edouard Michel, *L'Ecole flamande du XVᵉ siècle au Musée du Louvre* [Brussels, 1944], p. 43).

[2] For a complete discussion of the Braque and Brabant families, see Paul Leprieur, "Un Triptyque de Roger de la Pasture au Musée du Louvre," *Gazette des beaux-arts*, pér. 4, X (Oct., 1913), 276–280. See also Jules Destrée, *Roger de la Pasture—van der Weyden* (2 vols.; Paris and Brussels, 1930), I, 156–160. Both men base much of their evidence on the work of Adolphe Hocquet, conservator of the archives and library of Tournai, whose investigations were published in *La Revue tournaisienne*, no. 7 (July, 1913), pp. 157–159. He was the first to identify the coat of arms and thus discovered for whom the triptych was painted.

[3] On April 15, 1451, Catherine acquired some stock in the city of Tournai. At that time she was listed as the wife of Jean Braque. Other documents in the archives of Tournai indicate that she was not married prior to 1450 (Destrée, *op. cit.*, I, 160).

[4] Leprieur, *op. cit.*, p. 280.

[5] Erwin Panofsky, *Early Netherlandish Painting* (2 vols.; Cambridge, Mass., 1953), I, 275.

[6] Georges Hulin de Loo ("Roger van der Weyden," *Biographie nationale de Belgique* [Brussels, 1911–1913], XXVII, 236) thinks that the two heads of Christ were based on the same drawing.

[7] Leprieur, *op. cit.*, pp. 275–276, 280.

[8] *Ibid.*, p. 274. Catherine remarried sometime after 1461.

[9] *Ibid.*, pp. 274–275: "Item, je donne à maistre Jehan Villain un tableau à cinq ymaiges avec las custode." This testament does not identify the painter as Rogier; however, an inscription appears on the interior of the triptych on the headdress of the Magdalen. Ferdinand de Mély ("Signatures de primitifs: le retable de Roger de la Pasture au Musée du Louvre et l'inscription du turban de la Madeleine," *Revue archéologique*, sér. 5, VII [1918], 68 ff.) calls it a Kufic inscription that identifies the painting as being done by Rogier, who signs himself as "Wijden." Destrée (*op. cit.*, I, 160) remains skeptical of the evidence. There is, however, almost universal agreement, based on stylistic evidence, that the painting is Rogier's. For a recent argument to the contrary see Mojmír Frinta, *The Genius of Robert Campin* (The Hague and Paris, 1966), pp. 103–109.

[10] "Mires vous ci orgueilleux et avers / Mon corps fu beaux ore est viande a (vers)."

[11] "O mors qva*m* amara est memoria tva homi / inivsto [*certe per* homini ivsto] et pacem habente [*sic*] in svbsta*n*ciis svis viro qvieto et cvi*vs* die [*per* vie] directe svnt in om*n*ibvs et adhvc valenti accipere cibv*m*, eccl*ᶜⁱ* xlj°."

[12] Leprieur (*op. cit.*, p. 264 n. 1) suggests another possibility: "Peut-être ne serait-il pas impossible d'imaginer, conformément à l'ingéniosité subtile du Moyen âge, quelque intention d'armes parlantes dans les représentations des volets. Le mot flamand Braek (rupture, bris) n'est pas sans rappeler le brique mutilée, en même temps que le nom du

possesseur, et la forme même de la croix se rapproche de la croix ancrée des armes de Brabant." If the left wing presents a symbolic portrait, as I suggest above, Leprieur's idea might be added to the interpretation.

[13] Illus. Panofsky, *op. cit.*, II, pls. 210, 211. In the condensation of the Crucifixion scene into three parts—rock, skull, and cross represented in grisaille and spread across two panels—we are reminded not only of the Philadelphia diptych but also of the exterior of the Edelheer altarpiece (cf. pp. 17, 54 ff.).

[14] *Ibid.*, I, 294 n. 15. This particular arrangement and the positions of the figures on the interior of a triptych are quite unusual for the period. Later decades produced many triptychs with half-length Madonnas occupying the center panel and with the donors, sometimes half-length, sometimes full-length, located on the wings. But during the first half of the fifteenth century the figures on the interior of triptychs were usually shown full-length, clearly related to an illusionistic setting of some sort. The arrangement here is much closer to Rogier's diptych arrangement in which the Madonna and Child in half-length are found on one wing, and the donor, also *en buste*, is found on the other wing.

[15] Millard Meiss, " 'Highlands in the Lowlands': Jan van Eyck, the Master of Flémalle, and the Franco-Italian Tradition," *Gazette des beaux-arts*, pér. 6, LVII (May–June, 1961), 273–314 *passim*. For specific reference to the Braque altarpiece, see p. 314 n. 76.

[16] Illus. *ibid.*, p. 282.

[17] *Ibid.*, p. 307.

[18] In the "Seven Sacraments" altarpiece in the Musée royal in Antwerp (illus. Panofsky, *op. cit.*, II, 207), Rogier places the body of the crucified Christ in the clerestory, far above the worldly figures. No human figure transgresses His divine realm. He is surrounded only by light.

[19] In the Vienna "Crucifixion" triptych in the Kunsthistorisches Museum the figures of Christ and the angels are all set against the sky *above* the horizon line, whereas the other figures are on the ground, their heads all *below* the horizon line. Here the differentiation is made without the use of a plateau. I call this illusionistic symbolism, because, unlike disguised symbolism, it involves a subtle rearrangement of the actual illusionistic space in relation to the positions of the divine figures. It is not dependent upon a series of objects being added to or set into an already existing framework, as is disguised symbolism.

[20] For a discussion of the Eastern iconography of the Deesis and some examples, see Ernst Kantorowicz, "Ivories and Litanies," *Journal of the Warburg and Courtauld Institutes*, V (1942), 56–81.

[21] Louis Réau, *Iconographie de l'art chrétien* (6 vols.; Paris, 1955), II, pt. 2, p. 732. In many of the Winchester School manuscripts, St. Peter replaces St. John for similar reasons (Kantorowicz, *op. cit.*, p. 78).

[22] Emile Mâle, *The Gothic Image: Religious Art in France of the 13th Century*, trans.

D. Nussey (New York, 1958), p. 371 n. 2. The substitution is also frequent in French ivories of the time. See also Alexandre Masseron, *Saint Jean Baptiste dans l'art* (Paris, 1957), pp. 158–159.

[23] "Ego sum panis vivus qui de coelo descendi."

[24] Christ's words are occasioned by the miraculous feeding of the five thousand. "Here the idea of the Logos as the absolute principle of life is unfolded in the Messianic agency of Jesus. All spiritual life is nourished and maintained by Him. He is the bread of life, the heavenly manna that came down from heaven to give life to man. As bread must be eaten to support physical life, so the incarnate Word must be received into the spirit and coalesce with it in substantial unity" (Samuel Davidson, *An Introduction to the Study of the New Testament* [2 vols.; London, 1868], II, 330).

[25] "Et verbum caro factum est et habitavit in nobis."

[26] Maurice Vloberg, *L'Eucharistie dans l'art* (Paris, 1946), p. 256.

[27] Mâle, *op. cit.*, p. 369.

[28] *Ibid.*, p. 371 n. 4.

[29] Carla Gottlieb, "The Mystical Window in Paintings of the Salvator Mundi," *Gazette des beaux-arts*, pér. 6, LVI (Dec., 1960), 315 n. 4. For a discussion of the Braque altarpiece specifically, see pp. 315–317.

[30] The symbol originated in Campin's painting of "The Savior and the Virgin," located in the Philadelphia Museum of Art. Here the mystical window is in Christ's brooch. Rogier took the motif from Campin and used it in Christ's globe in the Braque altarpiece (*ibid.*, pp. 313–315; for its later use, see pp. 318 ff.).

[31] "Ecce agnus Dei qui tollit peccata mun[di]."

[32] "Magnificat anima mea dominum et exultavit spiritus meus in Deo sal[utari meo]."

[33] "Maria ergo accepit libram unguenti nardi pistici pretiose [*per* pretiosi] et unxit pedes Ihesu."

[34] When the Magdalen anointed Christ's feet with costly oil, Judas reprimanded her for her extravagance. Christ replied in her behalf: "Let her alone: against the day of my burying hath she kept this" (John 12:7). John implies that she did not use up all the ointment, but had some left in the vessel for the day of Christ's burial. Christ's words prophesied that in the act of anointment both in the house of Mary and Martha and at the tomb she would use the ointment. According to the Old Testament, anointment was symbolic of sanctity and the infusion of the Holy Spirit. Therefore Christ was called the Messiah or the Anointed One. Mary Magdalen performed the sacred office.

[35] This is the second of five reasons given for His appearance to the Magdalen (see Jacobus de Voragine, *The Golden Legend*, trans. William Caxton [1483] [7 vols.; London, 1900], I, 93).

[36] Yrjö Hirn, *The Sacred Shrine* (Boston, 1957), p. 218.

[37] See Davidson, *op. cit.*, II, 361.

[38] *Ibid.*, pp. 343–345.

4. The Last Judgment Altarpiece

[1] The hôtel-Dieu, which is a hospital run by clergy but not attached to a larger religious establishment such as an abbey, came into prominence in France during the eleventh century at the same time that hospitals began to multiply throughout Europe. Since the hôtel-Dieu was usually initiated and underwritten by a secular person (or family), the donor was responsible for the plan, organization, and decoration of the whole enterprise. See Charles Lucas, "Hôpital," *La grande Encyclopédie* (Paris, 1886–1902), XX, 252–253; and Joan Evans, *Art in Mediaeval France, 987–1498* (London, New York, and Toronto, 1948), pp. 244 ff.

[2] For the history of the hôtel-Dieu, see the following: Abbé J. B. Boudrot, *Fondation et statuts de l'Hôtel-Dieu de Beaune* (Beaune, 1878); Abbé J. B. Boudrot, "Inventaire de l'Hôtel-Dieu de Beaune en 1501," *Société d'histoire, d'archéologie, et de littérature de l'arrondissement de Beaune, Mémoires* (1874); Abbé Etienne Bavard, *L'Hôtel-Dieu de Beaune, 1443–1880* (Beaune, 1881); Joseph Carlet, *Le Jugement dernier, retable de l'Hôtel-Dieu de Beaune* (Beaune, 1884); Louis Cyrot, "Les Bâtiments du grand Hôtel-Dieu de Beaune" (Notice chronologique sur leur fondation et leurs accroissements d'après les archives de cet hôpital, 1443–1878), *Société d'histoire, d'archéologie, et de littérature de l'arrondissement de Beaune, Mémoires* (1881), pp. 1–59; Anne Leflaive, *L'Hôtel-Dieu de Beaune et les hospitalières* (Paris, 1959); Henri Stein, *L'Hôtel-Dieu de Beaune* (Paris, 1933).

[3] For the terms of the papal bull, see Stein, *op. cit.*, p. 15; Bavard, *op. cit.*, p. 5.

[4] Bavard, *loc. cit.*

[5] Abbé Gandelot, *Histoire de la ville de Beaune et de ses antiquités* (Dijon, 1772), p. 28.

[6] Philip provided all the timber necessary to build the hospital and granted a standing right to cut wood from the ducal forests to heat it. He also granted the hospital a substantial tax exemption and an annual income from the state (Leflaive, *op. cit.*, p. 14).

[7] The charter reads: ". . . en honneur du Dieu tout-puissant, et de sa très glorieuse mère Marie, toujours vierges, en veneration et en mémoire du beinheureux Antoine, abbé." The original charter is in the archives of the hôtel-Dieu in Beaune. It is quoted in Stein, *op. cit.*, pp. 7 ff., and in Leflaive, *op. cit.*, pp. 15 ff., among others.

[8] Boudrot, *Fondation et statuts*, p. 106: ". . . l'exercice complet des oeuvres de piété et de miséricorde."

[9] In fact the rich benefactors provided the principal means of support for the hospital (Bavard, *op. cit.*, pp. 33–34; Leflaive, *op. cit.*, pp. 72 ff.).

[10] Cyrot, *op. cit.*, pp. 6–9.

[11] Stein, *op. cit.*, p. 16; and *Dijon et Beaune et leurs environs* (Guides diamant ed.; Paris, 1921), p. 59. Although the patients were not received until December of 1451,

a few of the sisters may have come to the hôtel-Dieu as early as 1449 (see Cyrot, *op. cit.*, p. 11). In 1939 the sisters revised their constitution somewhat and officially assumed the name of the Hospital Sisters of St. Martha in Beaune (Leflaive, *op. cit.*, p. 167 n. 1).

[12] Cyrot, *loc. cit.*

[13] Jehan Wiscrère is called the architect in a poem of the period preserved in the archives of the sisters of Beaune (Leflaive, *op. cit.*, p. 20). Joan Evans (*op. cit.*, p. 249), however, believes that the hospital was built by Jehan Rateau.

[14] Bavard, *op. cit.*, p. 16.

[15] There are excellent descriptions of the hospital both in Cyrot, *op. cit.*, pp. 13 ff., and in Bavard, *op. cit.*, pp. 16 ff. See also the floor plan of the fifteenth-century building (31).

The hôtel-Dieu in Beaune was one of the finest establishments of its kind, serving as a model for many similar charitable institutions. Since its foundation, hospital sisters from Beaune have been called to administer hospitals throughout France. It was conceived so well by Rolin that it weathered all the political, social, and religious upheavals throughout Europe from the middle of the fifteenth century until the French Revolution. Only with the abolishment of many feudal privileges after 1789 was the patronage of Rolin's descendants suppressed. Since then a commission of the city of Beaune, headed by the mayor, has arranged for its support.

Even though its sustenance now comes from the community rather than from an individual family, the hôtel-Dieu retains much of its original appearance and organization. It is still administered by sisters who have preserved the rule and the costume of the Hospitalers of Valencienne. Many of the rooms and the exterior of the hospital look as they did in the fifteenth century. The great hall is no longer the largest room for the sick, since the grange has been converted into a two-hundred-bed room. While maintaining its medieval character, the hôtel-Dieu has been able to modernize its practice of medicine through the years, and it remains an excellent hospital even today. The wines from the hospital's vineyard are as famous today as they were in the fifteenth century. For five centuries bread was given to the poor every morning at eight o'clock, as Rolin had specified. Since World War II, however, this service has been performed only during the Easter season.

For the many hospitals affiliated with the hôtel-Dieu in Beaune, see Leflaive, *op. cit.*, pp. 181–197. For a brief history of the administrative changes from the fifteenth century to the present, see *ibid.*, pp. 51–180; Bavard, *op. cit.*, p. 61; Stein, *op. cit.*, pp. 23–43; and *Dijon et Beaune*, p. 59.

The major restoration of the hospital took place between 1875 and 1878. For a brief record of the restorations and additions, see Stein, *op. cit.*, p. 38. For a more complete listing of all the objects that have been restored and the men responsible for their restoration, see Boudrot, *Fondation et statuts*, pp. xvi f.; and Leflaive, *op. cit.*, pp. 151–163.

[16] This room was originally called the Chamber of the Cross. It was furnished so magnificently that when Charles VIII came to the hôtel-Dieu in 1484 he was given this

room. After his visit it was always called the Chamber of the King (Leflaive, *op. cit.*, p. 55).

[17] Much of the room can still be seen as it originally appeared. The vaulting, pavement, doors, screen, and stained-glass windows have all been restored. In some instances the restoration was based wholly on written descriptions; the large stained-glass window over the altar was restored on the basis of verbal tradition (see Bavard, *op. cit.*, p. 29).

[18] "Les fondateurs, en batissant l'hôpital, ont voulu le doter et le meubler d'une manière conforme à sa double destination d'Hôtel-Dieu et d'Hôpital. D'Hôtel-Dieu, c'est-à-dire de maison consacrée à Dieu, *ad ejus honorem et laudem, ut divinus servitium frequentatur.* D'Hôpital, c'est-à-dire de maison destinée aux pauvres malades, *pro receptione, usu et habitatione pauperum infirmorum.* C'est pour cette double raison que Nicolas Rolin a élevé le splendide édifice de l'Hôtel-Dieu . . ." (Abbé J. B. Boudrot, *Le Jugement dernier, retable de l'Hôtel-Dieu de Beaune* [Beaune, 1875], p. 39).

[19] Bavard, *op. cit.*, p. 28.

[20] *Ibid.*, p. 87.

[21] Erwin Panofsky made this observation (*Early Netherlandish Painting* [2 vols.; Cambridge, Mass., 1953], I, 268).

[22] Bavard, *op. cit.*, pp. 84–93; Leflaive, *op. cit.*, pp. 12–13.

[23] Leflaive, *op. cit.*, p. 13.

[24] Bavard, *op. cit.*, pp. 87–88.

[25] "Ce chancelier, . . . savait tout gouverner tout seul et à part lui manier et porter tout, fût de paix, fût de guerre, fût en fait de finances; de tout et en tout, le duc s'en attendoit de lui et sûr lui comme principal reposant, et n'y avoit ni office, ni bénéfice, ni par ville, ni par champs, en tous ses pays, ni don, ni emprunt fait, qui tout par lui ne se fît et conduisît et à lui ne répondît (comme le regardeur sur le tout) . . . dont il avoit tant et si inestimable profit qu'a bouche ne sauroit se dire, ni à conter, ni à coeur à peine écrire, tant étoit émerveillable" (Stein, *op. cit.*, p. 6). This description is frequently quoted in discussions of Rolin. Chastellain also admits, however, that Rolin was "un des hauts hommes et des plus recommandés du monde."

[26] For Rolin's biography, see Arsène Perier, *Un Chancelier au XV^e siècle: Nicolas Rolin, 1380–1461* (Paris, 1904); and Henri Pirenne, "Nicolas Rolin," *Biographie nationale de Belgique* (Brussels, 1911–1913), XIX, 828–839. Although Rolin later claimed to be descended from nobility, his claim cannot be substantiated (Pirenne, *op. cit.*, p. 828; Perier, *op. cit.*, p. 5). Rolin fell from the Duke's favor in 1457 because of the growing power and jealousy of the nobility, particularly among the de Croy family. Rolin, who had always tried to restrain the nobility, went so far as to have one of the highest lords, Jean de Granson, smothered. De Granson had made the mistake of instigating a rebellion among the nobles. His murder in 1455 was not taken casually by the de Croy family, who gradually succeeded in gaining the favor of, and finally for a brief time power over, Duke Philip (see Perier, *op. cit.*, pp. 336 ff.).

Rolin retired to Autun and died there in 1461. At his death Philip's continuing affec-

tion is evidenced by the following anecdote. Philip himself was quite ill at the time. His ministers withheld the news of Rolin's death from him, fearing that it would weaken his already precarious health. Finally Philip forced them to tell him why there had been no word from his beloved chancellor. "Ainsi que le redoutait l'entourage du Duc de Bourgogne, ce dernier reçut un choc se douloureux de la mort de Nicolas Rolin qu'il tomba en extrême maladie. Le bon Duc, avec les dévotés prières que le peuple fit pour sa santé, revint à convalescence, mais il ne fût depuis si ferme qu'il était auparavant" (Leflaive, *op. cit.*, pp. 41–42, quoted from the *Annales de Bourgogne* by Guillaume Parathin, p. 854). Philip died in 1467, but in the last years of his reign his power was only nominal. After 1463 Charles the Bold, the last Burgundian duke, assumed control of the affairs of the state.

[27] Pirenne, *op. cit.*, 828–839; Bavard, *op. cit.*, pp. 2 ff.

[28] Perier, *op. cit.*, pp. 64–85.

[29] Most of this land had belonged to Burgundian nobles who had been sympathetic to the royal cause. For a discussion of Rolin's part in the Peace of Arras, see Perier, *op. cit.*, pp. 151–169.

[30] Pirenne quotes Du Clerq's remark—"Il fût réputé un des plus sages hommes du royaume, à parler temporellement; car au regard de l'espirituel je m'en tais"—and Chastellain's criticism as evidence (*op. cit.*, pp. 836–838). On the other hand, Perier maintains that in building this hospital "le chancelier avait obéi à un pur sentiment religieux" (*op. cit.*, p. 366). Panofsky, however, maintains that Rolin built it to relieve his conscience (*op. cit.*, I, 268).

[31] Louis Réau, *Iconographie de l'art chrétien* (6 vols.; Paris, 1955), III, pt. 1, pp. 102–103.

[32] Rolin's first wife, Marie des Landes, died in 1410. They had four children: William, Anthony, Jean, and Philipote. Rolin and Guigone were married about 1411. They had three children: Louis, Louise, and Claudine. Rolin had at least two natural children: Anthony and Margaret (Pirenne, *op. cit.*, p. 839).

[33] This order was founded in 1382 by Albert of Bavaria, count of Hainault, Holland, and Zeeland.

[34] Leflaive, *op. cit.*, p. 19.

[35] *Ibid.*

[36] The fact that the dedication page of the *Chroniques du Hainault* (1446; Brussels, Bibliothèque royale, MS 9241; illus. Panofsky, *op, cit.*, II, pl. 192) shows a portrait of Nicolas which is very similar to his portrait on the altarpiece has led some to date the painting between 1443 and 1446. Panofsky (*op. cit.*, I, 268), accepting this evidence, thinks that the altarpiece was surely in progress by that time, but was probably finished only shortly before Rogier left for Italy in 1450. Rogier's trip to Italy was of short duration, however, and does not form a major stylistic caesura in his work. It seems unnecessary to assume that the large altarpiece could not have been completed after his return. This contention is supported by the fact that the head of Christ in the Last Judgment is very similar

to the head of Christ in the Braque triptych, which we believe was begun in the latter part of 1452 (see chap. 3, n. 6).

[37] Rolin's hospital did not admit plague victims because the disease was too contagious. The saints were invoked to prevent an outbreak of the plague among the sick already housed there.

[38] Ferdinand de Mély, "Le Retable de Beaune," *Gazette des beaux-arts*, pér. 3, XXXV (Jan., 1906), 28. Jules Destrée (*Roger de la Pasture—van der Weyden* [2 vols.; Paris and Brussels, 1930], I, 154 n. 1) says Sebastian is there as patron of hospitals.

[39] Panofsky (*op. cit.*, I, 268) calls it the work of "an indifferent assistant."

[40] Panofsky used this simile when discussing the Annunciation on the exterior of the Portinari altarpiece (*op. cit.*, I, 332–333).

[41] Bavard, *op. cit.*, pp. 30, 340–341. Three paraments of the fifteenth century were recorded in the inventory of the hôtel-Dieu. One displayed a blue ground with the emblems of Rolin and his wife: the tower and keys in gold; a second showed the Mystic Lamb, whose blood flowed into a chalice; and the third depicted the Annunciation. The three paraments correspond very closely to the major iconography of the triptych placed above them: the identification of Rolin and his wife, the Annunciation, and the saving blood of Christ shown in the parament as the Mystic Lamb rather than as Christ of the Last Judgment.

[42] "Venite benedicti patris mei possidete paratum vobis regnum a constitutione mundi" (Boudrot, *Le Jugement dernier*, p. 8).

[43] "Discedite a me, maledicti, in ignem aeternum qui paratus est diabolo etangelis ejus" (*ibid.*).

[44] *Ibid.*

[45] Mély's identifications (*op. cit.*, pp. 26 ff.) are based on the theory of precious stones found in the *Tropologie des gemmes*. See also Destrée, *op. cit.*, I, 153.

[46] For example, the blessed on the west facade of Chartres include a crowned king, a bishop, a deacon, and laymen, whereas the damned at Rheims include kings, a bishop, and a monk. There are many other examples (cf. the cathedral at Bourges, the Church of Notre Dame de la Couture in Le Mans, and Bamberg cathedral). In these instances "royal crown, papal tiara or episcopal mitre appear above anxious faces and emphasize man's equality before the tribunal of God." No such anxiety is displayed by the figures in the Rolin altarpiece (Emile Mâle, *The Gothic Image: Religious Art in France of the 13th Century*, trans. D. Nussey [New York, 1958], pp. 373–374).

[47] *Ibid.*, pp. 367–378.

[48] These gothicisms are discussed fully by Panofsky, *op. cit.*, I, 268 ff.

[49] Now in the Metropolitan Museum, New York (illus. *ibid.*, II, pl. 166). This painting was freely copied by Petrus Christus in 1452.

[50] See Frits Lugt and J. Vallery-Radot, *Inventaire général des dessins des écoles du nord* (Paris: Bibliothèque nationale cabinet des étampes, 1936), p. 2, no. 2. Destrée (*op. cit.*, I, 151) notes that all these Last Judgments were available to Rogier.

[51] In the Wallraf-Richartz Museum at Cologne (illus. Destrée, *op. cit.*, II, pl. 91).

[52] Panofsky, *op. cit.*, I, 269.

[53] For a complete explanation of this iconography, see *ibid.*, I, 271 ff.

[54] The altar to the right of the main altar was ornamented with a picture of Our Lady of Sorrows and the Raising of Lazarus. This painting was crowned by statues of Mary Magdalen, Martha, Lazarus, and Barbara. The altar to the left held a representation of the Resurrection, above which were statues of Our Lady, St. John the Evangelist, and SS. Catherine and Anthony. Over the altar in the infirmary were statues of SS. Christopher and Barbara. These are all recorded in the inventory of 1501. See Bavard, *op. cit.*, pp. 28 ff.

[55] For a long time it was thought that the turtledove and oak branch with the word *Seule* were melancholy references to Guigone's widowed state after Nicolas' death. This conjecture is hardly possible, however, since most of the furnishings and tiles that bear this device were finished long before Rolin died. For the proper explanation of the device, see Bavard, *op. cit.*, pp. 43–44, and A. Kleinclausz, *Dijon et Beaune* (Paris, 1907), p. 153. X. Barbier de Montault ("Une Visite archéologique à Beaune," *Revue de l'art chrétien*, 4th sér., II [1891], 232) perpetuates the earlier misinterpretation.

[56] See Jules Guiffrey ("Les Tapisseries de l'hôpital de Beaune," *Bulletin archéologique* [Paris, 1887], pp. 239–249) for a discussion of the tapestries and their function.

[57] Kleinclausz, *op. cit.*, p. 152.

[58] Bavard, *op. cit.*, p. 29.

[59] *Ibid.*, p. 93; Stein, *op. cit.*, pp. 26, 28.

[60] Guigone ordered the tomb plate long after Rolin's death. He had intended that she be buried next to him in Autun (Leflaive, *op. cit.*, p. 50).

[61] Boudrot, *Fondation et statuts*, p. 122.

[62] Perhaps we can view Rolin's later request to be buried in Autun, rather than in the hôtel-Dieu, as simply another precautionary measure. He wanted his final remains to be placed in even more holy ground. He was buried in the large collegiate Church of Notre Dame in a chapel that he had built. The church was under the authority of his son, then Cardinal Jean, bishop of Autun.

[63] This idea has been proposed by others. Boudrot (*Le Jugement dernier*, pp. 11–16) identified the figures as Pope Eugene IV, Philip the Good, Nicolas Rolin, and Jean Rolin, and, on the other side, Guigone, Isabel of Portugal, and Rolin's daughter, although an earlier tradition identified the last figure (the foremost one) as Marie des Landes. This identification was repeated by Bavard (*op. cit.*, pp. 347–348), Mély (*op. cit.*, pp. 114 ff.), Paul Lafond (*Roger van der Weyden* [Brussels, 1912], pp. 49 ff.), and others. A major obstacle to this theory has been pointed out by Destrée (*op. cit.*, I, 153–154), Stein (*op. cit.*, pp. 72 ff.), and Baron Verhaegen, "Le Polyptyque de Beaune," in *Congrès archéologique de France, 91 session* (Dijon, 1928), pp. 348 ff. It is unprecedented to represent living persons as nimbed saints. Verhaegen argued further that the features in the portraits are not close enough to those of the people named. Panofsky (*op. cit.*, I, 270) tried to solve the problem by calling them representatives of the community of saints: a pope, a bishop,

a prince, a monk, a virgin, a princess, and a married woman. This, however, seems an unsatisfactory solution. I am not yet fully convinced of their identities. Much more still needs to be done regarding the accuracy of the portraits.

[64] ". . . en ce jour de dimanche le 4 du mois d'août de l'an Seigneur 1443, négligeant toutes les sollicitudes humaines, et dans l'intérêt de mon salut, désirant par un heureux commerce échanger contre les biens célestes les biens temporels que je dois à la divine bonté, et de périssables, les rendre éternels . . . en reconnaissance des biens dont le Seigneur, source de toutes bontés, m'a comblé, dès maintenant et pour toujours, je fonde et dote irrévocablement dans la ville de Beaune un hôpital pour les pauvres malades . . " (Perier, *op. cit.*, p. 370).

5. The Edelheer Altarpiece

[1] In the seventeenth century the triptych was removed from the altar of the Edelheer chapel by William de Wargnie and placed on the wall of the chapel. It is now found on the wall of the north aisle. At one time it was also recorded as being in the Last Judgment chapel on the north side of the choir. See Edward van Even, *L'ancienne Ecole de peinture de Louvain* (Brussels and Louvain, 1870), pp. 44, 54.

[2] This is only one of a number of paintings that copied Rogier's "Descent from the Cross." For other copies, see Max J. Friedländer, *Die altniederländische Malerei* (14 vols.; Berlin, 1924–1933; Leiden, 1935–1937), II, nos. 3, 92; and Jules Destrée, *Roger de la Pasture—van der Weyden* (2 vols.; Paris and Brussels, 1930), II, pls. 61, 62, 63.

[3] Otto von Simson was the first to point out the new iconography of the exterior, but he treated it only in passing (see "*Compassio* and *Co-redemptio* in Roger van der Weyden's *Descent from the Cross*," *Art Bulletin*, XXXV [March 1953], 15).

[4] For a complete history and description of the Church of St. Peter's, see Edward van Even, *Louvain monumental ou description historique et artistique de tous les édifices civils et religieux de la dite ville* (Louvain, 1860), pp. 174 ff.; and Edward van Even, *Louvain dans le passé et dans le présent* (Louvain, 1895), pp. 312 ff. The latter book repeats much of the material found in the earlier work, but in order to get all of Even's information on the church, both books must be consulted. For the rebuilding of the tenth-century church, see *Louvain dans le passé*, p. 317; and Joseph Cuvelier, *Les Institutions de la ville de Louvain au moyen âge* (Brussels, 1935), pp. 181–182.

[5] The First Chapter of St. Peter was founded in 1054, when St. Peter's became a collegiate church. On May 23, 1443, the Chapter of the Second Foundation was formed by Pope Eugene IV at the request of Philip the Good. This chapter was made up entirely of members of the newly founded University of Louvain (1426). It was responsible for a

large part of the building program of the fifteenth century; however, the initial decision to rebuild the Gothic structure was made by the Chapter of the First Foundation (Even, *Louvain dans le passé*, pp. 312–314; and Cuvelier, *op. cit.*, pp. 180 ff.).

[6] Even, *Louvain monumental*, p. 175.

[7] *Ibid.*, p. 180.

[8] *Ibid.*, p. 180, and chaps. v, vi.

[9] The Church of St. Peter had always received a great deal of support both from the citizens of Louvain and from the ruling families of the North. Henry I, duke of Brabant, is sometimes called the founder of the church because of his generosity during the rebuilding of the twelfth-century structure (see Karl Baedeker, *Belgium and Holland* [Leipzig, London, and New York, 1910], p. 241). At his death in 1235 Henry was buried in the center of the choir. When the church was rebuilt in the fifteenth century, his tomb was moved to one of the chapels and an altar that he had richly endowed became the major altar of the new church (Even, *Louvain monumental*, pp. 179–201). Philip the Good contributed frequently to the building program. In 1443 he gave a large sum of money for five of the stained-glass windows in the choir. He and his wife Isabel appeared in one of these windows with their patron saints (Even, *Louvain monumental*, p. 178; Even, *Louvain dans le passé*, p. 324, shows a line drawing of the window). One of the bells was named for Philip the Good in 1462. Charles the Bold, Charles VII of France, and Maximilian of Austria continued the royal support.

[10] Even, *Louvain dans le passé*, p. 324. Edelheer inherited money from his father and also received a sizable income from his property. He is recorded as renting three houses and two farms (see Even, *L'ancienne Ecole*, p. 45).

[11] For a full discussion of all the choir chapels, see Even, *Louvain monumental*, pp. 204–209.

[12] *Ibid.*, p. 180. In that year the Confraternity of the Blessed Sacrament received their two chapels. It is very doubtful that Edelheer would have received his chapel before then. Even (*Louvain dans le passé*, p. 366) says that the Edelheer chapel was founded about 1438. He gives no documentation and no special reason for selecting that date. He knew the chapel was founded before Edelheer's death, and he may have simply used the preceding year as a reasonable approximation.

[13] The following extract gives information concerning the founding of the chapel and the role of Edelheer's son William, who was ordained a priest in 1431: "Wilhelmus Edelheer et Aleidis ejus uxor fundaverunt in ambitu ecclesiae parvum chorum, qui dicitur chorus Edelheer, et in eo fundaverunt capellaniam. Adjecerunt praeterea redditum 70 aureorum ridderorum illustrissimi ducis Philippi pro quotidiana missa, eleemosynis et aliis fundationibus.

"Wilhelmus Edelheer, filius, capellaniae a parentibus fundatae, cujus primus fuit possessor, per testamentum, quod condidit anno 1473, adjecit secundam, et haereditarie ad alias fundationes, 39 cum dimidio ridderos et 36 stuferos" (Johannes Molanus, *Historiae*

Louvaniensium libri xiv. Ex codice autographo edidit, commentario praevio de vita et scriptis Molani [2 vols.; Brussels, 1851], II, 708–709). See also Even, *Louvain dans le passé*, pp. 324–325.

¹⁴ "Wilhelmus Edelheer et Aleidis ejus uxor et dominus Wilhelmus ecrum filius fundarunt anno 1443 ad altare S. Spiritus, Deiparae Virginis et S. Jacobi Majoris, capellaniam in parvo choro, dicto *Edelheers*, in ambitu chori" (Molanus, *op. cit.*, I, 119). The literature, however, always refers to the chapel as the Edelheer chapel. It is the only chapel in the choir which is known by the name of an individual donor rather than by that of the dedicatory saint. For example, see Even, *Louvain dans le passé*, p. 325; Even, *Louvain monumental*, p. 207. See also n. 11 above and the floor plan (45) with the original fifteenth-century dedications.

¹⁵ Even, *Louvain dans le passé*, pp. 324–325.

¹⁶ "DESE TAFEL HEEFT VEREERT HEEREN WILLEM EDELHEER—ENDE ALYT SYN WERDINNE INT IAER ONS HEEREN MCCCC—ENDE XLIII" (recorded by Ch. Piot, "Un Tableau de Roger van der Weyden," *Revue d'histoire et d'archéologie*, III [1862], 197). The inscription is also visible on the painting, but it is in a very ruinous state.

¹⁷ For one example of this dating, see n. 14 above. Even says, with no documentation, that it was ordered in 1443 by the son William. He also says that the son commissioned it from Rogier van der Weyden (see *Louvain dans le passé*, p. 325).

¹⁸ See the Molanus extract in n. 14 above.

¹⁹ Erwin Panofsky, *Early Netherlandish Painting* (2 vols.; Cambridge, Mass., 1953), I, 257. The *terminus ante quem* for Rogier's painting is usually given as 1443, but it should be moved back to at least 1439, the year of Edelheer's death, and probably could be considered as early as 1436, the year after the death of Edelheer's son Louis.

²⁰ *Ibid.*, I, 256 n. 2. See also Hermann Beenken, *Rogier van der Weyden* (Munich, 1951), pp. 45–46. A document of 1574, the year in which the "Descent" was placed in the Escorial, gives the iconography of the wings, which by that time had been lost at sea (Destrée, *op. cit.*, I, 128).

²¹ Beenken, *loc. cit.*

²² See the genealogy of the Edelheer family in Even, *L'ancienne École*, pp. 48–49.

²³ Since St. Adelaide is carrying a crown, she had been incorrectly identified as St. Elizabeth. As Even correctly points out (*ibid.*, p. 52), St. Elizabeth is not the only queen identified in this manner.

²⁴ For the life of St. Adelaide, see Alban Butler, *Butler's Lives of the Saints*, ed. H. Thurston and D. Attwater (4 vols.; London, 1956), IV, 572–573.

²⁵ The chapel itself may have been dedicated to St. James alone (see Eduard Firmenich Richartz quoting Even in "Rogier van der Weyden, der Meister von Flémalle," *Zeitschrift für bildende Kunst* [Leipzig], XXXIV [1899], 132 n. 1).

²⁶ Piot, *op. cit.*, p. 198 n. 2. According to Molanus (*op. cit.*), Edelheer used both William and James at his Christian name.

²⁷ For a discussion of Rogier's painting as a critique of Campin's "Descent from the

Cross," see Panofsky, *op. cit.*, I, 257; and Karl M. Birkmeyer, "The Arch Motif in Netherlandish Painting of the Fifteenth Century," *Art Bulletin*, XLIII (March, 1961), 15–16.

[28] Louis Réau, *Iconographie de l'art chrétien* (6 vols.; Paris, 1955), II, pt. 2, p. 514.

[29] See St. Bonaventure, *Meditations on the Supper of Our Lord and the Hours of the Passion*, trans. Robert Manning of Brunne (*ca.* 1315–1330), ed. J. Cowper (London, 1875), p. 22, lines 703–706 (translated from Middle English):

> By her [the Virgin] stand John, and Mary's three,
> James, Magdelen, and Cleophe.
> Wonder is to tell what sorrow they make,
> For her sweet master is from them taken;

and p. 28, lines 891–896:

> A new company they saw coming
> Instruments and ointments with them bringing,
> Our Lady dread sore that they were enemies,
> Til John on them had set good eyes;
> "Be of good comfort," he said, "they seem
> Joseph of Aremathea and Nicodemus";

and p. 29, lines 915–917:

> When they had drawn out the nails with force,
> Joseph bore up the precious corpse,
> While his fellow to the feet went.

See also John 19:25–42; and Bonaventure, *pseud.*, *Meditations on the Life of Christ: An Illustrated Manuscript of the Fourteenth Century*, trans. Isa Ragusa, ed. Rosalie B. Green and Isa Ragusa (Princeton, 1961), pp. 338–342.

[30] Although according to the Synoptic Gospels, Simon was forced to carry Christ's cross, the gesture came to be looked upon in the late Middle Ages as one of compassion. Because St. Mark speaks of Simon as the father of Rufus and Alexander, who were thought to be Christian converts and friends of St. Peter, Simon is also thought of as a Christian. For a discussion of the iconography of Simon Carrying the Cross, see Réau, *op. cit.*, II, pt. 2, pp. 463–464. For a discussion of the biblical identity of Simon, see Salomon Reinach, "Simon de Cyrène," *Cultes, mythes et religions* (Paris), IV (1912), 181–188.

[31] During the fourteenth century in Italy the number of figures associated with the Crucifixion greatly increased under the effect of the teachings of SS. Francis and Bonaventure. Similarly, more figures were added in the scene of the Deposition. Often three men were shown lowering the body—one at the head, one receiving the body, and one removing the nails at the foot of the cross. Two of these men must be Nicodemus and Joseph of Arimathea. Identification of the third man as Simon is only tentative. For fourteenth-century examples of the three figures lowering the body, see Emile Mâle, *L'Art religieux*

de la fin du moyen âge en France (Paris, 1931), pp. 14–17, figs. 10, 11. One example shown is the Deposition from the Stefaneschi polyptych by Simone Martini.

[32] The derivation of this type of figure in Rogier's work must surely come from Campin. In the "Good Thief" fragment in Frankfurt both pagans below the cross are of the same type, the one on the right being very close to the Simon figure in Rogier's Descent. I would like to return to T. Musper's (*Untersuchungen zu Rogier van der Weyden und Jan van Eyck* [Stuttgart, 1948], p. 19) identification of this man as the Good rather than the Bad Thief. Panofsky refers to this identification (*op. cit.*, I, 168 n. 1), but rejects it. He gives all the stylistic reasons for calling the thief on Christ's left the Good Thief and is in fact tempted to do so himself. But he is restrained by the long iconographic tradition that established the Good Thief as always being on Christ's right. In addition to his convincing interpretation of this figure as a "heroic sinner" is the fact that he is not blind-folded whereas the thief on Christ's right is. Surely the conversion of the figure on Christ's left is suggested by the traditional convention of removing his blindfold. The centurions' attitudes and gestures suggest that they too "have seen" Christ by witnessing His for-giveness of the Good Thief. For some reason yet unknown to us, Campin must have reversed the traditional scheme.

Both Campin and Rogier seem to have consistently used the bulbous and deep-featured type for persons newly converted. Even the Good Thief bears a faint resemblance to the centurions and to Rogier's third Magus in the Bladelin altarpiece.

[33] There are a few examples of a black Magus from the thirteenth century (see Réau, *op. cit.*, II, pt. 2, pp. 240–241). When Memlinc copied the Columba "Adoration of the Magi" in the Jan Floreins altarpiece in the hospital of St. John and in his "Adoration of the Magi" in the Prado Museum, he used Rogier's older and middle-aged figures (both appear in the right wing of the Bladelin triptych), but he substituted a Negro for the third figure. When painting the Columba, Rogier himself replaced his Simon-type Magus with a portrait of Charles the Bold (Panofsky, *op. cit.*, I, 286).

[34] I am indebted to a former student, Miss Sherry Buckberrough, for this idea.

[35] Destrée (*op. cit.*, I, 126) quotes Lafond's identification of both Simon and St. Peter, but he is skeptical of it.

[36] Panofsky, *op. cit.*, I, 257. See n. 32 above for the identification of the Frankfurt fragment as the Good Thief.

[37] Panofsky (*op. cit.*, I, 256 n. 2) suggests that the Virgin in Campin's "Descent" (5) is a pre-Rogierian attempt to represent the same idea. The whole scene, however, is far more narrative in effect, and the Virgin's body has not yet been made to parallel the body of Christ. The parallel position was, after all, the motif that carried the icono-graphic idea. The swoon had long been in the iconographic tradition.

[38] See Simson (*op. cit.*, *passim*) for the most complete treatment of the iconography of the Virgin's compassionate imitation of Christ's Passion.

[39] Yrjö Hirn, *The Sacred Shrine* (Boston, 1957), p. 393, quoting St. Bridget: "And therefore I [Christ] wish to say that my Mother and I saved mankind with one heart, . . .

and she suffering the heart's sorrow and love. . . . I bear thee witness that thou (didst suffer) more and bear more agony in the hour of my death than any martyr."

[40] Bonaventure, *op. cit.*, p. 22, lines 690–692:

> Father! seest Thou not my Mother's pains?
> On the cross she is with me,
> I should be crucified, and not she;

and p. 25, lines 777–787:

> Now give we a meditation
> Of a sweet lamentation
> That Mary, mother meek and mild,
> Made for her dear worthy child.
> Great pains she suffered her before,
> But now she suffered much more;
> For when she saw him drawing to an end,
> She swooned, she pined, she waxed half dead,
> She fell to the ground, and beat her head.
> So John ran to her and her upbraided;

and p. 27, lines 861–868:

> Ah, wrong! Ah, wo! Ah, wickedness!
> To martyr her for her meekness.
> The son was dead he felt no smart
> But certain it pierced the mother's heart.
> They wounded her and heaped harm upon harm;
> She fell as for dead in the Madelen's arms,
> Ah, Jesus, this deed is wonder to me,
> That thou sufferest thy mother to be martyred for thee.

See also Bonaventure, *pseud.*, *Meditations*, pp. 337, 339.

[41] "Tout le temps que Nostre Seigneur souffri sa passion, la Vierge Marie y fu presente, et par compassion elle porta en soy mesmes toutes les choses qui y furent faittes" (*Speculum Humanae Salvationis*, trans. Jean Miélot [1448], ed. J. Lutz and P. Perdrizet [2 vols.; Mulhouse, 1907–1909], I, pt. 2, chap. xxvi, p. 144).

[42] Simson, *op. cit.*, p. 13, quoted from the *Speculum*. Chapter xxx of the *Speculum* establishes the parallelism between Christ's Passion and Mary's Compassion.

[43] For a discussion of the church, see Even, "Notre-dame-du-hors," in *Louvain dans le passé*, pp. 436 ff.

[44] *Ibid.*, p. 437.

[45] For a discussion of the pictorial invention of the Virgin and the Sword of Sorrow, see William H. Gerdts, "The Sword of Sorrow," *Art Quarterly*, XVII (Autumn, 1954), 213–229. In the Low Countries, toward the end of the fifteenth century, the swords grew in number to seven and were equated with the Seven Sorrows. Only then did the Virgin of the Seven Sorrows become a popular theme in art. The Feast of the Seven Sor-

rows was established in 1423, but the first confraternity was not founded until late in the century (see Mâle, *L'Art religieux*, pp. 124–126; and "La Vierge aux Sept Glaives," *Analecta Bollandiana*, XII [1893], 333–352).

[46] In Louvain the crossbowmen had already dedicated a chapel to St. George (Joseph Cuvelier, *La Formation de la ville de Louvain des origines à la fin du XIV^e siècle* [Brussels, 1935], p. 173).

[47] See Panofsky, *op. cit.*, I, 146 n. 6, 333 n. 2.

[48] Only the pedestals on which the figures stand depart by the slightest amount from traditional grisaille. The one on which John the Evangelist and Mary stand is now brown, whereas the one supporting the "Trinity of the Broken Body" is dark gray. Even (*Louvain dans le passé*, p. 325) says the pedestals were red.

[49] Erwin Panofsky, "Reintegration of a Book of Hours Executed in the Workshop of the 'Maître des Grandes Heures de Rohan,' " in *Medieval Studies in Memory of A. Kingsley Porter*, ed. W. Koehler (2 vols.; Cambridge, Mass., 1939), II, 490.

[50] Réau, *op. cit.*, II, pt. 1, pp. 11–14.

[51] For the history of this iconography, see Erwin Panofsky, "Imago Pietatis," in *Festschrift für Max J. Friedländer zum 60. Geburtstage* (Leipzig, 1927), pp. 261–308; and Georg Troescher, "Die 'Pitié-de-Nostre-Seigneur' oder Notgottes," *Wallraf-Richartz Jahrbuch*, IX (1936), 148–168.

[52] Wolfgang Braunfels, *Die Heilige Dreifaltigkeit* (Düsseldorf, 1954), p. xxxv.

[53] Mâle, *L'Art religieux*, pp. 142–145.

[54] Panofsky, *Early Netherlandish Painting*, I, 124–125: "The inference is that there existed, prior to 1430–1435, a Netherlandish archetype which showed the Man of Sorrows placing His right hand upon the wound in His side, upraising His left, clad in the robe of the Judge and attended by the Angels of Justice and Mercy—an archetype which probably preceded, possibly influenced and certainly did not depend upon the admirable composition by Master Francke.

"Now, since the gesture of showing the side wound is foreign to the iconography of the Man of Sorrows in earlier Northern art, the same archetype would seem to have influenced the Master of Flémalle in whose representations of the Trinity this gesture appears effectively, if not quite logically, transferred to the dead Christ supported by God the Father. And if this hypothesis were admitted, we should be confronted with a tradition, transmitted by and inseparable from our modest miniatures, which left its mark on major panel painting both in Germany and Flanders." See also Panofsky, "Imago Pietatis," pp. 274 ff. For a more recent, but very brief, discussion of the formation of this archetype, see John Rowlands, "A Man of Sorrows by Petrus Christus," *Burlington Magazine*, CIV (Oct., 1962), 419–423.

[55] Panofsky, *Early Netherlandish Painting*, I, 124. For a later example of the combined Man of Sorrows and Judge, see the little panel by Petrus Christus in the City Museum and Art Gallery in Birmingham, discussed and illustrated in Rowlands, *op. cit.*, pp. 419 ff.

[56] For a reproduction of this drawing and a brief discussion of its iconography, linking

it to the theme of the Man of Sorrows and the Mass of St. Gregory, see Rowlands, *op. cit.*, p. 421, fig. 8.

[57] Hirn, *op. cit.*, p. 393.

[58] Even, *Louvain dans le passé*, p. 325.

6. The Altarpiece of the Blessed Sacrament

[1] In the North Petrus Christus discovered focal-point perspective and began applying it about 1450. It may be seen in the Annunciation, one of the three scenes on two altar wings preserved in the Dahlem Museum in Berlin; the other scenes are the Nativity and the Last Judgment. Cf. Karl Doehlemann, "Die Entwicklung der Perspektive in der altniederländischen Kunst," *Repertorium für Kunstwissenschaft*, XXXIV (1911), 502–503; G. J. Kern, *Die Grundzüge der linear-perspektivischen Darstellung in der Kunst der Gebrüder van Eyck und ihrer Schule* (Leipzig, 1904), pp. 18 ff.; and Erwin Panofsky, "Die Perspektive als 'symbolische Form,' " *Vorträge der Bibliothek Warburg* (1924–25), pp. 258–330.

[2] For the most complete discussion of this work, see Wolfgang Schöne, *Dieric Bouts und seine Schule* (Berlin and Leipzig, 1938), pp. 8 f., 88–96. For information on the technique and the condition of the painting, see Paul Coremans, R. J. Gettens, and Jean Thissen, "La Technique des 'primitifs flamands.' Etude scientifique des matériaux, de la structure et de la technique picturale," *Studies in (Etudes de) Conservation*, I (1952), 1–29.

[3] Erwin Panofsky, *Early Netherlandish Painting* (2 vols.; Cambridge, Mass., 1953), I, 318.

[4] Mâle attributes the unusual arrangement of the disciples being seated on all four sides of a rectangular table to the influence of the mystery plays, which traditionally arranged the players in this manner. I think, however, that the arrangement may as easily have come from the logical ordering of the pictorial space. Bouts had an almost square panel with which to work. Having decided to limit the size of the room to the size of the panel, he found that a long rectangular table would not have fit into the space. A table in the form of a half circle would have been out of keeping with the rectilinear arrangement. He decided upon an almost square table, but found that it was virtually impossible to place all twelve Apostles on one side. I think that Bouts's table arrangement, like many other items in the painting (see pp. 67–68), stemmed from his innate sense of logic and order. Cf. Emile Mâle, "Le Renouvellement de l'art par les 'mystères' à la fin du moyen âge," *Gazette des beaux-arts*, pér. 3, XXXI (April, 1904), 290; Schöne, *op. cit.*, p. 93; and Ferd Peeters, *Le Triptyque eucharistique de Thierry Bouts à l'église Saint-Pierre de Louvain* (Léau, 1926), p. 42. Peeters does not believe that this painting is a literal depiction of a mystery play.

[5] Maurice Vloberg, *L'Eucharistie dans l'art* (Paris, 1946), pp. 87, 99; Louis Réau, *Iconographie de l'art chrétien* (6 vols.; Paris, 1955), II, pt. 2, pp. 410–420.

[6] Réau, *op. cit.*, II, pt. 2, p. 410.

[7] Vloberg, *op. cit.*, p. 87.

[8] *Ibid.*, pp. 93–94. This representation of John and Christ had been part of the Last Supper in Eastern art since the eleventh century.

[9] *Ibid.*, pp. 99–105; Réau, *op. cit.*, II, pt. 2, pp. 418–420.

[10] For other examples of this theme in the fifteenth century, see the "Last Supper" in Jean Fouquet's *Heures d'Etienne Chevalier* or the "Last Supper" by Signorelli in the Cortone Cathedral.

[11] Réau, *op. cit.*, II, pt. 2, p. 419; Vloberg, *op. cit.*, pp. 105–133.

[12] Neither Vloberg (*op. cit.*, p. 105) nor Réau (*op. cit.*, II, pt. 2, p. 420) mentions any example that predates Bouts's representation of 1464.

[13] Réau, *op. cit.*, II, pt. 2, p. 419.

[14] See the Master of the Catherine Legend, "Last Supper," Bruges, Seminar (illus. Max J. Friedländer, *Die altniederländische Malerei* [14 vols.; Berlin, 1924–1933; Leiden, 1935–1937], IV, no. 48, pl. xlvi).

[15] The same could also be said of the "Communion of the Apostles" by Joos van Ghent. This work was commissioned ten years later, in 1474, by the Confraternity of Corpus Domini in Urbino. For a thorough discussion of the confraternity's role in the determination of the subject see Marilyn Aronberg Lavin, "The Altar of Corpus Domini in Urbino: Paolo Ucello, Joos van Ghent, Piero della Francesca," *Art Bulletin*, XLIX (March, 1967), 1–24.

[16] See pp. 49–50.

[17] Edward van Even, *Louvain dans le passé, et dans le présent* (Louvain, 1895), p. 326.

[18] *Ibid.*, pp. 326 ff.; Schöne, *op. cit.*, p. 240, doc. 55. See also the copy of the contract for the painting quoted in n. 43 below. The painting was installed in the church in February of 1468.

[19] This is the reason suggested by Edward van Even (*L'ancienne Ecole de peinture de Louvain* [Brussels and Louvain, 1870], p. 162).

[20] For the life of St. Juliana, see Alban Butler, *Butler's Lives of the Saints*, ed. H. Thurston and D. Attwater (4 vols.; London, 1956), II, 37–38; Vloberg, *op. cit.*, p. 236; and E. Denis, *Sainte Julienne et Cornillon* (Liége, 1927).

[21] Raymond Webster, "Urban IV," *Catholic Encyclopedia*, XV, 212–214.

[22] Frances Mershman, "Corpus Christi," *Catholic Encyclopedia*, IV, 391. The miracle of Bolsena is supposed to have taken place in the Church of St. Christina in 1263. A Bohemian priest who was saying Mass in the church was skeptical about the doctrine of transubstantiation. When he was consecrating the host at the altar in the crypt of the church, the bread began to bleed. (Bolsena is only eleven miles from Orvieto.) See also E. H. Vollet, "Eucharistie," *La grande Encyclopédie* (Paris, 1886–1902), XVI, 720.

[23] This account is based upon the Synoptic Gospels. St. John, on the other hand, refers to the Last Supper as taking place on the eve of the Passover. The dispute, however, is one of modern scholarship and not of the fifteenth century. See Gregory Dix, *The Shape of the Liturgy* (London, 1945), pp. 50 ff.

[24] Mershman, *loc. cit.*; Vollet, *loc. cit.*

[25] The bull was decreed on September 8, 1264. Urban IV died on October 2, 1264. Belgium was the first country to celebrate the feast. Under Juliana's influence it had been celebrated in Liége since 1247.

[26] Mershman, *loc. cit.* Cologne celebrated the Feast of Corpus Christi in 1306, Worms in 1315, England between 1320 and 1325.

[27] Even (*Louvain dans le passé*, p. 315) states that the Kermesse celebrated the delivery of the country from the Normans.

[28] Edward van Even, *Louvain monumental ou description historique et artistique de tous les édifices civils et religieux de la dite ville* (Louvain, 1860), p. 199.

[29] For a history of the monstrance, see Josef Braun, *Das christliche Altargerät in seinem sein und in seiner Entwicklung* (Munich, 1932), pp. 348–411; Herbert Thurston, "Ostensorium," *Catholic Encyclopedia*, XI, 344–346; and Vloberg, *op. cit.*, p. 242.

[30] Vloberg, *loc. cit.*

[31] Matthew 26:26–29; Mark 14:22–26; Luke 22:19–20.

[32] The sign of the cross is made over the species just before the consecration begins after the doxology of the canon. During the consecration or communion the gesture is repeated several times.

[33] Emile Mâle, *L'Art religieux de la fin du moyen âge en France* (Paris, 1931), p. 60.

[34] The four attendants in the Last Supper have been identified as the four members of the confraternity by F. Baudouin and K. G. Boon (*Dieric Bouts Palais des beaux-arts, Brussels 1957–1958 Museum Prinsenhof, Delft* [Brussels, 1957], p. 47). See also Panofsky, *Early Netherlandish Painting*, I, 318 n. 2. The two attendants in the Meeting of Melchizedek and Abraham have been identified as the two theologians by Peeters (*op. cit.*, p. 15). For a detail of one of the heads, see *Flanders in the Fifteenth Century: Art and Civilization* (Detroit: Detroit Institute of Arts and the City of Bruges, 1960), p. 107.

[35] Recorded in Even, *Louvain monumental*, p. 206.

[36] Yngve Brilioth, *Eucharistic Faith and Practice, Evangelical and Catholic*, trans. A. G. Herbert (London, 1961), p. 81.

[37] B. J. Kidd, *The Later Medieval Doctrine of the Eucharistic Sacrifice* (London, 1958), pp. 38–40; Dix, *op. cit.*, p. 598.

[38] Kidd, *op. cit.*, p. 41; Brilioth, *op. cit.*, pp. 80–81.

[39] Kidd, *op. cit.*, p. 40.

[40] Edouard Dumoutet, *Le Désir de voir l'hostie* (Paris, 1926); Joseph Jungmann, *The Mass of the Roman Rite: Its Origins and Development* (2 vols.; New York, Boston, Cincinnati, Chicago, and San Francisco, 1951), I, 118 ff.; and T. W. Drury, *Elevation in the Eucharist: Its History and Rationale* (Cambridge, 1907), *passim*.

[41] Dumoutet, *op. cit.*, pp. 54 ff.; Jungmann, *op. cit.*, p. 121 n. 101, quoting Adrian Fortescue, *The Mass: A Study of the Roman Liturgy* (London, New York, and Toronto, 1955), pp. 341 f. Fortescue remarks that in England, if the celebrant did not elevate the host high enough, the people would cry out, "Hold up, Sir John, hold up. Heave it a little higher."

[42] See Panofsky, *Early Netherlandish Painting*, I, 318–319; and Karl M. Birkmeyer, "The Arch Motif in Netherlandish Painting of the Fifteenth Century," *Art Bulletin*, XLIII (June, 1961), 108.

[43] See Birkmeyer, *loc. cit.*, for a similar interpretation of the appearance of this document. The contract for the triptych was discovered in the church archives in 1898 and published by Edward van Even ("Le contrat pour l'exécution du triptyque de Thierry Bouts, de la collégiale Saint-Pierre à Louvain (1464)," *Bulletin de l'Académie royale des sciences, des lettres et des beaux-arts de Belgique*, sér. 3, XXXV [1898], 469–479). The following is an English translation of this contract (which no longer exists because the archive room was burned in 1914) from Wolfgang Stechow, *Northern Renaissance Art, 1400–1600* (Englewood Cliffs, N.J., 1966), pp. 10–11:

"All who will see the present document or will hear it read are hereby informed and notified that on the fifteenth March 1464 (after the reckoning of the venerable court of Liége) a firm agreement and contract was set up and concluded between the four administrators of the Brotherhood of the Holy Sacrament at the Church of St. Peter in Louvain, who act on and in behalf of said Brotherhood—that is, Rase van Baussele as principal, Laureys van Winghe, Reyner Stoop, and Staas Roelofs Beckere as the first party, and the painter, Master Dieric Bouts, as the second party, that he should make for them a precious altarpiece with scenes pertaining to the Holy Sacrament. In this altarpiece there shall be presented on the center panel the Supper of our Beloved Lord with His Twelve Apostles, and on each of the inner wings two representations from the Old Testament: 1) The Heavenly Bread, 2) Melchizedek, 3) Elijah, 4) the Eating of the Paschal Lamb as described in the Old Covenant. Item, on each of the outer wings there shall be one picture: on one, the scene with the Twelve Loaves which only the priests were allowed to eat, and on the other . . . [lacuna].

"And the aforementioned Master Dieric has contracted to make this altarpiece to the best of his ability, to spare neither labor nor time, but to do his utmost to demonstrate in it the art which God has bestowed on him, in such order and truth as the Reverend Masters Jan Vaernacker and Gillis Bailluwel, Professors of Theology, shall prescribe to him with regard to the aforementioned subjects. And it is understood that said Master Dieric, having begun work on this altarpiece, shall not contract any other work of this kind until this one has been completed. For his work said Master Dieric shall be paid and receive the sum of two hundred Rhenish guilders of twenty stivers each: to wit, twenty-five Rhenish guilders as soon as he has begun to paint this altarpiece, and further, twenty-five Rhenish guilders during the next half year, fifty Rhenish guilders after completing the work, and the remaining one hundred Rhenish guilders during the following year, not reckoning the first three months of the one after that. But if, by the grace of God, the good people should so amply demonstrate their charity and liberality toward said work that the above named sum can be paid in full to said Master Dieric for his completed work, and if that sum of money would otherwise lie unused in awaiting the aforementioned time limit, it has been contracted that said Master Dieric shall be paid in full as soon as he has fulfilled his obligation. This has

been witnessed (in addition to the Reverend Professors mentioned before) by Claes van Sinte Goericx, Knight, Master Laureys van Maeldote, Priest, and Master Gheert Fabri, Schoolmaster."

[44] When such a ewer or lavabo was used religiously, it was suspended over a drain in the vestry so that the water could flow directly to consecrated ground. In domestic use the water was merely caught in a basin below. See *Flanders in the Fifteenth Century: Art and Civilization*, pp. 279–280, for a picture and a description of the use of these fifteenth-century ewers.

[45] *Speculum Humanae Salvationis*, trans. Jean Miélot (1448), ed. J. Lutz and P. Perdrizet (2 vols.; Mulhouse, 1907–1909), I, pt. 2, chap. xvi, pp. 134–135; Hans von der Gabelentz, *Die Biblia Pauperum und Apokalypse der Grossherzogl. Bibliothek zu Weimar* (Strassburg, 1912), pp. 13, 43.

[46] *Speculum Humanae Salvationis*, I, pt. 2, chap. xvi, p. 135: "Melcisedech vint a l'encontre de Abraham et lui offri pain et vin, en quoy fu prefigure ce saint sacrement. Melcisedech estoit roy et prestre du souverain Dieu, et pour ce il portoit la figure de Jhesu Crist, qui est le roy des roys, lequel a cree tous les royaumes de ce monde. Il est aussi le prestre qui a celebre la premiere messe qui oncques fu. Melcisedech doncques, roy et prestre, offri a Abraham pain et vin. Mais Jhesu Crist, soubs espece de pain et de vin, a institue ce saint sacrement de l'autel. Pour ceste cause chacun prestre est appelle selon l'order de Melcisedech, pour ce que ce saint sacrement fu prefigure par l'oblation de Melcisedech, qui estoit prestre et prince royal, en quoy estoit raisonnablement prefigure la dignite sacerdotale. Certes les prestres se peuvent bien dire princes royaulx, pour ce que en leur dignite ilz sourmontent tous princes royaulx et imperiaulx. Car ilz transpassent les patriarches, prophetes et aucunement les angeles. Les prestres consacrent le corps de Dieu, que les angeles ne peuvent faire, ne les patriarches, ne ont peu faire les prophetes."

Because neither Melchizedek's birth nor his death is referred to in the Bible, he is without genealogy and therefore likened to Christ (see "Melchizedech," *Catholic Encyclopedia*, X, 156–157).

[47] Vloberg, *op. cit.*, p. 42.

[48] *Speculum Humanae Salvationis*, *loc. cit.*: "Ceste cene de Nostre Seigneur fu jadis prefiguree en l'aignel de Pasques, que les Juifz avoient acoustume de mengier le jeudi prochain devant le samedi de Pasques. Nostre Seigneur commanda aux enfans d'Israel qu'ilz mengaissent ledit aignel, lors qu'il delibera de les mettre hors de la captivite des Egyptiens. Samblablement Jhesu Crist institua adoncques premierement le saint sacrement de l'autel, quant il nous voult tirer hors de la puissance du diable."

[49] *Ibid.*, pp. 134–135: "Approchant le temps que Jhesu Crist vouloit souffrir mort et passion, il ordonna pour memoire perpetuele et establi la sainte communion de son sang et de son corps. . . . Ceci fu jadis prefigure en la sainte manne du ciel, qui fu donnee aux enfans d'Israel, lors qu'ilz estoient ou desert. . . . Jhesu Crist a envoye aux Juifz la sainte manne, qui est ung pain materiel et temporel, mais il nous a donne ung

pain trassubstancial et eternal. La sainte manne se appelloit le pain du ciel, et touteffois elle ne fu oncques dedens le vray ciel, ains fu cree de Dieu dedens l'air ou dedens le ciel plain de air. Certes Jhesu Crist, notre benoit sauveur, est le vray pain vif qui descendi du vray ciel et voult estre fait notre viande. Dieu donna tant seulement doncques aux Juifz la figure du vray pain, mais il nous a donne la verite du vray pain et non mie la figure. . . . Quant la sainte manne descendoit, lors avec elle descendoit la rousee du ciel, par quoy il est demoustre que a cellui qui est digne de recevoir le saint sacrement de l'autel, est aussi donnee la grace de Dieu."

[50] For other examples of Bouts's concern for pictorial composition at the expense of religious content, see Birkmeyer, *op. cit.*, pp. 105–110.

[51] Schöne (*op. cit.*, p. 93) cites this scene as a notable innovation of Bouts's triptych. In *Flanders in the Fifteenth Century: Art and Civilization*, p. 107, it is stated that the novelty of the scene was probably one of the reasons why the confraternity employed two doctors of theology. It may be, as Miss Janet Schaeffer, a former student, advised me, that the *Speculum* again suggested such a scene. In the discussion of the Meeting of Abraham and Melchizedek, we find a mystical concept derived from *The Golden Legend* which states that priests, because of their power to consecrate the body of Christ, surpass prophets, patriarchs, and angels. (See n. 45 above.) The patriarch Abraham bows to the priest Melchizedek, a prototype of Christ. The prophet Elijah and the angel do not literally bend before a priest, but are used as prefigurations of the central scene in which Christ is shown as priest.

[52] Genesis 14:17–20; Exodus 12:1–28; Exodus 16:11–35; I Kings 19:4–8.

[53] The wings were sawed apart and sold as four separate panels sometime before the nineteenth century. The fact that no one knew the original order of the scenes prompted a series of hypothetical arrangements by art historians, such as Friedländer (*op. cit.*, III, 21–22), Schöne (*op. cit.*, p. 90), and many others. The loss of a tight iconological unity made it impossible to establish the order with certainty according to the subjects. Thus most of the suggestions were based on esthetic considerations, primarily matters of composition. In 1960 in a singular display of common sense, R. Lefève and F. van Molle found the final solution by turning to the back and the sawed edges of the wings and matching the grain of the wood. Their solution corresponded to one of several proposed by Friedländer in 1925. See their article, "De oorspronkelijke schikking van de luiken van Bouts' Laatste Avondmaal," *Bulletin de l'Institut royal du patrimoine artistique*, III (1960), 5–19. For a résumé of the history of the wings and a bibliography of material relating to them, see *Flanders in the Fifteenth Century: Art and Civilization*, pp. 102–107.

[54] See chap. 1, n. 13.

[55] See the copy of the contract, n. 43 above. The shewbread reference is from Leviticus 24:5–9.

[56] Schöne, *op. cit.*, pp. 91, 241, doc. 63. The fact that they were gilded does not necessarily mean that they were not also painted. See also *Flanders in the Fifteenth Century*, p. 106.

7. The Martyrdom of St. Erasmus Altarpiece

[1] Wolfgang Schöne, following Van Even, concludes that the altarpiece was begun shortly before 1466 (*Dieric Bouts und seine Schule* [Berlin and Leipzig, 1938], p. 84). We know that the "Blessed Sacrament" was not put into place until 1468 and that Bouts was not supposed to work on any other piece until he had completed it. (See the contract, chap. vi, n. 43.) One wonders if the second commission for the confraternity kept Bouts from completing the exterior of the wings of the "Blessed Sacrament" altarpiece.

[2] For the life of St. Erasmus, see Louis Réau, *Iconographie de l'art chrétien* (6 vols.; Paris, 1955), III, pt. 1, pp. 437–440; Karl Künstle, *Ikonographie der christlichen Kunst* (2 vols.; Freiburg, 1928), II, 210–213; Nancy Bell, *Lives and Legends of the Great Hermits and Fathers of the Church with Other Contemporary Saints* (London, 1902), pp. 40–41; Alban Butler, *Butler's Lives of the Saints*, ed. H. Thurston and D. Attwater (4 vols.; London, 1956), II, 453–454.

[3] This opinion is shared by Charles Cahier (*Caractéristiques des saints dans l'art populaire* [2 vols.; Paris, 1867], I, 362) and Réau (*op. cit.*, III, pt. 1, p. 438), but not by Josef Braun (*Tracht und Attribute der Heiligen in der Deutschen Kunst* [Stuttgart, 1943], pp. 227–229).

[4] The fourteen auxiliary saints were George, Blasius, Erasmus, Pantaleon, Vitus, Christopher, Denis, Cyriacus, Acacius, Eustace, Giles, Margaret, Barbara, and Catherine of Alexandria.

[5] Réau, *loc. cit.*

[6] De Smet is sometimes called Gerardus Fabri. For the few documents that bear his name, see Schöne, *op. cit.*, pp. 84–85, 239–240, doc. 53. Edward van Even records the same findings which include the use of both names (*Louvain dans le passé et dans le présent* [Louvain, 1895], p. 327).

[7] The inscription on the frame which reads "Opus Theodorici Bouts Anno MCCCC4XVIII" dates from 1889 (see Schöne, *op. cit.*, p. 85).

[8] *Ibid.*

[9] The two inscriptions on the exterior were painted in the nineteenth century when the piece was restored. They read: "Hemlingii picturam novae tabulae ab L. Mortemard inductam MDCCCXXXX. Coloribus accurate interpolavit Carolus de Cauver MDCCCXXXXIII" (*ibid.*).

[10] B. J. Kidd, *The Later Medieval Doctrine of the Eucharistic Sacrifice* (London, 1958), pp. 27–28.

[11] *Ibid.*

[12] Schöne, *op. cit.*, pp. 84–85.

[13] He died in 1469 (*ibid.*).

[14] St. Bernard died in 1153 and was canonized in 1174. He was called the Illustrious Doctor by Innocent III in 1204. He was created a Doctor of the Church in 1830 by Pius VIII. For an account of the life of St. Bernard, see Réau, *op. cit.*, III, pt. 1, pp. 207–216.

[15] For a short summary of the life and iconography of St. Jerome, see Réau, *op. cit.*, III, pt. 2, pp. 740–750.

[16] Even (*Louvain dans le passé*, p. 312) records that the Chapter of the Second Foundation of the Church, which was granted by Pope Eugene IV in 1443, was made up exclusively of members of the university. Before this date, in 1426, the provost of the church became the chancellor of the university.

8. The Portinari Altarpiece

[1] Erwin Panofsky (*Early Netherlandish Painting* [2 vols.; Cambridge, Mass., 1953], I, 332–334) first revealed the meaning of this symbolism. I have here summarized his findings along with the discoveries made by Robert M. Walker, "The Demon of the Portinari Altarpiece," *Art Bulletin*, XLII (Sept., 1960), 218–219; M. B. McNamee, "Further Symbolism in the Portinari Altarpiece," *Art Bulletin*, XLV (June, 1963), 142–143; and Robert A. Koch, "Flower Symbolism in the Portinari Altar," *Art Bulletin*, XLVI (March, 1964), 70–77. See also Friedrich Winkler, *Das Werk des Hugo van der Goes* (Berlin, 1964), pp. 23–36.

[2] The hideous ghoul with claw extended was discovered by Robert Walker's sharp eye. It can be seen in a photograph in his article, cited in n. 1. For further discussion of the symbolism of the devil, see Koch, *op. cit.*, p. 72.

[3] Panofsky, *op. cit.*, I, 334. See also Joseph Destrée, *Hugo van der Goes* (Brussels and Paris, 1914), p. 98.

[4] See Anna Jameson, *Legends of the Madonna* (Boston and New York, 1861), p. 323.

[5] Panofsky, *op. cit.*, I, 333–334. See also Dom Gaspar Lefebvre, *Saint Andrew Missal* (Bruges, 1956), p. 59.

[6] For an informative and excellent discussion of the flower symbolism, see Koch, *op. cit.*

[7] This symbolism was discovered by Father McNamee; for a complete explanation see *op. cit.*, pp. 142–143.

[8] *Ibid.*, p. 143.

[9] For one example see the Christ Child in Rogier's Holy Family in the left panel of the "Miraflores" altarpiece (16).

[10] Bonaventure, *pseud.*, *Meditations on the Life of Christ: An Illustrated Manuscript*

of the Fourteenth Century, trans. Isa Ragusa, ed. Rosalie B. Green and Isa Ragusa (Princeton, 1961), pp. 31, 408–409.

¹¹ Rogier van der Weyden, "Visitation," Lütschena and Follower of Van der Weyden, "Visitation," Turin Gallery. Illus. Panofsky, *op. cit.*, II, pl. 174.

¹² Panofsky, *op. cit.*, I, 333.

¹³ This reversal has caused considerable discussion about the reason for the appearance of the saints and their identification. For a summary of the problems created and the present solution, see Panofsky, *op. cit.*, I, 333 n. 1.

¹⁴ *Ibid.*

¹⁵ *Ibid.*, I, 254. See either Rogier's "Annunciation" in the Louvre (illus. *ibid.*, II, pl. 173) or the Annunciation panel of the "Columba" altarpiece (14).

¹⁶ Panofsky discusses the reversal and attributes it to the influence of a French tradition (*ibid.*, I, 344 and n. 4).

¹⁷ *Ibid.*, I, 331.

¹⁸ Kurt S. Gutkind, *Cosimo de' Medici Pater Patriae, 1389–1464* (Oxford, 1938), pp. 174 n. 1, 182, 183, 203.

¹⁹ Aby Warburg, "Flandrische Kunst und Florentinische Frührenaissance Studien" (1902), in *Gesammelte Schriften* (2 vols.; Leipzig and Berlin, 1932), I, 197.

²⁰ *Ibid.*, p. 201. See also Richard Ehrenberg, *Capital and Finance in the Age of the Renaissance: A Study of the Fuggers and Their Connections*, trans. H. M. Lucas (New York, 1928), p. 198.

²¹ Gutkind, *op. cit.*, pp. 182 ff. Letters still exist which demonstrate how closely Cosimo watched his Bruges managers. If he was displeased with a manager's performance, it was not uncommon for him to send for the man and ask him to give an account of his activities. Cosimo respected Tommaso's quick intelligence, but, unlike his descendants, he realized Portinari had to be held in check. Cosimo sagaciously retained Agnolo Tani, a cautious, slow-witted individual, as Tommaso's partner. Upon making Portinari his partner, Piero sent Tani to the office in London. From then on the unrestrained branch manager grew more and more wealthy at the expense of the Medici. (See Gutkind, *loc. cit.*; and Ehrenberg, *op. cit.*, pp. 196 ff.)

²² Olivier de la Marche (*Mémoires*, III, 113) describes the wedding procession of Charles the Bold and Margaret: "Devant les marchands florentins marchoit Thomas Portunaire, chef de leur nacion, vestu comme les conseillers de Monseigneur le Duc, car il est de son conseil" (cited in Gutkind, *op. cit.*, p. 185 n. 1).

²³ Philippe de Commines records an example of this lavish lending. In 1471 Charles the Bold lent Edward IV 50,000 crowns to regain his kingdom; Tommaso gave the Duke security for this amount and soon after, security for 80,000 more (see Ehrenberg, *op. cit.*, pp. 196 ff.).

²⁴ Ferdinand Schevill, *History of Florence* (New York, 1936), p. 400.

²⁵ Ehrenberg, *op. cit.*, p. 197.

²⁶ Warburg, *op. cit.*, I, 200.

[27] Walter Paatz and Elisabeth Paatz, *Die Kirchen von Florenze* (6 vols.; Frankfurt, 1952–1955), IV, 2 n. 3.

[28] The best historical source for the location of the altarpiece is found in Giorgio Vasari (*Le Operi di Giorgio Vasari*, ed. G. Milanesi, I [Florence, 1878], 185): "Ugo d' Anversa, che fe la tavola di Santa Maria Nuova."

[29] Paatz and Paatz, *op. cit.*, I, 29.

[30] Janet Ross, *Old Florence and Modern Tuscany* (London, 1904), p. 61.

[31] *Ibid.*, p. 62.

[32] Paatz and Paatz, *op. cit.*, IV, 2, 5 ff.

[33] I believe that Robert Walker (*op. cit.*, p. 219) is incorrect in assuming this St. Giles to be the friend of St. Francis, the Blessed Giles of Assisi who died in 1262. The St. Giles of the Santa Maria Nuova church must be the popular medieval saint who lived during the seventh century in France (d. 712). The old Romanesque church, rebuilt by Bicci di Lorenzo, was already dedicated to this saint (Paatz and Paatz, *op. cit.*, IV, 2, 8). When the original church was built, the Blessed Giles, or Brother Egidius, had not yet been born. Furthermore, the coat of arms of the hospital was the crutch, a symbol of the French St. Giles, not the Italian (Ross, *op. cit.*, p. 63).

[34] Louis Réau, *Iconographie de l'art chrétien* (6 vols.; Paris, 1955), III, pt. 2, p. 595.

[35] Ross, *loc. cit.*

[36] Paatz and Paatz, *op. cit.*, IV, 5.

[37] Ross, *op. cit.*, p. 61.

[38] Illus. Raymond van Marle, *The Development of the Italian Schools of Painting* (19 vols.; The Hague, 1923–1938), IX, 12, fig. 6.

[39] Discussed and illustrated in *ibid.*, IX, 13 ff. and fig. 7.

[40] *Ibid.*, XIII, 471.

[41] *Ibid.*, X, 331, 376; Paatz and Paatz, *op. cit.*, IV, 24. The frescoes were probably whitewashed about 1650.

[42] Paatz and Paatz, *loc. cit.*

[43] *Ibid.*

[44] *Ibid.* Paatz and Paatz suggest that this painting may have been Monaco's "Adoration of the Kings" in the Uffizi, but give no reason for their suggestion.

[45] For a full discussion of the children's names and dates, see Aby Warburg, "Flandrische und Florentinische Kunst im Kreise des Lorenzo Medici um 1480" (1901), in *Gesammelte Schriften*, I, 209 ff. For Warburg's correction that Margherita and not Maria was their first child, see I, 378.

[46] Panofsky (*op. cit.*, I, 333 n. 1) discusses this evidence at length and concludes that the painting must have been commissioned before Guido was born and executed shortly thereafter.

[47] Warburg, *op. cit.*, I, 210.

[48] *Ibid.*

[49] Koch, *op. cit.*, p. 76.

[50] Panofsky, *op. cit.*, I, 338 ff.

[51] See the Monforte "Adoration," the Berlin "Nativity," and, by followers of Goes, the Lichtenstein "Adoration" and the Wilton House "Nativity," all illustrated in Panofsky, *op. cit.*, II, pls. 301, 312, 315.

[52] Illus. *ibid.*, II, pls. 298–300. For discussion see *ibid.*, I, pp. 338–340. The explanation for the unusual combination and the St. Genevieve who appears on the exterior may never be known without the discovery of the original commission of the piece. See Winkler (*op. cit.*, pp. 37–38) for a more recent discussion of the iconography. He relates the contrast between the two interior wings to earlier diptychs, such as Campin's in Leningrad.

[53] Illus. Panofsky, *op. cit.*, II, pls. 309–311. From the Holyrood Palace, on loan to the National Gallery of Scotland.

[54] The Church of the Holy Trinity was founded by Queen Mary, the widow of King James II of Scotland. Her son, James III, contributed a substantial amount of money for an organ for the church. The supposed wings for the organ were given by Sir Edward Boncle. On the exterior they depict the Holy Trinity, commemorating the dedication of the church, and on the right wing Sir Edward Boncle kneels next to an organ, obviously commemorating his gift. On the interior King James III is being crowned by the patron saint of Scotland, St. Andrew. His son, the future James IV, kneels at his side. The right wing depicts his wife Queen Margaret of Denmark and St. Canute, the patron of Denmark. (See *ibid.*, I, 335 ff.; Winkler, *op. cit.*, pp. 63–75.)

I have some doubts that the two panels were originally organ wings, as Panofsky concludes. On the exterior Goes has ingeniously directed the devotion of the provost toward the church and toward the gift of the organ in one representation. He has avoided the problem of focusing on the crack and has created a unique exterior representation. The interior wings are typical of the traditional use of donor portraiture for triptychs. Are we to believe that the devotees address their serious devotion to an organ? We have no other precedent in the work of Goes for this sort of iconographic mishandling. It would be more believable if it were the work of Memlinc or even of David, but I do not think it would be consistent with Goes's sense of religious rationality. The panels must originally have been wings of a triptych.

9. The Altarpiece of the Two St. Johns

[1] Ad. Duclos, *Bruges: Histoire et souvenirs* (Bruges, 1910), p. 300. In return, the city asked that the hospital be responsible for "the interment of all malefactors and undesirables of all kinds" (see Malcolm Letts, *Bruges and Its Past* [London and Bruges, 1926], p. 33).

[2] For information concerning the original building and its additions, see Duclos, *op. cit.*, pp. 32, 341, 499; and W. H. James Weale, *Bruges et ses environs* (Bruges, 1884), pp. 172 ff.

[3] Duclos, *op. cit.*, p. 499.

[4] Weale, *op. cit.*, p. 174.

[5] For the iconography of the tympanum, see p. 91, above. The portal sculpture dates from *ca.* 1270, the year in which the prophets and Apostles were placed into their niches (*ibid.*, p. 173).

[6] The original inscription on the frame reads: + OPUS + IOHANNIS + MEM-LINC + ANNO + M + CCCC + LXXIX + 1479 + ☩ +. For a complete technical discussion of the painting, see Paul Coremans, René Sneyers, and Jean Thissen, "Memlinc's Mystiek Huwelijk van de H. Katharina. Onderzoek en behandeling," *Bulletin de l'Institut royal du patrimoine artistique*, II (1959), 83–96.

[7] W. H. James Weale, *Hans Memlinc* (London, 1907), p. 39.

[8] At first only brothers officiated at the hospital; later sisters were added. Since 1397 they have followed the Augustinian rule (Duclos, *op. cit.*, p. 499).

[9] The Floreins triptych was given to the hospital in 1479 by brother Jan Floreins. He appears kneeling behind a wall to the left of the scene of the Adoration of the Magi in the center panel. His brother Jacques stands behind him (see Weale, *Memlinc*, pp. 32–33). The "Shrine of St. Ursula" was built to contain the relics of St. Ursula which the hospital already possessed. It was given to the hospital in 1489 by Josine de Dudzele and Anne van de Moortele, who are seen kneeling before the Madonna on one end of the shrine (illus. Karl Voll, *Memling: Des Meisters Gemälde* [Stuttgart and Leipzig, 1909], pp. 78–87).

[10] See Joan Evans, *Art in Medieval France, 987–1498* (London, New York, and Toronto, 1948), pp. 122, 130.

[11] For the identification of all the clerics, see Weale, *Memlinc*, pp. 39–40.

[12] Quoted from Weale by Fierens-Gevaert, *Histoire de le peinture flamande des origines à la fin du XVe siècle* (3 vols.; Paris and Brussels, 1927–1929), III, 63–64.

[13] Weale, *Bruges et ses environs*, p. 177 n. 1.

[14] *Ibid.*; and Edmond Pilon, *Bruges* (Paris, 1939), p. 77.

[15] Fierens-Gevaert, *op. cit.*, p. 63.

[16] *Ibid.*

[17] Fierens-Gevaert (*loc. cit.*) identifies him as Josse Willems. Weale (*Bruges et ses environs*, p. 176) identifies him as Jan Floreins.

[18] Cf. Jean Fouquet's illustration in the *Heures d'Etienne Chevalier* (illus. F. Al. Gruyer, *Les Quarante Fouquet* [Paris, 1900], p. 144, pl. xxxii). See also H. Bosch, "St. John on Patmos," in Dahlem Museum, Berlin (illus. Max J. Friedländer, *Die altniederländische Malerei* [14 vols.; Berlin, 1924–1933; Leiden, 1935–1937], V, Pl. LXVI); and the Limbourg brothers, *Très Riches Heures du duc de Berry*.

[19] The scene of the Disciples Visiting John in Prison is rarely seen in painting. The

best justification for identifying the barefooted men in the courtyard as two disciples is that Memlinc was probably aware of the story through the work of Rogier. It is represented in the St. John altarpiece—the second scene on the right in the archivolt above the scene of the Beheading of St. John. Here we have an example of Rogier's borrowing this unusual motif from the Baptistry doors in Florence by Pisano. Panofsky (*Early Netherlandish Painting* [2 vols.; Cambridge, Mass., 1953], I, 281 and n. 4) suggests that Rogier was probably also inspired by Pisano in the iconography of the Naming of John the Baptist. Memlinc does not use the Florentine and later Rogierian scheme of the two men looking into the prison window. Instead he places them near the entrance to the courtyard of Herod's palace.

[20] There seems to be some confusion as to whether or not the hospital was dedicated to John the Baptist and John the Evangelist or just to the Baptist. Coremans, Sneyers, and Thissen (*op. cit.*, p. 83), who have written the most recent work on the subject, claim it was dedicated to both St. Johns, whereas Edmond Pilon (*op. cit.*, p. 77) and others say that it was dedicated only to John the Baptist. The chapel dedication is unknown.

[21] Louis Réau, *Iconographie de l'art chrétien* (6 vols.; Paris, 1955), III, pt. 2, p. 713. See also Alexandre Masseron, *Saint Jean Baptiste dans l'art* (Paris, 1957), pp. 153–159.

[22] Réau, *loc. cit.*

[23] The former dating of *ca.* 1468 for the Donne triptych was based on the fact that Sir John Donne was in Bruges in 1468 for the marriage of Charles the Bold and Margaret of York and that he was believed to have been slain in the battle of Edgecote in 1469. The latter claim has been disproved, and the altarpiece may be dated as late as 1480. For a discussion of the triptych see the London National Gallery catalogue, *Acquisitions 1953–62* (London, 1963), pp. 60–64.

[24] For another example of Memlinc's repetition of this theme see the "Betrothal of St. Catherine" in the Metropolitan Museum of Art in which the Virgin, Catherine, and Barbara are in an almost identical position and dress as in the altarpiece of the two St. Johns.

[25] Duclos, *op. cit.*, p. 487; and Anna Jameson, *Legends of the Madonna* (Boston and New York, 1861), pp. 196–197.

[26] See p. 156 n. 9.

[27] Memlinc's borrowing of Rogierian motifs is widely known. For a few of the most obvious examples in which he took over whole Rogierian compositions, see the "Adoration of the Kings" altarpiece, Madrid, Prado; the Jan Floreins altarpiece, Bruges, hospital of St. John; the "Last Judgment" altarpiece, Danzig, Marienkirche; the "Deposition," Granada, Capilla Real; the "Annunciation," New York, Lehman Collection.

[28] For example, in Coremans, Sneyers, and Thissen, *op. cit.* Réau (*op. cit.*, III, pt. 1, p. 263) states that the Mystic Marriage of Catherine did not appear in the first edition of *The Golden Legend*, but appeared for the first time in the 1438 English edition by F. Jean de Bungay. Hence it is not represented very frequently until the fifteenth century. At that time it became a popular motif. Catherine soon became as identifiable by the mystic union

as by her sword and wheel. It gives her a unique proximity to the Christ Child, but it does not seem to carry additional meaning in scenes wherein she is represented with a group of other saints.

[29] Coremans, Sneyers, and Thissen, *op. cit.*, p. 83.

[30] Similarly, on the exterior wings of the Jan Floreins triptych the focal point is on the crack (see Karl M. Birkmeyer, "The Arch Motif in Netherlandish Painting of the Fifteenth Century," *Art Bulletin*, XLIII [June, 1961], 111). But in this instance the wings contain two saints in a landscape rather than kneeling donors whose veneration is scientifically fixed upon the crack.

[31] See my discussion, p. 12.

[32] Birkmeyer, *op. cit., passim.*

[33] *Ibid.*, pp. 16–20.

10. The Dissolution of the Triptych

[1] For information concerning the life of William Moreel and his family, see A. Janssens de Bisthoven, *Musée communal des beaux-arts Bruges (Musée Groeninge)*, (Antwerp, 1959), pp. 92 ff. For the earliest published material on the family, see W. H. James Weale, *Hans Memlinc* (London, 1907), pp. 40–41; and W. H. James Weale, "Généalogie de la famille Moreel," *Le Beffroi* (Bruges), II (1864–65), 179–196.

[2] Weale, "Généalogie," p. 180. Moreel's father had received the title in 1435 with the purchase of a landed estate from Roland de Cleyhem. As the eldest son, William had inherited both the land and the title.

[3] Weale, *Memlinc*, p. 41.

[4] Weale, "Généalogie," p. 181. Janssens de Bisthoven, following Friedländer, says that Moreel was burgomaster from 1478 to 1483. Weale states that Moreel was burgomaster in 1478 *and* 1483. The latter dates seem more plausible, since Moreel was imprisoned in 1481.

[5] Weale, "Généalogie," p. 181.

[6] Weale, *Memlinc*, pp. 40–41.

[7] Janssens de Bisthoven (*op. cit.*, p. 92) gives the names of all the children and, whenever possible, their dates of birth and death. See also Weale, "Généalogie," pp. 181–182.

[8] Along with these families, Charles the Bold was a major contributor, for he lived nearby and often frequented St. Jacques. For the construction and financing of St. Jacques, see Ad. Duclos, *Bruges: Histoire et souvenirs* (Bruges, 1910), pp. 480–481; and W. H. James Weale, *Bruges et ses environs* (Bruges, 1884), pp. 131–132.

[9] Janssens de Bisthoven, *op. cit.*, p. 94.

[10] *Ibid.*

[11] The marble slab that formerly covered the tomb may now be seen outside the southern door of the Church of St. Jacques, along with many others (Weale, *Bruges*, p. 150).

[12] Janssens de Bisthoven, *loc. cit.*

[13] *Ibid.*

[14] These two panels bear the arms of William and Barbara on the reverse and thus are identified with certainty. Because of the similarity of the portraits to those of the heads of William and Barbara in the St. Christopher triptych, the triptych is positively identified as belonging to them.

Erwin Panofsky (*Early Netherlandish Painting* [2 vols.; Cambridge, Mass., 1953], I, 294 n. 16) assumes that the two wings in Brussels must have been part of a triptych since William appears praying toward the right. According to custom, in a devotional diptych the man is always shown praying toward the left. In a triptych, however, the man would appear on the left wing praying toward the right, as William does in the Brussels panel, giving the lesser position on the right wing to his wife.

If the two portraits were originally part of a triptych, it would be unusual for the donors to appear without their patron saints. In Hugo van der Goes's Frankfurt triptych (illus. Panofsky, *op. cit.*, II, pl. 297), although the donors appear in three-quarter length, their patrons still stand behind them. It does not seem unlikely that Memlinc might have expanded the private devotional diptych, a favorite form with him, into the triptych, using two donors instead of one. He was familiar with the Braque triptych, the first triptych to use a series of bust-length figures, which correspond very closely in proportion to the Moreel portraits, although none of them are worldly personages.

The only problem with this new triptych form is the scale relationship between the holy figure and the donor. In the devotional diptych the holy image can easily be the same size and proportion as the donor since they are on panels of equal size. In a triptych, if the donors appear in bust position on the wings, it would be difficult to keep the central devotional image in proportion to these figures because of the three-to-two relationship. Any full-length figure would appear too small. If a single figure such as a bust-length Madonna is used, then the rest of the panel must be expanded with motifs like angels or architectural devices such as columns, arches, or a balcony. The other alternative is to use two bust-length central figures, such as the Man of Sorrows and the *Mater Dolorosa* or the Virgin praying before Christ.

[15] The interior of the triptych may have been completed as early as 1484. It must have been finished by 1489, for in that year the seventeenth child was born. Memlinc surely would have included her (Weale, "Généalogie," p. 185). For the most recent discussion of the triptych and a résumé of the bibliography and documents concerning the painting, see Henri Pauwels, *Catalogue—Musée Groeninge* (Bruges, 1963), pp. 36–37.

[16] There is some question about the identification of the three boys in the rear. X rays have revealed the figure of another child behind William, suggesting either a change in composition or an overpainting done while the painting was being executed. For a dis-

cussion of this change and the X-ray evidence, see Janssens de Bisthoven, *op. cit.*, p. 91 and Pls. CCXV, CCXVI, CCXVII; for an admittedly feeble attempt to explain the change, see *ibid.*, p. 97.

[17] For the legend of St. William of Aquitaine, see Louis Réau, *Iconographie de l'art chrétien* (6 vols.; Paris, 1955), III, pt. 2, pp. 624–626.

[18] Janssens de Bisthoven, *op. cit.*, p. 94 and Pl. CCXXVIII.

[19] Weale, *Memlinc*, pp. 43–44.

[20] For details of the heads of William and Barbara in the St. Christopher triptych, see Janssens de Bisthoven, *op. cit.*, Pls. CCXXIII, CCXXVII.

[21] Some examples are the school of Bruges triptych of "St. Jerome Penitent" in the Escorial; the anonymous "Life of St. James Major" in the collection of Madame de Argüelles, Madrid, dated between 1460 and 1480; the "Retable of Job" by the Master of the Catherine Legend and the Master of the Barbara Legend in the Wallraf-Richartz Museum in Cologne, dated *ca.* 1490; the "Life of St. Godelieve" by the Master of the Legend of St. Godelieve in the Metropolitan Museum, dated between 1470 and 1480. The numerous masters at the end of the century who are identified by the lives of the saints whom they painted, such as the Masters of the Barbara, Magdalen, Catherine, Ursula, and Godelieve legends, demonstrate the growing popularity of these themes. I have not, however, yet found a triptych whose center panel is devoted to the life of a saint which predates the work of Bouts.

[22] See chap. 7 and illus. 53.

[23] Dated *ca.* 1470–1480. For the iconography and reproductions of this work, see E. Haverkamp Begemann, "De Meester van de Godelieve-Legende, een Brugs schilder uit het einde van de XVᵉ eeuw," *Miscellanea Erwin Panofsky: Bulletin Musées royaux des beaux-arts* (Brussels), nos. 1–3 (March–Sept., 1955), pp. 185–199.

[24] Illus. Max J. Friedländer, *Die altniederländische Malerei* (14 vols.; Berlin 1924–1933; Leiden, 1935–1937), IV, Pl. LI. The Master of the Legend of St. Barbara was active about 1480.

[25] "School of Bouts—Legends of St. James," *Ten Primitives in the James E. Roberts Collection of Paintings* (Indianapolis: John Herron Art Institute, 1924). The work is dated 1470–1475.

[26] Attributed to the Master of the Magdalen Legend, active at the end of the fifteenth century and in the first half of the sixteenth century (Jos. de Coo, *Museum Mayer van den Bergh, Catalogue I* [Antwerp, 1960], p. 94, no. 363).

[27] This triptych belongs to the Escorial.

[28] Illus. Charles de Tolnay, *Hieronymus Bosch* (Basel, 1937): St. Anthony, pls. 37–53; Hermits, pls. 54–55; St. Julia, pls. 76–79.

[29] See pp. 75–76.

[30] See Wolfgang Schöne, *Dieric Bouts und seine Schule* (Berlin and Leipzig, 1938), pp. 39 f., 168 f.; *Flanders in the Fifteenth Century: Art and Civilization* (Detroit: Detroit Institute of Arts and the City of Bruges, 1960), pp. 108–112; and Friedrich Winkler, *Der Meister von Flémalle und Rogier van der Weyden* (Strassburg, 1913), pp. 51–54.

[31] All the burial records referred to here are found in Weale, "Généalogie," pp. 180 ff.

[32] See Paul Kristeller, *Andrea Mantegna* (London, New York, and Bombay, 1901), pp. 61–118.

[33] Réau, *op. cit.*, III, pt. 1, p. 305.

[34] From the Latin:

> Christophori Sancti speciem quicumque tuetur,
> Illo namque die nullo languore tenetur.

The inscription is quoted in Clara Clement Waters, *A Handbook of Christian Symbols and Stories of the Saints* (Boston, 1886), p. 85.

[35] From the French:

> Quand du grand saint Christophe on a vu le portrait
> De la mort, ce jour-là, on ne craint plus le trait.

The inscription is quoted in Réau, *op. cit.*, III, pt. 1, p. 306.

[36] Lucie Ninane suggests that St. Christopher may have been venerated by Moreel because of his protection of sea voyages. Moreel belonged to the Corporation of Grocers, and much of his wealth was due to the importation of precious commodities. See the catalogue, *Musée royaux des beaux-arts de Bruxelles, Art ancien* (Brussels, 1958), p. 13.

[37] For the life of St. Giles, see Réau, *op. cit.*, III, pt. 2, pp. 593–597. In this triptych he is identified by the faithful deer at his side and the arrow shot at both of them by the Visigothic king, Wamba. As a result of the incident he founded a Benedictine monastery of St. Giles near the mouth of the Rhone.

[38] K. Smits, *De Iconografie van de Nederlandsche Primitieven* (Amsterdam, 1933), p. 191.

[39] For the complete legend, see Réau, *op. cit.*, III, pt. 2, pp. 593 ff.; and Jacobus de Voragine, *The Golden Legend*, trans. William Caxton (1483) (7 vols.; London, 1900), V, 91–96.

[40] Weale, "Généalogie," p. 179.

[41] See Janssens de Bisthoven (*op. cit.*, p. 92) for identification of the saint as Maur rather than Benedict or Bernard.

[42] *Ibid.*, p. 95 (citing W. H. James Weale, *Catalogue du Musée de l'académie de Bruges* [Bruges and London, 1861], p. 25). Henri Pauwels (*op. cit.*, p. 36) believes that stylistic evidence indicates that the exterior wings were done at the same time as the interior.

[43] Weale, *Bruges*, p. 56.

[44] Although many of the plants are minutely presented and therefore identifiable, they seem to carry no symbolic significance which might aid the general interpretation (see Janssens de Bisthoven, *op. cit.*, p. 93; and Lottlisa Behling, *Die Pflanze in der mittelalterlichen Tafelmalerei* [Weimar, 1957], pp. 67–68).

[45] The two major sources for information regarding this altarpiece are Max Hasse, "Der Lübecker Passionsaltar Hans Memlings als Denkmal Mittelalterlicher Frömmigkeit," *Der Wagen* (1958), pp. 37–42; and Hans Schröder, *Der Passions-Altar des Hans Memling in Dom zu Lübeck* (Leipzig, 1937). The brief information regarding the Greverade

family comes from these authors. See also Max Hasse, *Lübeck Sankt Annen-Museum. Die Sakralen Werke des Mittelalters*, I (Lübeck, 1964), 37–39, 140–143. For the most complete reproductions of the altarpiece, see Carl Georg Heise, *Der Lübecker Passionsaltar von Hans Memling* (Hamburg, 1950).

[46] For the role of Bruges in the Hanseatic League see E. Gee Nash, *The Hansa: Its History and Romance* (London and New York, 1929), pp. 130 ff.

[47] Schröder, *op. cit.*, p. 6.

[48] *Ibid.*, p. 7.

[49] Hasse, "Der Lübecker Passionsaltar," p. 37.

[50] *Ibid.*; Schröder, *loc. cit.*

[51] Schröder, *loc. cit.*; Hasse, "Der Lübecker Passionsaltar," p. 38. Both paintings were destroyed during World War II.

[52] Memlinc painted many diptychs and triptychs. For examples of the latter, see the "Madonna Enthroned" in the Staatsgalerie, Vienna; the Jan Floreins triptych and the Adrian Reyns triptych in the hospital of St. John in Bruges; the "Resurrection" triptych in the Louvre; and the "Last Judgment" altarpiece in the Marienkirche in Danzig. He painted only one double-winged polyptych: the Greverade altarpiece.

[53] Hasse, "Der Lübecker Passionsaltar," p. 39.

[54] The following explanation is found in *ibid.*, pp. 38–39.

[55] *Ibid.*, p. 38.

[56] Weale, *Memlinc*, pp. 57–58; Friedländer, *op. cit.*, VI, p. 114, no. 3.

[57] Schröder, *op. cit.*, p. 6.

[58] In 1493 the brothers founded their funerary chapel in the north aisle of the Cathedral of Lübeck. Its altar was dedicated to the Holy Cross, the Blessed Virgin, and SS. John the Baptist, Jerome, Blasius, and Giles (Weale, *Memlinc*, pp. 57–58).

[59] The interior Crucifixion must have been selected by the Greverades, since it also appeared in the Rode diptych (Hasse, "Der Lübecker Passionsaltar," p. 41).

[60] *Ibid.*; and Réau, *op. cit.*, III, pt. 1, p. 228.

[61] Schröder, *op. cit.*, p. 8. Hasse ("Der Lübecker Passionsaltar," p. 40) adds that St. Giles may also have been associated with the cathedral. He was the patron of the nearby Church of St. Giles. The monks of this church were always loyal to the cathedral, whereas the monks of St. Catherine often spoke very critically of the clergy of the cathedral. Thus St. Giles was regarded as an adopted patron of the cathedral.

[62] For example, see the photograph of these wings in Karl Voll, *Die altniederländische Malerei von Jan van Eyck bis Memling* (Leipzig, 1906), pl. 100.

[63] Réau, *op. cit.*, III, pt. 1, pp. 227–233.

[64] Illus. Karl Voll, *Memling: Des Meisters Gemälde* (Stuttgart and Leipzig, 1909), pls. 32–39. Dated *ca.* 1480.

[65] Schröder (*op. cit.*, p. 14) also suggests that the three men under the cross of the Good Thief are perhaps all donors: Canon Adolphe, his brother Heinrich, and the nephew of the donors, Heinrich the Younger, who later executed his uncle's testament. This sug-

gestion merely points up our inability in these late triptychs to recognize donors who are obviously in a devotional attitude as well as those impersonating historical figures.

⁶⁶ For a discussion of his submission to Rogier, see Panofsky, *op. cit.*, I, 347 f.

⁶⁷ The loss of stylistic consistency might be explained on the basis of more than one artist. Weale (*Memlinc*, p. 57) believes that the two sets of exterior wings were done by a pupil of Memlinc's. But if so, the changes in attitude still are not explained. The scenes are too close to Memlinc both in style and in concept. If he did not complete them, he must have laid out the original scheme.

⁶⁸ Hasse, "Der Lübecker Passionsaltar," p. 41.

⁶⁹ Illus. Panofsky, *op. cit.*, II, pls. 293–295.

⁷⁰ Illus. *ibid.*, II, pl. 193.

⁷¹ Illus. *ibid.*, II, pl. 194.

⁷² Now in the London National Gallery (illus. Voll, *Memling*, pl. 18).

⁷³ In works like the Donne triptych, the donors are located in the center panel, in close proximity to the Virgin and Child, but they are placed in the most conventional way. They kneel before her, being presented by their patrons in a scheme familiar in funerary monuments for centuries. Though within the sacred environment, they neither play a dramatic role within a Christological scene nor activate and qualify the space, as did Van Eyck's donors when placed in an attitude of adoration before the Virgin. Memlinc's placement of donors is another of his archaisms.

⁷⁴ This triptych is presently located in the Musée communal in Bruges. For a résumé of its attributions, see Eberhard von Bodenhausen, *Gerard David und seine Schule* (Munich, 1905), p. 147 n. 3; and Janssens de Bisthoven, *op. cit.*, pp. 37–38. The latter includes copies of all the original documents surrounding the work. See also Pauwels, *op. cit.*, pp. 48–49.

⁷⁵ For the original research on this altarpiece and on the life of Jean des Trompes, see W. H. James Weale, "Triptyque du Baptême du Christ," *Le Beffroi* (Bruges), I (1863), 276–287; and Weale, "Généalogie de la famille des Trompes," *ibid.*, pp. 257–275. Weale's findings in these articles have been restated many times since. For the most complete discussion of the painting and its commission, see Janssens de Bisthoven, *op. cit.*, pp. 32–47 and Pls. LXXXVII–CXXVII. For a summary see *Flanders in the Fifteenth Century*, pp. 181–184.

⁷⁶ Weale, "Généalogie de la famille des Trompes," p. 259.

⁷⁷ *Ibid.* Curiously, although Trompes served Bruges loyally all his life, he remained a partisan of Maximilian. When Bruges revolted from the control of the Hapsburgs, he was almost put to death.

⁷⁸ *Ibid.*

⁷⁹ Janssens de Bisthoven, *op. cit.*, p. 34.

⁸⁰ For other borrowings in David's "Baptism" triptych, see Bodenhausen, *op. cit.*, p. 148.

[81] For the identification of many of the plants, see Janssens de Bisthoven, *op. cit.*, pp. 33–34; and Behling, *op. cit.*, p. 67.

[82] Panofsky, *op. cit.*, I, 351.

[83] Cf. Pls. CVIII, CXIII, CXIV, and CXXI in Janssens de Bisthoven, *op. cit.*

[84] Cf. Pls. CXIII and CXXI in *ibid.*

[85] *Ibid.*, pp. 37–38.

[86] Weale, *Bruges*, p. 162; illus. in Jean de Vincennes, *Eglises de Bruges* (Bruges, 1950), Basilique du Saint-Sang pl. 2. See n. 92, below.

[87] Weale, *Bruges*, p. 162. This group of men is referred to as the "Clercs du tribunal and the Clercs de Vierscaere."

[88] Vincennes, *op. cit.*, pp. 107–108.

[89] Janssens de Bisthoven, *op. cit.*, p. 38.

[90] *Ibid.*, p. 37.

[91] *Ibid.*

[92] *Ibid.*, pp. 35–36. There is a slight doubt as to whether or not the triptych was first intended for this chapel. Since the chapel was built at the time the altarpiece was commissioned, it seems peculiar that it was not placed there until after the death of Jean and almost twenty years after it was painted. It is assumed that Jean des Trompes's third wife carried out his original wishes (*ibid.*, pp. 37–38). At this time the Confraternity of the Clerks was asked to say a Mass for Jean des Trompes and the Holy Spirit on the feast day of SS. James and Christopher. This fact suggests another possibility for des Trompes's selection of the Baptism—a familial veneration of the Holy Spirit.

Bibliography

Alberti, Leon Battista. *On Painting*. Trans. John Spencer. New Haven, 1956.

Allen, J., and E. Gardner. *A Concise Catalogue of the European Paintings in the Metropolitan Museum of Art*. New York, 1954.

Baedeker, Karl. *Belgium and Holland*. Leipzig, London, and New York, 1910.

Baltzer, Johann, and F. Bruns. *Die Bau- und Kunstdenkmäler der Freien und Hansestadt Lübeck*. Vol. III. Lübeck, 1920.

Barbier de Montault, X. "Une Visite archéologique à Beaune," *Revue de l'art chrétien*, 4th sér., II (1891), 228–233.

Baudouin, F., and K. G. Boon. *Dieric Bouts. Palais des beaux-arts, Brussels 1957–1958 Museum Prinsenhof, Delft*. Brussels, 1957.

Bavard, Abbé Etienne. *L'Hôtel-Dieu de Beaune, 1443–1880*. Beaune, 1881.

Beaulieu, M., and J. Baylé. *Le Costume en Bourgogne de Philippe le Hardi à la mort de Charles le Téméraire (1364–1477)*. Paris, 1956.

Beenken, Hermann. *Rogier van der Weyden*. Munich, 1951.

Begemann, E. Haverkamp. "De Meester van de Godelieve-Legende, een Brugs schilder uit het einde van de XVᵉ eeuw," *Miscellanea Erwin Panofsky, Bulletin Musées royaux des beaux-arts* (Brussels), nos. 1–3 (1955), 185–199.

Behling, Lottlisa. *Die Pflanze in der mittelalterlichen Tafelmalerei*. Weimar, 1957.

Bell, Nancy. *Lives and Legends of the Great Hermits and Fathers of the Church with Other Contemporary Saints*. London, 1902.

Berthelot, Derenbourg, *et al.*, eds. *La grande Encyclopédie*. Paris, 1886–1902.

Bertholet, Father Jean. *Histoire de l'institution de la Fête-Dieu*. Liége, 1746.

Biographie nationale de Belgique. Brussels: L'Académie royale des sciences, des lettres et des beaux-arts de Belgique, 1911–1913.

Birkmeyer, Karl M. "The Arch Motif in Netherlandish Painting of the Fifteenth Century," *Art Bulletin*, XLIII (March, 1961), 1–20; (June, 1961), 99–112.

Bodenhausen, Eberhard von. *Gerard David und seine Schule*. Munich, 1905.

Bonaventure, *pseud. Meditations on the Life of Christ: An Illustrated Manuscript of the Fourteenth Century*. Trans. Isa Ragusa. Ed. Rosalie B. Green and Isa Ragusa. Princeton, 1961.

Bonaventure. *The Mirrour of the Blessed Lyf of Jesu Christ.* Trans. Nicholas Love (before 1410). London, Edinburgh, New York, and Toronto, 1908.

Bonaventure, St. *Meditations on the Supper of Our Lord and the Hours of the Passion.* Trans. Robert Manning of Brunne (*ca.* 1315–1330). Ed. J. Cowper. London, 1875.

Boudrot, Abbé J. B. *Fondation et statuts de l'Hôtel-Dieu de Beaune.* Beaune, 1878.

————. "Inventaire de l'Hôtel-Dieu de Beaune en 1501," *Société d'histoire, d'archéologie, et de littérature de l'arrondissement de Beaune, Mémoires* (1874).

————. *Le Jugement dernier, retable de l'Hôtel-Dieu de Beaune.* Beaune, 1875.

————. *Le petit Cartulaire de l'Hôtel-Dieu de Beaune.* Beaune, 1880.

Braun, Josef. *Das christliche Altargerät in seinem sein und in seiner Entwicklung.* Munich, 1932.

————. *Tracht und Attribute der Heiligen in der Deutschen Kunst.* Stuttgart, 1943.

Braunfels, Wolfgang. *Die Heilige Dreifaltigkeit.* Düsseldorf, 1954.

Brilioth, Yngve. *Eucharistic Faith and Practice, Evangelical and Catholic.* Trans. A. G. Herbert. London, 1961.

Butler, Alban. *Butler's Lives of the Saints.* Ed. H. Thurston and D. Attwater. London, 1956. 4 vols.

Cahier, Charles. *Caractéristiques des saints dans l'art populaire.* Paris, 1867. 2 vols.

Carlet, Joseph. *Le Jugement dernier, retable de l'Hôtel-Dieu de Beaune.* Beaune, 1884.

Carli, Enzo. *Guide to the Pinacoteca of Siena.* Milan, 1958.

Coo, Jos. de. *Museum Mayer van den Bergh, Catalogue I.* Antwerp, 1960.

Coremans, Paul, R. J. Gettens, and Jean Thissen. "La Technique des 'primitifs flamands.' Etude scientifique des matériaux, de la structure et de la technique picturale," *Studies in (Etudes de) Conservation,* I (1952), 1–29.

Coremans, Paul, René Sneyers, and Jean Thissen. "Memlinc's Mystiek Huwelijk van de H. Katharina. Onderzoek en behandeling," *Bulletin de l'Institut royal du patrimoine artistique,* II (1959), 83–96.

Cornell, Henrik. *The Iconography of the Nativity of Christ.* Uppsala, 1924.

Cuvelier, Joseph. *La Formation de la ville de Louvain des origines à la fin du XIVᵉ siècle.* Brussels, 1935.

————. *Les Institutions de la ville de Louvain au moyen âge.* Brussels, 1935.

Cyrot, Louis. "Les Bâtiments du grand Hôtel-Dieu de Beaune" (Notice chronologique sur leur fondation et leurs accroissements d'après les archives de cet hôpital, 1443–1878), *Société d'histoire, d'archéologie, et de littérature de l'arrondissement de Beaune, Mémoires* (1881), pp. 1–59.

Davidson, Samuel. *An Introduction to the Study of the New Testament.* London, 1868. 2 vols.

Delaissé, L. M. J. *La Miniature flamande à l'époque de Philippe le Bon.* Milan, 1956.

Denis, E. *Sainte Julienne et Cornillon.* Liége, 1927.

De Potter, F. *Second cartulaire de Gand.* Ghent, 1886.

De Schryver, A. P., and R. H. Marijnissen. *De oorspronkelijke plaats van het Lam Gods-*

retabel. *Nieuwe gegevens betreffende het van Eyck–probleem* (*Les Primitifs flamands*, III. *Contributions à l'étude des primitifs flamands*, 1). Antwerp, 1952.

De Smet, J. J. "Le Chevalier Bladelin surnommé Leestemakere et la ville de Middelbourg en Flandre," *Académie royale de Belgique, extrait des bulletins*, 2$^{\text{ième}}$ sér., XXII, no. 11 (1866), 1–11.

————. "Notice sur Middelbourg en Flandre," *Messager des sciences et des arts de la Belgique*, IV (1836), 333 ff.

De Smidt, F. *Krypte en Koor van de voomalige Sint-Janskerk te Gent.* Ghent, 1959.

Destrée, Joseph. *Hugo van der Goes.* Brussels and Paris, 1914.

Destrée, Jules. *Roger de la Pasture—van der Weyden.* Paris and Brussels, 1930. 2 vols.

De Tolnay, Charles. "Conceptions religieuses dans la peinture de Piero della Francesca," *Arte Antica e Moderna*, no. 23 (July–Sept., 1963), 205–241.

————. "Flemish Paintings in the National Gallery of Art," *Magazine of Art*, XXXIV (1941), 174–200.

————. *Hieronymus Bosch.* Basel, 1937.

————. *Le Maître de Flémalle et les frères van Eyck.* Brussels, 1939.

Dierick, Alfons. *Van Eyck, the Mystic Lamb.* Trans. Monique Odent. Ghent, 1958.

Dijon et Beaune et leurs environs. Guides diamant ed. Paris, 1921.

Dix, Gregory. *The Shape of the Liturgy.* London, 1945.

Doehlemann, Karl. "Die Entwicklung der Perspektive in der altniederländischen Kunst,'' *Repertorium für Kunstwissenschaft*, XXXIV (1911), 392–422, 500–535.

Duclos, Ad. *Bruges: Histoire et souvenirs.* Bruges, 1910.

Dumoutet, Edouard. *Le Désir de voir l'hostie.* Paris, 1926.

Ehrenberg, Richard. *Capital and Finance in the Age of the Renaissance: A Study of the Fuggers and Their Connections.* Trans. H. M. Lucas. New York, 1928.

Evans, Joan. *Art in Mediaeval France, 987–1498.* London, New York, and Toronto, 1948.

Even, Edward van. *L'ancienne Ecole de peinture de Louvain.* Brussels and Louvain, 1870.

————. "Le Contrat pour l'exécution du triptyque de Thierry Bouts, de la collégiale Saint-Pierre à Louvain (1464)," *Bulletin de l'Académie royale des sciences, des lettres et des beaux-arts de Belgique*, sér. 3, XXXV (1898), 469–479.

————. *Louvain dans le passé et dans le présent.* Louvain, 1895.

————. *Louvain monumental ou description historique et artistique de tous les édifices civils et religieux de la dite ville.* Louvain, 1860.

Fierens-Gevaert. *Histoire de la peinture flamande des origines à la fin du XVe siècle.* Paris and Brussels, 1927–1929. 3 vols.

————. *La Peinture en Belgique: les primitifs-flamands.* Brussels, 1908–1912. 4 vols.

Flanders in the Fifteenth Century: Art and Civilization. Catalogue of the exhibition "Masterpieces of Flemish Art: Van Eyck to Bosch." Detroit: Detroit Institute of Arts and the City of Bruges, 1960.

Fortescue, Adrian, and J. O'Connell. *The Ceremonies of the Roman Rite Described.* London, 1937.

Fortescue. *The Mass: A Study of the Roman Liturgy*. London, New York, and Toronto, 1955.

Friedländer, Max J. *Die altniederländische Malerei*. Vols. I–XI. Berlin, 1924–1933. Vols. XII–XIV. Leiden, 1935–1937.

Frinta, Mojmír. *The Genius of Robert Campin*. The Hague and Paris, 1966.

Gabelentz, Hans von der. *Die Biblia Pauperum und Apokalypse der Grossherzogl. Bibliothek zu Weimar*. Strassburg, 1912.

Gandelot, Abbé. *Histoire de la ville de Beaune et de ses antiquités*. Dijon, 1772.

Garrison, Edward B. *Italian Romanesque Panel Painting*. Florence, 1949.

Gerdts, William H. "The Sword of Sorrow," *Art Quarterly*, XVII (Autumn, 1954), 213–229.

Gilliat-Smith, Ernest. *The Story of Bruges*. London, 1905.

Gottlieb, Carla. "The Mystical Window in Paintings of the Salvator Mundi," *Gazette des beaux-arts*, pér. 6, LVI (Dec., 1960), 313–332.

Gruyer, F. Al. *Les Quarante Fouquet*. Paris, 1900.

Guiffrey, Jules. "Les Tapisseries de l'hôpital de Beaune," *Bulletin archéologique* (Paris, 1887), pp. 239–249.

Gutkind, Kurt S. *Cosimo de' Medici Pater Patriae, 1389–1464*. Oxford, 1938.

Hasse, Max. "Der Lübecker Passionsaltar Hans Memlings als Denkmal Mittelalterlicher Frömmigkeit," *Der Wagen* (1958), pp. 37–42.

――――. *Lübeck Sankt Annen-Museum. Die Sakralen Werke des Mittelalters*. Vol. I. Lübeck, 1964.

Hirn, Yrjö. *The Sacred Shrine*. Boston, 1957.

Hocquet, Adolphe. Article in *La Revue tournaisienne*, no. 7 (July, 1913), 157–159.

Huelsen, Charles. "The Legend of Aracoeli," *British and American Archeological Society of Rome Journal*, IV (Feb. 14, 1907), 39–48.

Hulin de Loo, Georges. *Bruges 1902. Exposition de tableaux flamands des XIVᵉ, XVᵉ et XVIᵉ siècles. Catalogue critique précédé d'une introduction sur l'identité de certains maîtres anonymes*. Ghent, 1902.

Jacobus de Voragine. *The Golden Legend*. Trans. G. Ryan and H. Ripperger. London, New York, and Toronto, 1941. 2 vols.

――――. *The Golden Legend*. Trans. William Caxton (1483). London, 1900. 7 vols.

Jameson, Anna. *Legends of the Madonna*. Boston and New York, 1861.

――――. *Sacred and Legendary Art*. London, 1905. 2 vols.

Janssens de Bisthoven, A. *Musée communal des beaux-arts (Musée Groeninge), Bruges (Les Primitifs flamands*, I. *Corpus de la peinture des anciens Pays-Bas méridionaux au quinzième siècle*, 1). 2d rev. and enl. ed. Antwerp, 1959.

Jungmann, Joseph. *The Mass of the Roman Rite: Its Origins and Development*. New York, Boston, Cincinnati, Chicago, and San Francisco, 1951. 2 vols.

Justi, Carl. "Altflandrische Bilder in Spanien und Portugal," *Zeitschrift für bildende Kunst*, XXI (1886), 93–98, 133–140; XXII (1887), 179–186, 244–251.

Kantorowicz, Ernst. "Ivories and Litanies," *Journal of the Warburg and Courtauld Institutes*, V (1942), 56–81.

Kern, G. J. *Die Grundzüge der linear-perspektivischen Darstellung in der Kunst der Gebrüder van Eyck und ihrer Schule*. Leipzig, 1904.

Kervyn de Lettenhove, H. *La Toison d'or*. Brussels, 1907.

Kervyn de Volkaersbeke, Philippe. *Les Eglises de Gand*. Ghent, 1857–1858. 2 vols.

Kidd, B. J. *The Later Medieval Doctrine of the Eucharistic Sacrifice*. London, 1958.

Kleinclausz, A. *Dijon et Beaune*. Paris, 1907.

Koch, Robert A. "Flower Symbolism in the Portinari Altar," *Art Bulletin*, XLVI (March, 1964), 70–77.

―――. "Two Sculpture Groups after Rogier's 'Descent from the Cross' in the Escorial," *Journal of the Walters Art Gallery*, XI (1947), 38–43.

Krautheimer, Richard, and T. Krautheimer-Hess. *Lorenzo Ghiberti*. Princeton, 1956.

Kristeller, Paul. *Andrea Mantegna*. London, New York, and Bombay, 1901.

Künstle, Karl. *Ikonographie der christlichen Kunst*. Freiburg, 1928. 2 vols.

Lafond, Paul. *Roger van der Weyden*. Brussels, 1912.

Lavin, Marilyn Aronberg. "The Altar of Corpus Domini in Urbino: Paolo Ucello, Joos van Ghent, Piero della Francesca," *Art Bulletin*, XLIX (March, 1967), 1–24.

Lefebvre, Dom Gaspar. *Saint Andrew Daily Missal*. Bruges, 1956.

Lefève, R., and F. Van Molle. "De oorspronkelijke schikking van de luiken van Bouts' Laatste Avondmaal," *Bulletin de l'Institut royal du patrimoine artistique*, III (1960), 5–19.

Leflaive, Anne. *L'Hôtel-Dieu de Beaune et les hospitalières*. Paris, 1959.

Leprieur, Paul. "Un Triptyque de Roger de la Pasture au Musée du Louvre," *Gazette des beaux-arts*, pér. 4, X (Oct., 1913), 257–280.

Letts, Malcolm. *Bruges and Its Past*. London and Bruges, 1926.

London National Gallery. *Acquisitions 1953–62*. (Catalogue of the exhibition of acquisitions, 1953–1962.) London, 1963.

Lugt, Frits, and J. Vallery-Radot. *Inventaire général des dessins des écoles du nord*. Paris: Bibliothèque nationale cabinet des étampes, 1936.

McNamee, M. B., S. J. "Further Symbolism in the Portinari Altarpiece," *Art Bulletin*, XLV (June, 1963), 142–143.

Mâle, Emile. *L'Art religieux de la fin du moyen âge en France*. Paris, 1931.

―――. "L'Art symbolique à la fin du moyen âge," II, *La Revue de l'art ancien et moderne*, XVIII (Sept., 1905), 195–209.

―――. *The Gothic Image: Religious Art in France of the 13th Century*. Trans. D. Nussey. New York, 1958.

―――. "Le Renouvellement de l'art par les 'mystères' à la fin du moyen âge," *Gazette des beaux-arts*, pér. 3, XXXI (Feb.–May, 1904), 89–106, 215–230, 282–301, 379–394.

Martindale, C. C. *St. John the Evangelist*. London, 1922. 2 vols.

Masseron, Alexandre. *Saint Jean Baptiste dans l'art.* Paris, 1957.

Meiss, Millard. " 'Highlands in the Lowlands': Jan van Eyck, the Master of Flémalle, and the Franco-Italian Tradition," *Gazette des beaux-arts*, pér. 6, LVII (May–June, 1961), 273–314.

Mély, Ferdinand de. "Le Retable de Beaune," *Gazette des beaux-arts*, pér. 3, XXXV (Jan., 1906), 21–38, 113–130.

———. "Signatures de primitifs: le retable de Roger de la Pasture au Musée du Louvre et l'inscription du turban de la Madeleine," *Revue archéologique*, sér. 5, VII (1918), 50–75.

Michel, Edouard. *L'Ecole flamande du XVe siècle au Musée du Louvre.* Brussels, 1944.

———. "Rogier van der Weyden et le Maître de Flémalle," *Revue de l'art ancien et moderne*, LVII (May, 1930), 267–276.

Michiels, Alfred. "Rogier van der Weyden, sa biographie," *Gazette des beaux-arts*, XXI (June–Aug., 1866), 201–225, 349–371.

Molanus, Johannes. *Historiae Lovaniensium libri xiv. Ex codice autographo edidit, commentario praevio de vita et scriptis Molani.* Brussels, 1851. 2 vols.

Montille, L. de. "Les Armes de Bourgogne et du chancelier Rolin de l'Hôtel-Dieu de Beaune," *Société d'histoire, d'archéologie, et de littérature de l'arrondissement de Beaune, Mémoires.* Beaune, 1879.

Moore, T. Sturge. *Albert Durer.* London and New York, 1905.

Murray, John. *Murray's Handbook of Florence and Its Environs.* London, 1863.

Musper, T. *Untersuchungen zu Rogier van der Weyden und Jan van Eyck.* Stuttgart, 1948.

Nash, E. Gee. *The Hansa: Its History and Romance.* London and New York, 1929.

Paatz, Walter. *Die Marienkirche zu Lübeck.* Burg, 1926.

Paatz, Walter, and Elisabeth Paatz. *Die Kirchen von Florenz.* Frankfurt, 1952–1955. 6 vols.

Panofsky, Erwin. *Early Netherlandish Painting.* Cambridge, Mass., 1953. 2 vols.

———. "Imago Pietatis." In *Festschrift für Max J. Friedländer zum 60. Geburtstage.* Pp. 261–308. Leipzig, 1927.

———. "Die Perspektive als 'symbolische Form,' " *Vorträgender Bibliothek Warburg* (1924–25), pp. 258–330.

———. "Reintegration of a Book of Hours Executed in the Workshop of the 'Maître des Grandes Heures de Rohan.' " In *Medieval Studies in Memory of A. Kingsley Porter.* Ed. W. Koehler. Vol. 2, pp. 479–499. Cambridge, Mass., 1939.

———. *Renaissance and Renascences in Western Art.* Uppsala, 1960. 2 vols.

Parsch, Pius. *The Liturgy of the Mass.* St. Louis and London, 1945.

Pauwels, Henri. *Catalogue—Musée Groeninge.* Bruges, 1963.

Peeters, Ferd. *Le Triptyque eucharistique de Thierry Bouts à l'église Saint-Pierre de Louvain.* Léau, 1926.

Perier, Arsène. *Un Chancelier au XVe siècle: Nicolas Rolin, 1380–1461.* Paris, 1904.

Perry, Mary Phillips. "On the Psychostasis in Christian Art," *Burlington Magazine*, XXII (1912–13), 94–105, 208–218.

Pilon, Edmond. *Bruges*. Paris, 1939.

Piot, Ch. "Un Tableau de Roger van der Weyden," *Revue d'histoire et d'archéologie*, III (1862), 197–203.

Réau, Louis. *Iconographie de l'art chrétien*. Paris, 1955. 6 vols.

Reinach, Salomon. "Simon de Cyrène," *Cultes, mythes et religions* (Paris), IV (1912), 181–188.

Rhein, André. "Hôtel-Dieu, Beaune." In *Congrès archéologique de France, 91 session*. Pp. 320–327. Dijon, 1928.

Richartz, Eduard Firmenich. "Rogier van der Weyden, der Meister von Flémalle," *Zeitschrift für bildende Kunst* (Leipzig), XXXIV (1899), 129–144.

Ringbom, Sixten. *Icon to Narrative*. Acta Academiae Aboensis, Ser. A, XXXI, no. 2. Abo, 1965.

Robb, David M. "The Iconography of the Annunciation in the Fourteenth and Fifteenth Centuries," *Art Bulletin*, XVIII (Dec., 1936), 480–526.

Rorimer, James. *The Metropolitan Museum of Art, the Cloisters Catalogue*. New York, 1951.

Ross, Janet. *Old Florence and Modern Tuscany*. London, 1904.

Rowlands, John. "A Man of Sorrows by Petrus Christus," *Burlington Magazine*, CIV (Oct., 1962), 419–423.

Sanderus, Antonius. *Flandria Illustrata*. Cologne, 1641–1644. 3 vols.

Schevill, Ferdinand. *History of Florence*. New York, 1936.

Schöne, Wolfgang. *Dieric Bouts und seine Schule*. Berlin and Leipzig, 1938.

———. *Die grossen Meister der niederländischen Malerei des 15. Jahrhunderts*. Leipzig, 1939.

Schröder, Hans. *Der Passions-Altar des Hans Memling im Dom zu Lübeck*. Leipzig, 1937.

Simson, Otto von. "*Compassio* and *Co-redemptio* in Roger van der Weyden's *Descent from the Cross*," *Art Bulletin*, XXXV (March, 1953), 9–16.

———. *Sacred Fortress*. Chicago, 1948.

Smits, K. *De Iconografie van de Nederlandsche Primitieven*. Amsterdam, 1933.

Speculum Humanae Salvationis. Trans. Jean Miélot (1448). Ed. J. Lutz and P. Perdrizet. Mulhouse, 1907–1909. 2 vols.

Stechow, Wolfgang. *Northern Renaissance Art, 1400–1600*. Sources and Documents in the History of Art Series. Englewood Cliffs, N.J., 1966.

Stein, Henri. *L'Hôtel-Dieu de Beaune*. Paris, 1933.

Teasdale-Smith, Molly. "The Use of Grisaille as a Lenten Observance," *Marsyas*, VIII (1959), 43–54.

Ten Primitives in the James E. Roberts Collection of Paintings. Indianapolis: John Herron Art Institute, 1924.

"Un Triptyque de Roger van der Weyden," *Le Beffroi* (Bruges), I (1863), 105–111.

Troescher, Georg. "Die 'Pitié-de-Nostre-Seigneur' oder Notgottes," *Wallraf-Richartz Jahrbuch*, IX (1936), 148–168.

Uberwasser, Walter. *Rogier van der Weyden. Paintings from the Escorial and Prado Museum*. London, 1947.

Van Gelder, J. G. "An Early Work by Robert Campin," *Oud Holland*, LXXXII, pt. 1/2 (1967), 1–17.

Van Marle, Raymond. *The Development of the Italian Schools of Painting*. The Hague, 1923–1938. 19 vols.

Vasari, Giorgio. *Le Operi di Giorgio Vasari*. Ed. G. Milanesi. Vol. I. Florence, 1878.

Verhaegen, Baron. "Le Polyptyque de Beaune." In *Congrès archéologique de France, 91 session*. Pp. 327–350. Dijon, 1928.

Verschelde, Karel. *Geschiedenis van Middelburg in Vlaenderen*. Bruges, 1867.

———. "Testament de Pierre Bladelin Fondateur de Middelbourg en Flandre," *Annales de la Société d'émulation pour l'étude de l'histoire et des antiquités de la Flandre, Bruges*, 4ᵉ sér., III (1879), 1–32.

"La Vierge aux Sept Glaives," *Analecta Bollandiana*, XII (1893), 333–352.

Vincennes, Jean de. *Eglises de Bruges*. Bruges, 1950.

Vloberg, Maurice. *L'Eucharistie dans l'art*. Paris, 1946.

Voillery, Abbé. "A quel Titre saint Sébastien est patron du chancelier Rolin et saint Antoine de Guigone de Salins," *Société d'archéologie de Beaune, Mémoires* (1906–07).

Voll, Karl. *Die altniederländische Malerei von Jan van Eyck bis Memling*. Leipzig, 1906.

———. *Memling: Des Meisters Gemälde*. Klassiker der Kunst, XIV. Stuttgart and Leipzig, 1909.

Walker, Robert M. "The Demon of the Portinari Altarpiece," *Art Bulletin*, XLII (Sept., 1960), 218–219.

Warburg, Aby. *Gesammelte Schriften*. Leipzig and Berlin, 1932. 2 vols.

Waters, Clara Clement. *A Handbook of Christian Symbols and Stories of the Saints*. Boston, 1886.

Weale, W. H. James. *Bruges et ses environs*. Bruges, 1884.

———. "Généalogie de la famille des Trompes, "*Le Beffroi* (Bruges), I (1863), 257–276.

———. "Généalogie de la famille Moreel," *Le Beffroi* (Bruges), II (1864–65), 179–196.

———. *Hans Memlinc*. London, 1907.

———. "Triptyque du Baptême du Christ," *Le Beffroi* (Bruges), I (1863), 276–287.

White, John. *The Birth and Rebirth of Pictorial Space*. London, 1957.

Winkler, Friedrich. *Der Meister von Flémalle und Rogier van der Weyden*. Strassburg, 1913.

———. *Das Werk des Hugo van der Goes*. Berlin, 1964.

Index

Illustrations

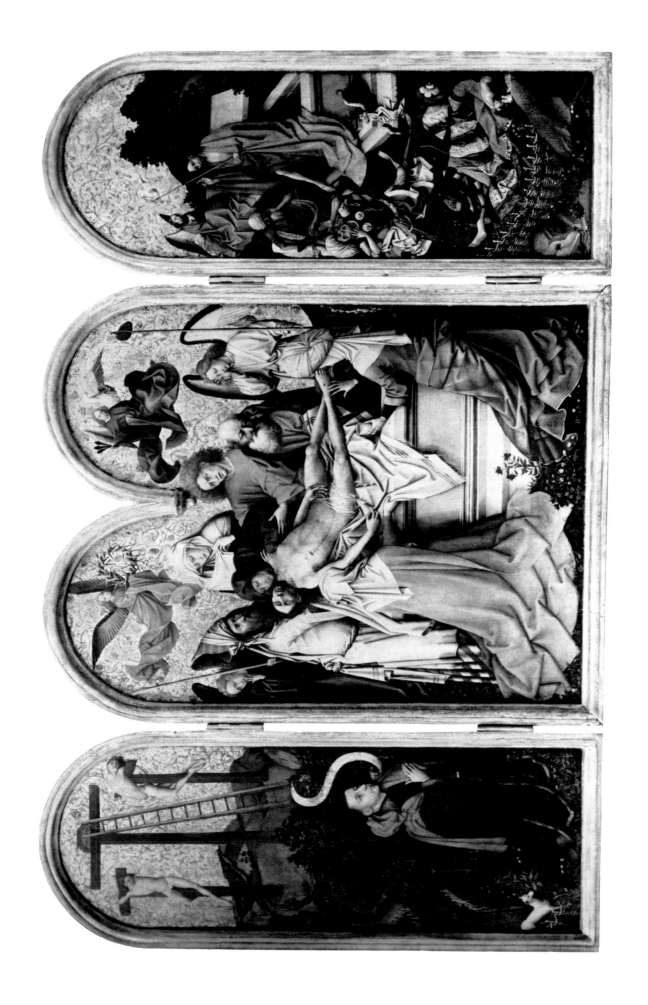

1. Robert Campin: Seilern altarpiece. London, Count Antoine Seilern Collection.

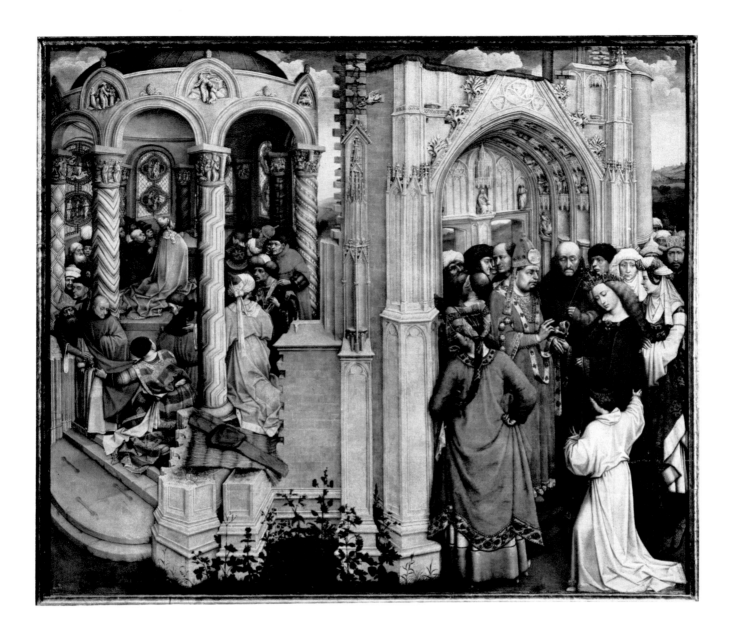

2. Robert Campin: Betrothal of the Virgin. Madrid, Prado. *Copyright ACL Brussels.*

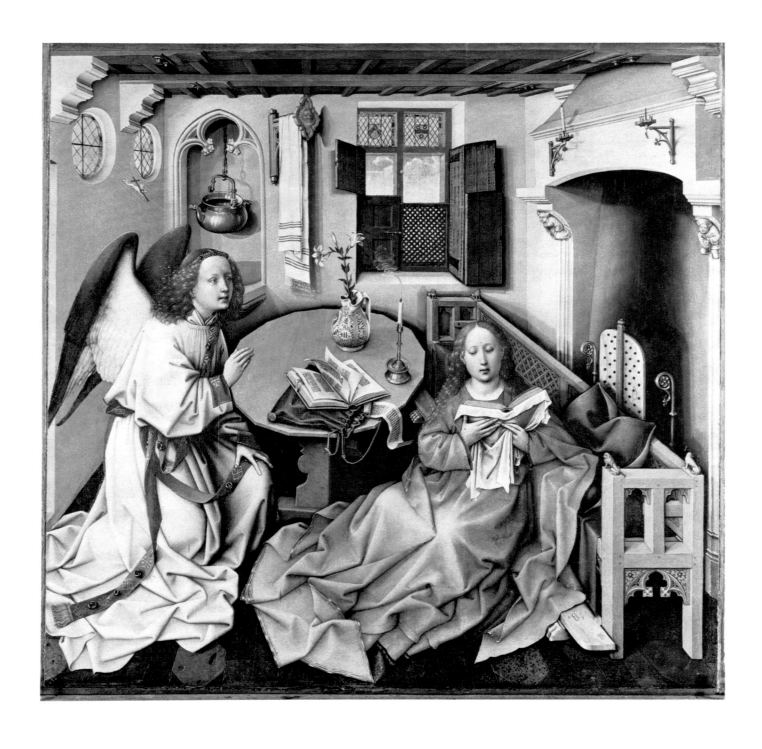

3. Robert Campin: Annunciation, center panel of Mérode altarpiece. New York, The Metropolitan Museum of Art, The Cloisters Collection, purchase.

11. Hubert and Jan van Eyck: Ghent altarpiece, interior. Ghent, Cathedral of St. Bavon. *Copyright ACL Brussels.*

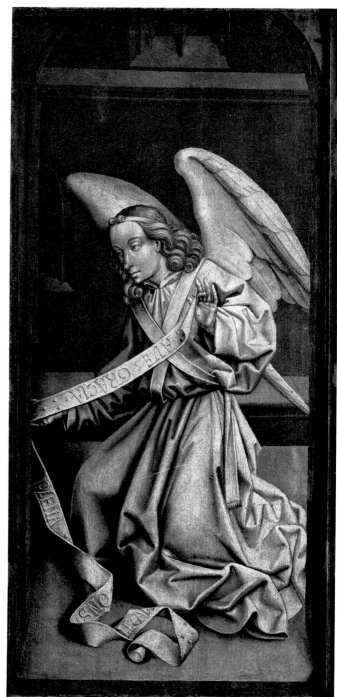

12. Follower of Rogier van der Weyden: Annunciation, exterior of Bladelin altarpiece. Staatliche Museen Berlin, Gemäldegalerie Dahlem.

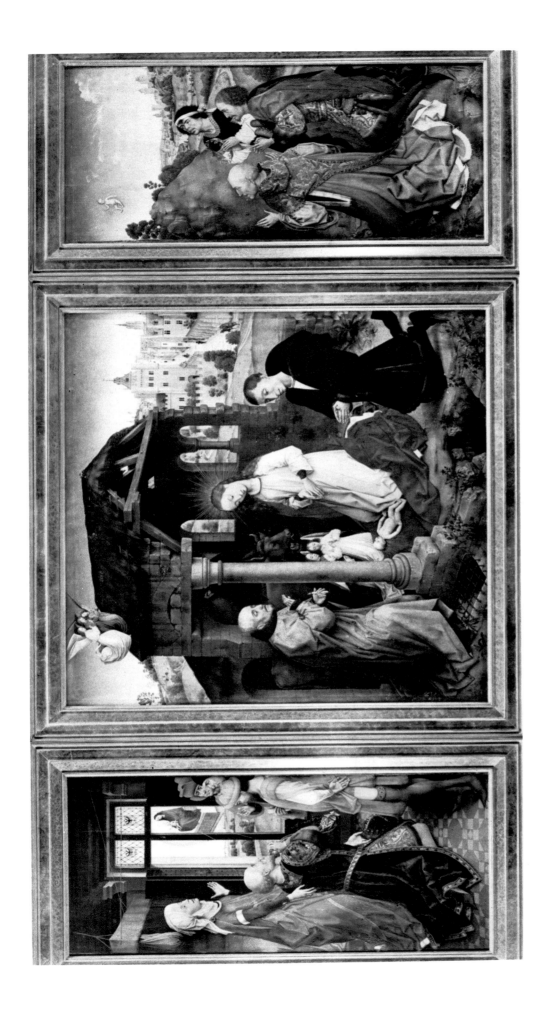

13. Rogier van der Weyden: Bladelin altarpiece, interior. Staatliche Museen Berlin, Gemäldegalerie Dahlem.

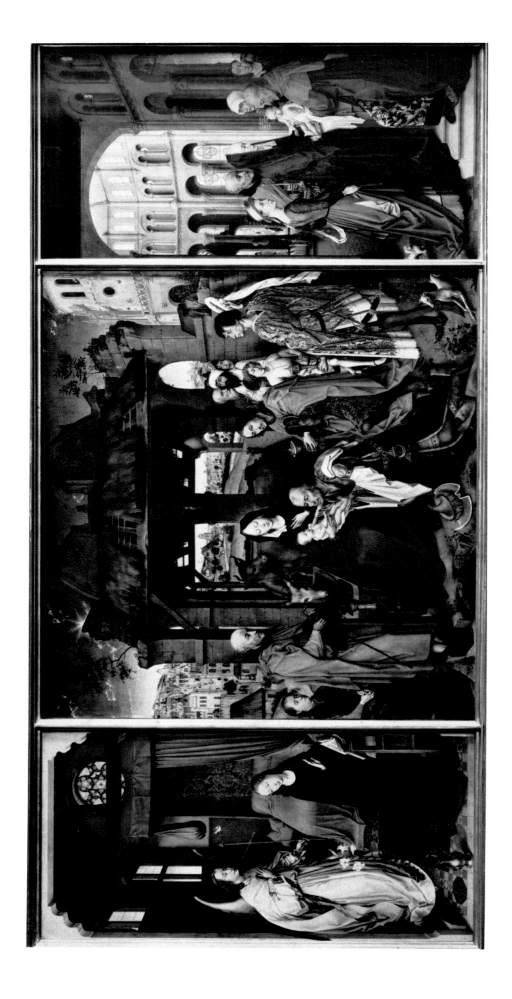

14. Rogier van der Weyden: Columba altarpiece. Munich, Alte Pinakothek.

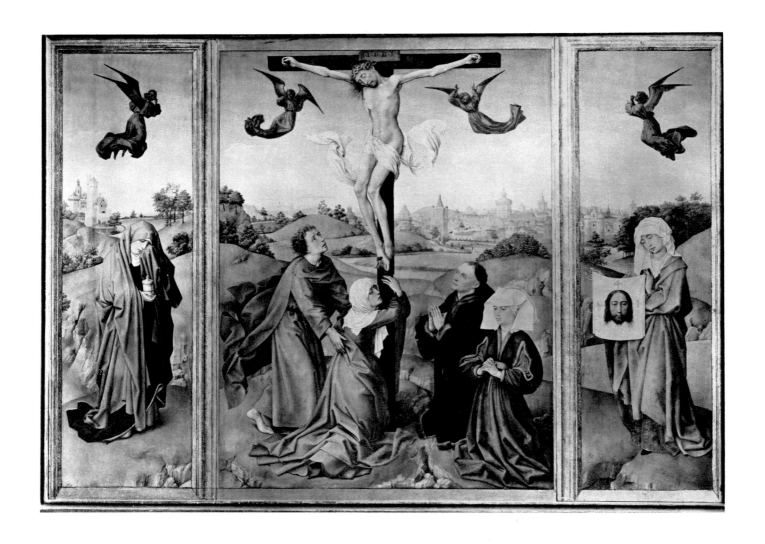

15. Rogier van der Weyden: Crucifixion with Donors. Vienna, Kunsthistorisches Museum.

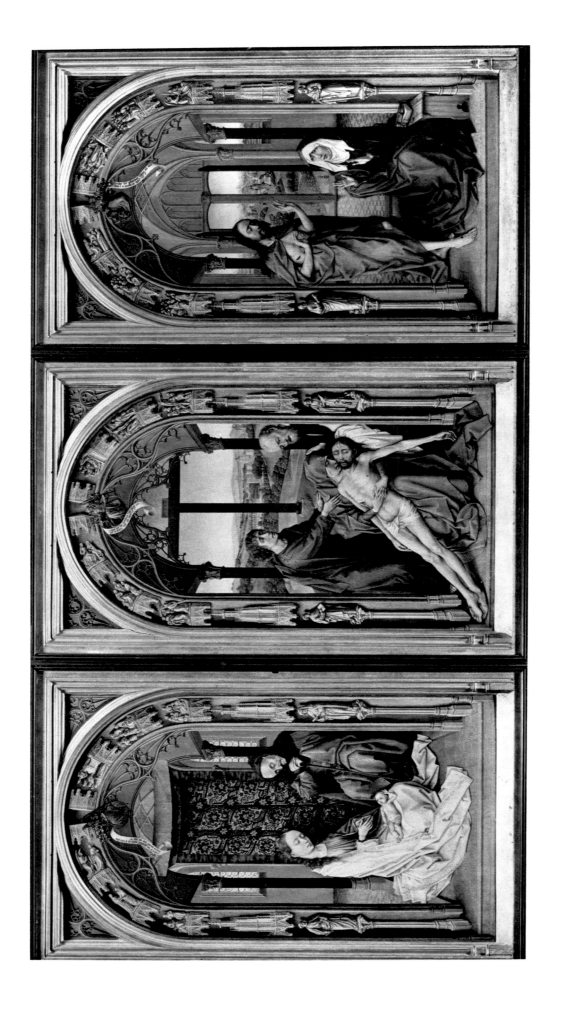

16. Rogier van der Weyden: Miraflores altarpiece. Staatliche Museen Berlin, Gemäldegalerie Dahlem.

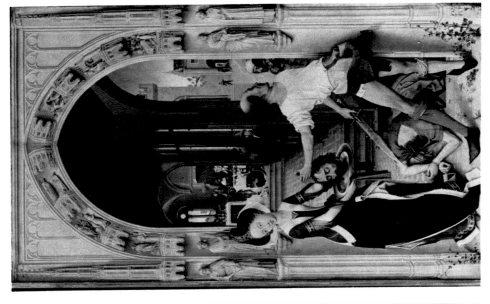

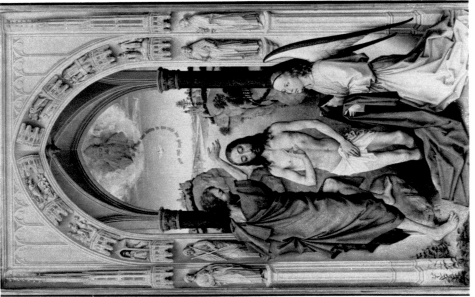

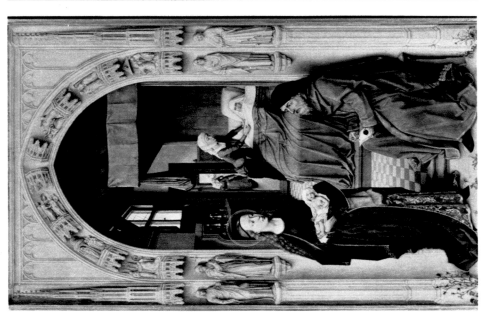

17. Rogier van der Weyden: St. John altarpiece. Staatliche Museen Berlin, Gemäldegalerie Dahlem.

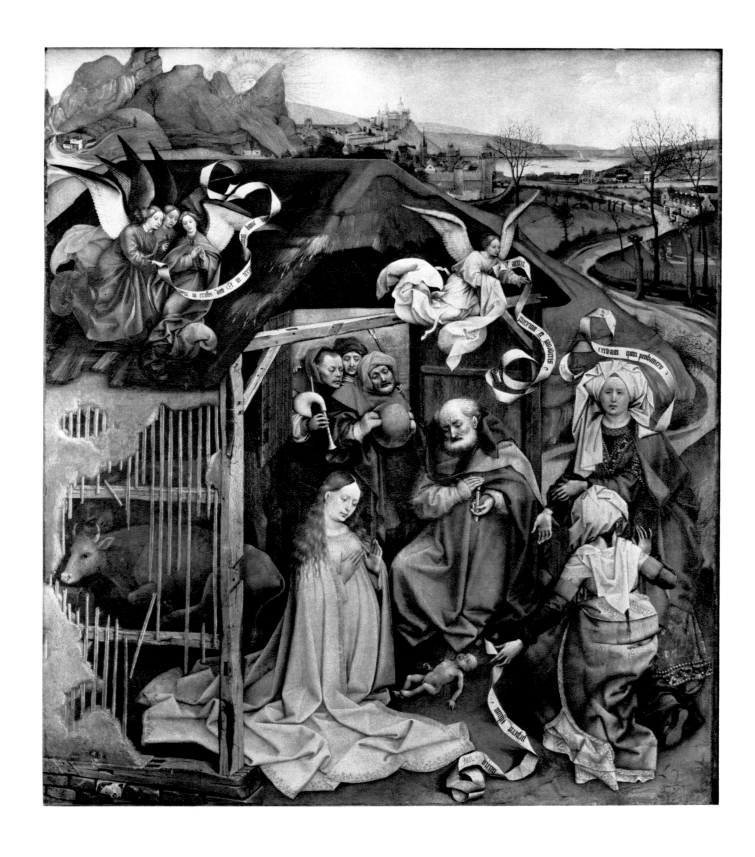

18. Robert Campin: Nativity. Dijon, Musée de la Ville. *Archives photographiques, Paris.*

19. Rogier van der Weyden: David Receiving the Cistern Water (fragment). Formerly
Paris, Schloss Collection.

20. Middelburg, Church of SS. Peter and Paul, choir with tomb of Peter Bladelin.

21. Drawing by Antonious Sanderus: Bladelin's chateau in Middelburg. *Flandria Illustrata*.

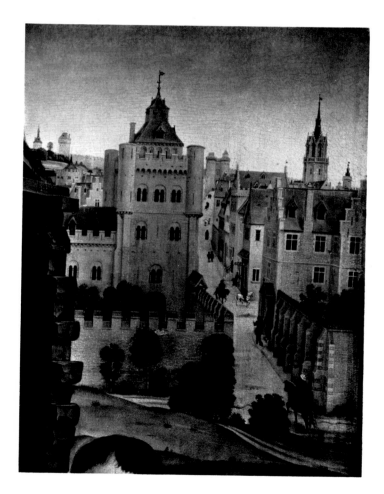

22. Rogier van der Weyden: Bladelin's chateau, detail of illus. 13.

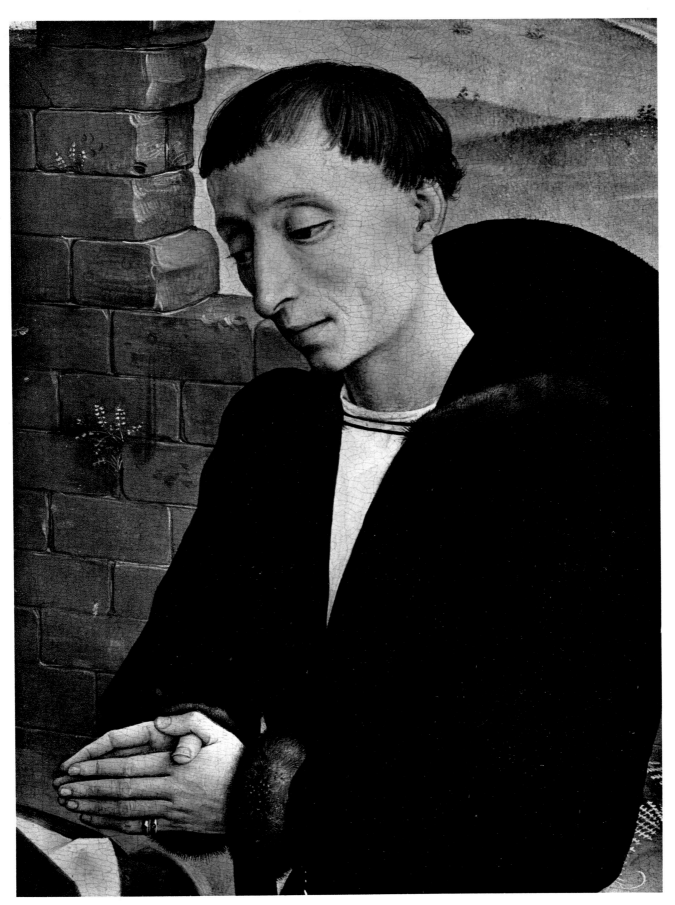

23. Rogier van der Weyden: Peter Bladelin, detail of illus. 13.

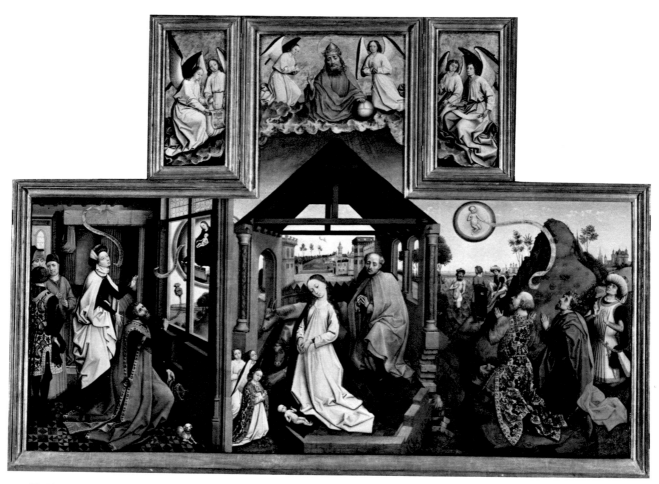

24. Follower of Rogier van der Weyden: Center panels of Nativity altarpiece. New York, The Metropolitan Museum of Art, The Cloisters Collection, 1949.

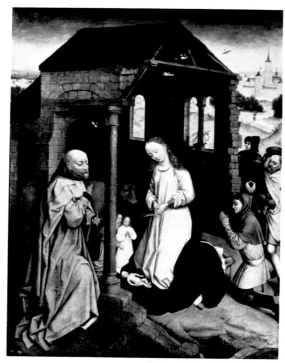

25. Follower of Rogier van der Weyden: Nativity. Whereabouts unknown. *Photograph courtesy of Minneapolis Institute of Arts.*

26. Rogier van der Weyden: Braque altarpiece, exterior. Paris, Louvre. *Copyright ACL Brussels.*

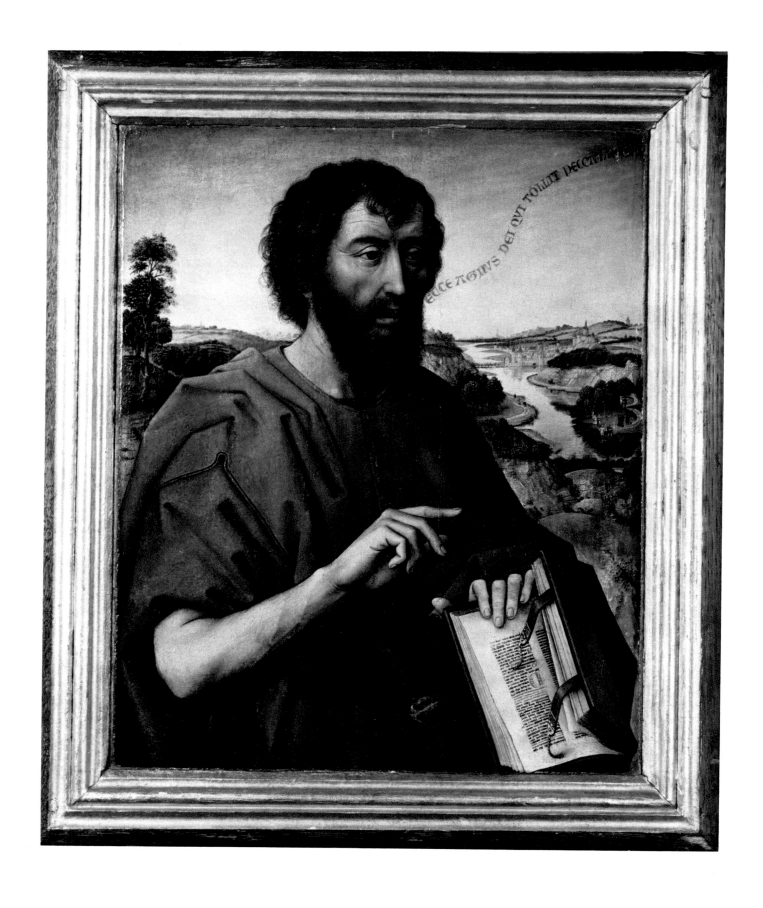

27. Rogier van der Weyden: St. John the Baptist, left wing of Braque altarpiece. Paris, Louvre. *Copyright ACL Brussels.*

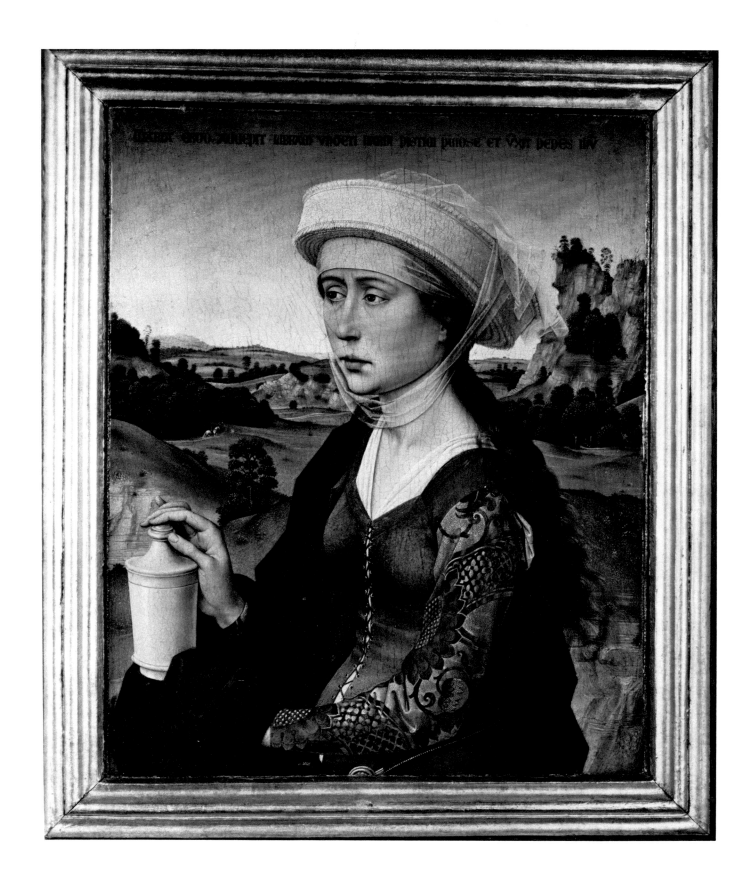

28. Rogier van der Weyden: Mary Magdalen, right wing of Braque altarpiece. Paris, Louvre. *Copyright ACL Brussels.*

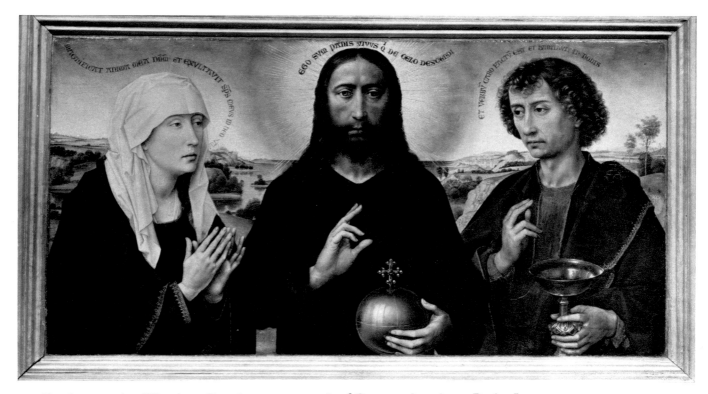

29. Rogier van der Weyden: Deesis, center panel of Braque altarpiece. Paris, Louvre.
Copyright ACL Brussels.

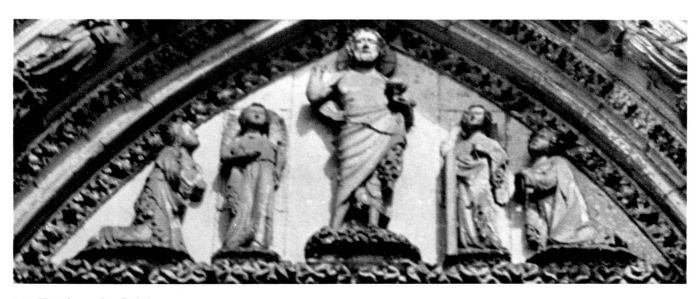

30. Favières, St. Sulpice, tympanum.

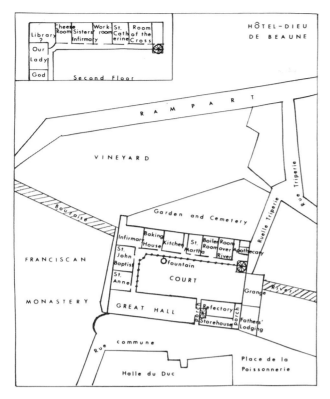

31. Beaune, Hôtel-Dieu, plan.

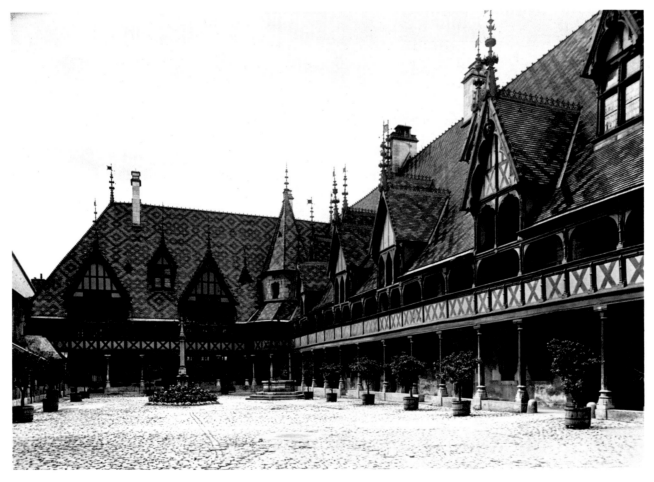

32. Beaune, Hôtel-Dieu, interior court. *Archives photographiques, Paris.*

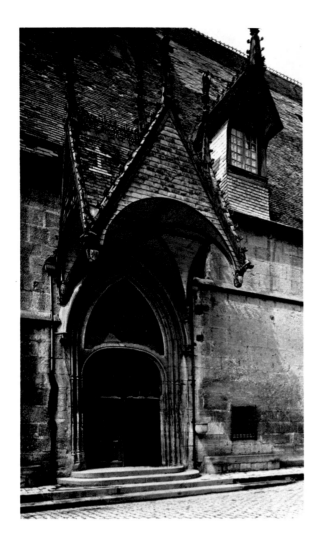
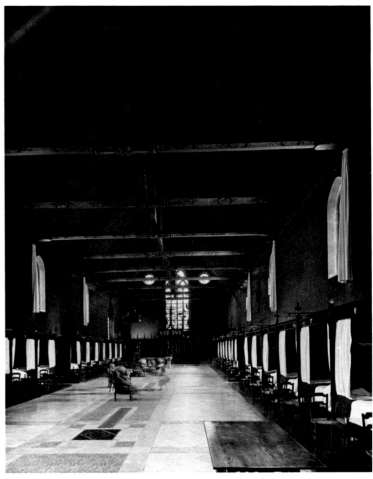

33. (L) Beaune, Hôtel-Dieu, portal. *Archives photographiques, Paris.*
34. (R) Beaune, Hôtel-Dieu, great hall. *Archives photographiques, Paris.*

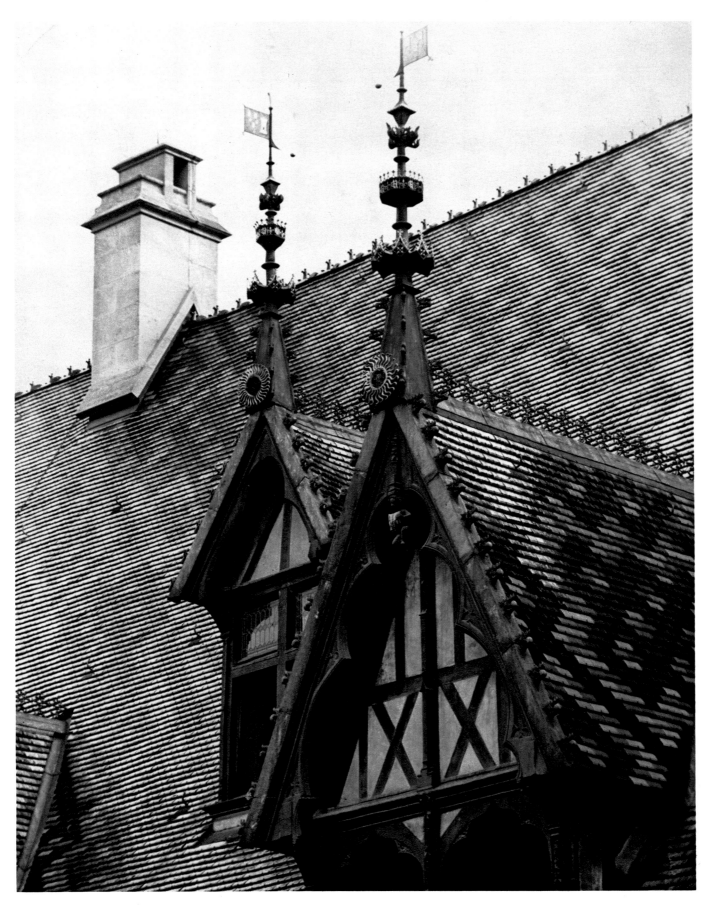

35. Beaune, Hôtel-Dieu, roof and dormers. *Archives photographiques, Paris.*

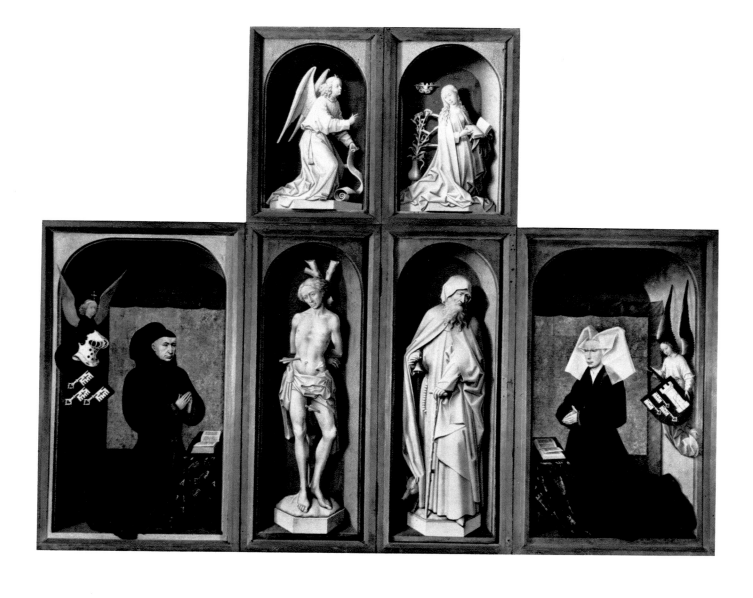

36. Rogier van der Weyden: Last Judgment altarpiece, exterior. Beaune, Hôtel-Dieu.

37. Rogier van der Weyden: St. Michael, center panel of Last Judgment altarpiece. Beaune, Hôtel-Dieu.

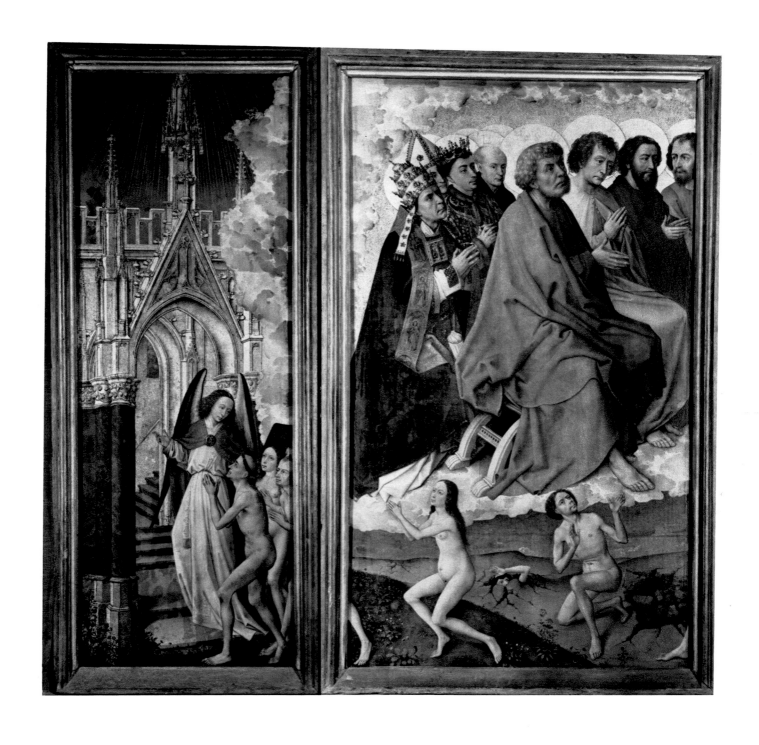

38. Rogier van der Weyden: Entrance to Paradise, two left panels of Last Judgment altarpiece. Beaune, Hôtel-Dieu.

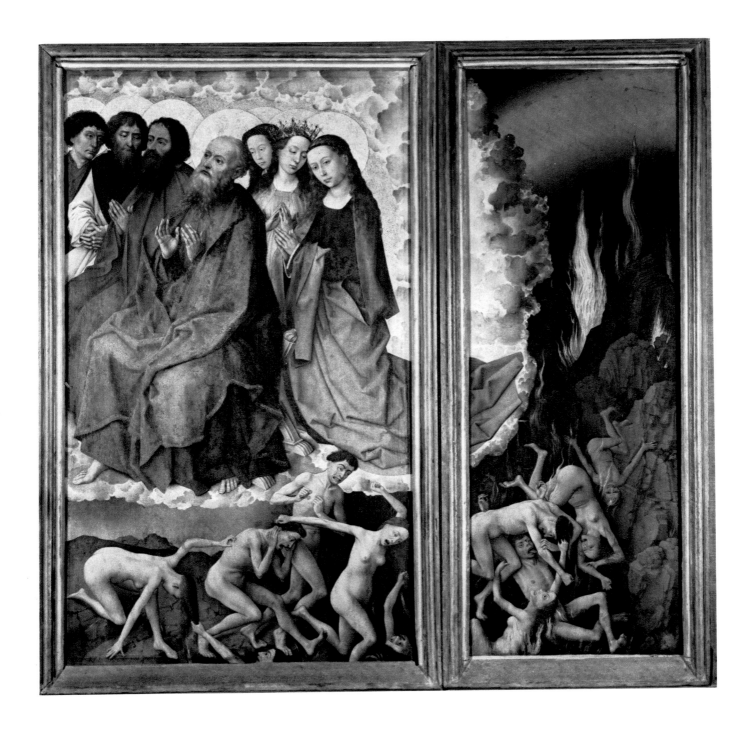

39. Rogier van der Weyden: Entrance to Hell, two right panels of Last Judgment altarpiece. Beaune, Hôtel-Dieu.

40. Tapestry of St. Anthony with the arms of the founders. Beaune, Hôtel-Dieu.

41. Parement of the Annunciation. Beaune, Hôtel-Dieu.

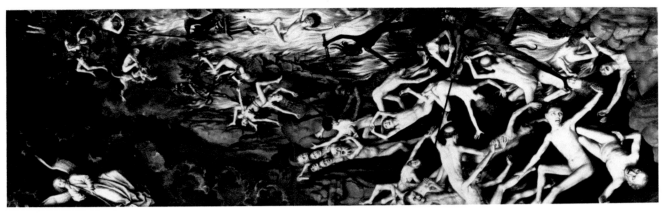

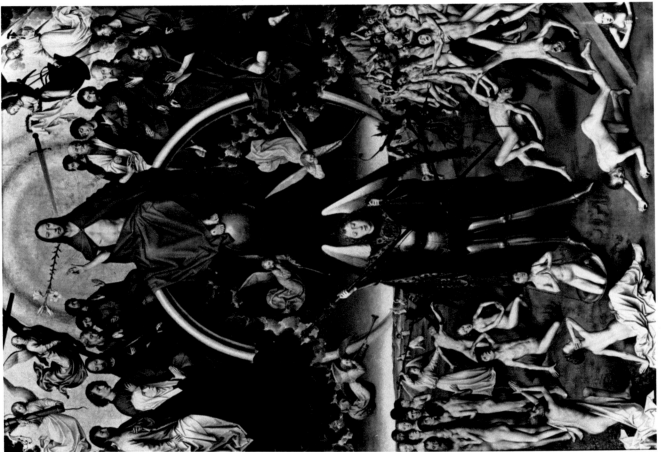

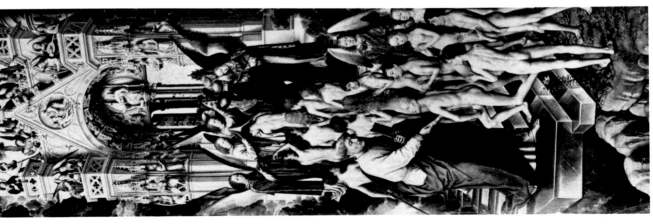

42. Hans Memlinc: Last Judgment altarpiece. Gdańsku (Danzig), Muzeum Pomorskie.

43. Follower of Rogier van der Weyden: Edelheer altarpiece, exterior. Louvain, Church of St. Peter. *Copyright ACL Brussels.*

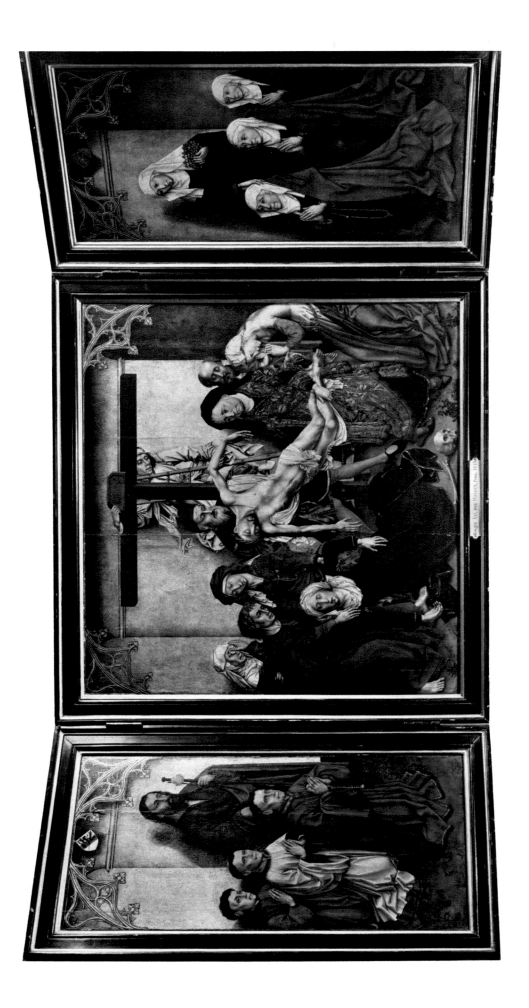

44. Follower of Rogier van der Weyden: Edelheer altarpiece, interior. Louvain, Church of St. Peter. *Copyright ACL Brussels.*

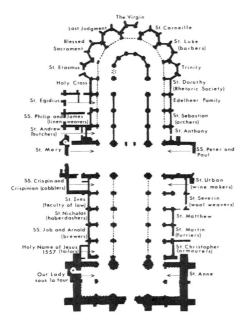

45. Louvain, Church of St. Peter, plan.

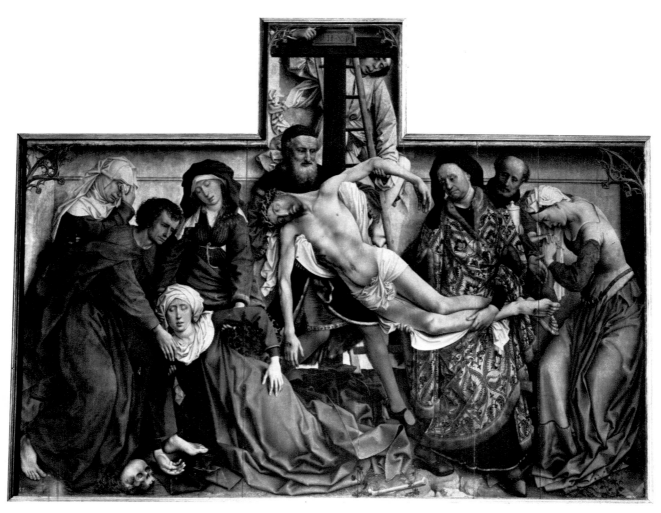

46. Rogier van der Weyden: Descent from the Cross. Madrid, Prado. *Copyright ACL Brussels.*

47. (L) Robert Campin: Trinity. Frankfurt, Städelsches Kunstinstitut. *Copyright ACL Brussels.*

48. (R) Master of the Grand Hours of Rohan: Descent from the Cross and Pietà. Princeton University Library, Robert Garrett Collection of Medieval and Renaissance Manuscripts.

49. Jean Malouel (?): Trinity with the Virgin and St. John the Evangelist. Paris, Louvre.
Archives photographiques, Paris.

50. Master Francke: Man of Sorrows. Hamburg, Kunsthalle.

51. Dieric Bouts: Blessed Sacrament altarpiece. Louvain, Church of St. Peter. *Copyright ACL Brussels.*

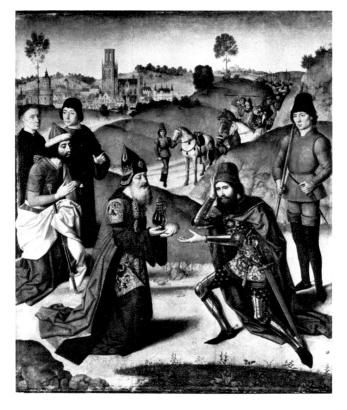
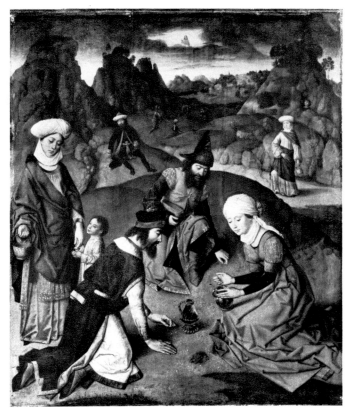
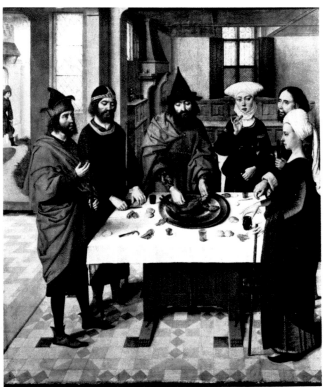

52. (L) Dieric Bouts: Meeting of Abraham and Melchizedek and Feast of the Passover, left wing of Blessed Sacrament altarpiece. Louvain, Church of St. Peter.

53. (R) Dieric Bouts: Gathering of the Manna and Dream of Elijah, right wing of Blessed Sacrament altarpiece. Louvain, Church of St. Peter. *Copyright ACL Brussels.*

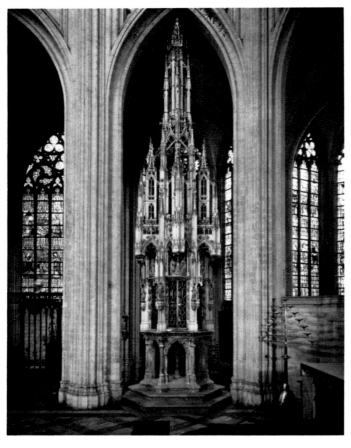

54. Matthew of Layens: Monstrance tower. Louvain, Church of St. Peter. *Copyright ACL Brussels.*

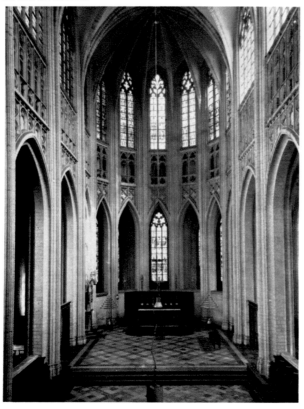

55. Louvain, Church of St. Peter, choir. *Copyright ACL Brussels.*

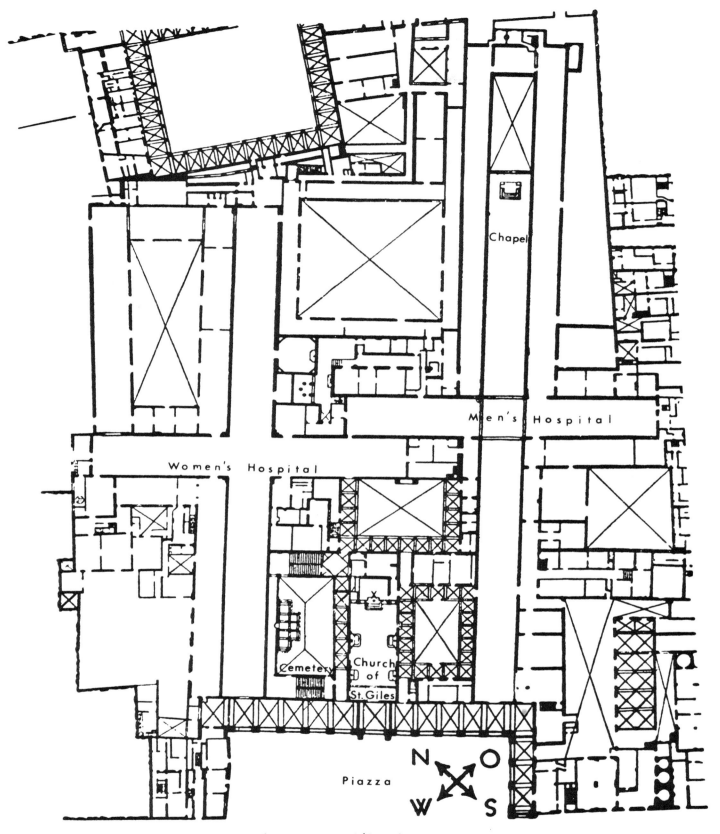

Chapel

Men's Hospital

Women's Hospital

Cemetery

Church of St. Giles

Piazza

N O W S

X Location of Portinari Altarpiece

56. Florence, Santa Maria Nuova, plan.

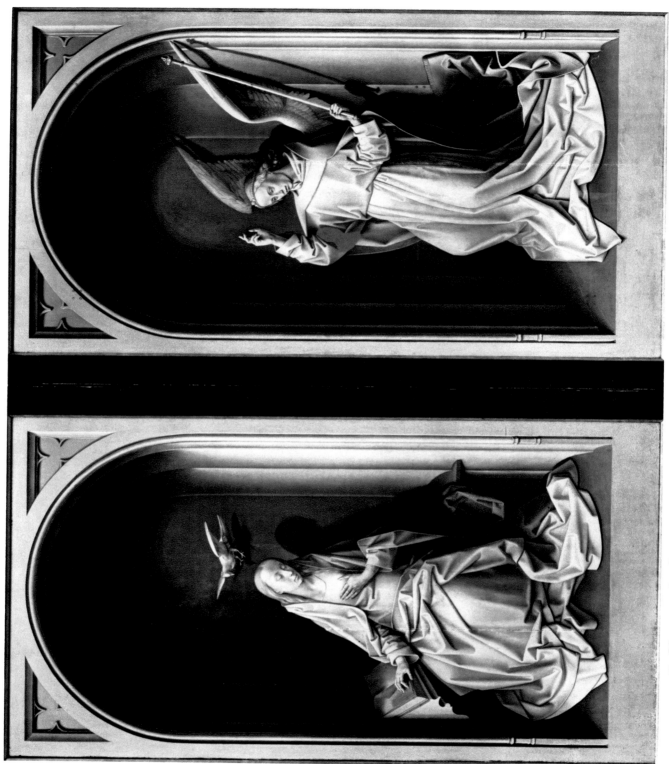

57. Hugo van der Goes: *Annunciation, exterior of Portinari altarpiece. Florence, Uffizi. Alinari.*

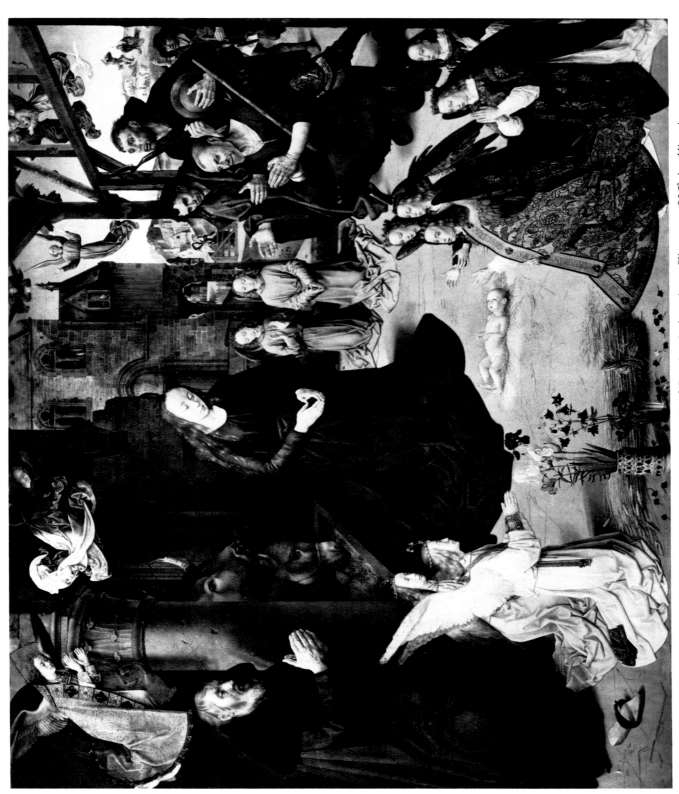

58. Hugo van der Goes: Nativity, center panel of Portinari altarpiece. Florence, Uffizi. *Alinari.*

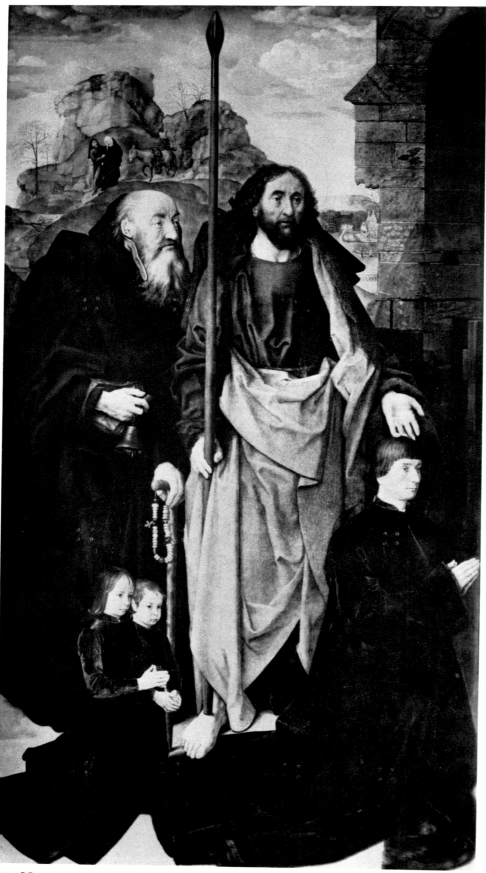

59. Hugo van der Goes: SS. Anthony Abbot and Thomas with Tommaso Portinari and his two sons, left wing of Portinari altarpiece. Florence, Uffizi. *Alinari.*

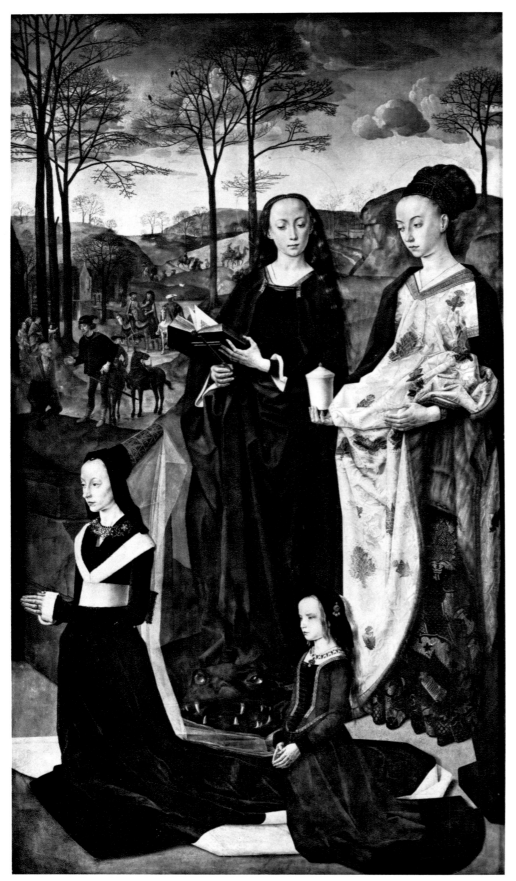

60. Hugo van der Goes: SS. Margaret and Mary Magdalen with Maria Baroncelli and her daughter, right wing of Portinari altarpiece. Florence, Uffizi. *Alinari*.

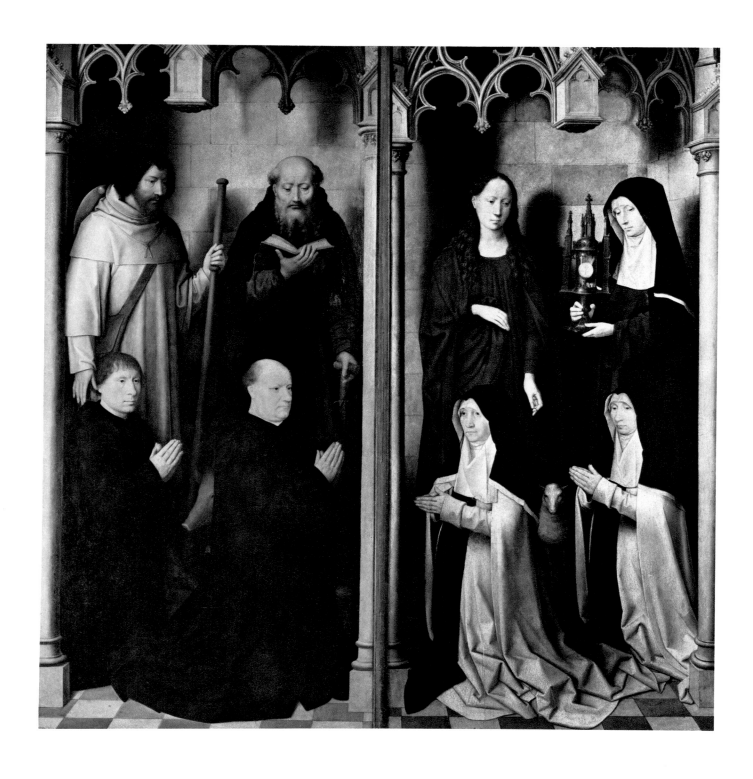

61. Hans Memlinc: SS. James Major, Anthony, Agnes, and Clare with donors, exterior of Altarpiece of the Two St. Johns. Bruges, Hospital of St. John. *Copyright ACL Brussels.*

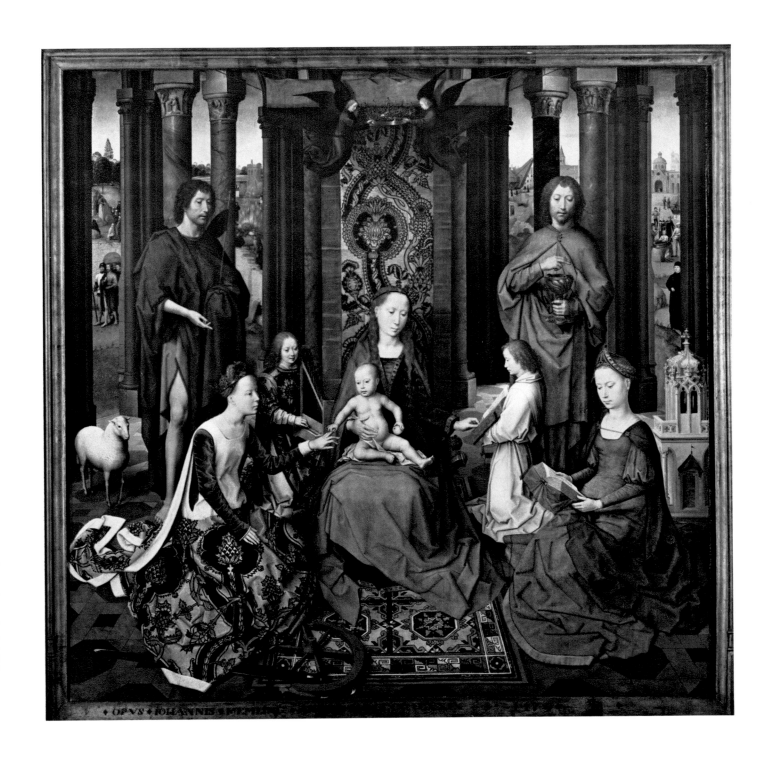

62. Hans Memlinc: Virgin with Saints, center panel of Altarpiece of the Two St. Johns. Bruges, Hospital of St. John. *Copyright ACL Brussels.*

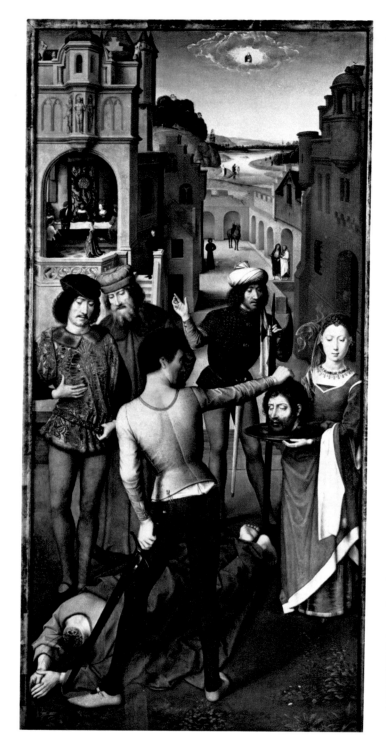 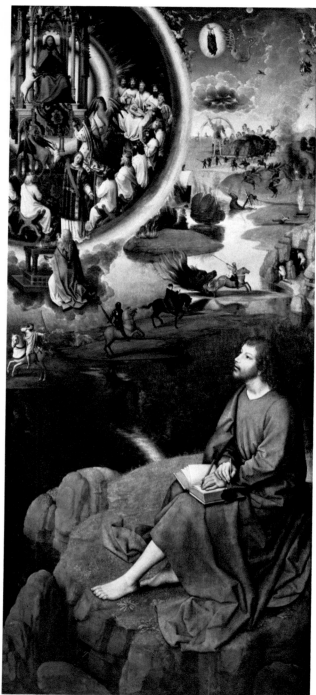

63. (L) Hans Memlinc: Beheading of John the Baptist, left wing of Altarpiece of the Two
St. Johns. Bruges, Hospital of St. John.

64. (R) Hans Memlinc: John the Evangelist on Patmos, right wing of Altarpiece of the
Two St. Johns. Bruges, Hospital of St. John. *Copyright ACL Brussels.*

65. Hans Memlinc: Sir John Donne altarpiece. London, The National Gallery. *Reproduced by courtesy of the trustees.*

66. Bruges, Hospital of St. John, infirmary. *Copyright ACL Brussels*.

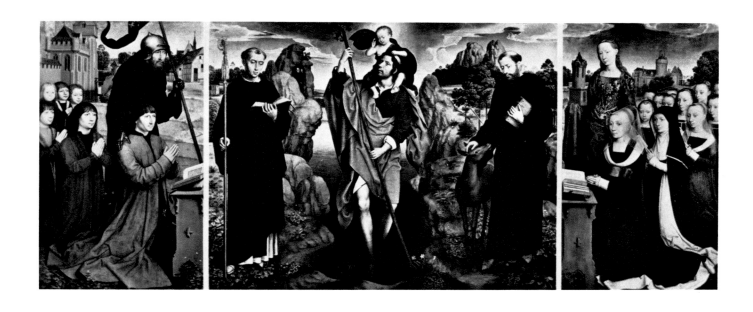

67. Hans Memlinc: St. Christopher altarpiece, interior. Bruges, Musée Communal des Beaux-Arts. *Copyright ACL Brussels*.

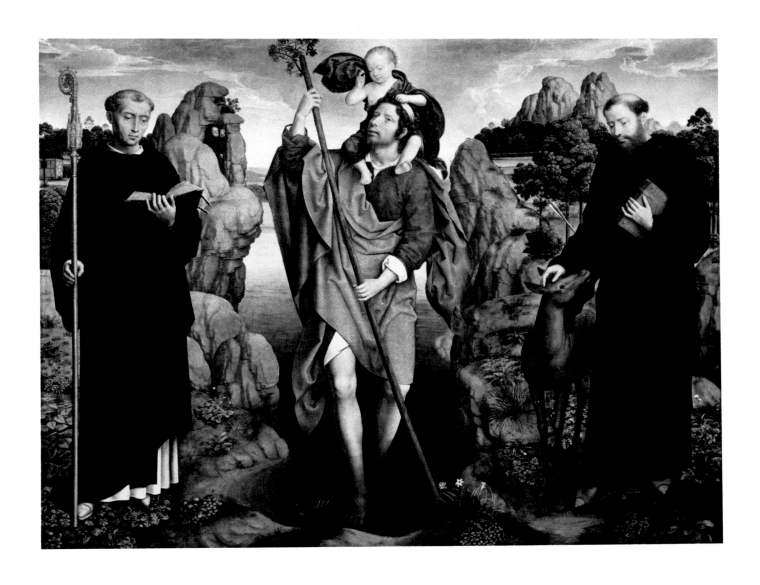

68. Hans Memlinc: SS. Maur, Christopher, and Giles, center panel of St. Christopher altarpiece. Bruges, Musée Communal des Beaux-Arts. *Copyright ACL Brussels.*

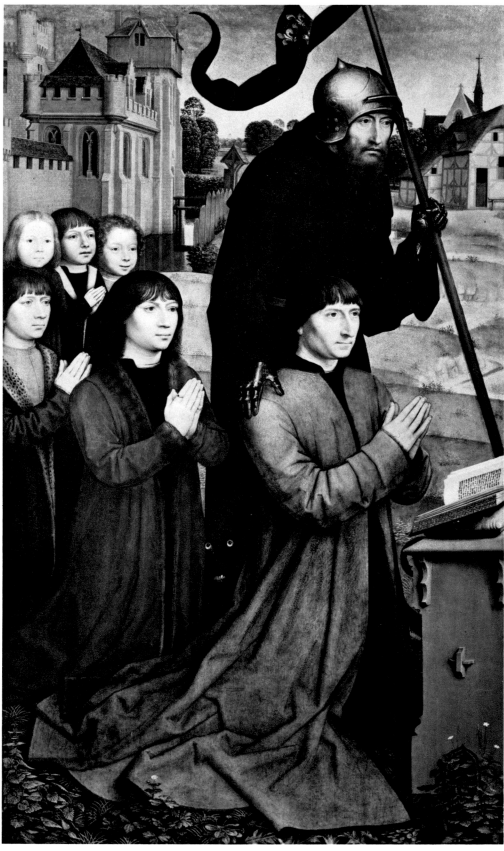

69. Hans Memlinc: St. William of Aquitaine with William Moreel and his five sons, left wing of St. Christopher altarpiece. Bruges, Musée Communal des Beaux-Arts. *Copyright ACL Brussels.*

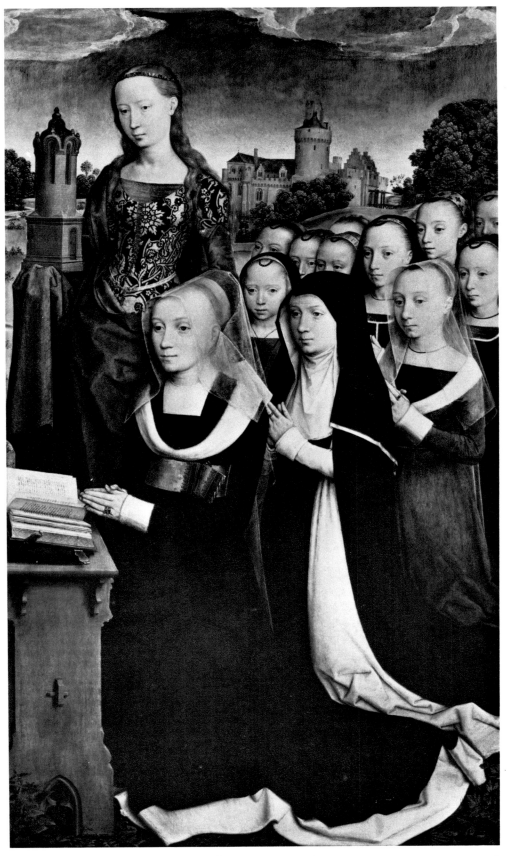

70. Hans Memlinc: St. Barbara with Barbara Vlaenderberghe and her eleven daughters, right wing of St. Christopher altarpiece. Bruges, Musée Communal des Beaux-Arts. *Copyright ACL Brussels.*

71. Hans Memlinc: SS. John the Baptist and George, exterior of St. Christopher altar-piece. Bruges, Musée Communal des Beaux-Arts. *Copyright ACL Brussels.*

72. Dieric Bouts and Hugo van der Goes: Martyrdom of St. Hippolytus, interior. Bruges, Musée Saint-Sauveur. *Copyright ACL Brussels.*

73. Follower of Hans Memlinc: Annunciation, exterior of Greverade altarpiece. Lübeck, St. Annen-Museum.

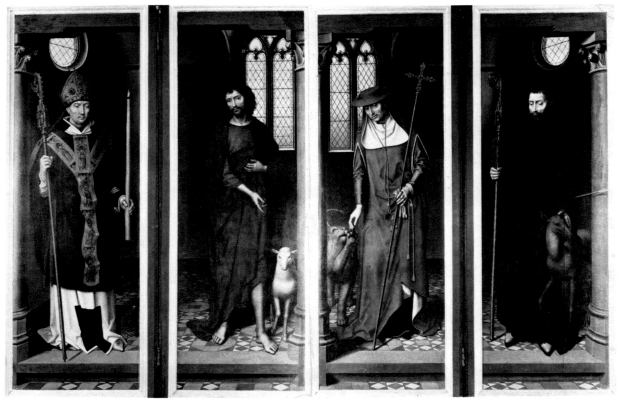

74. Follower of Hans Memlinc: SS. Blasius, John the Baptist, Jerome, and Giles, first set of interior wings of Greverade altarpiece. Lübeck, St. Annen-Museum.

75. Hans Memlinc: Scenes of the Passion, Greverade altarpiece, interior. Lübeck, St. Annen-Museum.

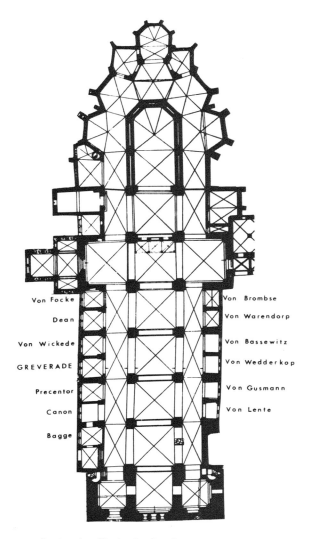

Von Focke Von Brombse

Dean Von Warendorp

Von Wickede Von Bassewitz

GREVERADE Von Wedderkop

Precentor Von Gusmann

Canon Von Lente

Bagge

76. Lübeck, Cathedral, plan.

77. (L) Herman Rode: Crucifixion diptych, exterior. Formerly in Lübeck, Marienkirche.

78. (R) Herman Rode: Crucifixion, interior right wing of Crucifixion diptych. Formerly in Lübeck, Marienkirche.

79. Hans Memlinc: Scenes of the Passion. Turin, Galleria Sabauda.

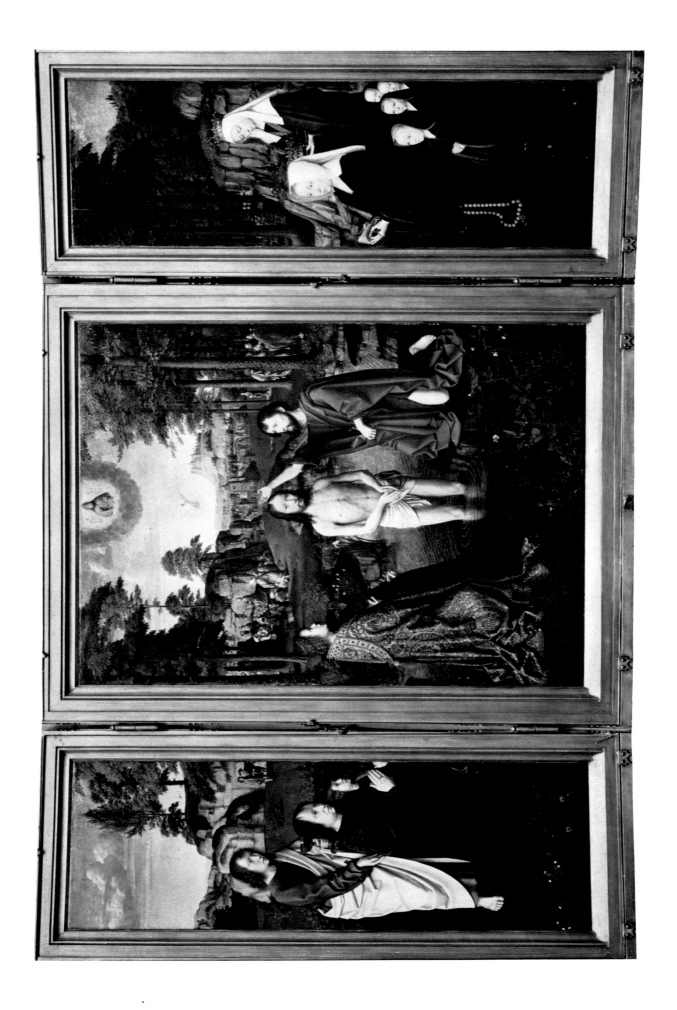

80. Gerard David: Baptism altarpiece, interior. Bruges, Musée Communal des Beaux-Arts. *Copyright ACL Brussels.*